D1440211

How to Read Contemporary Art

For Jude and Grey

Michael Wilson

How to Read
Contemporary Art

Acknowledgments
The author would like to thank the following for their
advice, suggestions, help and support: Becky Beasley,
Brooklyn Writers Space, Kevin and Jackie Broughan,
Nathan Carter and Miko McGinty, Lauren Cornell, Lorin
Davies, Lizzie Hughes, Master of Fine Art students at
Hunter College, City University of New York, Nicole
Lanctot, Eric LoPresti and Lisa Marie Schilling, Piers
Masterson, Hilary Robinson, Martha Schwendener,
Collin Sundt, and Clive and Jennifer Wilson.

Front Cover
**Takashi Murakami, And then, and then and then
and then and then (Abstraktes Bild), 2006.**
© Takashi Murakami/Kaikai Kiki Co., Ltd.
All Rights Reserved.

Editing
Christopher Dell

Design and typesetting
Livin Mentens

Picture research
De Lichte Cavalerie/Mieke Renders

Production
Emiel Godefroit

Colour separations and printing
ebs Editoriale Bortolazzi ste s.r.l., Verona

First published in the United Kingdom in 2013
by Thames & Hudson Ltd, 181A High Holborn,
London WC1V 7QX

British Library Cataloguing-in-Publication Data
A catalogue record for this book is available
from the British Library

ISBN: 978-0-500-97044-7

Printed and bound in Italy

To find out about all our publications, please visit
www.thamesandhudson.com
There you can subscribe to our e-newsletter, browse
or download our current catalogue, and buy any titles
that are in print.

Contents

Preface

Over the past twenty years or so – roughly the span of time covered by the art discussed in this book – the very meaning of the term *contemporary* has changed. In an increasingly (though still unevenly) globalized art world, it appears that even the linguistic centre cannot hold, that the significance of an outwardly self-explanatory term shifts according to its context. In its most basic definition, contemporary art is simply that art which is made during our lifetime. A slightly more nuanced description would distinguish it from modern art, which if measured from the earliest use of the term *postmodern,* could be considered to finish around 1970. Yet is all art that fits inside this timespan the same? Surely there is a measure of judgment at work in what we consider truly contemporary as opposed to merely extant or in progress? Thomas Kinkade, the 'most collected artist in America', is a prolific painter of sentimental kitsch who also mass-markets printed reproductions of his work. His popularity and commercial success are undeniable, yet few would claim serious critical merit for his work. Kinkade is practising in the current moment, yet seems to do so in a kind of bubble, insulated from the concerns of those artists who seek, in Ezra Pound's words, to 'make it new'.

Contemporary art is occasionally referred to as 'post-movement' art, the implication being that the stylistic groupings into which its predecessors are organized have fallen away, leaving a space in which each individual artist is free – or condemned – to steer independently. To an extent, this is an accurate characterization, yet it fails to account for the common ground that many artists who resist categorization as any kind of '-ist' nonetheless share. This book illustrates an extraordinary range of practices, yet mediums and ideas do recur. In pushing forward – or, better, *outward* – the featured artists maintain a sophisticated awareness both of art history and of the activities of their peers. The myth of the artist as lone genius, isolated from the outside world and operating without recourse to research, dialogue or collaboration, has long since been shattered. The committed contemporary artist is, on the contrary, almost invariably part of a network of curators, critics, academics, dealers, collectors, enthusiasts and, of course, other artists. And while not all use new technology in the making of their work, most employ it as an administrative tool.

Yet even this falls short of encompassing all the complexities and apparent contradictions to which a thorough formulation of contemporaneity gives rise. Standards, tastes and opinions change, and artists who suffer derision in one period may enjoy a critical rehabilitation in the next – or at least see their work stir up renewed debate. Norman Rockwell (1894-1978), for example, was a famous and talented illustrator, but was not taken seriously as an artist until New York's Solomon R. Guggenheim Museum hosted a retrospective of his work in 2001. Respected art-world figures took the opportunity (or were recruited) to reconsider Rockwell's importance, and while by no means everyone was convinced, a healthy discussion around issues of nostalgia, realism, populism and value ensued. Might a similar destiny await Kinkade? At the time of writing it seems unlikely, yet already the self-styled 'painter of light' has earned a grudging respect for the sheer scale of his operation, seen by some as a 'people's version' of Warhol's Factory, or a middle-American answer to Damien Hirst's extended product line. So while not considered serious in his own right, Kinkade may yet become a lightning rod for discussion.

This is not to argue that contemporary art is beyond value judgment, or that serious status can truly adhere to arbitrarily chosen bits of cultural flotsam and jetsam. Criteria for the success or failure of a contemporary artwork are essentially the same as those applied to one from any other era: Does it pose and prompt interesting questions?

Do its material, formal and conceptual elements work effectively with each other? Does it interact productively with its context? Does it achieve what it set out to achieve? This book focuses primarily on 'mid-career' artists, that is, those who have achieved a level of international recognition, usually through solo museum exhibitions and appearances in important biennials and surveys. Seen against the background of culture at large, this is a rarefied group indeed, yet such is the health of the art world that it is still wide-ranging in terms of background, approach, emphasis and influence. Younger artists are included when they have exercised an influence beyond their years, and older artists are included when they have remained at the centre of debate in their late careers.

A complaint heard periodically, especially in those cities with busy gallery circuits – New York, Los Angeles, London, Berlin and a handful of others – is that there is currently an art glut that has seen undeserving artists and works promoted above their just deserts. The argument becomes especially persuasive after a visit to one of the major contemporary art fairs such as Art Basel, the Armory Show or the Frieze Art Fair. Such jamborees can be profoundly dispiriting even for industry insiders; there's a feeling that only the flashiest survive and that money and status are being allowed to take priority over creativity and criticality. Yet while they accommodate a lot of bad (or at least highly ephemeral) work, the good still tends to outshine and outlast the pack.

In selecting artists for this book, then, I have not always prioritized those who are currently the most celebrated, but also those who are well regarded by other artists and who have exercised a significant influence without themselves becoming celebrities. Brian Eno once argued that the first Velvet Underground album, although it sold only ten thousand copies, was influential because everyone who bought it formed a band. Similarly, artists like Michael Asher, Cady Noland and Brian O'Doherty have left an imprint on current practice far beyond what their exhibition or sales records might suggest. Some are included because they have affected the perceptions of a broad public, in turn reforming the art world's internal operations. Damien Hirst is one obvious example; a supreme manipulator of the media, he has also succeeded in upending the routines and expectations of professional institutions such as auction houses.

Also featured are artists who have achieved significant reputations in part as a result of working within popular fields such as cinema, music and comics. These are artists who have clearly transcended the conventions of their respective genres – surely part of any definition of the contemporary. Emergent fields such as digital/net art and street art are represented too, though there is much more to discover of both. This book does not pretend to be a definitive account, but functions instead as a personal snapshot that I hope will also guide the reader in looking at and thinking about contemporary art in general. As a critic from London living in New York, my experience is naturally slanted toward those cities and their neighbours, and I make no apology for a strong bias toward work that I have experienced in person. With this very much in mind, I hope most of all that *How to Read Contemporary Art* will serve as a prompt to further exploration and discovery.

MICHAEL WILSON

Eva and Franco Mattes aka 0100101110101101.ORG

Born in Italy, 1976; began collaborating in 1994, they now live and work in New York, USA. The Matteses have been the subject of solo exhibitions at Galerija Vžigalica, Ljubljana; [plug.in], Basel; Postmasters, New York; and Carroll/Fletcher, London. Their work has also been included in group shows and biennials at Lentos Kunstmuseum, Linz; New Museum, New York; NTT ICC Museum, Tokyo; and MoMA PS1, New York. Their work is represented in the collections of the Walker Art Center, Minneapolis, and Museum für angewandte Kunst, Vienna.

In 'The National Anthem', an instalment of the British television drama series 'Black Mirror', a princess is abducted and held for a curious and disturbing ransom. In order to secure the royal's safe release, the anonymous kidnapper demands that the Prime Minister has sex with a pig on live television. After a failed attempt at simulation and at the mercy of public opinion, he is eventually forced to comply. Once the captive is set free, it emerges that the bizarre crime's perpetrator, who confesses his guilt in a suicide note, was an artist named Carlton Bloom, and that the disturbing broadcast was to be considered his final work. The story, a dark satire on the power of instant mass communication, was written by critic and satirical screenwriter Charlie Brooker, but the highly mediated territory it describes has also been mapped extensively in the work of Eva and Franco Mattes aka 0100101110101101.ORG.

In Darko Maver, 1998–2000, the Matteses invented their own fictional artist, harnessing the power of rumour to initiate a complex hoax that unfolded over the course of two years, convincing not only their professional colleagues but also the mainstream news media. The backstory, which spread virally through the European scene on the basis of an illustrated website, described a tortured character who produced a succession of grotesquely violent figure sculptures while wandering homeless through Yugoslavia. Copies of these provocative works found their way into several exhibitions and were even included in the Venice Biennale, adding to the controversy around their maker's name and persona. It was only in 2000, after Maver had supposedly died in prison, that the iconoclastic personality was revealed as a fabrication.

A similar stunt formed the basis of No Fun, 2010, an online performance for which the Matteses simulated Franco's suicide in the webcam-based chat room Chatroulette, later presenting a documentary video of the chillingly convincing scenario alongside participants' real-time responses. As the artist's body appears to hang lifeless in his studio, viewers observing the scene at random are thrown into various states of disbelief, hilarity and horror. A mordant commentary on our voyeuristic appetite for humiliation, No Fun is every bit the equal of Brooker's drama, and perhaps the more effective work in its genuine interweaving of simulation and veracity.

While 0100101110101101.ORG often takes aim at the internal rules and hierarchies of contemporary art, it also targets the world at large.

As pioneers of net art and 'culture jamming', the Matteses have made such edgy territory their own, approaching the Web as a medium with the potential to facilitate an endless variety of mischievous and subversive interventions. Crucially, however, the duo does not confine its activities to the virtual realm but employs the structure of the Internet as a model for affecting real spaces, institutions and individuals. And while 0100101110101101.ORG often takes aim at the internal rules and hierarchies of contemporary art, it also targets the world at large; in 2003-2004's 'Nike Ground' series, it erected a slick informational pavilion that helped convince the population of Vienna that Nike had contrived to purchase the city's historic Karlsplatz and planned to rename it in their own honour.

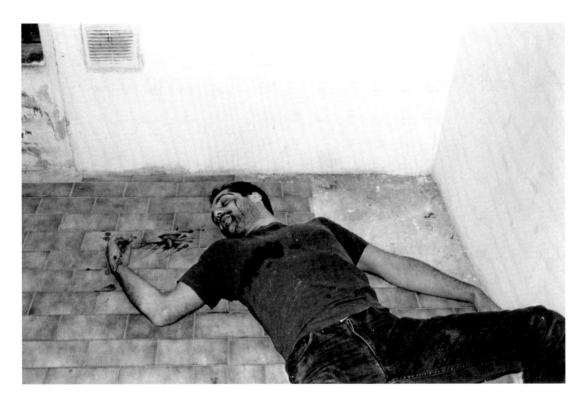

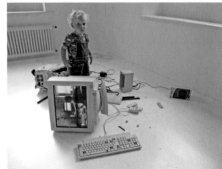

My Generation, 2010. Video collage, broken computer.

No Fun, 2010. Online performance, HD colour video with sound, 15 minutes 46 seconds.

Adel Abdessemed

Born in Constantine, Algeria, 1971; lives and works in Paris, France. Abdessemed has been the subject of solo exhibitions at Le Magasin-Centre National d'Art Contemporain, Grenoble; San Francisco Art Institute; and Liberia Borges Institute for Contemporary Art, Guangzhou. He has participated in biennials in Havana, Venice, Lyon, Istanbul and São Paulo, and is represented in the collections of, among others, MAMCO, Geneva, and Fundación NMAC Montenmedio Arte Contemporáneo, Vejer de la Frontera, Spain.

Adel Abdessemed has a habit of whipping up controversy in an art world that likes to think of itself as unshockable. His 'Don't Trust Me', a 2008 exhibition at San Francisco Art Institute that included a video depicting the slaughter of horses, pigs and other animals, elicited protests that led to the show's closure after just five days. And his video *Usine*, 2008, which shows dogs, mice, roosters, snakes and scorpions fighting it out in a pen, enraged many viewers when it was first shown at David Zwirner in New York. The debate around such works has even given rise to proposed legislation: the Humanitarian Art Ordinance, passed in 2009 by a council in Southern California, states that artwork should be deemed illegal when its maker has caused, created or contributed to animal abuse in the process of its making.

In spite of such responses, Abdessemed remains unapologetic about his embattled stance. 'I do not live between two cultures. I am not a post-colonial artist. I am not working on the scar and am not mending anything. I am just a detector,' he says. 'In the public sphere, I use passion and rage, nothing else. I don't do illusions.'[1] Employing a wide range of media from sculpture and installation to photography and video – and sometimes working on a monumental scale – he engineers public situations (he calls them 'acts') that are documented in images and objects. His early works in particular confront taboo subjects around religion and politics head-on, and the violence that shadows everyday life remains a consistent theme.

Adel Abdessemed has a habit of whipping up controversy in an art world that likes to think of itself as unshockable.

In refusing to shy away from unpleasant subject-matter, Abdessemed shoulders all the difficulties attendant on the 'moral' artist – including accusations of immorality.

Abdessemed has an easier time of it when he steers away from animals to place human beings and our troublesome creations at the centre of his work. *Habibi*, 2003 (the title translates as 'beloved') is a 21-metre-long skeleton – supposedly based on the artist's own – that has been equipped with a jet engine and is displayed suspended from the ceiling like a monstrous Halloween prop. (*Messieurs les Volontaristes*, 2008, a kind of three-dimensional diagram constructed from metal tubing, outlines the shape of a coffin proportioned to house the earlier work.) Also aeronautically inspired is *Telle mère tel fils*, 2008, a twisted amalgamation of three airliner fuselages that suggests we may have tied ourselves in a technological knot.

Nowadays, of course, air travel is the locus of fears around global terrorism, a subject that Abdessemed also explores more directly in works such as *Hot Blood*, 2008. This features singer David Moss, who also collaborated with the artist on an earlier video, *Trust Me*, 2006. 'I asked him to sing a simple sentence of my devising: "I am a terrorist, you are, you I, am I, am I a terrorist?"', explains Abdessemed. 'I put him, singing this little tune, on the sidewalk outside my home, like a piece of red meat. Perhaps luckily, there were not so many people out that day....'[2]

1 The artist in Elisabeth Lebovici, 'Adel Abdessemed in Conversation with Elisabeth Lebovici', *À l'attaque: Adel Abdessemed* (Zurich: JRP/Ringier, 2007), 111.
2 The artist in Brian Sholis, '500 Words: Adel Abdessemed', *artforum.com*, 13 October 2008. http://artforum.com/words/id=21266

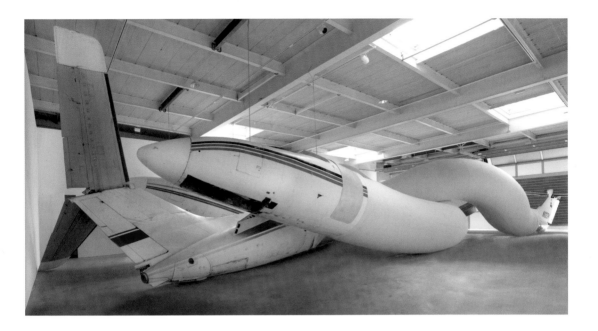

Hot Blood, 2008. Colour video with sound, 27 seconds.

Usine, 2008. Colour video with sound, 1 minute 27 seconds.

Adel Abdessemed, Habibi, 2003. Resin, fiberglass, polystyrene, airplane engine turbine, 21 m long. Installation view, David Zwirner, New York.

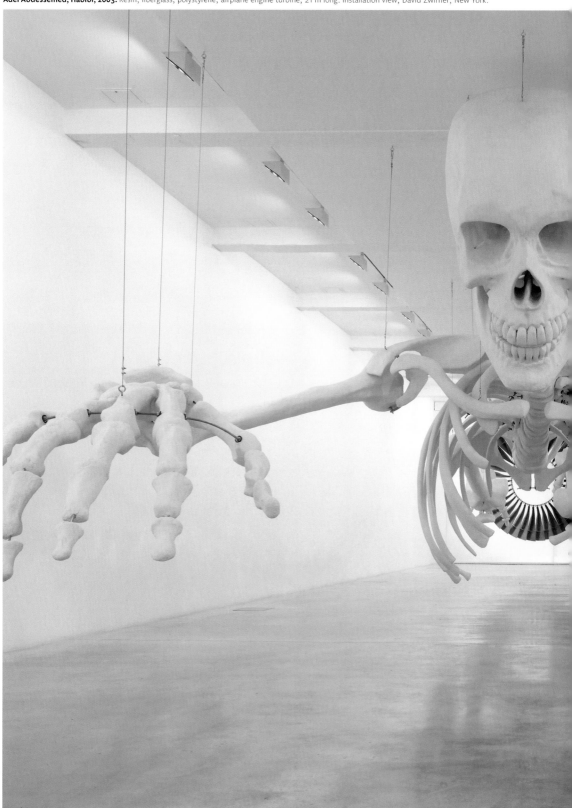

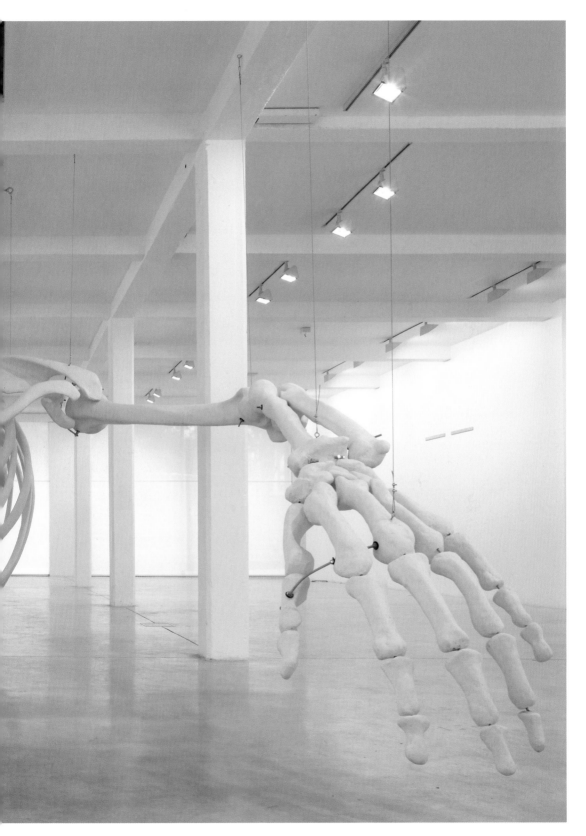

Marina Abramović

Born in Belgrade, Yugoslavia, 1946; lives and works in New York, USA. Abramović's work has been featured in numerous large-scale international exhibitions including the Venice Biennale and Documenta. In 1998, her exhibition 'Artist Body–Public Body' toured extensively, and in 2004 she exhibited at the Whitney Biennial in New York, and at the Marugame Museum of Contemporary Art and Contemporary Art Museum Kumamoto in Japan. In 2011, she was the subject of a major retrospective at the Garage Center for Contemporary Culture in Moscow, Russia.

For a performance of such outward simplicity, Marina Abramović's *The Artist is Present*, 2010, had an extraordinary power, one that utterly transcended its genre's customary marginalization. Over the three months of its duration, the work became a popular focal point – and, for some participants, something of a rite of passage. Since then, having cemented the artist's status as the *grande dame* of performance art, it has entered the canon as an example of the continued artistic potential of gesture, presence and personality. Staged during Abramović's retrospective at the Museum of Modern Art in New York, *The Artist is Present* was performed between 14 March and 31 May 2010, but survives in the form of countless visitors' photographs and videos, written and spoken testimonies.

The Artist is Present, which was executed every day that its host institution was open to the public, hinged on a stark and unusual scenario. Dressed in a flowing gown, Abramović was seated behind a small wooden table in the centre of the building's spacious atrium, her expression unwaveringly impassive. Visitors were encouraged to sit across from her for as long as they chose, engaging in a silent tête-à-tête that took on a surprising diversity of moods and meanings as word of the encounter spread. Some regarded the artist's silence as provocative, a challenge to be met with stares or laughter; others felt transported by its apparent tranquillity, or moved to tears by what they experienced as an underlying sadness.

The Artist is Present might best be understood in terms of endurance and encounter.

Abramović turned from painting to performance in the late 1960s, and her earliest forays into the medium were similarly confrontational: *Rhythm 0*, 1974, for example, saw the artist invite audience members to apply objects to her naked body in an unknowing echo of Yoko Ono's *Cut Piece*, 1964. In 1976, she met German artist Ulay with whom she collaborated for more than a decade, most famously on *Rest/Energy*, 1980, in which the pair held a bow and arrow taut so that only their balanced body weights prevented it from shooting at Abramović's heart. More recent works have explored Balkan folk culture, and a 2005 programme at the Solomon R. Guggenheim Museum in New York saw the artist re-create iconic performances by other artists from Joseph Beuys to Valie Export.

A direct address to the public through the medium of the human body in a particular space and time, *The Artist is Present* might best be understood in terms of endurance and encounter. Abramović's longest ever solo perform-ance, it immediately took its place in a lineage of creative acts designed to test the connotations and limits of strength, stamina and patience. At MoMA, through its juxtaposition with documentation and 're-performances' of past projects, the new work also made a case for performance as a collectible and preservable form. And without offering a conclusion, it drew an effective line under the artist's career to date, resonating with both her previous use of one-on-one collaboration and her consistent positioning of audiences as active agents in the realization of a work.

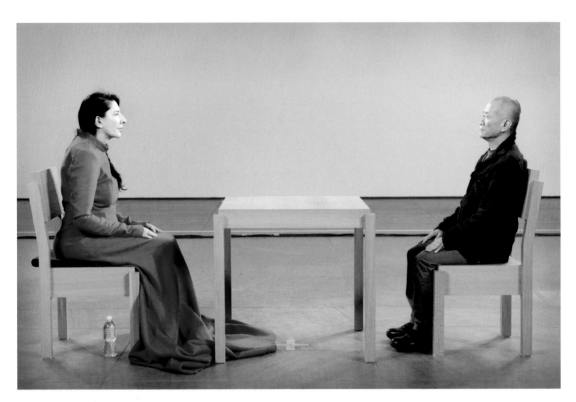

Marina Abramović performing **Joseph Beuys's How to Explain Pictures to a Dead Hare, 1965.** Performance view, Solomon R. Guggenheim Museum, New York, 13 November 2005.

Rhythm 0, 1974. 35 mm colour and black-and-white slide projection, assorted objects, duration and dimensions variable.

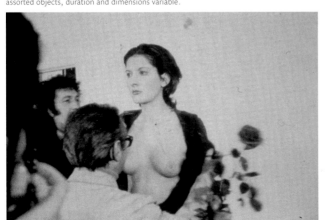

Marina Abramović and Ulay, Rest/Energy, 1980. 16 mm colour film with sound transferred to video, 4 minutes 7 seconds.

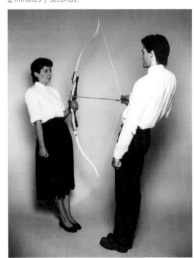

Tomma Abts

Born in Kiel, Germany, 1967; lives and works in London, England. Abts won the Paul Hamlyn Foundation Award in 2004 and the Turner Prize in 2006, and was the subject of a retrospective at the New Museum, New York, in 2008. She has been the subject of solo exhibitions at the Kunsthalle Düsseldorf and the Kunsthalle zu Kiel, both in Germany. Her work is represented in the collections of, among others, the Museum of Modern Art, New York; Tate Britain, London; and the San Francisco Museum of Modern Art.

Tomma Abts maintains the same modest scale (a portrait format measuring 48 x 38 cm) and traditional media (oil and acrylic paint on canvas) throughout her work. She also eschews source material and largely omits pre-planning, allowing abstract compositions to emerge through a process of improvisation – an approach that makes her something of a rarity among contemporary artists. The seeming restrictions that Abts imposes, combined with her embrace of chance and change, allow each painting to assume its own particular focus. And while she applies paint precisely, the decisions that she has taken in arriving at each end result are always partially visible on or through the surface of the work, contributing to a natural, almost geologic feel.

The artist's methodology is readily apparent in *Tys*, 2010 (Abts derives her titles from a dictionary of first names, and applies them only when works are complete). Employing a rich palette of saturated reds and oranges, blues and greens, Abts constructs a complex but clearly delineated form that owes something to the visual trickery of Op Art and M.C. Escher in its description of a non-existent (and perhaps unbuildable) form. A dazzling swirl of pattern, it seems suspended between movement and stasis, two and three dimensions. But *Tys*, as is the case with Abts's paintings in general, cannot be perceived fully in reproduction. Areas that seem to exist in the foreground of its depicted space may not be those that are physically closest to us. The layers of paint from which Abts has constructed the image fight against the possibility of it representing something we might touch, generating a tension between solid actuality and flat illusion.

Despite a uniformity of format and style, each canvas presents its own world.

Abts typically works on several paintings at any given time and devotes serious consideration to their sequencing and placement within an exhibition, but it would be inaccurate to think of hers as a 'serial' practice. Despite a uniformity of format and style, each canvas presents its own world with its own independent existence and its own particular atmosphere. *Tys* is no exception, and while consistent with Abts's interest in investigating – and to some extent disrupting – the 'craft' of painting, it also has an ambiguous character that speaks of broader human experience. 'I know when a painting is finished,' says the artist, 'because the painting comes alive. It suddenly has an atmosphere and makes you feel something.'[1] In this sense, *Tys* might be regarded as a psychological portrait of an imaginary subject that doubles as a reflection of the viewer.

Tys, then, occupies several positions. While it embodies a critique of the material process of painting, it also celebrates this conventional technique's continued worth. And though it was made without direct allusion in mind, it points both to other art and to cinema (Abts worked in film before becoming a painter) and graphic design. A painting 'of' nothing but itself, *Tys* conforms to the artist's ideal of a finished painting not as the solution to a particular 'problem', but as endlessly and invitingly open.

1 From an interview conducted by Jan Verwoert, 2006.

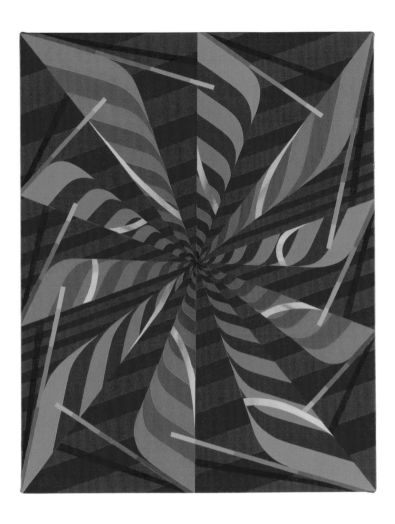

Ert, 2003. Acrylic and oil on canvas, 48 x 38 cm.

Feio, 2007. Acrylic and oil on canvas, 48 x 38 cm.

Koene, 2001. Acrylic and oil on canvas, 48 x 38 cm.

Vito Acconci/Acconci Studio

Born in New York, USA, in 1940; lives and works there. Since his first solo exhibition in 1969, at the Rhode Island School of Design, Acconci has participated in exhibitions and projects worldwide. Retrospectives of his work have been held at the Stedelijk Museum, Amsterdam, and at the Museum of Contemporary Art, Chicago. He is the recipient of fellowships from the National Endowment for the Arts and the John Simon Guggenheim Memorial Foundation.

In 2003, the Austrian town of Graz witnessed the arrival of a floating structure spanning the River Mur. *Mur Island* ('Murinsel' in German) is a project by New York-based Acconci Studio. An undulating shell-like form made of steel and glass, it houses an amphitheatre and café separated by a playground-like maze of ropes and slides. Ramps connect the main structure to both banks of the river, and a water-cooled roof shelters the curving seats and stage of the 300-person capacity performance area. Built to celebrate Graz being named the 2003 European Capital of Culture – and to mark the urban waterway's long-awaited cleanup – the island makes for a startlingly futuristic addition to the landscape, and provides residents with an important resource and focal point.

Mur Island is not presented as an artwork in its own right, but neither is it an ordinary architectural commission – though it certainly makes a functional as well as an aesthetic contribution to its site. And while it has value as a building whether or not one is aware of its designer's background, familiarity with Acconci Studio's practice in general, and founder Vito Acconci's oeuvre in particular, gives it additional significance. Acconci Studio has worked on private and public building projects since 1988, treating architecture as a tool for the reinvention of space much in the manner of an installation or intervention artist. The company also represents an important phase in the career of an artist who established his reputation in the 1960s and 1970s through pioneering work in poetry, performance and video.

Acconci's projects, whether in writing, art or design, have consistently focused on the body as it occupies and negotiates space.

Acconci's projects, whether in writing, art or design, have consistently focused on the body as it occupies and negotiates space. In 1969, he began using photography to document simple physical movements, and executed performances such as *Following Piece*, in which he shadowed passers-by on the street. Other early actions relied on the arena of an exhibition; 1972's *Seedbed*, to take one notorious example, saw him masturbate beneath a specially constructed floor at New York's Sonnabend Gallery while visitors walked overhead. The themes of narcissism and gender relations explored in this confrontational work can also be found in the artist's short films. In *Three Relationship Studies*,1970, he alternately spars with his shadow, attempts to mirror the gestures of another man, and directs the movements of a naked woman's hands over her body by motioning with his own.

In the later 1970s, Acconci began producing sculptures referencing buildings and furniture, and requiring viewer participation to complete their physical makeup. It was not a vast leap to his then becoming involved in large-scale public art and subsequently, with the help of a collaborative team, architecture and landscaping. Other Acconci Studio projects with formal and thematic connections to *Mur Island* include *Personal Island*, 1992, an environmental alteration for the Floriade in Zoetermeer in the Netherlands, *Flying Floors for Ticketing Pavilion*, 1998, a set of benches for Philadelphia International Airport, and *A Skate Park that Glides the Land & Drops into the Sea*, 2004, designed for San Juan, Puerto Rico. In these and other structures, the corporeal and the constructed are uniquely intertwined.

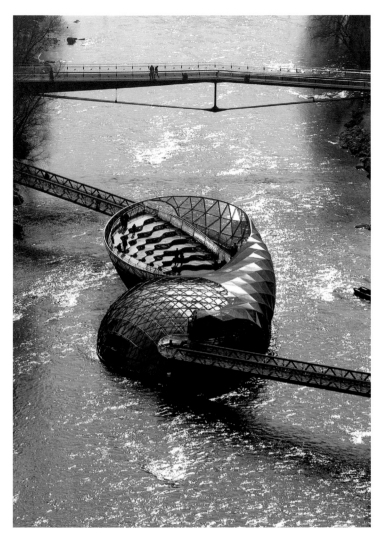

Personal Island, 1992.
Temporary installation, Zoetermeer,
the Netherlands.

A Skate Park that Glides the Land & Drops into the Sea (San Juan, Portorico), 2004.
Colour photograph.

Three Relationship Studies, 1970.
Black-and-white and colour 8 mm film transferred
to video, silent, 12 minutes 30 seconds.
Electronic Arts Intermix, New York.

Eija-Liisa Ahtila

Born in Hämeenlinna, Finland, in 1959; lives and works in Helsinki. Ahtila has received numerous awards, including the Vincent Award in 2000, and the Artes Mundi Prize in 2006. She exhibited in Documenta 11 and at the 50th Venice Biennale, and her film work has been shown frequently on European television. A retrospective of her work was held at Jeu de Paume, Paris, in 2008.

'The moving image is the medium through which people see what's happening around them and how they get information about society. It's the most common way of interpreting our society. It's no wonder that artists want to make work with moving images.'[1] For Eija-Liisa Ahtila, film is the perfect tool with which to reflect on the subtleties of human relationships as they influence and are influenced by political and social history. In work that regularly features multi-frame images and multi-tracked sound, often in the context of walk-through installations, Ahtila employs the language of cinema within an expanded artistic field. And by blending the vocabulary of narrative film with the technical traits of music video and television advertising, she also reflects on the dissolution of boundaries between contemporary mediums.

Ahtila's multi-channel video installation *Where is Where?*, 2008, connects two violent incidents that occurred during the Franco-Algerian War of the 1950s. The work's thematic starting point is the nocturnal massacre of forty male villagers by French troops, an event juxtaposed with the subsequent murder of a young French boy by two Algerian playmates, Adel and Ismael. Shifting between past and present, Ahtila also tracks the efforts of a contemporary European poet – aided by the profoundly disquieting figure of a robed and hooded Death – to comprehend what took place over half a century ago. To these three interlinked foci are added supplemental plots set in other times and places, the various elements adding up to a layered and complex whole distinguished by its powerful emotional heft.

Where is Where? reflects Ahtila's interest in addressing the divergent ways that events are interpreted by individuals and groups identified with opposing worldviews, and the ways in which these might be reconciled. But the artist is careful not to make her characters into one-dimensional spokespeople for clashing ideologies; her concern is as much individual psychology as it is issues of, as here, colonialism and its legacy. Ahtila conducts detailed preliminary research, but also discusses her oeuvre in terms of 'human drama' reliant on personal experience. *Where is Where?* reveals, as do other recent works such as *The Hour of Prayer*, 2005, an artist fascinated by the permeable and ultimately subjective nature of the divisions between people, as well as those between past and present, home and abroad.

The House, 2002. Three-channel colour video installation with sound, 14 minutes.

In formal terms, *Where is Where?* is similarly representative of Ahtila's current approach. Projected as four separate but precisely aligned images backed by a complex, interwoven soundtrack, it is further distinguished by a richness of colour that at times evokes classical painting (the grandeur of the Algerian landscape is another key ingredient in the work's immediate power). That its visual depth and compound focus encourage us to alternate between different characters, events and perspectives is not only consistent with the artist's aim of deconstructing the story first related by Frantz Fanon in *The Wretched of the Earth*, 1961, but also makes *Where is Where?* challenging and rewarding to watch.

1 From an interview with the artist by Chris Drake in *Vertigo*, vol. 2, no. 3, Summer 2002.

Sunflower Seeds, 2010

Painted porcelain. Installation view, Mary Boone Gallery, New York.

Ai Weiwei

Born in Beijing, China, 1957; lives and works there. Ai lived and studied in New York between 1981 and 1993, and has since exhibited internationally. He has been the subject of solo exhibitions at Jeu de Paume, Paris; Los Angeles County Museum of Art; Kunsthaus Bregenz; Kunsthalle Bern; Haus der Kunst, Munich; and Mori Art Museum, Tokyo. His work was featured in 'Contemplating the Void' at the Solomon R. Guggenheim Museum, New York, in 2010, and he has also participated in biennales of Venice and Sydney and the triennial of Guangzhou.

As the best-known contemporary artist in China, Ai Weiwei has borne the brunt of repeated attacks from his country's government and media. Most notoriously, in April 2011, he was placed under house arrest and spent eighty-one days in detention while police investigated what they referred to as 'economic crimes' involving back taxes and penalties. To most observers however, it was clear that what had more likely raised the authorities' hackles was Ai's outspoken support for freedom of political and artistic expression, and his critical stance toward the ruling party's record on human rights. Ultimately, Ai's ordeal only added to his visibility, landing him in *Time* magazine's annual list of the world's 100 most influential people, and at the top of *ArtReview* magazine's 'Power 100'.

When not involved in social and cultural criticism, Ai works in sculpture, installation, photography and video. He has also involved himself in a range of collaborative curatorial and architectural enterprises, establishing the experimental project space China Art Archives and Warehouse (CAAW), in Beijing in 1997, co-founding architecture studio FAKE Design in Caochangdi in 2003, and consulting with Swiss firm Herzog and de Meuron on the Beijing National Stadium for the Summer Olympics in 2008. But even when Ai exhibits in the context of an established international showcase for solo presentations, he tends to enlist other people. In *Fairytale*, made for Documenta 12 in 2007, he invited 1,001 people from all over China to Kassel in Germany, where the event takes place, and allowed them to wander around the show for its duration, framing their experience as his contribution.

***Sunflower Seeds* consists of 100 million seeds modelled in porcelain and hand-painted to closely resemble the real thing.**

In October 2010, Ai installed *Sunflower Seeds* in the Turbine Hall of Tate Modern in London. This uniquely flexible sculpture consists of 100 million seeds modelled in porcelain and hand-painted to closely resemble the real thing by artisans in the Chinese town of Jingdezhen. Scattering the seeds across the vast exhibition space, Ai encouraged visitors to walk across the work and experience it to the full (an invitation that was later withdrawn by the museum after health concerns were raised over the dangers of ceramic dust). In 2011, a 100 kg pile of the seeds sold at Sotheby's in London for more than half a million dollars, and in 2012, after a version was displayed at Mary Boone Gallery in New York, the Tate purchased ten tonnes (about eight million seeds) for its permanent collection.

Sunflower Seeds makes visual, as did *Fairytale*, the problems of overpopulation and overproduction, the invisibility of manual workers, and the implications of a drastic shift in scale or numbers. Just as *Fairytale* revealed the logistical complexities of moving and housing a large group of people, and the implications of subsuming their individual lives into a collective presentation, *Sunflower Seeds* questions the Chinese manufacturing phenomenon and what it means when specialized skills and traditional ways of living are taken for granted or ignored. They also have a political dimension, recalling images of Chairman Mao surrounded by sunflowers representing the Chinese citizenry.

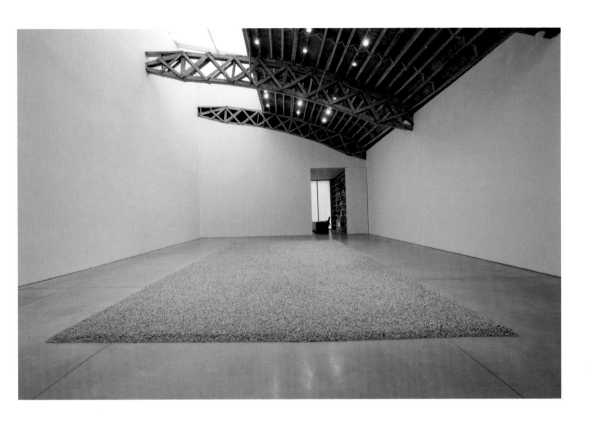

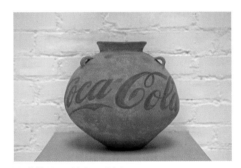

Neolithic Vase with Coca-Cola Logo, 2010.
Paint, neolithic vase (5000-3000 BC), 24.8 x 24.8 x 24.8 cm.

Descending Light, 2007.
Glass crystals, stainless brass, electric lights, 396 x 457 x 680 cm.

Template (Before Collapsing), 2007.
Wooden doors and windows from destroyed Ming and Qing dynasty houses, 718 x 1200 x 850 cm. Installation view, Documenta 12, Kassel, Germany.

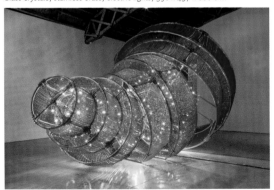

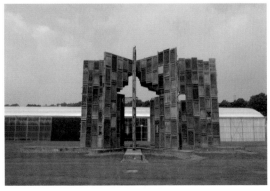

Migration, 2008

Single- or three-channel colour video installation with sound, 24 minutes.

Doug Aitken

Born in Redondo Beach, USA, in 1968; lives and works in Los Angeles and New York. Aitken has been the subject of solo exhibitions at the Musée d'Art moderne de la Ville de Paris; Serpentine Gallery, London; Kunsthalle Zürich; Kunsthaus Bregenz; and Tokyo Opera City Art Gallery. He participated in the Whitney Biennial in 1997 and 2000, and won the International Prize at the Venice Biennale in 1999. In 2011, Aitken's multiform artwork *Black Mirror* was staged on a barge off Athens and Hydra Island, Greece.

A horse raises and lowers a hoof on a salmon-pink deep-pile carpet; a deer walks up to a swimming pool, dips its head to the water, and begins to drink; a beaver slips into a bathtub, wetting its broad head under the running tap; an owl stares intently ahead, turning for a moment as the red light on a telephone blinks on and off; a door creaks open and a fox pads in. In these scenes from Doug Aitken's video installation *Migration*, 2008, two worlds collide. The unexplained presence of wild animals in ordinary and otherwise empty hotel rooms creates a powerfully dreamlike impression that is heightened by rhythmic editing, hypnotic music, and phased projection across several screens. Images of animals migrating en masse – birds flocking together, horses galloping in their hundreds across dusty plains – are interspersed with solitary interior shots, making the eeriness of the latter still more imposing.

The unexplained presence of wild animals in ordinary and otherwise empty hotel rooms creates a powerfully dreamlike impression.

Migration was first shown on the façade of the Carnegie Museum of Art in Pittsburgh during the 2008 Carnegie International, and was subsequently projected onto billboards at 303 Gallery in New York and Regen Projects in Los Angeles. A lyrical essay on naturalness and artifice, the gulf between humans and animals, and the generic, transitory nature of contemporary American architecture, its surreal tone and lush, cinematic style contribute to an immediate impact and a lengthy afterlife in memory. The first instalment of a three-part cycle titled 'Empire', it typifies the scope of its maker's ambition, and his thoroughgoing attention to detail. While he also makes photographs, sculptures and audio works, Aitken has since the mid-1990s employed the large scale and complex orchestration that characterize *Migration* to expand the parameters of the video medium, and to reflect more completely and affectingly the diffuse, fragmented nature of modern urban life.

In *Electric Earth*, 1999, which won the International Prize at the Venice Biennale, Aitken draws on a range of established forms including music video and narrative film to create a modern fable in which the unceasing flux of technology becomes a kind of ambient music. Spread across eight screens in three rooms, the work follows a young man on his journey through the city after dark, and its critical and popular success established Aitken's reputation for immersive integrations of psychological and architectural space. More recent projects have seen the artist elaborate further on this formal-conceptual conjunction. *Sleepwalkers*, 2007, for example, centres on a series of interlocking vignettes that were projected around and onto the exterior of the Museum of Modern Art in New York. Presented in conjunction with a programme of live events inside the building, the work tells the stories of five individuals from the moment they wake up in the morning but again dispenses with linear narrative, allowing viewers to enter and leave the work at different points. While operating within outwardly tighter constraints, and speaking the visual language of confinement, *Migration* hinges on a similar openness to imaginative interpretation.

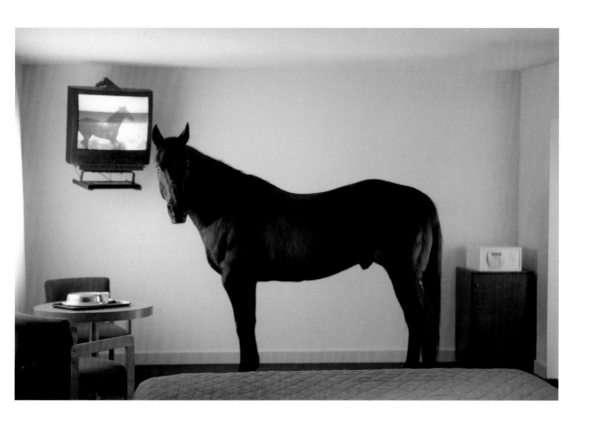

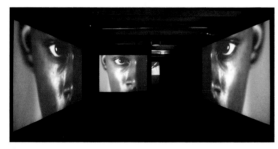

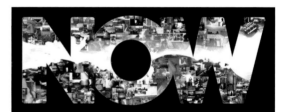

Electric Earth, 1999. Colour film with sound transferred to eight-channel video, 9 minutes 50 seconds.

Now, 2009. LED-lit lightbox, 109.2 x 335.3 x 20.3 cm.

Sleepwalkers, 2007. Six-channel outdoor video installation, colour with sound, 13 minutes. Installation view, The Museum of Modern Art, New York.

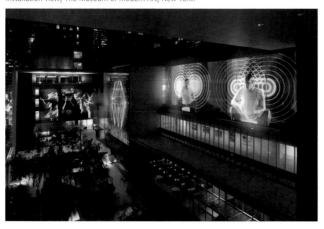

Chantal Akerman

Born in Brussels, Belgium, in 1950; lives and works in Paris, France, and Boston, USA. Akerman started making films in the late 1960s and began to work with video installation in 1995. She has made over forty works – including 35 mm features, video essays and experimental documentaries – and has exhibited at the Venice Biennale and Documenta. Her solo exhibition 'Chantal Akerman: Moving through Time and Space' toured major American museums in 2008, and a retrospective of her films toured Brazil in 2009.

Chantal Akerman, whose mother was a Holocaust survivor, adopts a sophisticated documentary mode to confront the spectres of personal and cultural history. A director of commercial feature films, Akerman also makes experimental works, including complex video installations designed for gallery display. *To Walk Next to One's Shoelaces in an Empty Fridge*, 2004, which incorporates three separate projections and occupies multiple rooms, is one such project. On two connected screens, the artist and her mother are shown discussing Chantal's late grandmother who died at Auschwitz. A third screen made of translucent fabric is suspended in front of the others and shows diary entries that Akerman's grandmother wrote as a teenager. As Chantal and her mother read and discuss these intimate accounts, we observe their stricken reactions.

Our prior knowledge of the diarist's fate – it is also communicated in a new text by the artist projected in an introductory space – makes it particularly affecting to watch the artist and her mother struggle to come to terms with their common heritage. The Holocaust has been the subject of countless works of art, but Akerman's avoids cliché by fusing an individual relic with its ongoing legacy. As the reading and conversation progress, we learn more about the writer's Jewish roots and courageous temperament, but also about her fear and loneliness in a desperate situation. And by doubling and blurring the image, the artist also reminds us that individual viewpoints on historical events inevitably differ from each other and suffer from distortion, especially when those events are inflected by the shortcomings of individual and collective memory.

Akerman first established her reputation with a more conventionally presented but equally affecting film, *Jeanne Dielman, 23 Quai du Commerce, 1080 Bruxelles*, 1975. Over more than three hours, this immersive drama explores in exacting detail the day-to-day relationship between a young widow – who turns out to be a prostitute – and her teenage son. When Jeanne murders one of her clients, the violent crime feels all the more shocking in contrast with the slow, measured pace of the action up to that point, and all the more memorable for Akerman's unabashedly feminist perspective. *Jeanne Dielman* is a difficult watch, but earned its maker deserved and enduring respect as an uncompromising auteur in the vein of Jonas Mekas and Jean-Luc Godard.

Akerman addresses her avant-gardist influences directly, and with knowing wit.

In a few more recent works, Akerman addresses her avant-gardist influences directly, and with knowing wit. The five-channel video installation *Women from Antwerp in November*, 2008, for example, which was originally produced for a multimedia presentation by Jan Fabre, gives a cheeky nod to Godard's obsession with stylish European girls. In twenty short sequences, the artist portrays a chain of young female smokers as they light up in parks and on street corners, so archly self-aware in their pouting cool that the whole idea of smoking seems to go from the sublime to the ridiculous and back again in the space of twenty minutes. Where *To Walk Next to One's Shoelaces* is meditative and solemn, *Women from Antwerp* slides joyfully down the surface of things.

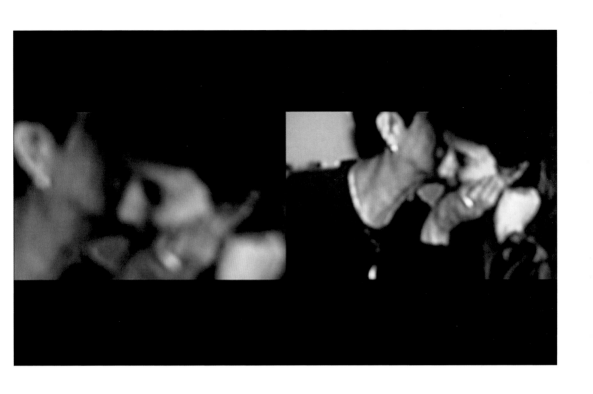

Women from Antwerp in November, 2008.
Five-channel colour video installation with sound, 20 minutes.

Jeanne Dielman, 23 Quai du Commerce, 1080 Bruxelles, 1975.
Colour 35 mm film with sound, 3 hours 21 minutes.

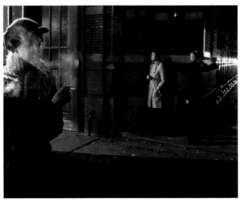

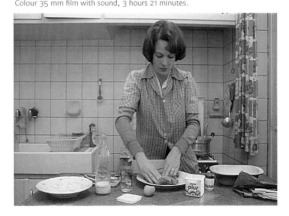

Richard Aldrich

Born in Hampton, Virginia, USA, in 1975; lives and works in New York. Aldrich was the subject of a survey at the San Francisco Museum of Modern Art in 2011. He has also been featured in exhibitions including 'Richard Aldrich and the 19th Century French Painting' at the Contemporary Art Museum St. Louis; 'Rational Abstraction' at Centro Galego de Arte Contemporánea, Santiago de Compostela; and 'Time Again' at the Sculpture Center, New York. He has performed at venues including the Palais de Tokyo, Paris, and the Kitchen, New York.

The success of Richard Aldrich's loose-limbed mixed-media paintings is difficult to quantify; they often appear to be on the verge of collapse, half-finished, sometimes barely even begun. Hinging on internal contradiction and incongruity, they are also presented as components of what the artist characterizes as a grouping of systems, a totality that is 'not about a balance or a thought, a final idea or an idealized end, nor a perceived direction, but rather a body in which things are happening – aesthetic things, slow things, long drawn out jokes, sad truths.' They are, he contends, 'props' in an open-ended drama that implicates and reflects both artist and viewer. Alluding to chance but exercising a judicious editorial touch, Aldrich ultimately conveys what critic Roberta Smith has described as 'an understated, almost visionary fervour'.

The cumulative impact of Aldrich's work makes singling out a representative example problematic. Which should we consider to be more 'characteristic' of his practice: a painterly abstraction like *Untitled (Large)*, 2008, with its map-like field of dark shapes floating in a grey-brown sea, or a quasi-sculptural play on the medium's structural conventions such as *Future Painting #1*, 2008, with its white muslin pulled over an eccentrically shaped stretcher? Perhaps a paean to a fellow artist such as *Homage to Daan van Golden*, 2011, with its shadowed blue capitals spelling out the word PAINTING on an upward-reading diagonal, would be more apposite? Or a canvas untouched by pigment but adorned instead with objects, like *Spirit Animal*, 2010, with its arrangement of wood, mirrored glass and patterned fabric?

That Aldrich's oeuvre exhibits such heterogeneity might seem to damn him as an artist in search of a subject, or a painter solely preoccupied with formal effect. Yet influences and ideas abound in his works even when they seem to refer to nothing outside themselves. There are nods to Robert Rauschenberg in the artist's treatment of the canvas as an object to be deconstructed, and to German artist Georg Herold in his discomfiting juxtapositions of delicacy and heft. And even when his painting or construction is outwardly abstract, Aldrich provides clues via context. In the 2010 Whitney Biennial, he exhibited found-object sculptures alongside paintings, allowing their associations to complicate the narrative at large – thus *Gift*, 2009, a boxed set of Marcel Proust's *In Search of Lost Time*, coloured an otherwise elusive suite with reflections on memory and loss.

The thinking behind Aldrich's work also finds expression in lengthy, elliptical statements. Introducing his 2009 exhibition at Bortolami in New York, the artist offered the following fable: 'A wanderer comes across a pile of chipped porcelain pieces. Set to work with glue, they construct an elegant saucer. When the previous owner, before they no longer had a use for it, first found the pile of chipped porcelain pieces they had constructed a tea cup, and the owner before them a figurine of Adonis. Thus is the nature of history: many pieces always being found and then reconstructed.'

Untitled (Large), 2008.
Oil, wax and matte medium on linen,
213.4 x 147.3 cm.

Future Painting #1, 2008.
Gessoed muslin on artist's stretcher,
51.4 x 33 x 5.1 cm.

Gift, 2009. Books, 132.1 x 33 x 45.7 cm.

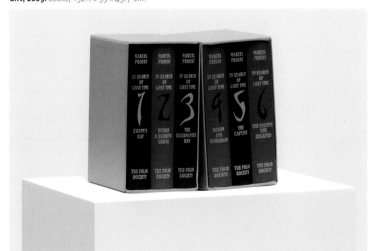

Homage to Daan van Golden, 2011.
Enamel on dibond panel, 213.4 x 144.8 cm.

Stop, Repair, Prepare: Variations on 'Ode to Joy' for a Prepared Piano, 2008

Performance with prepared Bechstein piano, pianist, 81 minutes, Haus der Kunst, Munich.

Jennifer Allora and Guillermo Calzadilla

Jennifer Allora: born in Philadelphia, USA, 1974; Guillermo Calzadilla: born in Havana, Cuba, 1971. Both live and work in San Juan, Puerto Rico. Allora and Calzadilla have been collaborating since 1995 and have exhibited at the Nasjonalmuseet, Oslo; Stedelijk Museum, Amsterdam; and Whitechapel Gallery, London. Their work is represented in the collections of the Centre Pompidou, Paris; the Museum of Contemporary Art, Chicago; and the Kunstmuseen, Krefeld. Allora and Calzadilla represented the United States at the 2011 Venice Biennale.

Jennifer Allora and Guillermo Calzadilla's first collaborative work was *Charcoal Dancefloor*, 1997, a large-scale figure drawing that gallery visitors were encouraged to walk on, thus gradually blurring the image into illegibility. Since then, the duo has continued to make films, installations, sculptures and performances that can be read as allegories of global politics. Their performance *Stop, Repair, Prepare: Variations on 'Ode to Joy' for a Prepared Piano* was first staged in 2008 at Haus der Kunst, Munich, then at Gladstone Gallery and the Museum of Modern Art, both in New York, in 2009. On the latter occasion, it was described by *The New York Times* critic Roberta Smith as 'poetic, athletic, and more than a little erotic',[1] an instant classic that combined reflective subtlety with a direct appeal to the senses.

To 'prepare' the early 20th-century piano used in the work, Allora and Calzadilla bored a hole through its centre big enough to accommodate a standing pianist (an act that renders two octaves of strings useless but leaves the rest fully functional) and reversed the pedals. The performer inserts him or herself into the instrument and proceeds to play the Fourth Movement of Beethoven's Ninth Symphony, famous for its 'Ode to Joy' theme. This act is complicated not only by the fact that the pianist must reach for the keyboard from an inverted and backward position, but also by the artists' requirement that he or she should continually move through the gallery, wheeling slowly across the floor according to a predetermined choreography.

The result of these impositions is a radical revision of a piece that has accrued many diverse associations since its completion in 1824. Allora and Calzadilla singled out Beethoven's epic composition because aside from being one of Hitler's favorite pieces of music and later the national anthem of Rhodesia under apartheid, it was also endorsed by the Chinese during the Cultural Revolution and is now the anthem of the European Union. That the 'Ode' has been allied with such contradictory agendas makes it of particular fascination to artists with an interest in how creative projects lose their initial autonomy to external forces. In *Stop, Repair, Prepare*, Beethoven's tune remains recognizable but is mutated; its evocations of unity and fraternity also persist, but in similarly altered form, reopening these ideals to question.

Photographer unknown, John Cage, c. 1940.

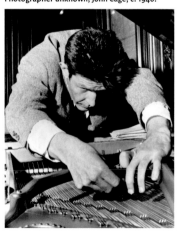

But the work is not a cold conceptual exercise. It is concerned with immediate experience as well as with the history of thought and expression. And while the artist's alterations bring to mind a host of creative precedents, from John Cage's foundational experiments in forcibly extending the piano's range to Gordon Matta-Clark's drastic alterations to urban buildings, it does not lean on any of them too heavily. 'Music is very important to us in terms of how it triggers feelings,'[2] says Calzadilla, and *Stop, Repair, Prepare* is, crucially, a sculptural-musical presentation with the power to evoke a gut reaction, whether or not one also takes stock of its fascinating intellectual implications.

1 Roberta Smith, 'I Just Popped Out to Play Beethoven', *The New York Times*, 9 December 2010.
2 From *Behind the Scenes: Performance 9: Allora & Calzadilla*, a video produced by Ben Coccio for the Museum of Modern Art, New York, http://www.moma.org/explore/multimedia/videos/132/825

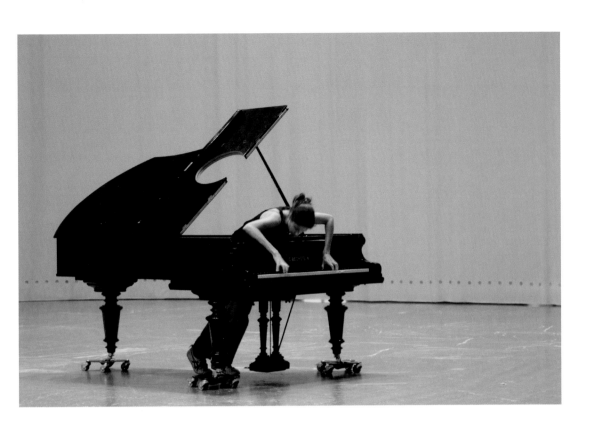

Under Discussion, 2005. Single-channel colour video with sound, 6 minutes 14 seconds.

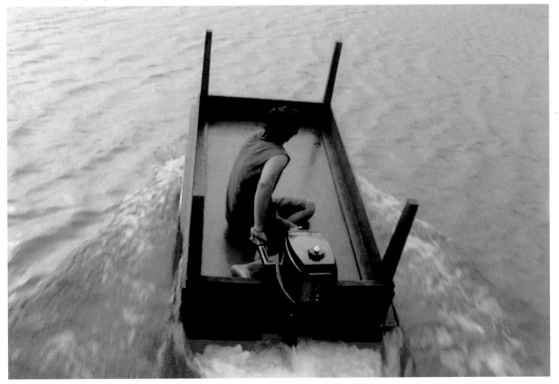

Ellen Altfest

Born in New York, USA, 1970; lives and works there. Altfest received her MFA from Yale University School of Art in 1997 and has been the subject of solo exhibitions at the Chinati Foundation, Marfa, Texas; White Cube, London; and Bellwether Gallery, New York. A number of her works are included in the Saatchi collection, and in 2006 she was featured in 'USA Today', curated by Charles Saatchi at the Royal Academy of Arts, London. In the same year, she received the Richard and Hinda Rosenthal Foundation Award from the American Academy of Arts and Letters, New York.

One of a handful of American artists endeavouring to revitalize the naturalist figurative tradition in painting, Ellen Altfest produces modestly sized but intensely worked canvases depicting fragments of the natural world. These have included renderings of houseplants, weeds and timber – everyday subjects that encourage an immersion in detail – as well as figure studies. Unusual in that she works directly from life rather than using photographs, Altfest enters into a concentrated engagement with the objects of her gaze, investing close observation with psychological import. Looking at or rather *into* her images, the viewer becomes lost in a kind of inner space, a silent universe of minute incident that constitutes a meditation on both the material world itself and, to quote Marcel Proust, 'the vast structure of recollection' with which it continually intersects. Yet while Altfest shows impressive technical skill, her work is never alienating because the effort that has been poured into it remains outwardly apparent.

In *Penis*, 2006, Altfest confronts the viewer with a close-up view of the male member. A section of the paint-splattered chair on which the model sits is visible in front of him, but there are no further clues to either context or identity. We are left with no choice but to examine the subject with almost scientific objectivity, almost as if it were a laboratory specimen. There is no variation of focus in the work; every surface is described with equal attention, every hair, vein, blemish, wrinkle and change in skin texture and hue. Yet this intimate portrait is not quite photorealistic; the artist's hand is apparent in any number of small stylistic decisions, which together lend the painting a vital human warmth. Thus *Penis* combines the traits of a figure painting with those of a still life and even an abstract experiment; it alludes to sexual desire in its obsessive, exclusive bodily focus, but is concerned equally with the endless mutability of paint – and of representation itself.

Penis was first shown in an exhibition titled 'Men' that Altfest curated for the New York gallery I-20 in 2006. On that occasion, critic Jerry Saltz compared the painting to Gustave Courbet's notorious depiction of female genitalia, *The Origin of the World*, 1866, also noting stylistic echoes of American painters Andrew Wyeth and Philip Pearlstein in Altfest's fidgety brushwork. He might equally have evoked divisive depictions of the penis (or its substitutes) in works by Lynda Benglis and Robert Mapplethorpe, or pointed out resemblances to paintings by British artists Lucian Freud and Stanley Spencer (the latter's *Double Nude Portrait*, 1937, in particular). Yet while Altfest's take on her subject may seem almost academic in its treatment as just another form, it has, for the same reason, a feminist edge. Altfest's eye is so unforgiving that anatomy becomes personal politics. We may not quite be able to read the subject through his organ (that would require a very different artist, or an especially perceptive viewer) but we are made aware of a particular working relationship – woman paints man – that is still rather rare.

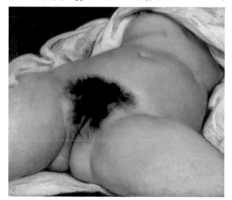

Gustave Courbet, The Origin of the World, 1866.
Oil on canvas, 46 x 55 cm. Musée d'Orsay, Paris.

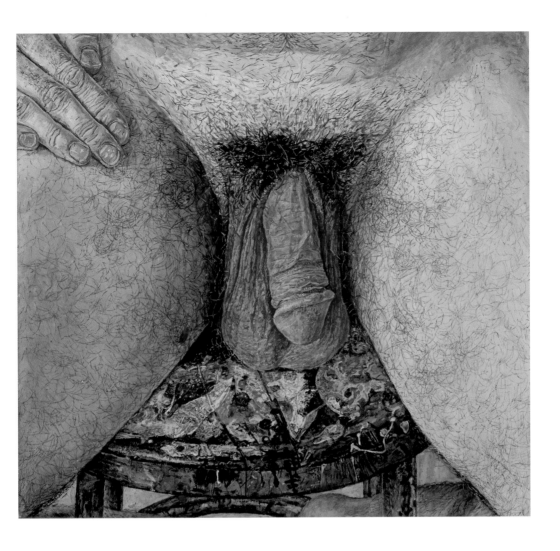

Gourds, 2006–2007. Oil on canvas, 48.3 x 96.5 cm.

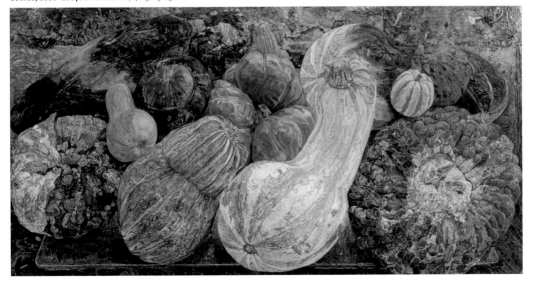

Paweł Althamer

Born in Warsaw, Poland, 1967; lives and works there. Althamer has been the subject of solo exhibitions at Modern Art Oxford; Secession, Vienna; Fondazione Nicola Trussardi, Milan; Centre Pompidou, Paris; and Zachęta National Gallery of Art, Warsaw. He has participated in biennials in Brussels, Shanghai, Berlin and Istanbul. In 2004, he was included in the Carnegie International at the Carnegie Museum of Art, Pittsburgh, and won the Vincent Award.

Paweł Althamer is best known as a sculptor - albeit one ambitious enough to produce a 21-metre long inflatable self-portrait nude (*Balloon*, 1999-2007) - but his *Common Task* project is very far from being a single discrete object. It is, rather, a series of thoroughly documented group activities that together make up a futuristic (which is to say, post-post-Communist) reimagining of the artist's milieu. Stage one is centred on the fanciful remodelling of the staircase leading to Althamer's Warsaw apartment. Stage two originates with three journeys taken to locations distinguished by their progressive or unusual architecture. And a planned stage three will see the artist and his neighbours, each watching a televised image in his or her own apartment, initiate their habitat's virtual lift-off into space by communally simulating a countdown. Participants in these events wear golden body suits that identify them as members of a group and, according to the artist, symbolically ease their passage into a panoply of alternate realms.

The first of *Common Task*'s three journeys, which took place in March 2009, saw Althamer lead a small group to the city of Brasilia. Here, artist and entourage studied the iconic modernist buildings of Oscar Niemeyer and visited the Vale do Amanhecer (Valley of the Dawn), an outré religious cult based in a temple complex just outside the city. Members of this obscure order dress in flamboyant costumes and worship a litany of figures ranging from Egyptian pharaohs to 'astral commanders'. For the second trip in March 2009, Althamer flew - in a golden Boeing 737, no less - with a larger group of 150 compatriots. Their purpose was to celebrate twenty years since the fall of Communism and this time, their destination was the Atomium in Brussels (a monument constructed for the 1958 World's Fair). For the third voyage, the artist reverted to travelling with a smaller team, visiting the Dogon people of central Mali. On this occasion, he commissioned his hosts to produce a ceremonial mask for the group.

The artist consciously overlooks the most immediate 'issues' presented by his selection of co-creators in favour of broader commonalities.

Recounting these bizarre activities - and their attendant administrative complications - in a cover article for *Artforum*, Claire Bishop astutely summarizes Althamer's methodology as a kind of 'civic dada' characterized by 'a singular approach to collaboration: one that falls outside (and exists in playful tension with) the dominant, earnestly ameliorative norm of this mode.'[1] In its dependence on multiple players, and in the absurdist situations and images to which it gives rise, *Common Task* is consistent with this view of the artist's extra-sculptural practice as distinguished by degree of risk-taking. *Common Task* is a self-consciously ragged undertaking, its loose, fluctuating structure and extended time frame practically guaranteeing variable and unexpected results. Althamer enlists 'non-expert' help in order to test and extend communication across lines of culture, politics and history. *Common Task* shares critical common ground with other group projects in which he has recruited prisoners, children and disabled adults. In each such undertaking, the artist consciously overlooks the most immediate 'issues' presented by his selection of co-creators in favour of broader commonalities - even when these run mischievously counter to the prevailing discourse.

1 Claire Bishop, 'Something for Everyone', *Artforum*, vol. XLIX, no. 6, February 2011, 176.

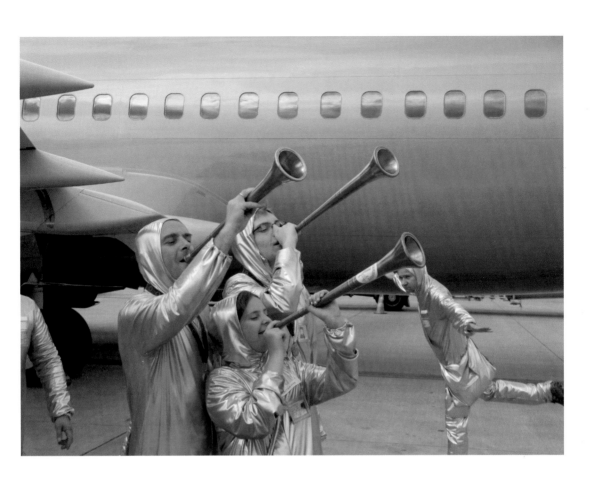

Self-Portrait, 1993.
Mixed media, 189 x 76 x 70 cm.

Balloon, 1999–2007. Nylon, polyester, acrylic, rope, helium, 2100 x 671 x 366 cm.
Installation view, Fondazione Nicola Trussardi, Milan.

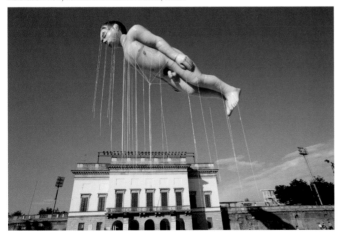

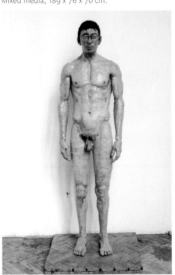

Untitled, 2007

Oil, lacquer, tempera and poster on cloth, 98.4 x 82.6 x 4.1 cm.

Kai Althoff

Born in Cologne, Germany, 1966; lives and works there. Althoff has been the subject of solo exhibitions at the Institute of Contemporary Art, Boston; Museum of Contemporary Art, Chicago; and Kunsthalle Zürich. He participated in the 1993 and 2003 Venice Biennales, and his work has been included in major group exhibitions at the Museum of Contemporary Art, Los Angeles; Saatchi Gallery, London; Museum of Modern Art, New York; Centre Pompidou, Paris; and Museum of Contemporary Art, North Miami.

Working in a confounding diversity of modes, often collaborating with others, and constantly on the move, Kai Althoff can be a challenging proposition for the uninitiated viewer. A musician as well as a painter, sculptor, photographer, videographer and performance artist, Althoff co-founded the band Workshop and is also involved with a creative advocacy group of the same name; both entities also feature in his visual work. He makes few concessions to conventional ideals of beauty or good taste, but unabashedly confronts the nastier moments of European history. Critic Jerry Saltz has described him as toeing 'a fabulously dangerous line between the conservative and the twisted, the academic and the out-there', and in his free reworkings of Romantic and Expressionist tropes Althoff steadfastly refuses to overlook the horrors and mysteries of his nation's past and present.

He makes few concessions to conventional ideals of beauty or good taste, but unabashedly confronts the nastier moments of European history.

Profiling Althoff for *Artforum* in 2002, critic Tom Holert described an artist happy to stand apart from 'obvious signifiers of "contemporaneity"', who wields 'stylistic incoherence' with contrarian gusto. Yet despite the deliberately awkward appearance of his work, Althoff is not without his influences and predecessors. Much of his work is figurative, and evokes the spectres of Egon Schiele, Otto Dix, James Ensor and other visionaries characterized by varying degrees of eccentricity. Stirring together extant political, religious and folk imagery with partially or wholly invented characters and situations, Althoff cooks up a rich mix that can border on the indigestible. Yet from what appears at first to be improvised confusion, the artist distils a highly self-aware exploration of myriad narratives suggested by his gnarled cultural-psychological milieu.

In Althoff's painting *Untitled*, 2007, two men in white coats - doctors? - stand at the foot of a bed occupied by a diminutive female figure - a child? - clad in dirty pink. A seated figure leans over holding something in her outstretched hand while other attendants hover around the edge of the frame. The colours are sickly and clashing, the composition violently off-kilter, and the figures lanky, angular, even slightly grotesque. The image as a whole exerts an emotional pull that is undeniable but hard to pin down, combining a sense of moral ambiguity with a raw, almost primitive visual impact. In this work, Althoff's instinct for storytelling is readily apparent, though as usual the scene's precise circumstances remain opaque.

While paintings like *Untitled* function as stand-alone works, they are also often seen in the context of large, rambling installations. In 'We Are Better Friends For It', Althoff's 2007 collaborative exhibition with American ex-graffiti artist Nick Z. at Gladstone Gallery in New York, several related canvases appeared alongside a host of other paintings, drawings and sculptural elements. Working together in the gallery over a period of weeks, the two artists transformed its interior into a series of quasi-domestic spaces, filling each with an array of loosely connected images and artifacts that generate a wilfully perverse commentary on the cults of youth and personality. Fully inhabiting his own artistic world, Althoff is an outsider who can also boast deep roots and a thorough sensitivity to context.

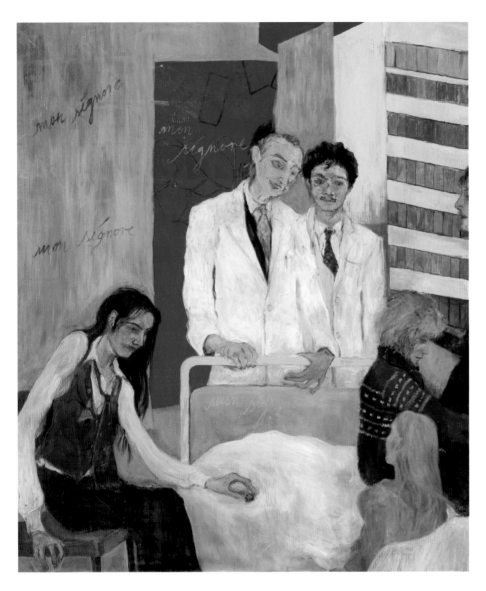

Punkt, Absatz, Blümli (period, paragraph, Blümli), 2011.
Exhibition view, Gladstone Gallery, New York.

Kai Althoff and Nick Z., 'We Are Better Friends For It', 2007.
Exhibition view, Gladstone Gallery, New York.

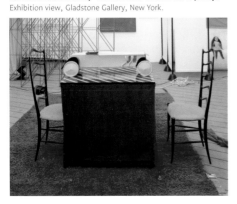

Francis Alÿs

Born in Antwerp, Belgium, 1959; lives and works in Mexico City, Mexico. Alÿs studied architecture at the École supérieure des Arts Saint-Luc in Tournai, Belgium, and at the Istituto Universitario di Architettura in Venice. He has been the subject of solo exhibitions at the Museo de Arte Moderno, Mexico City; Musée Picasso, Antibes; Wadsworth Atheneum Museum of Art, Hartford, Connecticut; and the Museum of Modern Art, New York. In 2002, Alÿs was a finalist for the Guggenheim Museum's Hugo Boss Prize.

A surprising number of modern and contemporary artists have made the outwardly simple act of walking a central part of their practice. Consider, for example, Situationist Guy Debord's theorization of the meandering *dérive* (translated literally as 'drift') as a radical strategy for exploring urban Paris. Or the epic, ninety-day trek along the Great Wall of China undertaken by Marina Abramović and Ulay prior to their separation. Or the numerous rural expeditions documented in sculpture, photography and text by British artists Richard Long and Hamish Fulton. Walking has, then, gradually passed from being understood as just the most direct way of experiencing and observing our environment, whether natural or built, to occupying an additional and fertile conceptual territory as both medium and metaphor.

Francis Alÿs has frequently used walking as a focus for solo and collaborative projects ranging across a dizzying variety of formats and locations. For Alÿs, this basic act reflects a methodology that is never divorced from everyday life, allowing for a range of subtle interventions into the structure of society at large. In his performance *The Collector*, 1990–1992, for example, the artist paced the streets of Mexico City, dragging a magnetic toy dog behind him. A video documenting the event reveals how the dog was slowly transformed as it accumulated a cluster of metallic flotsam and jetsam. Another performance, also documented on video, marked the temporary move of the Museum of Modern Art, New York, from Manhattan to Queens. *The Modern Procession*, 2002, witnessed the staging of a ritualized parade in which participants carried replicas of canonical works from the institution's collection from borough to borough.

Alÿs has frequently used walking as a focus for solo and collaborative projects ranging across a dizzying variety of formats and locations.

In Alÿs's *The Green Line*, 2004, a walk occupies the centre of a multipartite project that questions the validity of ideologically determined boundaries. The work's title alludes to the armistice lines that were drawn in 1949 to formally separate Israel from the neighbouring territories of Syria, Egypt, Jordan and Lebanon, a consequence of the Arab-Israeli War. The name of the Green Line itself makes reference to the colour of the pencil in which the border was drawn on a map during official negotiations. Responding to the division's seeming absurdity, Alÿs walked a length of the Line in Jerusalem in the summer of 2004. He carried with him a leaking tin of green paint, producing a visible trace in situ that invited spontaneous reactions from locals on both sides.

Alÿs's *Green Line* consists not only of this characteristically witty and provocative act, but also includes a film (made in collaboration with director Julien Devaux), a map of the artist's route, and several related paintings, drawings, photocollages and sculptures. Among the latter is a wooden 'camgun,' a cine camera modelled – using typically humble salvaged components – after a machine gun. The project thus remains true to its subtitle in exploring the intersection of real-world conflict with a tradition of symbolic action often (erroneously) thought of as belonging exclusively to the realm of art.

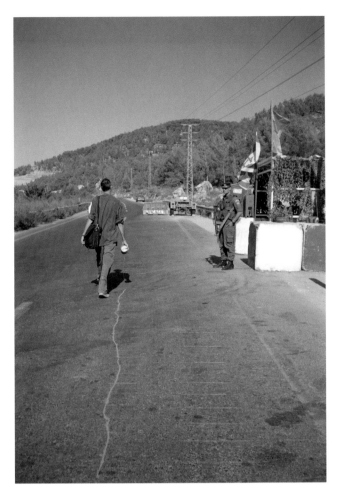

Francis Alÿs and Felipe Sanabria, The Collector, 1990–1992. Magnetic sculptures with rubber wheels and video documentation of an action in Mexico City.

Francis Alÿs and Rafael Ortega, The Modern Procession, 2002. Video documentation of an action in New York, 7 minutes 22 seconds.

Francis Alÿs, Cuauhtémoc Medina and Rafael Ortega, When Faith Moves Mountains, 2002.
Video (36 minutes) and photographic documentation of an action (15 minutes).

Mamma Andersson

Born in Luleå, Sweden, 1962; lives and works in Stockholm. In 2003, Andersson represented Sweden at the 50th Venice Biennale, and in 2007 she was the subject of a major travelling exhibition organized by Moderna Museet, Stockholm. Her work has appeared in exhibitions including 'Officescapes' at Galleri Magnus Karlsson, Stockholm; 'Essential Painting' at the National Museum of Art, Osaka; and 'Zones of Contact', at the 15th Sydney Biennale, Art Gallery of New South Wales, Sydney.

Mamma Andersson grew up in a rural district of northern Sweden, and her work is deeply informed by archetypal painterly depictions of Nordic landscapes and interiors. But while the scenes she creates may initially appear straightforward and comfortable, their outward familiarity soon gives way to a sense of the otherworldly and an undercurrent of profound disquiet. Andersson hints at narrative but offers no beginnings or endings, her set-like tableaux instead suggesting the existence of a dreamlike arena beyond known time and space in which the viewer is prompted to stage his or her own psychodrama. The artist has spoken of her attraction to 'places with a destroyed feeling', and the world she creates, while superficially picturesque, feels overshadowed by a brooding sense of tragedy and loss.

Yet while in many ways introspective, Andersson's paintings are unabashed in acknowledging the influence of other artists and disciplines. Pictures like *Stairway to the Stars*, 2002, even incorporate depictions of existing works that the artist admires – in this case, an array of well-known canvases by Manet, Monet, Gauguin, Hopper and Peter Doig. Andersson has noted the importance of Munch and Van Gogh, as well as that of Swedish artists John E. Franzén, Enno Hallek and Dick Bengtsson, in the development of her emotionally charged aesthetic. The impact of theatre is also readily apparent: Andersson's domestic scenes in particular echo descriptions in the plays of Harold Pinter, for whom she was commissioned to make a painting on the occasion of his winning the Nobel Prize for Literature in 2005.

The world Andersson creates, while superficially picturesque, feels overshadowed by a brooding sense of tragedy and loss.

In *Kitchen Fight*, 2010, the atmosphere of creeping menace that haunts Andersson's paintings is made rather more explicit than usual, though the setting is typically banal and the depicted aftermath of a violent act strangely easy to overlook. The titular room is rendered in the muted tones characteristic of the artist, and at first the focus seems to be on two toy bears placed facing one another on a table as if in the middle of a brawl. A closer look, however, reveals what appears to be a dead body slumped on a bed in the background and bleeding quietly onto the dark green floor. That this unfortunate figure has been incorporated so subtly into the scene makes its eventual discovery all the more disturbing.

Crucial to the production of such effects is Andersson's fluent technique. Most often working on wood panels in oils and acrylics, she habitually juxtaposes areas of thick impasto with passages of lighter, drier-looking paint and translucent washes of pure colour. And when it serves her purpose, she rejects standard brushwork in favour of less controlled or more visceral methods – dragging, shoving and scraping the pigment across its support – or even lets the surface crack as if it were damaged or antique. This movement between formal approaches is consistent not only with the artist's juxtaposition of the mundane and the quasi-supernatural, but also with the diversity of her themes and inspirations. The results are paintings that critic Kim Levin describes as 'weird, sure of themselves, and absolutely disaffected'.

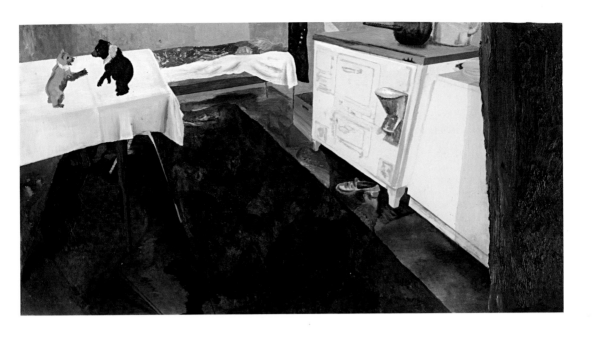

Pigeon House, 2010. Acrylic and oil on panel, 85.1 x 121.9 cm.

Abandoned, 2008. Colour spit bite and sugar lift aquatint with aquatint and soft ground etching on paper, 61.6 x 91.4 cm.

Various Self-Playing Bowling Games (aka Beat the Champ), 2011

Hacked video game controllers, game consoles, cartridges, disks and video, dimensions variable. Installation view, The Barbican Centre, London.

Cory Arcangel

Born in Buffalo, New York, USA, 1978; lives and works in New York. Arcangel studied technology in music at Oberlin College and has been the subject of solo exhibitions at the Neue Nationalgalerie Berlin; Museum of Contemporary Art, North Miami; University of Michigan Museum of Art; and Northern Gallery for Contemporary Art, Sunderland, England. His work has also been shown at the Museum of Modern Art and the Solomon R. Guggenheim Museum, New York; Nam June Paik Art Center, Gyeonggi-do, South Korea; and Museum der Moderne, Salzburg, Austria.

An epic multi-screen video projection that assaults viewers' senses with a barrage of garish imagery and synthesized sound, Cory Arcangel's *Various Self-Playing Bowling Games*, 2011, is a kind of archive, albeit an unusually noisy one. Gathering various examples of the titular electronic toys dating from the 1970s to the 2000s – the exact number varies from site to site – Arcangel presents a compacted history of four decades of domestic computing technology. Immediately apparent from one screen to the next – they are arranged chronologically in an extended frieze – is an increase in the sophistication of the games' graphic and audio simulations. The earliest example is a near-abstract diagram of a generic bowling alley occupied by a stick-figure avatar; later versions feature more convincingly rendered players and environments.

The game consoles form part of the installation but, as its title suggests, we are prevented from touching them; Arcangel has attached a circuit to each controller that maintains constant activity while precluding human interaction. What viewers see onscreen is thus deliberately frustrating, and in more ways than one. Not only are we prevented from taking part in the competition – the games in progress are all 'recordings' of ones played earlier by the artist – we are also denied even the modest satisfaction of witnessing a strike, since no bowler ever manages to topple even a single pin. The artist thus toys with our expectations of technology – specifically our persistent tendency to think of it as being almost akin to magic – and transforms a signifier of leisure into a tantalisation.

Arcangel's focus is on the moment when new technologies, often ones that have made the transition from professional to amateur use, begin to fade into obsolescence – a process that occurs with increasing rapidity, and which bears numerous formal and functional implications. The artist titled his 2011 exhibition at the Whitney Museum of American Art in New York 'Pro Tools', acknowledging this continual slippage between realms through reference to the popular music-editing program, and often customizes existing products and processes to highlight their inherent absurdities and limitations. In doing so, he draws attention to the received ideas of taste they embody, and to the ongoing exchange of ideas between fine art and popular culture.

Photoshop CS: 84 by 66 inches, 300 DPI, RGB, square pixels, default gradient *Spectrum*, **mouse down y=8900 x=15,600, mouse up y=13,800 x=0, 2009.**
Chromogenic print, 213.4 x 167.6 cm.

To this end, Arcangel has also made use of forms and processes including automated mechanical sculpture, digital printmaking and video derived from the Web. He often structures works around 'remixes', and combines natural and artificial means to reveal the inherent awkwardness of simulation. The results, which expose the gaps between act and representation, the physical and the virtual, are frequently humorous. In *Paganini Caprice #5*, 2011, for example, innumerable fragments from YouTube videos of heavy metal guitarists are cut together so that each performer seems to play a single note of the notoriously difficult composition. *Various Self-Playing Bowling Games* displays a comparable mix of irony and bathos, seeming to revel in the way people and machines finally expose each other's shortcomings. As Arcangel observes: 'It's humiliating – what's more humiliating than throwing a gutter ball? – but a bit funny at the same time.'[1]

1 The artist in Allesse Thomson Baker, '500 Words: Cory Arcangel', *artforum.com*, 5 March 2011.
 http://artforum.com/words/id=27700

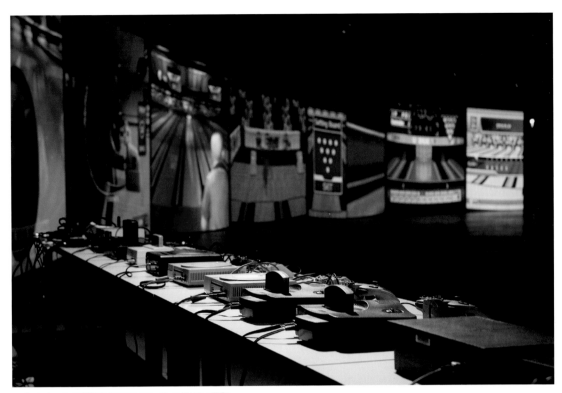

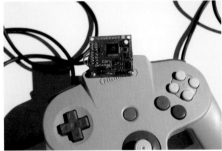

Various Self-Playing Bowling Games (aka Beat the Champ)
(detail), 2011.

Super Mario Clouds, 2002. Colour video with sound.

Paganini Caprice #5, 2011.
Colour video with sound, 3 minutes 41 seconds.

Michael Asher

Born in Los Angeles, USA, 1943; lives and works there. Asher was featured in the Documenta 5 and 7, the 1976 Venice Biennale and the 2010 Whitney Biennial. He has been the subject of solo exhibitions at the Centre Pompidou, Paris; Los Angeles County Museum of Art; Art Institute of Chicago; Santa Monica Museum of Art; and the Museum of Modern Art, New York. He is a recipient of the John Simon Guggenheim Fellowship, a National Endowment for the Arts Fellowship and the Bucksbaum Award.

As an artist and critic, Michael Asher was instrumental in the evolution of Institutional Critique, an enduring subset of conceptual practice focused on deconstructing and reframing the social, political and economic mechanisms through which art is administered, contextualized and shown. Rather than manufacturing and showing discrete images or objects, Asher intervenes in existing public environments and other shared situations, altering them in ways that highlight their obscured histories and biases. Typically, this involves him manipulating the physical structure of a museum or gallery space in order to reveal or highlight certain elements of its intent or operation. Asher has also been highly influential as a teacher, especially through his 'post-studio' seminar course at the California Institute of the Arts.

Asher began to hone his approach in the late 1960s, but it retains a radical edge even today. While they are generally simple to describe, the adjustments that the artist makes to a given site have a resonance that is rigorously intellectual but also sensory and even emotional, disrupting all-too-familiar modes of presentation and reception in ways that are at once confrontational and disarming. Coruscating in his ability to penetrate the layers of hyperbole and preconception in which art is routinely enveloped, Asher is also mindful of the need to avoid replacing one form of alienation with another. To this end, his works incorporate a significant experiential dimension; as thoroughly as it may be understood on paper, each project demands to be confronted in the flesh, and preferably in company. For example a 1992 project at Kunsthalle Bern that involved moving all the buiding's radiators into its lobby altered the distribution of heat throughout the building.

Rather than manufacturing and showing discrete images or objects, Asher intervenes in existing public environments.

For a 2008 project at the Santa Monica Museum of Art (SMMoA), Asher reconstructed all the temporary walls that had been erected in the space over the previous ten years, a period in which some forty-four exhibitions came and went. But instead of opaque barriers, the artist used only the walls' stud reinforcements, resulting in a labyrinth of metal bars that suggested a giant cage. This was paired with a 'documentation room' that housed all the past shows' floor plans, copies of which were made available for visitors' reference as they walked through the installation. As a non-collecting institution, SMMoA lacks a cumulative physical history; by exposing to view the means by which this *façon d'etre* is rendered practical, Asher's project reminded viewers of the labour that underpinned their experience of its more conventional displays - one reflective of managerial and architectural concerns as well as those of artists.

For his contribution to the 2010 Whitney Biennial, Asher proposed a change not in the museum's architecture but in its opening hours, suggesting that it remain open twenty-four hours a day for an entire week. In the event, the work's duration was reduced from seven days to just three because of 'budgetary and human resources limitations'. Ironically, the announcement of this fact ensured the work's success, exposing as it did the limits of its host.

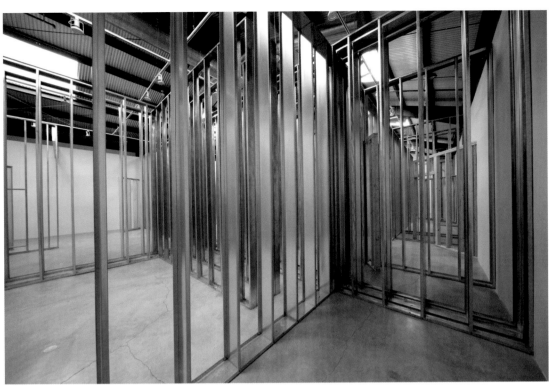

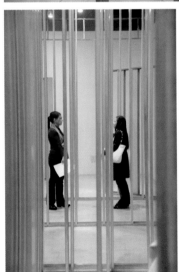

Installation Münster (Caravan), 2007.
Installation view, Münster Skulptur Projekte, 2007.

Ron Athey

Born in Groton, Connecticut, USA, 1961; lives and works in Los Angeles. Since his first theatrical performance, *Martyrs and Saints*, 1992, at LACE Gallery, Los Angeles, Athey has exhibited at the Institute of Contemporary Arts, London; NRLA, Glasgow; Tate Liverpool; Artists Space, New York; and Walker Art Center, Minneapolis, as well as at other institutions in France, Germany, Denmark, Croatia, Italy and Brazil. With Vaginal Davis, he co-curated the Platinum Oasis Outfest live art festival at the Coral Sands Motel, Los Angeles, in 2001, and the international 'Visions of Excess' series.

Athey is fearless in his investigation of the living body and its actual and symbolic power.

Ron Athey represents a strand of performance that is frequently sidelined or neglected, but which continues to speak to audiences – and influence emerging artists – with an emotional force absent from much other recent work. Tackling difficult subjects in a visceral and often disturbing manner, Athey is fearless in his investigation of the living body and its actual and symbolic power. Filtering queer sexuality and aspects of traumatic experience through ritualized 'body play' and religious iconography, he works in the confrontational tradition of artists such as Hermann Nitsch and the Vienna Action Group, further aligning himself with contemporaries such as Franko B. An extended reflection on his tempestuous upbringing in a Pentecostal household at the hands of a schizophrenic mother, Athey's process is also one of personal exorcism.

In 1994, Athey staged an extract from his performance *Four Scenes from a Harsh Life* (part of a 'torture trilogy' that also includes *Martyrs and Saints* and *Deliverance*) at the Walker Art Center, Minneapolis. The event drew fire from conservative politicians, who erroneously accused the artist of endangering his audience and questioned his right to federal funding. The controversy originated in a scene during which Athey makes cuts in fellow performer Divinity Fudge's back, then blots the wounds with paper towels that he hoists into the air using a pulley. Some critics worried aloud that the artist, who is HIV-positive, had exposed his audience to infected blood, and even once this was shown to be false, the furore continued to influence perceptions of Athey's practice.

A later action achieved similar notoriety. *The Solar Anus*, 1998–2000 (the title is a reference to a text by philosopher Georges Bataille), is described by critic Dominic Johnson as 'a tour de force of unseemly erotics.'[1] It begins with the artist extracting a string of pearls from his anus, around which is tattooed a flaming sun. He then inserts hooks into his face and attaches them to a golden crown, contorting his features. Finally, he forces a succession of dildos slowly and repeatedly into his rectum. 'Shot through with his and our shame, and beauty, and elegant terror,' writes Johnson, 'Athey's imposing frame vibrates in the grazed eye of the spectator, lit and punctured by "the indecency of the solar ray", and its correlate – in Bataille's terms – the scandal of the phallus.'[2]

The collapsing of sadomasochistic practice into religious symbolism is a consistent trope of Athey's work. He has implanted surgical needles into his scalp in reference to Christ's crown of thorns, re-enacted Saint Sebastian's piercing with arrows, and carried out 'genital stapling' in reference to faith-based psychic surgery. In the multimedia theatrical presentation *Joyce*, 2002, such physical trials are endured en route to a deconstruction of faith in the explicit context of family, as projected images juxtapose a young Athey's self-mutilation with the equally taxing activities of his unstable relatives. The scenario is characteristically hard to watch, but its maker's aim is not to shock. Rather, it is to push beyond the limits of conventional taste and comfort and achieve a kind of freedom.

1 Dominic Johnson, 'Ron Athey's Visions of Excess: Performance After Georges Bataille', *Papers of Surrealism*, issue 8, Spring 2010.
2 Ibid.

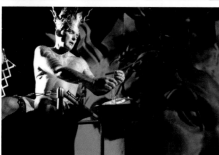

Self Obliteration #1: Ecstatic, 2007. Colour photograph, 76.2 x 50.8 cm.

A New Order for a New Economy – to Form and Content
(A Proposal to Re-arrange the Ads of Artforum), 2006–2007
Magazine, wooden shelf and glass, dimensions variable. Installation view, Andrew Kreps Gallery, New York.

Fia Backström

Born in Stockholm, Sweden, 1970; lives and works in Stockholm and New York, USA. Backström holds an MFA from Konstfack University College of Arts, Crafts and Design in Stockholm. She has been the subject of solo exhibitions at the Contemporary Art Museum St. Louis; the Institute of Contemporary Arts, London; White Columns, New York; Marabouparken Annex, Stockholm; and the Apartment, Vancouver. Her work was featured in the 2009 Momentum Nordic Festival of Contemporary Art in Moss, Norway, the 2008 Whitney Biennial and the 2011 Venice Biennale.

The primary subject of Fia Backström's work, which spans a range of formats including images and objects, performances and texts, is the exhibition itself, in all its complexities and contradictions. Her aim is to render the display mechanisms and support structures of the contemporary art world visible, highlighting and questioning the complicity of its participants – viewers very much included – in a system that does not allow for the theoretical purity of any given part. In Backström's deconstructive practice, context becomes content, especially when that context embodies or reflects the impossibility of hermetically sealed originality in an era of instant and continual communication. In questioning the fixity of extant boundaries between artist and audience, artwork and commentary, politics and commerce, she suggests a broader way of thinking about the place of art in culture and society at large.

To produce *A New Order for a New Economy – to Form and Content (A Proposal to Re-arrange the Ads of Artforum)*, 2006–2007, Backström extracted all the promotional content from an issue of *Artforum* magazine and reordered it according to her own criteria. The resultant strip of pages eschews the sequence imposed by the publication itself – one determined largely by financial considerations – and replaces it with a system based on formal and thematic groupings such as colour, composition, typography and subject. Juxtapositions between commercial and editorial content in the original journal, whether planned or incidental, are lost as new pairings between the ads themselves emerge. By excising *Artforum*'s critical meat, the artist foregrounds a parallel vein of content that offers its own commentary on the gallery world in general, and on the health of the modern and contemporary art market in particular.

By excising *Artforum's* critical meat, the artist foregrounds a parallel vein of content that offers its own commentary.

A New Order (the title's first part is both a literal description of the work and an echo of the various political agendas that have made use of it since Antonio Gramsci launched his leftist paper *L'Ordine Nuovo* in the 1920s) thus constitutes a targeted critique of the art market as manifested in what is widely regarded as the industry's paper of record. Its implication that the interdependence of art and money might at any time be subject to a sweeping 'correction' seems, in retrospect, eerily prescient; the physical heft of a given issue of *Artforum* is often cited as an indicator of the art market's health at the time. Backström's project also represents a sly reworking of strategies long associated with systems art and appropriation. *A New Order* is in one sense simply a collage, but in its rigorous use of established organizational templates (the colour spectrum, say), and in its at-one-remove exploitation of the work of other artists, it is considerably more.

Backström has made such provocative reframings a central component of her work, but beyond simply incorporating borrowed images, she also argues for the artistic legitimacy of more collaborative activities, such as publishing interviews with artists. And whatever form her work takes, site remains a key consideration. In 2010, Backström occupied the Museum of Modern Art's 'Nine Screens' lobby display space with her video *Misty Harbor*. Reworking MoMA's graphics to reflect on the interior's notoriously corporate feel, it traces – as does *A New Order* – fault lines in an outwardly rock-solid institution.

Picasso's Peace Wallpaper, 2008.
Printed wallpaper and axe. 68.6 x 1372 cm roll.
Edition produced for the Swiss Institute of Contemporary Art.

Let's Decorate and Let's Do It Professionally!, 2008.
Installation view, Whitney Museum of American Art, New York.

Misty Harbor, 2009.
Installation view, The Museum of Modern Art, New York.

Jules de Balincourt

Born in Paris, France, 1972; lives and works in New York, USA. De Balincourt's work has been exhibited at the Galerie Thaddaeus Ropac and the Palais de Tokyo, both in Paris, and Mori Art Museum, Tokyo, and has been featured in influential exhibitions such as 'Greater New York' at MoMA PS1, New York, and 'USA Today' at the Royal Academy, London.
His work is represented in the collections of the Saatchi Gallery, London; Brooklyn Museum, New York; and Museum of Contemporary Art, Los Angeles.

Jules de Balincourt's wood-panel painting *Speculator*, 2010, has an imposing presence, and not just because of its sheer size. A curtain of bright streamers descends from somewhere above the picture plane before sweeping past the viewer right and left, while the work's title is spelled out in bold block letters along its bottom edge. Small coloured rectangles flit across the surface like confetti, giving it a twinkling, kaleidoscopic look. But what looks at first like an abstract composition soon resolves itself into a figure study, as the silhouettes of two almond-shaped eyes, two black-booted legs and two hands – one of which holds a staff – emerge through the swirl of colour and shape. This, presumably, is the subject: an investor, collector or high-rolling gambler – perhaps all three – obscured behind a thicket of connections.

Speculator's fusion of the figurative and the abstract is characteristic of de Balincourt's approach, as is its folksy, outsider-ish styling and tactile, handmade quality (the artist is fond of rough masking, spray-paint and stencils). The work's almost psychedelic feel seems to have been informed by its maker's travels through countries like India and Peru, but also represents an inward journey, an embrace of pure imagination. But there is an element of real-world critique at play too. The shadowy figure of the subject occupies a highly ambiguous position, influential but unidentifiable, a puppet master pulling strings disguised as celebratory ribbons. A suspicion of people in power, the standard-bearers of corporate America in particular, has been an important component of de Balincourt's work for years, and functions here with accumulated force.

The shadowy figure of the subject occupies a highly ambiguous position, influential but unidentifiable.

If *Speculator* thus evokes, in appearance at least, the self-conscious New Age-isms of contemporary West Coast artists such as Chris Johanson, Margaret Kilgallen and other members of the so-called Mission School, the political dimension lends it a tougher edge. Among the projects with which de Balincourt made his name was 'US World Studies', a series of map paintings showing the United States reorganized along alternative lines. In one entry, territories are reallocated to their original inhabitants; in another, the country's geographical relation to its neighbours is re-jigged in acknowledgment of its notorious insularity. Other paintings cycle through a range of loosely related themes, from crowds of indeterminate composition – are these people protestors? students? tourists? – to unplaceable landscapes (sometimes jarringly interrupted by signage) and forbidding office interiors.

In addition to achieving success as an artist in his own right, de Balincourt has proved influential as a scene-maker. In 2006, he founded Starr Street Project Space (later simply Starr Space), an independent venue in the now-burgeoning Bushwick neighbourhood of Brooklyn, New York. In the three years it was operational, Starr Space was a locus of creative activity, hosting performances and other events by Terence Koh, Rita Ackermann, Lucky Dragons and various neighbours. This immersion in shared activity (a remnant, perhaps, of the artist's time in a California commune) is consistent with de Balincourt's drive to visualize relationships between people and the places in which they operate – even (or especially) when those relationships are never comfortably resolved.

US World Studies II, 2005. Oil and enamel on panel, 122 x 173 cm.

Untitled (Billboard), 2006. Oil on panel, 121.9 x 142.2 cm.

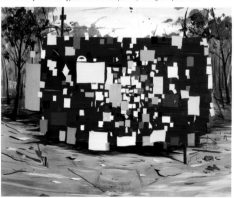

Matthew Barney

Born in San Francisco, USA, 1967; lives and works in New York. Barney has been the subject of numerous solo exhibitions organized by venues including Astrup Fearnley Museet for Moderne Kunst, Oslo, and Fondazione Merz, Turin. Barney is a winner of the Hugo Boss Prize; the Skowhegan Medal for Combined Media; and the Glen Dimplex Artists Award. 'Matthew Barney: The Cremaster Cycle' premiered at the Museum Ludwig, Cologne, before travelling to the Musée d'Art moderne de la Ville de Paris and the Solomon R. Guggenheim Museum, New York.

Even Matthew Barney's detractors – and there are a healthy number – concede that the sheer ambition on display in his five-part 'Cremaster Cycle' places it far beyond anything attempted by his peers. Few other artists in any discipline or medium have ever envisioned a cosmology as elaborate and fantastical, or marshalled such resources in its obsessively detailed realization. The 'Cycle', which consists of five feature-length films accompanied by a host of related sculptures, artifacts, photographs, drawings and books, was made over a period of nine years (1994–2002) and remains Barney's emblematic achievement. The films were produced out of chronological order, *Cremaster 4*, 1994, being the first, followed by *Cremaster 1* in 1995, *Cremaster 5* in 1997, *Cremaster 2* in 1999, and the final instalment, *Cremaster 3*, in 2002.

Such is the metaphoric complexity and epic scope of these works that a brief summary can scarcely do them justice. The series is named for a muscle that controls testicular contractions, and contains numerous allusions to the position of the reproductive organs during embryonic sexual differentiation. Juxtaposed with this investigation of nascent bodily function is a dense mix of geology, biography, history, ritual and myth. The films also borrow stylistic conventions and settings identified with various cinematic and theatrical genres, from *Cremaster 1*'s musical revue to *Cremaster 5*'s grand opera. In *Cremaster 3*, it is the locations that stand out, with scenes staged in and around New York's Solomon R. Guggenheim Museum and Chrysler Building (the construction of the latter is a key narrative element).

Few other artists in any discipline or medium have ever envisioned a cosmology as elaborate and fantastical.

The central conflict in *Cremaster 3* is between Hiram Abiff, a.k.a. the Architect (played by sculptor Richard Serra) and the Entered Apprentice (played by Barney). It begins in the Chrysler Building with the enactment of Abiff's murder and resurrection during a Masonic initiation. The Apprentice then converts a fleet of vintage cars into battering rams and makes a cast of an ashlar, a stone that represents moral rectitude in Masonic lore. In a subsequent scene, hit men break his teeth as punishment for this deceptive act. Apprentice and Architect then confront each other in a gruesome surgical exchange. In the Guggenheim, an incarnation of the Apprentice participates in a climbing game called The Order before, back atop the Chrysler Building, Apprentice kills Architect – and building kills Apprentice.

As in all of the 'Cremaster' films, and in other of Barney's works such as the similarly extended and ongoing 'Drawing Restraint' series, 1987–, *Cremaster 3* interweaves the heedless pursuit of highly (some might say impenetrably) coded allegorical storytelling with a surprisingly prosaic interest in the workings of the body and the production of objects. Barney has long been informed by the erotics of sport – he trained as an athlete and, as a student, staged performances in Yale University's gym – and in recent years has moved increasingly toward autonomous sculpture. But even when the convoluted fictions that steer the artist's screen-based work are absent, he continues to revel in a retinal and tactile opulence that attracts – and repels – in its fusion of the recognizable with the utterly strange.

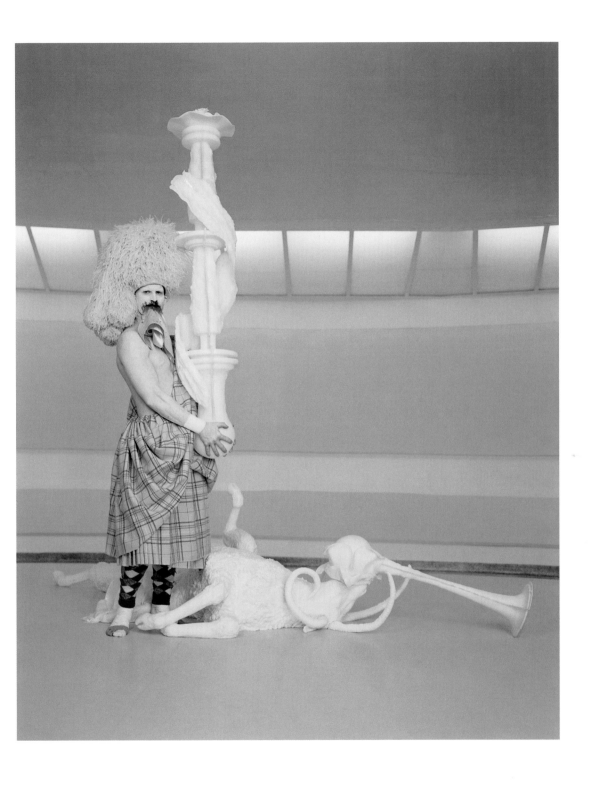

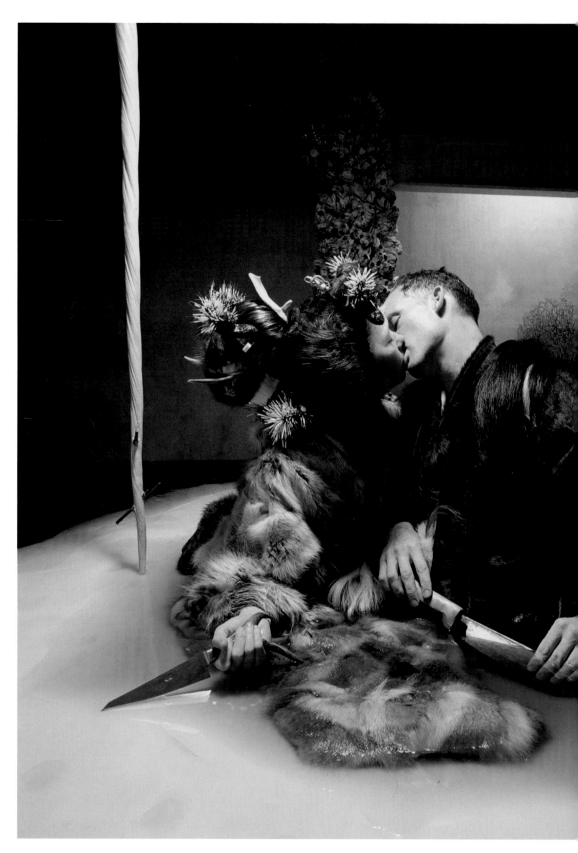

Matthew Barney, Drawing Restraint 9: Shimenawa, 2005.
Chromogenic print in self-lubricating plastic frame, 109.2 x 109.2 cm.
The Museum of Modern Art, New York, Gift of Barbara Gladstone.

Uta Barth

Born in Berlin, Germany, 1958; lives and works in Los Angeles, USA. In 2011, a survey exhibition of Barth's work was held at the Henry Art Gallery, Seattle, and at the Art Institute of Chicago. Her work is represented in the collections of, among others, the Whitney Museum of American Art, New York; the Museum of Contemporary Art, Chicago; and the Museum of Contemporary Art, Los Angeles. She was a recipient of the John Simon Guggenheim Fellowship in 2004 and the United States Artists Broad Fellowship in 2007.

While the Düsseldorf school – Andreas Gursky, Thomas Struth, Thomas Ruff – still casts a long shadow over German art photography, Uta Barth has proved that a less objective, more allusive approach can be equally effective. Rather than training her lens on public life to produce hyper-real visions of society as if observed by an extra-terrestrial outsider, Barth leans on the peculiarities of the photographic medium, and of human perception itself, to arrive at a subtler view. In her ethereal shots of landscapes, interiors and objects, it is atmosphere and ambiguity that are the defining characteristics. By manipulating colour, focus and depth of field, and by sidelining or obscuring the 'foreground' of a scene, the artist engineers a corresponding shift in the viewer's comprehension.

Barth prefers not to seek out spectacle when finding a site or subject, concentrating instead on the intimate and the everyday; the artist's 2007 'Sundial' series was taken entirely inside her own house. Even here, however, it is often difficult to say exactly what the photographs are of. Barth seems to prefer looking past or through that which is directly in front of her lens, capturing instead a kind of periphery or after-image. 'Sundial' consists, as do many of her series, of a set of double- and multi-panel sequences. Barth exploits the narrative connotations of this format by introducing tiny changes from one shot to the next, suggesting a slow, silent progression through time and space. These are introspective but luminous works in which the presence of dream and memory seems almost palpable. Yet while concerned with the fleeting and subjective overlap between perception and thought, Barth's work also points beyond itself to echo the formal languages of cinema and painting.

Barth prefers not to seek out spectacle when finding a site or subject, concentrating instead on the intimate and the everyday.

Untitled, 07.13, 2007, an entry in the 'Sundial' series, is a triptych of colour photographs depicting the pattern of light and shade on a white interior wall. The left-hand image is a relatively straightforward shot in which the silhouettes of a chair and table, a vase of flowers and various small objects appear as shadows cast onto the plain surface, while slivers of furniture and floor occupy the margins of the scene. It is in itself a pleasing composition that recalls a tradition of quasi-abstract photography stretching back to the experiments of László Moholy-Nagy and others at the Bauhaus school. The central image is a colour-negative version of the first, the pale squares of light cast by a window inverted into fields of inky black, over which the flowers in particular seem to stand out with enhanced clarity. The colours of the wall's surroundings are altered too, though the contrast here is less strident. In the right-hand image, the composition is enlarged but cropped to the same size as its neighbours, framing the flowers and omitting the rest of the scene. Here the image looks misty, as if spray-painted or rendered in soft charcoal. The three 'versions' together make up a typically multivalent treatment, suggesting that even the commonplace can be observed and represented in new and varied ways.

... to Walk without Destination and to See Only to See. (Untitled 10.3), 2010.
Inkjet prints in lacquered aluminium frames, 104.8 x 202.6 cm (overall).

Ground #42, 1994. Ektacolour print on panel, 28.6 x 26.7 cm.

Tamy Ben-Tor

Born in Jerusalem, Israel, 1975; lives and works in New York, USA. Ben-Tor has been the subject of solo exhibitions at the Moderna Museet, Stockholm; Cubitt, London; and Zach Feuer Gallery, New York. She has been featured in group exhibitions at the Mori Art Museum, Tokyo; Museum of Contemporary Art, Los Angeles; and Museo Nacional Centro de Arte Reina Sofía, Madrid. Ben-Tor appeared in Performa 05 and 07 in New York, and in 2010 was included in the Sydney Biennale.

'I find it necessary to escape into another universe in which I am not myself and language isn't used to deliver information,' writes Tamy Ben-Tor. 'The characters I portray are not real. However they are specific.' Ever since Marcel Duchamp debuted his female alter ego Rrose Sélavy, artists have adopted personas as a way of investigating the construction of identity. Arguably, women have become the most significant inventors of such personalities, using them to cast doubt on the presumptions and demands of a patriarchal art world and society at large. Eleanor Antin, Martha Wilson, Cindy Sherman, Alex Bag and others have all used disguise and play-acting as critical tools. But while Ben-Tor's performances and videos take aim at male archetypes, her targets also include representatives of less easily defined opinions and attitudes – not least of which are characters drawn from her Israeli upbringing and education.

Whether she is imitating a specific person or a general type, Ben-Tor displays a remarkable talent for critical mimicry.

Ben-Tor made a name for herself while an MFA student at New York's Columbia University with a series of video monologues in which she transformed herself into various contemporary grotesques. In *The End of Art*, 2006, she imitates Rirkrit Tiravanija, subjecting the influential Thai artist to unsparing parody. Elsewhere, she plays the part of a busy-busy art star whose endless self-serving phone discussions of this or that unspecified 'project' take on a grating uniformity. Both works owe a clear debt to stand-up and sketch comedy, trading in exaggeration and absurdity but centred on a core of sometimes awkward, uncomfortable truth. And whether she is imitating a specific person or a general type, Ben-Tor displays a remarkable talent for critical mimicry.

Ben-Tor's approach to perceptions of Jewishness is more ambiguous, and, like the close-to-the-knuckle humour of US comedian Sarah Silverman, has periodically caused offence in its deliberate blurring of positions. The subjects of *Women Talk about Adolf Hitler*, 2004, for example, appear almost jealous of their elders for having had such a charismatic enemy, while in *Gewald*, 2008, two women adopt stances similarly dogged by contradiction. One, an Egyptian, rails about the role of Jews in bolstering American power while commending her own nation's efficacy; the other, a Ukrainian, sings lyrics derived from Primo Levi's Holocaust memoir *If This Is A Man*, apparently addressing them to a roomful of children. Here, Ben-Tor's characters transcend mere caricature but, in their greater complexity, still end up confused.

Man Ray, Portrait of Rrose Sélavy, 1920.

As part of the performance art festival Performa in 2007, Ben-Tor presented a work titled *Judensau* (literally 'Jewish pig') at New York gallery Salon 94 and alternative space The Kitchen. Featuring, in the artist's own description, 'a sick Swedish man, a possessed German woman, a secular Jewish dwarf, and a prophet', the piece was delivered in appropriate costumes – and four different languages. Again starting from a play on cultural stereotypes, it mixed deliberate overstatement with more believably messy character traits en route to a teasing deconstruction of the artist's spiritual heritage. Attracted to performance for its metaphorical adaptability and seeming closeness to real life, Ben-Tor continues to explore an alternate world with powerful echoes of our own.

The End of Art, 2006. Colour video with sound, 7 minutes.

Out of Blue, 2002

Colour 16 mm film with sound transferred to DVD, 24 minutes 25 seconds.

Zarina Bhimji

Born in Mbarara, Uganda, 1963; lives and works in London, England. Bhimji has exhibited at the Walker Art Center, Minneapolis; Lumen Travo Galerie, Amsterdam; Whitechapel Gallery and Tate Britain, London; and Ikon Gallery, Birmingham. Her work has been featured in the Sydney Biennale; Istanbul Biennale; the British Art Show; and Documenta. Bhimji won the EAST award at EAST International in 2001 and the International Center for Photography's Infinity Award for Art Photography in 2003. She was shortlisted for the Turner Prize in 2007.

In her compelling short film *Out of Blue*, 2002, Zarina Bhimji leads the viewer on a voyage across her native Uganda, pairing images of the country's natural and artificial landscape – including the scars left on both by recent strife – with an evocative soundtrack that pits lulling natural sounds against the noise of violent upheaval. Born to Indian parents, Bhimji moved to the United Kingdom in 1974, two years after Idi Amin ordered the forcible expulsion of tens of thousands of South Asians, and this intersection of personal and political histories is reflected in *Out of Blue*'s brooding tone. It is, finally, a mournful reflection on conflict and loss, but also exploits formal contrasts of light, colour, texture and atmosphere to recontextualize Uganda's current condition.

Opening with a view over lush, green hills wreathed in mist, the film then focuses on a small grass fire, which grows in size and intensity to the accompaniment of gathering noise. The crackle of flame and the twitter of birdsong are joined by the barking of orders by Amin's forces and the anguished prayers and cries of their victims. The shift 'kicks you in the stomach', writes Ugandan-born British journalist Yasmin Alibhai-Brown, 'raising panic without a name'.[1] Bhimji's camera then tracks slowly over a succession of empty roads and prison cells, lingering on abandoned buildings, from crumbling mansions to battered, tin-roofed shacks. The images are often virtually static, but the aural backdrop produces a sense of momentum, further binding complex present to traumatic past.

***Out of Blue* is concerned with the discernment of 'difference' in various forms and degrees.**

The artist herself writes that *Out of Blue* is concerned with the discernment of 'difference' in various forms and degrees. And while not exclusively autobiographical, it is concerned with ethical concerns that have impacted her directly. 'I want to register these issues,' she states, 'to mark what has happened; elimination, extermination and erasure.'[2] To this end, the film reflects similarities between Uganda's history and those of Kosovo and Rwanda. *Out of Blue* is also complemented by a more recent film, *Yellow Patch*, 2011, which explores the histories of trade and migration across the Indian Ocean. Here, the artist juxtaposes austere close-ups of deserted Haveli palaces and colonial offices in Mumbai with more expansive views of ocean and desert, again making use of powerfully emotive sound.

Bhimji's rich oeuvre, which includes large-format and lightbox still photography as well as film and film installation, is marked by a consistent interest in what might be termed 'psycho-archaeology', a study of history and society pursued through the personal and subjective resonances of built space. In Bhimji's work, architectural structures are revealed as the storehouses not only of physical artifacts, but also of memories and dreams, ideas and ideologies. Walls and windows encapsulate the sensibilities of their designers and makers, and the fates of their users; populations reveal themselves less through their physical presence than through their lingering material culture. Its basis in research notwithstanding, Bhimji's is thus an expressly humanist art, in which global narratives of struggle and longing take subtle, affecting and intimate form.

1 Yasmin Alibhi-Brown, 'Out of Africa', *Tate Magazine*, issue 4, http://www.tate.org.uk/magazine/issue4/outofblue.htm
2 http://www.zarinabhimji.com/dspseries/12/1FW.htm

Yellow Patch, 2011. Single screen installation with sound, 35mm film transferred to HD video, 29 minutes 43 seconds.

Bapa Closed His Heart, It was Over, 2001–2006. Ilfochrome Ciba Classic Print, mounted on aluminium, Denglas and frame, 127 x 160 cm.

Shadows and Disturbances, 2007. Ilfochrome Ciba Classic Print, mounted on aluminium, 127 x 160 cm.

Following the Right Hand of Louise Brooks in 'Beauty Prize', 2009

Marker on Plexiglas over chromogenic print, 76.2 x 101.6 cm.

Pierre Bismuth

Born in Neuilly-sur-Seine, France, 1963; lives and works in Brussels, Belgium. Bismuth has exhibited at the British Film Institute, London; the Kunsthalle Basel; Villa Arson, Nice; Witte de With, Rotterdam; MAMCO, Geneva; and Kunsthalle Vienna. He has participated in group exhibitions at the Centre Pompidou, Paris; Institute of Contemporary Arts, London; Sprengel Museum, Hanover; Museum für Moderne Kunst, Frankfurt; Kunsthalle Bern; Ludwig Museum, Cologne; and Stedelijk Museum, Amsterdam. His work was included in the 2001 Venice Biennale and in Manifesta 4 in 2002 in Frankfurt.

Artists are often involved in competitions, but very rarely do they find themselves in the running for anything with the popular prestige of an Oscar. In 2005 however, one artist did pick up an Academy Award: Pierre Bismuth shared that year's Best Original Screenplay prize with Michel Gondry and Charlie Kaufman for the feature film *Eternal Sunshine of the Spotless Mind*. The win is not quite as incongruous as it may seem; Bismuth works extensively with cinematic imagery, in particular that of classic Hollywood, as part of a conceptually driven practice that revolves around the appropriation of pop- and high-cultural sources. His series 'Following the Right Hand...' is derived directly from projected films, which the artist reworks in still images that combine photography and drawing.

Following the Right Hand of Louise Brooks in 'Beauty Prize', 2009, was, like the rest of the series, made by projecting the titular film onto a sheet of Plexiglas and tracing the movements of the star's right hand in black ink. The resultant abstraction is mounted over a large black-and-white still depicting Brooks at the moment that he ceased following her gestures. The density of the scrambled field of lines reflects how far into the film this disengagement took place; in some entries in the series it resembles a scrawled signature but here it is more expansive and web-like. There is an ungoverned, expressionistic quality to Bismuth's alteration that evokes doodling and graffiti, and recalls Arnulf Rainer's overpainted self-portrait photographs of the 1960s and 1970s.

Bismuth works extensively with cinematic imagery, in particular that of classic Hollywood, as part of a conceptually driven practice.

The partially obscured subject of *Louise Brooks* enjoys a new role, her hand 'conducting' the action and thereby regaining for its owner a measure of the authorial control she surrendered as an actress working within the early Hollywood studio system. The screen of marks Brooks has created (Bismuth being a mere facilitator) builds a kind of symbolic defence against prying eyes that prevents audiences from getting too close to their idol. A graph of body language, it layers one form of potential communication over another, contrasting Brooks's overdetermined image with her indecipherable movements. In other entries in the series, the likes of Ingrid Bergman, Sophia Loren and Marilyn Monroe receive similar treatment, their lingering glamour and influence at once veiled and accentuated via Bismuth's peculiar emphasis.

Addition, erasure, reversal and similar kinds of alteration also determine the forms of other movie-based works by Bismuth. In *Respect for the Dead - The Magnificent Seven*, 2003, for example, footage from seven films including *Dirty Harry*, 1971, and *À bout de souffle* (Breathless), 1960, fades to black when the first death takes place. This introduction of a measure of reality (our involvement dies with the characters') into the world of fiction is oddly satisfying. Yet while Bismuth makes continual reference to popular culture, he does not believe that it must exist in the same sphere as art, and also makes works that recast gallery space. 'Art is not necessarily for all,' he opines, 'but only for everybody who thinks it is for them.'

Eternal Sunshine of the Spotless Mind, 2004.
Colour 35 mm film with sound, 1 hour 48 minutes, directed by Michel Gondry.

One Size Fits All, 2007. Installation view, Mary Boone Gallery, New York.

**Pierre Bismuth and Stefan Brüggemann,
Shallow, 2010.**
Neon spray paint, dimensions variable.

One at the Time, 2003

Oil on canvas, 85 x 100 cm. Art Institute of Chicago.

Michaël Borremans

Born in Geraardsbergen, Belgium, 1963; lives and works in Ghent. In 2011, Borremans was the subject of a survey exhibition, 'Eating the Beard', which travelled from Württembergischer Kunstverein, Stuttgart, to Műcsarnok Kunsthalle, Budapest, and Kunsthalle Helsinki. He has also exhibited at the Stedelijk Museum voor Actuele Kunst, Ghent; Cleveland Museum of Art, Ohio; and de Appel Arts Center, Amsterdam. His work is featured in collections including those of the High Museum of Art, Atlanta, and Israel Museum, Jerusalem.

Three figures in unmarked white uniforms – they could be doctors, cleaners, cooks – stand around a cloth-covered table. The room they occupy is unexceptional, but the shadows that loom across its drab cream walls create an ominous feeling of claustrophobia. Two of the figures, both men, are somehow manoeuvring a short stack of translucent panels into position above the table, each milky sheet appearing to float a few inches above the other. The third figure, a woman, approaches carrying a smaller panel in her outstretched hands like a waitress bearing a tray. There is an air of seriousness, even solemnity about the scene, though what exactly is going on remains obscure.

Michaël Borremans's canvas One at the Time, 2003, bears all the painter's hallmarks. Its muted, almost sepia coloration makes it appear antique, suggesting that its meaning might once have been quotidian but is now lost to time. The peculiar quality of the image's light – stark but uneven, as if generated by a spotlight or camera flash – reveals the artist's interest in the aesthetics of early photography and cinema. And the stiff, staged feel of its composition suggests a textbook illustration or documentary record. All these elements may be unremarkable on their own, but in Borremans's hands they function to emphasize the strangeness of the picture's central action. Looking at One at the Time feels like observing a surreal parallel world.

The sense of historical displacement in Borremans's work is exacerbated by the period style of the figures he depicts. Many are outfitted in clothes from the 1930s or 1940s, and seem to belong to some lost bureaucratic-industrial dystopia with echoes of Kafka or Orwell. The artist has a strong sense of narrative, but any potential plots in his paintings go unresolved. Even when he branches out into filmmaking, atmosphere takes the place of character and storyline. The Feeding, 2006, for example, depicts a situation almost identical to that shown in One at the Time, again with two men directing levitating sheets. But the movement of the image provides little in the way of explication; motivation and method remain a mystery, and there is no beginning or end to the drama.

'I make paintings,' Borremans concludes, 'because my subject matter, to a large extent, is painting.'

Yet while Borremans's work is memorable for the absurd situations it illustrates, it is effective too as an essay on the oddities of format and medium. Though tending to reference artists of previous eras – including Manet, Goya and various 17th-century portraitists – rather than his own, and while setting great store by skilful figuration, he also likes to experiment with variations in scale (of his paintings' subjects and of the canvases themselves) and finish. In so doing, he reminds us of the work's objecthood as well as its power to suggest and simulate. However completely the ostensible theme of One at the Time draws us in, we can't ignore its purely physical qualities, the ways in which paint has been used to build texture and transparency, lightness and weight. 'I make paintings,' Borremans concludes, 'because my subject matter, to a large extent, is painting.'

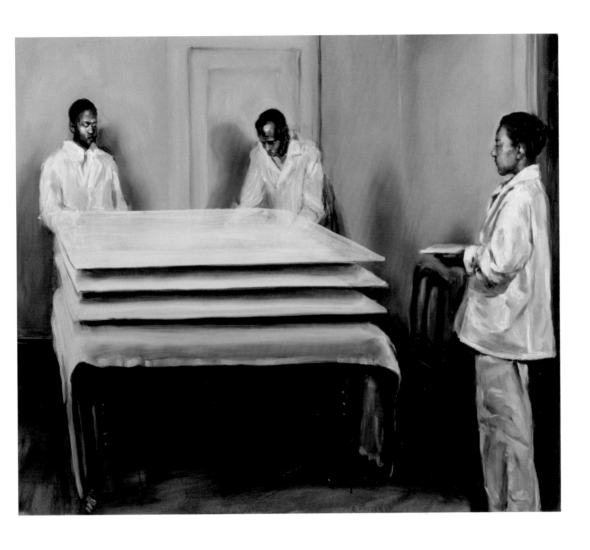

The Barn, 2003. Oil on canvas, 60 x 70 cm.

The Feeding, 2006. LCD monitor in wooden frame, 35 mm film (colour, silent) transferred to DVD, 4 minutes 50 seconds.

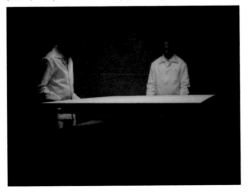

Carol Bove

Born in Geneva, Switzerland, 1971; lives and works in New York, USA. Bove has been the subject of solo exhibitions at Kunsthalle Zürich and Hamburg Kunstverein. She has also been featured in numerous two-person and group exhibitions including 'The Joy of Sex: Carol Bove and Charles Raymond' at Cubitt, London; 'Influence, Anxiety, and Gratitude' at the MIT List Visual Arts Center, Cambridge, Massachusetts, and 'Plastic, Plush and Politics: Echoes of the '70s in Contemporary Art' at Städtische Galerie Nordhorn, Germany.

Through the sculptural arrangement and conceptual recontextualization of period objects and books, Carol Bove explores post-war cultural history with a particular focus on utopianism in sexuality, politics and art. However, as critic Tom Moody observes, the tradition of freethinking becomes in her work 'a kind of frozen, museological idealism, in which the Minimalist design trends of the 1960s eclipse the wild-in-the-streets, getting naked side of the decade'. Using pedestals, tables and especially shelves to present stacks of well-thumbed paperbacks alongside natural and artificial objects, Bove's art hints at the waning influence of practitioners, theorists and commentators who were *au courant* around the time of her birth.

Bove's methodology strongly suggests the influence of 1980s appropriation art in its mix-and-match juxtaposition of readymade artifacts. But in place of the slickness that characterizes the work of practitioners such as Haim Steinbach and Sherrie Levine, she introduces a more intimate, even domestic sense of everyday wear and tear. In addition to reminding us that each component of a given work has its own story as a physical object in the world, this feeling is entirely appropriate to a conception of late modernism as a period distinguished by high-minded ambitions that were never fully realized. But far from representing a condemnation with the benefit of hindsight, or a simplistic act of nostalgia, Bove's visual and material choices result from a subtler approach to exploring the recent past.

Conversations with Jorge Luis Borges, 2003, is a wall-mounted wood and metal shelving unit, the three tiers of which bear a selection of books and two other objects - an old metronome and an abstract geometrical model made from wood and string. Two of the books are opened on black-and-white photographic spreads; one shows three stylized sculpted figures, the other a group of people swinging another, barefoot, above their heads. The title of the work refers to the Argentinian novelist and poet Jorge Luis Borges, who became known internationally in the 1960s, and seems to hint at a correspondence between his work and that of other writers of the time. The fact that Borges, author of such stories as 'The Library of Babel' (1941), was himself a bibliophile also makes him an ideal touchstone for the artist.

Setting for A. Pomodoro, 2006.
Mixed media, dimensions variable. Installation view, Camden Arts Centre, 2007-2008.

In other works, Bove demonstrates an ability to orchestrate objects on a larger scale. *Setting for A. Pomodoro*, 2006, for example, is a multipart installation in which ephemeral bits of flotsam and jetsam such as peacock feathers and pieces of driftwood join crafted metal and concrete in a formal tableau that toys with the conventions of museological display and theatrical set design. Latterly, the artist has also extended her historical reach from the 'hippie years' back to the 1930s, and further still to the Renaissance and classical antiquity. By making strategic use of anachronism, and by also considering each and every element of the contexts in which her works are exhibited - including the architecture and history of the galleries and museums themselves - Bove arrives at a highly nuanced way of rethinking our cultural heritage.

Untitled (Martha Rosler), 2001-2003. Collage from vintage Playboy magazines, 61 x 121.9 cm.

Coloured pencil on paper, 92 x 183.5 cm.

Andrea Bowers

Born in Wilmington, USA, 1965; lives and works in Los Angeles. Bowers has exhibited at venues including the Secession, Vienna; REDCAT, Los Angeles; Santa Monica Museum of Art; Whitney Museum of American Art, New York; Bard College, New York; Kunsthalle Basel; Museum of Contemporary Art, Los Angeles; New Museum, New York; Frankfurter Kunstverein; Stedelijk Museum voor Actuele Kunst, Ghent; Hammer Museum, Los Angeles; Kunstmuseum Bonn; and the Museum of Contemporary Art, Chicago.

Central to Andrea Bowers's practice is the connection of art to politics. In videos, installations and drawings, she conducts an inquiry into issues of control and empowerment that has shifted from a broad-based exploration of performance and participation to a thoroughgoing focus on the history and aesthetics of injustice and activism. In her multipart project 'The Weight of Relevance', Bowers focuses on those responsible for maintaining and displaying the AIDS Memorial Quilt. Made by thousands of individuals from around the world, the quilt is composed of numerous panels, each of which memorializes a single name. Conceived of in 1987 as a way to draw attention to the disease, the work has not been exhibited in its entirety since being laid over the Mall in Washington, D.C. in October 1996.

'The Weight of Relevance' includes a series of photorealistic drawings that mirror the quilt's proportions and manner of display, and a three-channel video that documents the labour of the dwindling, mostly female staff employed to sew and repair it. Bowers's interest in the quilt and its custodians is centred on the object's dual role as historical artifact and tool of protest. As the disease remains incurable and its toll continues to rise, the quilt has become so unwieldy – it now weighs more than 54 tons – that

In videos, installations and drawings, Bowers conducts an inquiry into issues of control and empowerment.

only sections of it may now be displayed. And as the urgency that accompanied its initial appearance has gradually evolved into a more complex range of emotions, the quilt itself has been left in a strange and rather precarious position.

In her large-scale multipart drawing *No Olvidado (Not Forgotten)*, 2010, Bowers commemorates another group: those who have died attempting to cross the border between Mexico and the United States. The list of names featured in the work was sourced from Border Angels, an organization that aims to protect those travelling through the Imperial Valley desert region, the mountains around San Diego County, and the border region itself. However, this roll call remains incomplete because so many casualties of the attempted transition remain unidentified. And while most of the dead succumbed to challenging weather conditions, others were the victims of hate crime. 'The Vietnam Memorial is government sanctioned and paid for,' says Bowers. 'I don't believe the government would ever sanction and pay for a memorial like this.'[1]

But while Bowers concentrates increasingly on issues around the rights and representation of people, she never forgets the crucial significance of visual style. For example, as part of 'The New Women's Survival Guide', a 2011 exhibition at Andrew Kreps Gallery in New York, she installed a series of drawings on top of a quilt-like wallpaper pieced together from signs, flyers and other printed materials that trace a history of feminist protest over the past four decades. While these ephemera, collected from feminist organizations like Planned Parenthood, NOW and Code Pink, convey a fascinating matrix of attitudes and agendas, they also document an active engagement with aesthetics. In Bowers's hands, art and design are shown to have a peculiarly direct impact and value.

1 The artist in Julie Henson, 'The Political Landscape: A Conversation with Andrea Bowers', *Daily Serving*, 7 August 2010.

No Olvidado (Not Forgotten), 2010. Graphite on paper, 23 drawings, 120 x 50 cm (each). Susanne Vielmetter Los Angeles Projects.

The Weight of Relevance, 2007.
Three-channel colour video projection with sound, 26 minutes 15 seconds.

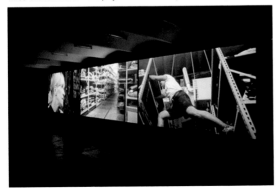

The New Women's Survival Guide, 2011.
Installation view, Andrew Kreps Gallery, New York.

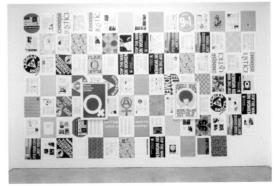

Mark Bradford

Born in Los Angeles, USA, 1961; lives and works there. Bradford has been the subject of solo exhibitions at the Whitney Museum of American Art and the Studio Museum in Harlem, both in New York; Los Angeles County Museum of Art; and ArtPace, San Antonio, Texas. He has also participated in numerous major group exhibitions including Prospect 1 New Orleans and 'Life on Mars', the 55th Carnegie International at the Carnegie Museum of Art, Pittsburgh. He won the Louis Comfort Tiffany Foundation Award in 2003 and the Bucksbaum Award in 2006.

The dense matrix that occupies most of Mark Bradford's large-scale collage *Ghost Money*, 2007, appears both constructed and organic. Like the bustling metropolis it evokes, this vaguely heart-like shape seems to have grown from some originating seed into a pulsating mass whose boundaries are indeterminate and fluctuating. Surrounding it is a variegated sea of silver-grey, a kind of unmapped interzone that offers only the potential for further expansion. Seen in reproduction, *Ghost Money* might appear to be a painting, but it is in fact a collage with painted additions. It is constructed, as are most of Bradford's works, from reclaimed billboard advertisements and the pages of magazines, comic books and newspapers, cut and adhered to the canvas in layers. The result is a living document constructed from the very stuff of urban life.

Bradford derives his ripped-and-torn technique in part from the Surrealist technique of *décollage*, and in part from the *affichiste* method first employed by Jacques Villeglé and Raymond Hains in the 1950s. But while the approach of the French nouveaux réalistes in particular was characterized by the recombination of street-poster fragments into wholly abstract compositions, Bradford augments his surfaces with enamel, ink and other materials to engineer a detailed diagrammatic figuration. And by also sanding or ironing those surfaces, sometimes using bleach to alter colour or scraping away certain areas in a kind of subtractive drawing process, he adds still further complexity. The final effect can be almost overwhelming, a quasi-psychedelic patchwork of image, text, pattern and texture.

Bradford augments his surfaces with enamel, ink and other materials to engineer a detailed diagrammatic figuration.

As *Ghost Money* demonstrates, Bradford's practice is steeped not only in the visual intensity of Los Angeles, but also in the richness of its culture and economy. Much more than just a map of a fixed geographical location, the collage embodies a highly subjective view of a continually changing situation that is defined by the interaction of many and varied communities. The words and pictures that flicker across its surface also visualize the way in which memory is absorbed into topography and architecture, the feeling that spectres of the past haunt our experience of the present. Other works contain images of crowds, as well as allusions to popular music and echoes of Bradford's background as a hair stylist at his mother's beauty salon (some earlier canvases feature hair dye and endpapers). It's all grist for the artist's mill.

Though Bradford's work is routinely placed in the context of Abstract Expressionist painting and its legacy, curator Heather Pesanti also suggests Robert Smithson as a precedent. Pesanti evokes the spirit of the Land artist's 'non-site' projects as a precursor to Bradford's importation of materials from specific real-world locations into the gallery setting. *Ghost Money* thus alludes to various pasts – those of its maker, his hometown, the viewer and of art itself – while remaining rooted firmly in the present. And while presenting a raft of ideas and issues around urbanism, communication and the stratification of cultural influence, it also conveys an immediate pleasure in the tactile qualities of materials new and reclaimed.

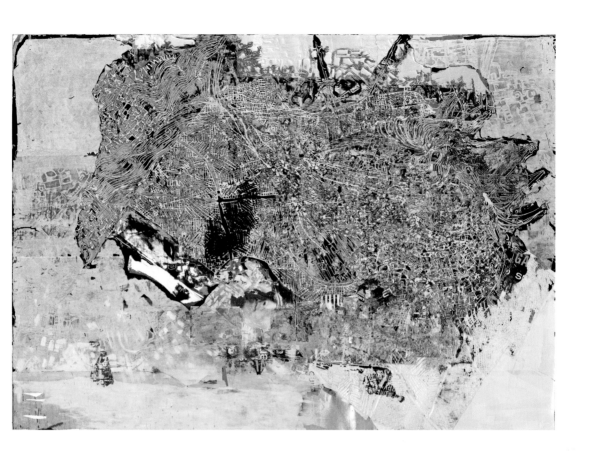

Los Moscos, 2004. Mixed media on canvas, 317.5 x 483.9 cm.

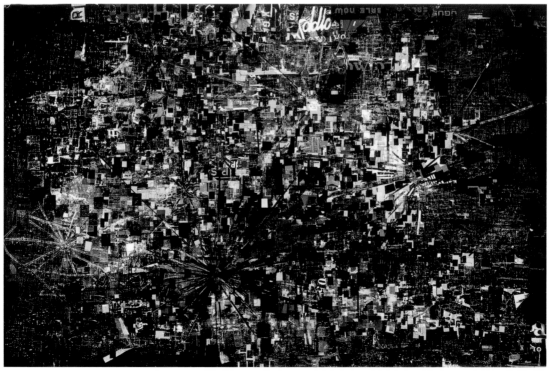

Mark Bradford, White Painting, 2009. Mixed media, collage on canvas, 259 x 366 cm.

Ulla von Brandenburg

Born in Karlsruhe, Germany, 1974; lives and works in Paris, France, and Hamburg. Von Brandenburg has been the subject of solo exhibitions at Kunsthalle, Düsseldorf; MoMA PS1, New York; Art: Concept, Paris; Produzentengalerie, Hamburg; Palais de Tokyo, Paris; and Kunsthalle Zürich. She has also participated in biennials in Jerusalem, Bucharest, Prague and Sydney, and in group exhibitions including Performa, New York; 'The World as a Stage' at Tate Modern, London; and 'Against Time' at Bonniers Konsthall, Stockholm.

Betraying her training in set design, much of Ulla von Brandenburg's recent activity has been focused on the production of tableaux vivants, the 'living pictures' that were a popular diversion in the 19th century. Stirring together a strange mix of theatre, painting and photography, the form's originators posed live models in elaborate settings, dressing and lighting them to produce static three-dimensional images. Brandenburg documents her set-ups in short films and photographs, drawing attention to their artificiality and reflecting on the key historical moment from which they borrow. This emphasis on investigating the past – the 19th century in particular – runs throughout the artist's work; other projects have seen her delve into magic and the occult, Expressionist theatre, Hollywood film and psychoanalytic practice prior to Freud.

In the short film *Kugel* (Sphere), 2007, Brandenburg trains her lens not on the tableau itself, but on its reflection in a mirrored ball. This emphasizes the unreality of the scene, making the group of figures she assembles resemble ghosts trapped inside a silvery bubble. The scene, set in a garden, feels antique, though it is impossible to assign it any precise date. And in a further reminder of the work's artfully constructed nature, the sphere also reflects an image of the artist and her camera. Pulling an outmoded form into the present, Brandenburg prompts a consideration of the changes, both cultural and technological, that have occurred since the established forms of theatre and painting were first challenged by the possibilities of photography.

Brandenburg documents her set-ups in short films and photographs, drawing attention to their artificiality.

In the installation *Curtain*, also from 2007, Brandenburg again directs our attention toward a convention of performance by reconstructing a set of patchwork curtains that was designed in 1932 for use at the Royal Shakespeare Theatre in Stratford-upon-Avon. Allowing them to remain very slightly open, she raises the question: are we performers or spectators? *Five Folded Curtains*, 2008, created for that year's Turin Triennale, uses heavy red velvet to similar effect, suggesting an empty stage waiting to be filled. Fabric plays a key role in other of the artist's works too. In her 2010 exhibition 'Wagon Wheel', Brandenburg displayed a series of embroidered quilts based on 19th-century African-American designs from the Underground Railroad, which were encoded with information to help escaping slaves.

Given her fascination with the theatre, it is unsurprising that Brandenburg also scripts and mounts her own performances. *Chorspiel*, which was shown at Malmö's Lilith Performance Studio in 2010 and also made into a film, features four members of a family whose domestic ennui is interrupted by the enigmatic Wanderer. As its title suggests, the *Chorspiel* also incorporates vocal music, which was also written by the artist. Sung by a choir, the lyrics are also mimicked – inexpertly – by the actors. Set against the artist's 70-metre wall painting, a stylized rendering of an epic landscape, the performance has a characteristic period feel but achieves a contemporary relevance via the universality of its themes – entrenched familial relationships, the necessity of change and the impact of the unexpected.

'Wagon Wheel', 2009-2010. Installation view, Pilar Corrias Gallery, London.

Chorspiel, 2010. Black-and-white 16 mm film with sound, 10 minutes 20 seconds. The Common Guild, Glasgow.

Five Folded Curtains, 2008.
Fabric, wooden floor. 5.5 x 6.1. x 12 m.

The Bruce High Quality Foundation

Established 2004, New York, USA; based there. The Bruce High Quality Foundation is made up of five to eight rotating and anonymous members, many or all of whom are graduates of Cooper Union. The group's first exhibition in a New York commercial gallery was 'The Retrospective' at Susan Inglett Gallery in 2008. The following year saw the first screening of the collective's film, *Isle of the Dead*, at an exhibition organized by Creative Time on Governors Island. The Foundation was ranked 99 in *ArtReview* magazine's 2010 guide to the 100 most powerful figures in contemporary art.

'The Bruce High Quality Foundation, the official arbiter of the estate of Bruce High Quality, is dedicated to the preservation of the legacy of the late social sculptor, Bruce High Quality. In the spirit of the life and work of Bruce High Quality, we aspire to invest the experience of public space with wonder, to resurrect art history from the bowels of despair, and to impregnate the institutions of art with the joy of man's desiring. Professional Problems. Amateur Solutions.' The tone of the Bruce High Quality Foundation's mission statement, with its mix of tongue-in-cheek mythologizing and pseudo-official pronouncement, reveals this shadowy organization to be more than just a gang of mates making fun of the art world. Rather, it is a collective that finds humour to be an effective tool for asking serious questions about the development and dissemination of visual culture.

Like any other artists' group, the Foundation makes objects and images for exhibition, but is perhaps better known for public lectures, events and interventions. Its mission is strongly pedagogical; 11 September 2009 saw the founding of the Bruce High Quality Foundation University, an unaccredited, community-driven research institute pitched by its creators as 'a "fuck you" to the hegemony of critical solemnity and market-mediocre despair.' The University offers monthly classes organized by its participants, and aims to hold the imperfect economic model of art instruction, especially as it exists in the United States, up to scrutiny. In 2010, the Foundation, in association with public art agency Creative Time, launched a national tour called Teach 4 America, beginning their journey with a rally at Cooper Union in New York – not coincidentally the alma mater of several of its members.

The Bruce High Quality Foundation is a collective that finds humour to be an effective tool for asking serious questions.

As befits a group concerned with the processes by which not only works of art but also artists and audiences are 'made', the Foundation often makes irreverent reference to more established predecessors and contemporaries. Its 2005 action *The Gate: Not the Idea of the Thing but the Thing Itself*, for example, thumbed a nose at the posthumous realization of Robert Smithson's *Floating Island to Travel Around Manhattan Island*. As the Smithson platform set sail, Foundation members gave chase in their own craft, pulling behind them a comically diminutive model of one of the orange gates then recently installed in Central Park by Christo and Jeanne-Claude.

The Foundation's works for gallery and museum display vary wildly in form but share the educational thrust – as well as the cheekily subversive edge – of such antics. Its contribution to the 2010 instalment of MoMA PS1's periodic metropolitan survey of Greater New York, for example, consisted of nothing more than a roomful of battered white pedestals. Initially suggesting a poorly executed take on Minimalist sculpture, this was in fact the result of a new-for-old exchange programme with nearby institutions. And for a 2009 solo exhibition at New York's Susan Inglett Gallery, the Foundation produced a series of sculptures based – in teasing reference to their use by another famous artist-teacher, Joseph Beuys – on classroom blackboards. It also published an accompanying reader, sealing a limited edition of the book with a scarlet lipstick kiss.

THE**Arts**

The New York Times

A Miniature Gate in Hot Pursuit of a Miniature Central Park

In the Future Everyone Will Be a Foundation, 2009.
Chalkboard with 'retireables', 138.4 x 144.8 x 38.1 cm.

The Bruce High Quality Foundation Foundation & Other Ideas, 2008.
160-page catalogue (edition of 25 signed with a kiss).

Live Forever, 2001

Fibreglass capsule with acoustic foam and leather upholstery, electronic equipment, 254 x 152.4 x 96.5 cm.

Lee Bul

Born in Seoul, South Korea, 1964; lives and works there. Bul was a finalist for the Hugo Boss Prize in 1998 and represented South Korea at the Venice Biennale in 1999. She has been the subject of solo exhibitions at the Fondation Cartier pour l'art contemporain, Paris; Power Plant, Toronto and the Museum of Modern Art, New York, among other venues. She has also participated in many important group exhibitions including 'Let's Entertain' at the Walker Art Center, Minneapolis; 'Global Feminisms' at the Brooklyn Museum, New York; and 'The New Decor' at the Hayward Gallery, London.

There is a striking paradox at the heart of Lee Bul's *Live Forever*, 2001. An interactive installation that takes the form of three private, individual karaoke machines, it demands viewers' active engagement but turns their vocal performances in on themselves, insulating them completely from public hearing and view. Each glossy, upholstered fibreglass capsule contains music and video equipment and accommodates one person, who is required to lie down and don headphones before choosing from an on-screen menu of popular songs. While watching short films of the generic variety familiar from the machines' more conventional commercial equivalents, singers can make use of a voice-enhancing microphone but remain their own audience to the total exclusion of others.

In transforming a form of entertainment that usually revolves around group dynamics - the reactions of friends and bystanders to a karaoke rendition would seem to be the only measure of its success - into a kind of secret ritual, Bul acts counter to the arguably more familiar artistic strategy of exporting customarily private actions into the public realm. Participants no longer have to contend with other people's responses, only with their own. In the womb-like, soundproofed seclusion that *Live Forever* offers, they are free to ponder the song's personal meanings and associations, and to interpret it in the style of their choice rather than simply attempting to imitate an original. But this freedom is far from being absolute, as singers remain under the work's technological and physical thumb.

Bul's interest in technology, especially as it inflects representations of the human body, is long-standing.

Bul's interest in technology, especially as it inflects representations of the human body, is long-standing. In the early 1990s, she constructed a series of costumes that subjected her own figure to a catalogue of grotesque mutations, and later produced silicone and porcelain sculptures that conjure still more extreme distortions of the female form. The critic Eleanor Heartney describes the exaggerated sexual characteristics of the latter as suggestive of 'stereotypical male fantasies of a world in which female energy is potentially monstrous and also necessarily curtailed'. The feminist aspect of such works persists, in less explicit form, in the phallic shape of *Live Forever*'s pods and, arguably, in their suggestion of the way in which the Internet - a 'personal' technology shared by millions - has impacted on the negotiation of sexual relationships and gender roles.

In more recent projects, Bul has begun to explore the historical, metaphysical and poetic implications of architectural structures and environments. These works, which are sometimes wall-mounted or suspended, at other times freestanding, often communicate a fascination with collapse and reconstruction. Intricate mixed-media constructions such as *Untitled Sculpture W1*, 2010, resemble miniature building sites, their execution appearing to have been interrupted somewhere between drawing board and final phase. Ruins, infused as they are with a density of symbolic and allegorical implications, are firmly established as an artistic motif; Bul's contemporary take breaks new ground while retaining critical links to a storied past. As is the case with *Live Forever*, it ranges over a surprisingly broad field of reference, reinterpreting enduring themes for a generation caught up in the whirlwind of 'progress'.

Untitled Sculpture W1, 2010.
Stainless steel, aluminium, mirror, wood, polyurethane sheet, glass beads, acrylic mirror, 212 x 147 x 143 cm.

Thaw, 2007.
Fibreglass, resin, acrylic paint, black crystals and mixed media, 93 x 113 x 212 cm.

The Forty Part Motet, 2001

Loudspeakers on stands, amplifiers, computer, dimensions variable, audio 14 minutes. Installation view, Musée d'art contemporain de Montréal.

Janet Cardiff

Born in Brussels, Canada, 1957; lives and works in Berlin, Germany, and Grindrod, British Columbia, Canada. Cardiff and her partner George Bures Miller represented Canada at the 49th Venice Biennale, and have also exhibited at the Art Gallery of Alberta; the Miami Art Museum; Art Gallery of Ontario; and National Gallery of Canada. Cardiff has made audio walks in London, Florence, Pittsburgh, San Francisco, and elsewhere. A mid-career retrospective, 'Janet Cardiff: A Survey of Works including Collaborations with George Bures Miller', opened at MoMA PS1, New York, in 2001 and has since travelled to Montreal, Oslo and Turin.

Janet Cardiff's audio installation *The Forty Part Motet* is a reworking of *Spem in Alium* by Thomas Tallis that allows an audience to experience the music from the standpoint of its performers. Forty separate loudspeakers are arranged around a gallery, each one broadcasting the voice of a different individual singer from Salisbury Cathedral Choir. As the audience moves around the room, the mix of sound they hear is affected by their own location. The speakers' ovoid configuration further emphasizes what Cardiff calls the polyphonic song's 'sculptural' makeup (it was originally written by Tallis with a group's physical positioning in mind). The sound seems to jump as particular members of the choir perform their respective parts, becoming almost overpowering in those moments when they all join in.

The Forty Part Motet reflects Cardiff's consistent interest in the fusion of aural and spatial experience. Often working collaboratively with her partner, George Bures Miller, she began making sound tours or 'audio walks' in 1995. Participants in these walks are given portable music players and directed to specific locations. The CD or digital music file that each individual hears combines effects recorded on site with music, instructions and narration. Produced using multi-track technology, the walks are completely immersive and radically alter listeners' perceptions of their environment. *Her Long Black Hair*, 2004, for example, is based on a stroll around New York's Central Park - supposedly following in the footsteps of a mysterious heroine - and periodically refers to a set of photographs that enhance the trail's atmosphere and illustrate the artist's story.

In *The Forty Part Motet*, the audience is not required to retrace an existing path; instead, it is their free movement around the work that determines its final shape. In this, *Motet* echoes La Monte Young and Marian Zazeela's *Dream House*, a 'sound and light environment' that has been on display in New York since 1993. In Young and Zazeela's project, visitors' perception of a continuous synthesized drone shifts dramatically according to the position they occupy within the installation's carpeted room. While Cardiff's work revolves around an outwardly very different kind of music - though Minimalist composers such as Young often claim common ground with 'early music' figures like Tallis - it revolves around a comparable exploration of recorded music as less fixed and static than we tend to imagine.

Cardiff effectively lifts the weight of history, granting us renewed freedom to experience the piece as a sonic event.

Cardiff further complicates the listening experience by including sounds - comments, coughs and shuffles - made before and after the actual performance. This lends the situation a more intimate feel by reminding us that *Motet*'s ethereal sound originally issued from the mouths of ordinary human beings. *Spem in Alium* was penned in 1573, but here Cardiff effectively lifts the weight of history, granting us renewed freedom to experience the piece as not only a cultural artifact, but also as a sonic event unfolding in the here and now. To this end, Cardiff and Miller have expanded the format in some more recent works: 2008's *The Murder of Crows*, for example, gathers a 'flock' of 98 speakers to conjure a phantasmagorical dreamscape of music, speech and noise.

Her Long Black Hair, 2004. Audio walk with photographs, 46 minutes.
Public Art Fund, New York.

Janet Cardiff and George Bures Miller, The Murder of Crows, 2008.
Mixed media, dimensions variable, audio 30 minutes. Installation view,
Hamburger Bahnhof-Museum für Gegenwart, Berlin.

Los Carpinteros

Los Carpinteros are Marco Antonio Castillo Valdés (born in Havana, Cuba, 1971) and Dagoberto Rodríguez Sánchez (born in Havana, 1969). They live and work in Havana and have participated in exhibitions at the New Museum and the Museum of Modern Art, New York. Their work is represented in institutional collections including those of the Los Angeles County Museum of Art; Solomon R. Guggenheim Museum, New York; Museo de Bellas Artes, Havana; and Museo Nacional Centro de Arte Reina Sofía, Madrid.

In an age when traditional craft practices, while still valued by artists and their audiences, are often delegated to anonymous outside agents, Los Carpinteros are something of an anomaly. Formed with the explicit aim of privileging group work and manual skill over individual authorship and farmed-out production, the duo – they began as a trio in 1991 and assumed their current name in 1994 after the departure of co-founder Alexandre Arrechea – makes extensive and transparent use of hard-earned practical know-how in design and construction. In drawings, sculptures and installations, the artists cross and re-cross the boundaries between ornament, abstraction and functionality, especially in relation to building and furniture design.

Sala de Lectura Ovalada, 2011 – the Spanish title translates as 'oval reading room' – is a large, framework-like structure, the walls of which suggest rows of empty shelves. The sculpture's overall shape is derived from the panopticon prisons conceived in the 18th century by Jeremy Bentham (and famously deconstructed by Michel Foucault in his 1975 book *Discipline and Punish*), but also suggests the inverted skeleton of an antique ship. The lightweight fibreboard used in the work's construction has been left unpainted, lending it – the evident care devoted to its arrangement notwithstanding – a somewhat provisional feel. Thus the room is both cell and celebration, a quasi-spiritual vessel for reading and thought that remains under continual observation from unnamed outside agencies.

Sala de Lectura Ovalada is characteristic of Los Carpinteros' approach not only in its stripped-down, 'new-build' aesthetic, but also in its address of the intersection between art, architecture and society at large. The duo has moved gradually from an exploration of conditions specific to Cuba and its history to a globally applicable study of planning and assembly in the context of urban life. Since the very beginning, however, their practice has been pervaded by dark humour. 'The way we construct a joke or commentary is the same way we create and construct our artwork,' explains Sanchez to writer and artist Trinie Dalton. 'The name Los Carpinteros itself is a joke. When people first see us, they think we are carpenters who are trying to make art.'

'The name Los Carpinteros itself is a joke. When people first see us, they think we are carpenters who are trying to make art.'

Just as diagrams and blueprints are vital to a carpenter, so drawing is a key component of Los Carpinteros' oeuvre. The duo borrows the look of technical renderings to imagine a dizzying range of objects and scenarios, some of which are based on existing projects, others of which have yet to be built, and a third group of which are destined to remain visionary fantasies. Curator Laura Hoptman describes one particular set that pictures a variety of fantastic swimming pool designs; one in the shape of a machine gun, another modelled after a vast gaping mouth. Whether such proposals ultimately leave the page or not, she concludes, they act as 'metaphors for the communication among the [...] artists and for collaboration, not towards specific ends but for its own sake.' In this, they revive and expand upon the communal spirit of the guild just as thoroughly as anything sawn, sanded, nailed or glued.

Free Basket, 2010. Mixed media, dimensions variable.
Indianapolis Museum of Art.

Show Room, 2008. Mixed media, dimensions variable.
Installation view, Hayward Gallery, London.

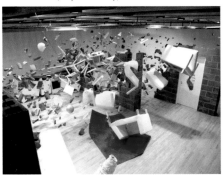

Mesas IV, 2010. Watercolour on paper, 65 x 104 cm.

Nathan Carter

Born in Dallas, Texas, USA, 1970; lives and works in New York. Carter has been the subject of solo exhibitions at venues including the Museo de Arte Raul Anguiano, Guadalajara, Mexico; ArtPace, San Antonio, Texas; Locust Projects, Miami; and Artist's Space, New York. In 2010, his work was included in 'Alexander Calder and Contemporary Art: Form, Balance, Joy', which travelled from the Museum of Contemporary Art, Chicago, to Nasher Sculpture Center, Dallas; Orange County Museum of Art, Newport Beach; and Nasher Museum of Art, Duke University, Durham.

'Oooo, LOOK!!! What's that?!? Near the corner of New Utrecht Avenue and 79th street in South Brooklyn under the staircase that leads up to the elevated D train, teetering on the edge of a scary looking subterranean storm drain was a small plastic orange circle. It had been run over by several cars and its colour was starting to fade due to the rain, I quickly picked it up and added it to the other shrapnel in my pocket.' Nathan Carter's account of hunting down components for his mixed-media constructions, which introduces the press release for his 2010 exhibition at Casey Kaplan Gallery in New York, communicates an infectious joy in discovery that is notably rare in contemporary practice, infused as it tends to be with self-conscious cool.

In *Radar Reflector Origin Petit Calivigny Grenada,* 2009 (the capitalized run-on title is typical of the artist), flotsam and jetsam of this kind takes its place in a circular assemblage designed – loosely – to suggest a piece of electronic equipment. Carter's work reveals a fascination with vintage communications apparatus, from semaphore flags to pirate radio transmitters, and references to these things crop up in sculptures and works on paper that often appear at first to be wholly abstract. His production has shifted gradually from intricate map-like forms in cut and painted plywood that resemble model railways or racetracks to looser-knit collections of found and manufactured materials that allude to systems and networks of different types.

In its foregrounding of flat saturated colour and simple biomorphic shapes, Carter's work displays an aesthetic affiliation with that of certain modern masters, most notably Jean Arp, Joan Miró and Alexander Calder. In 2010, he participated in an exhibition that explored this last connection at the Museum of Contemporary Art, Chicago. 'Alexander Calder and Contemporary Art: Form, Balance, Joy' traced a return to the handmade and a renewed interest in the colour and movement of the past in Carter and his contemporaries. But while the artist acknowledges the influence of his forebears, he also emphasizes interference and accident above reverent art-historical homage. His attraction to vintage gear and salvaged stuff also stems from the possibility of mistranslation or distortion they offer, the likelihood of crossed lines and garbled code.

It is no surprise then that *Radar Reflector* was inspired in part by a misremembered Calder, and suggests a riot of incoming/outgoing information seemingly fated to result in a further clash of ideas. But there is also an appealing decorative element to it that offers an effective counterpoint to the hobbyist masculinity of its ostensible subject. *Radar Reflector* is at once carefully designed and wholly eccentric, a combination of the planned and the improvised that, as its title suggests, echoes the attempts of developing nations to emulate Western high technology using basic materials and methods. While formally simple compared to Carter's earlier map works, and more self-contained than his recent stage-set-like installations, *Radar Reflector* is similarly energized by the beauty of the unexpected and the excitement of its attempted expression.

Flowing Rainbow Cherry Ripe Code, 2007.
Mixed media, 123 x 193 cm.

Williamsburg Brooklyn Public Housing Project Concealed Swindon Call and Response, 2010. Mixed media, dimensions variable.

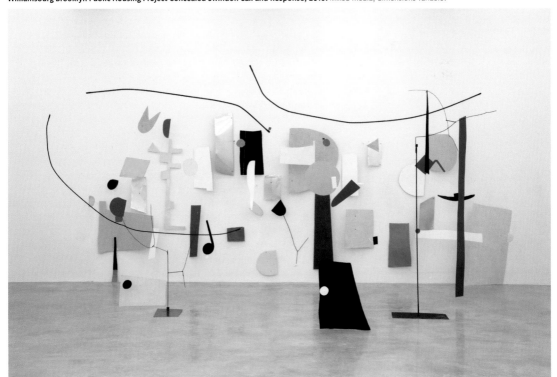

Maurizio Cattelan

Born in Padua, Italy, 1960; lives and works in New York, USA, and Milan. Cattelan has been the subject of solo exhibitions at Tate Modern, London; Museum of Contemporary Art, Los Angeles; DESTE Foundation for Contemporary Art, Athens; and Museum Ludwig, Cologne. He participated in the Venice Biennale in 1993, 1997, 1999 and 2001, Skulptur Projekte, Münster, and was a finalist for the Guggenheim's Hugo Boss Prize in 2000. Cattelan's retrospective exhibition, 'All', opened at the Solomon R. Guggenheim Museum, New York, in 2011.

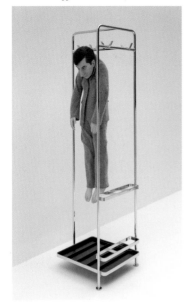

**La Rivoluzione siamo noi
(We are the Revolution), 2000.**
Polyester resin, wax, pigment, felt suit and metal coat rack. Figure: 123.8 x 35.6 x 43.2 cm; coat rack: 189.9 x 47 x 52.1 cm.
Solomon R. Guggenheim Museum, New York.

At the end of 2011, Maurizio Cattelan's retrospective 'All' ended up topping critics' lists of the year's best and worst exhibitions in virtually equal measure. An exhaustive gathering of the divisive artist's oeuvre – marking, he claimed, the finale of his career – the exhibition not only filled the Solomon R. Guggenheim Museum with 123 extraordinary objects and images, but also did so in a uniquely eccentric style. Leaving the museum's walls and floors empty and instead suspending his output from the apex of the building's famous rotunda by a chaotic-looking arrangement of ropes, Cattelan presented a characteristically mischievous challenge to the rules of organization, contextualization and display – and, indeed, to the very notion of a 'serious' formal exhibition. Even its fiercest detractors were forced to admit that 'All' at least had guts.

According to the exhibition's curator, Nancy Spector, 'All' represented 'an exercise in disrespect: the artist has hung up his work like laundry to dry.' Recognizing the fundamental inappropriateness of a retrospective format to deal with work that often was dependent on specific sites or situations for its full effect, Cattelan produced a deliberately contrarian display that chimed with his mistrust of authority and pranksterish reputation. Since his emergence in the late 1980s, the artist has consistently taken aim at officialdom, from politics, religion and the law to the conventions of social and professional interaction and the machinations of the art world itself. In 'All', the full range of these provocative explorations was laid out, and revealed in its totality as a notably moral project.

In testing the limits of individual and institutional tolerance, Cattelan often makes reference to iconic or notorious public or historical figures, or places himself or his colleagues at the centre of the action. One of the first works to garner him both widespread acclaim and controversy was *La Nona Ora* (The Ninth Hour), 1999, a life-size model of Pope John Paul II lying under a meteorite that seems to have plummeted through the ceiling and knocked him to the floor. The similarly confrontational *Him*, 2001, takes the form of a tiny figure of Adolf Hitler kneeling in prayer. In *La Rivoluzione siamo noi* (We are the Revolution), 2000, it is Cattelan himself who appears as a doll, wearing a Joseph Beuys-style felt suit and hanging from a coat rack.

The nod to Beuys here is a telling one. While the German artist adopted a quasi-shamanic persona in his efforts toward more direct communication with the viewer, Cattelan is something closer to a holy fool, a reckless trickster with the nerve to speak truth to power. Yet while he has a wickedly ironic sense of humour and – as did Beuys – trades on personal charisma, the artist goes far beyond mere nose-thumbing or attention-seeking. The hardships of Cattelan's youth imbued him with a highly ambivalent attitude toward work, whether menial or prestigious, and its attendant notions of success, failure and influence. 'All', with its purported finality and intimation of hanging, underlines his absorption both in the absurdity of life and the inevitability of death.

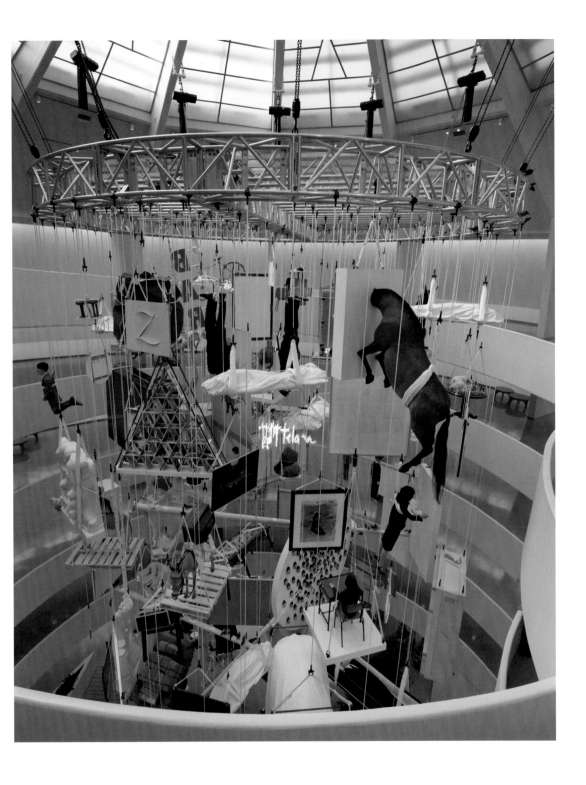

Synthetic human hair, wool, metal armature, 274.3 x 91.4 x 73.7 cm.

Nick Cave

Born in Fulton, Missouri, USA, 1959; lives and works in Chicago. A travelling solo exhibition of Cave's work was organized by Yerba Buena Center for the Arts, San Francisco, in 2009. He has participated in group exhibitions at the Museum of Contemporary Art, Chicago; Göteborgs Konsthall; and Kunstmuseum Wolfsburg, Germany, among others. His work is represented in the collections of the Brooklyn Museum of Art, New York; Detroit Institute of Arts; and Hirshhorn Museum and Sculpture Garden, Washington, D.C.

At the heart of Nick Cave's hybrid creative practice are his extraordinary 'soundsuits'. These wildly ornate outfits are produced for static exhibition, but can also be worn in frenetic, dance-like performances that are documented by the artist in photographs and videos. Modelled on the dimensions of Cave's own body and designed to completely cover and disguise the wearer, the suits have a shamanic aura and vivid, psychedelic appearance that recalls carnival costumes and African ceremonial garb. Pieced together with a tailor's skill from myriad components both ordinary and unusual, their riotous combinations of colour and texture celebrate the joyful chaos of everyday life while hinting at a parallel world of ritual and magic – one accessible only through movement and colour, music and noise.

Cave made his first suit from twigs that he collected in his local park. 'I didn't know it was a *sound* suit until I put it on,' he remembers, 'but I realized through moving in it that this rustling sound came about from the twigs hitting each other.'[1] The discovery led him to experiment with many other found materials, from buttons, beads and sequins to socks, lint and dyed hair. The results have a playful, fanciful quality, but also function to conceal the race and sex of whoever puts them on, conjuring an arena of activity, thought and imagination in which such classifications are rendered secondary or irrelevant. 'I just want to get the suit back to a place where we dream,' he says. 'Hopefully, I'm able to jumpstart that. Am I doing it?'

Cave's 'soundsuits' have a shamanic aura and vivid, psychedelic appearance.

Along with a visual arts education focused on textiles, Cave received dance training from choreographer and activist Alvin Ailey, and this has clearly and productively influenced his approach; even when his suits are displayed on mannequins, they have a dynamic, animated feel. In live settings and on video, they are brought even more fully to life, transforming human beings into benevolent, Muppet-like monsters. Aside from the famous products of the Jim Henson Workshop, the suits also echo the aesthetic strategies of other artists and designers, notably the cosmic figures of the Forcefield collective and the identity-transforming getups of fashion icon Leigh Bowery. And while an association with forbidding voodoo and shamanic gear persists, the impression they leave tends toward the light and liberating.

Untitled, 2009.

In 2011, two concurrent New York exhibitions gave full rein to Cave's compulsive vision. A freeform installation of dazzling suits at Mary Boone Gallery was presented as 'a playground without rules', and focused on the works' embodiment of carefree individuality. *Soundsuit (Untitled),* 2009, is typical of this particular set, an outlandish rainbow agglomeration of clothing, toys and bric-a-brac. Meanwhile, at Jack Shainman Gallery, a more restrained group of suits in muted colours aimed at linking Cave's oeuvre to a reflection of society at large. In *Speak Louder*, 2011, for example, the artist connects several figures together and coats their surfaces with thousands of assorted black buttons, alluding in the process to the coexistence of a multiplicity of voices.

1 From an interview with the artist, http://www.youtube.com/watch?v=s0KLXCov9kU&feature=related

Center for Land Use Interpretation

Founded in Oakland, California, USA, in 1994; main office in Culver City, Los Angeles, and outposts in the Mojave Desert; Wendover, Utah; Houston, Texas; Troy, New York; Albuquerque, New Mexico; and Lebanon, Kansas. The CLUI is a not-for-profit organization that produces exhibitions for its own and other venues, conducts field trips, maintains a residency programme and publishes a newsletter (*The Lay of the Land*). It is the lead agency in the establishment of the American Land Museum, a network of landscape exhibition sites across the United States.

'We believe that the manmade landscape is a cultural inscription, that can be read to better understand who we are, and what we are doing.' The Center for Land Use Interpretation was established with the aim of researching and rethinking the ways in which we interact with our surroundings. Combining the roles of educational body and artistic-curatorial collective, it not only mounts exhibitions but also maintains a library and website, and pursues residence and publishing programmes. 'Neither an environmental group nor an industry affiliated organization,' states its website, 'the Center integrates the many approaches to land user – the many perspectives of the landscaper – into a single vision that illustrates the common ground in "land use" debates.'

Matthew Coolidge founded the CLUI in 1994 near Oakland, California, subsequently relocating it to Culver City and establishing outposts in Wendover, Utah and Troy, New York, as well as a research station in the Mojave Desert. Perhaps even more significant than these physical locations is the organization's Land Use Database, an archive of field reports about a succession of 'exemplary' American locations. In exploring how the scientific focus and deadpan presentation of such activities shades into a more overtly creative practice, critic Michael Ned Holte cites the CLUI's adoption of Robert Smithson's 'site-seer/tour guide' persona. 'Like Smithson's *Spiral Jetty*,' he writes, 'the Center's various tours do not aspire to the sublime, but rather operate as an agent for the mediation of the sublime.'

In further defining the CLUI's unusual status, Holte links its idiosyncratic methodology with that of conceptually oriented art practice, mentioning in particular projects by Dan Graham, Gordon Matta-Clark and Douglas Huebler. A dip into the Land Use Database also reveals the Center's willingness to examine projects clearly designated as art alongside 'accidental' or other seemingly unrelated phenomena. An entry on the state of Nebraska, for example, lists Art Farm's 'architectural curiosity/wonder and artist residence programme' next to the notorious 'Carhenge' monument ('built during a family reunion in 1987'), and a large underground bunker built in 1956 as a regional control center. The CLUI has itself produced installations that would not seem out of place on such a list, including a device that emits the sound of 'gently lapping water' from a dried-up lake bed.

Terminal Island, the subject of an exhibit at the CLUI Los Angeles, 2005.
Port of LA photo, modified by CLUI.

The CLUI is, however, still best known for exhibitions such as 1999's 'Territory in Photo-Color: The Post Cards by Merle Porter', which collected images of abandoned buildings and other ordinary sites as photographed, annotated, printed and sold by one family business, and 2005's 'Terminal Island', which presented research into an artificial landform in the Long Beach district of Los Angeles that is the country's largest container port. CLUI expeditions such as 2004's 'A Tour of the Monuments of the Great American Void' have also helped fuel its reputation. Commissioned by the Los Angeles Museum of Contemporary Art, this two-day bus trip around the Great Salt Lake area took participants to *Spiral Jetty*, 1970, and Nancy Holt's *Sun Tunnels*, 1973–1976, before skirting less welcoming landmarks such as the Bingham pit, the so-called 'biggest hole on earth'.

'Territory in Photo-Color: The Post Cards by Merle Porter', 1999. Installation view, The CLUI Los Angeles Exhibit Hall.

Paul Chan

Born in Hong Kong, China, 1973; lives and works in New York, USA. Chan has been the subject of solo exhibitions at the Renaissance Society at the University of Chicago; Carpenter Center for the Visual Arts at Harvard University, Cambridge, Massachusetts; Institute of Contemporary Art, Boston; Serpentine Gallery, London; Para/site Art Space, Hong Kong; New Museum, New York; and he has participated in group exhibitions at the Whitney Museum of American Art, New York, among others. He was awarded a Rockefeller Foundation New Media Arts Fellowship in 2003, and founded Badlands Unlimited Press in 2010.

In addition to his work as an artist, Paul Chan maintains a busy life as a political activist, involving himself in the aid group Voices in the Wilderness, co-authoring *The People's Guide to the Republican National Convention* (a map of Manhattan designed for use by protesters at the divisive 2004 event), co-founding the New York chapter of independent media network Indymedia, and posting inspirational quotations on his website, www.nationalphilistine.com. Yet while he tends to frame such projects as separate from the work he produces for museum and gallery display, they are consistent with his thoroughgoing commitment to uncovering connections between the dominant and the repressed, the venerated and the dismissed, the high and the low, across a diverse array of social, cultural and aesthetic realms.

In *Sade for Sade's Sake*, 2009, it is sexual desire and violence that come under Chan's spotlight, via a wall-filling video projection that depicts silhouetted figures engaged in the kinds of lewd acts beloved of – as the title suggests – the redoubtable Marquis de Sade. As shadowy images find one another and disjointed body parts swim into and out of sight, the action becomes stylized, even abstracted, reflecting the poetics of the author's obsessive vision. When first shown at Greene Naftali Gallery in New York in 2009, the video was paired with an installation featuring a computer with keys shaped like gravestones, and a set of large drawings and texts based in part on Sadeian dialogue. In the latter, obscured words and phrases hint at censorship or redaction.

Chan displays a thoroughgoing commitment to uncovering connections between the dominant and the repressed.

Sade for Sade's Sake recalls Chan's earlier series 'The 7 ~~Lights~~', 2005-2008, in its use of projection and silhouette. A sequence of animations projected wholly or partly onto the floor, 'The 7 ~~Lights~~' represents a set of daily cycles, evoking the passage of time as registered in fragments through a high window. As the shapes of people and objects tumble across each triangular or trapezoidal rectangle, the impression builds of a world in the process of collapse, of a light that, as the line through the word in the title suggests, is gradually dying out. The series could also be seen as evoking Plato's allegory of the cave, suggesting that what we regard as reality may be just the shadow of a world beyond reach.

A similarly apocalyptic quality can be found in *Waiting for Godot in New Orleans*, Chan's November 2007 adaptation of the characteristically melancholic but oddly hopeful Samuel Beckett drama. Staged in two outdoor locations in the hurricane-ravaged city – an intersection in the Lower Ninth Ward, and the front yard of an abandoned house in Gentilly – the production aimed at encouraging viewers to focus on the seemingly devastated landscape's potential for reconstruction. Chan also spent several months in New Orleans prior to the debut of the play (which has been staged in a number of other politically sensitive locations over the years, including embattled Sarajevo and San Quentin prison in California), working with local artists, activists and community leaders to extend the project into a larger set of activities and artifacts.

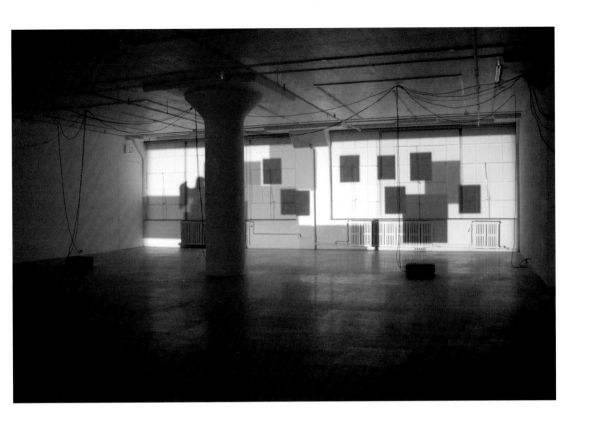

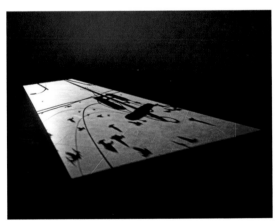

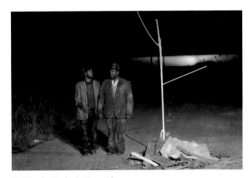

Waiting for Godot in New Orleans, 2007.
Performance view, Lower Ninth Ward, New Orleans.

1st Light, 2005. Digital video projection onto floor, 14 minutes.

My Birds... Trash... The Future, 2004. Two-channel colour video with sound, 16 minutes 36 seconds.

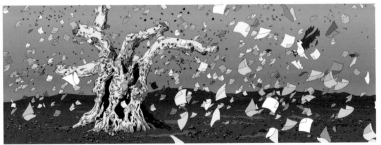

Larry Clark

Born in Tulsa, Oklahoma, USA, 1943; lives and works in New York and Los Angeles. Clark published the photography book *Tulsa* in 1971, and released the feature film *Kids* in 1995. He is also the director of *Another Day in Paradise*, *Bully*, *Teenage Caveman*, *Ken Park* and *WASSUP ROCKERS*. Clark's work is included in the collections of the Metropolitan Museum of Art, New York; Museum of Contemporary Art, Los Angeles; and the Frankfurt Museum für Moderne Kunst. A retrospective of his work was held at the Musée d'Art moderne de la Ville de Paris in 2010.

Filmmaker and photographer Larry Clark established a reputation for controversial imagery at the beginning of his career with the book *Tulsa*, 1971. This collection of stark black-and-white photographs documented the sometimes violent pursuit of illicit sex and drugs by his hometown's young people with an unflinching but sympathetic eye. Pieced together from shots taken between 1963 and its publication date, the book revealed an artist who had become intimately engaged with his subjects without seeking to pass moral judgment on their activities or make a larger point about the society in which they lived; these people were simply his friends and contemporaries. Yet while the content of *Tulsa* is often disturbing, the collection exhibits a transcendent formal beauty. A follow-up, *Teenage Lust*, 1983, explores similar territory.

Clark came to wider public attention with his debut feature film, *Kids*, in 1995. Based on a script by Clark and Harmony Korine, the drama follows a group of New York City teenagers through a day of reckless behaviour. Critically divisive, *Kids* was also lambasted on its release for its perceived amorality, in particular for its deadpan portrayal of sexual violence and drug abuse by pre-adolescent boys and girls. But as in his early photographic projects, Clark's refusal to pass judgment is here augmented by the profundity of affect that comes only from combining genuine personal investment with a refined visual aesthetic. The subsequent films *Another Day in Paradise*, 1998; *Bully*, 2001; *Teenage Caveman*, 2001; *Ken Park*, 2002; and *WASSUP ROCKERS*, 2005, deepened their maker's uncompromising vision.

Jonathan Velasquez & Eddie, 2003, is an entry in Clark's photographic series 'Los Angeles 2003–2006', which chronicles four years in the life of Jonathan Velasquez, the inspiration for *WASSUP ROCKERS*. As with Clark's previous work, these images focus on the contradictions and conflicts, as well as on the physical and stylistic exuberance, of teenage boys. They also reflect an interest in the chaotic interweaving of ethnic groups and youth subcultures; Velasquez is a Latino boy growing up in Los Angeles who identifies with punk rock and skateboarding. Clark's photographs reflect both the specific details of their subject's affiliations and a broader sense of what it means to be on the cusp of adulthood. There is a certain glamour to Velasquez, but also a gentleness and vulnerability.

Clark's refusal of critical distance, while discomfiting, does not invalidate his project.

In Clark's view, boys of Velasquez's age are at once demonized and fetishized by society, and the gaze they offer the camera is suitably challenging, even aggressive, but seductive too. Detractors insist that such images are voyeuristic and exploitative in their sexualized portrayal of youth, but Clark's refusal of critical distance, while discomfiting, does not invalidate his project. In terms of its confrontational presentation of an underrepresented milieu, Clark's oeuvre might be compared to those of artists such as Nan Goldin, or even crime-scene photographers like Weegee. Just as the skate kids in *WASSUP ROCKERS* refuse to be bounded by their South Central 'hood and head to Beverly Hills in search of trouble and fun, so Clark presents us, unapologetically, with his own peculiar compulsions.

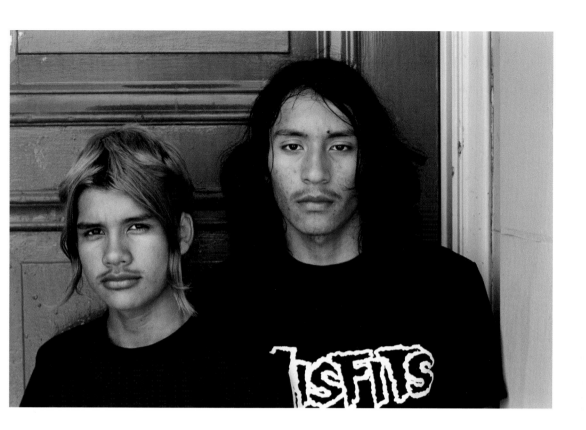

Kids, 1995.
35 mm colour film with sound, 91 minutes.

Untitled, 1972. Black-and-white photograph, 27.9 x 35.6 cm.

Untitled, 1979.
Black-and-white photograph, 35.6 x 27.9 cm.

Chromogenic prints, 133 x 79 cm (each).

Jan De Cock

Born in Brussels, Belgium, 1976; lives and works there. De Cock was educated in Ghent and Brussels and has exhibited at venues around the world, including Tate Modern, London; the Museum of Modern Art, New York; Schirn Kunsthalle, Frankfurt; Bozar, Brussels; De Appel Arts Centre, Amsterdam; and in the Art Statements section of Art Basel Miami Beach. De Cock won the Young Belgian Painters Award in 2003.

Jan De Cock's *Denkmal 11*, 2008, a meandering installation designed for the Museum of Modern Art in New York, appears at first to be an exploded art-historical timeline. The display, which juxtaposes shots of existing artifacts with the artist's photographs (some of them depicting the museum itself) is in fact not even sequential, but reflects instead a multi-perspectival approach to the understanding of visual culture. De Cock's interest is in the way we make connections *between* images and objects, and this is further reflected in his use of reframing, fragmentation and other symbolic devices. The inclusion of images within images in *Denkmal* implies a non-hierarchical approach to the reception and making of art, one that acknowledges its history without kowtowing to one exclusive view of its development or direction.

Denkmal 11 – the title is derived from the German word for 'monument' and from the museum's address, but also contains the Dutch words *denk* (think) and *mal* (mould) – is sculptural as well as photographic. At its debut, the work occupied various parts of the museum, responding to the design, content and functionality of the building's theatre, library and conservation labs, as well as to its galleries. Works by artists represented in MoMA's permanent collection – Brancusi, Hopper, Judd – are illustrated and obliquely recontextualized by juxtaposition with images from the history of architecture, photography and cinema. De Cock embeds these references in a labyrinthine display structure that alludes both to early modernist sculpture and architecture, and to the designs of other installation artists such as Aernout Mik.

As befits a work concerned with the construction of meaning through sequences and their interruption, *Denkmal 11* was presented at MoMA both as one instalment in a series-in-progress (other parts have appeared at Tate Modern in London and Bozar in Brussels) and as the starting point for 'American Odyssey'. This new project by De Cock involved a documentation of US monuments that was itself inspired by Jean-Luc Godard's collage film *Histoire(s) du cinéma*, 1988–1998, and gives a self-referential nod to the work's title. Shots taken with the latter in mind, some of them made into photomontages, appear in *Denkmal 11*, but it is left to the viewer to assess their relative and ultimate significance. The landmark images, which are characterized by a cinematic style, form part of a consciously disparate whole.

Denkmal is educational, but what it teaches us depends on the route we take through it.

In focusing more on the institutional context of art than on the production of unique or autonomous works, De Cock follows in the footsteps of another Belgian artist, Marcel Broodthaers (1924–1976). But where Broodthaers made his own tongue-in-cheek 'museums', beginning in his own house with the 1968 installation *Musée d'Art Moderne, Département des Aigles*, De Cock prefers to work within and in response to existing institutions, destabilizing their authority through textual, visual and physical overload. *Denkmal* is educational, but what it teaches us depends on the route we take through it, our prioritization of some aspects over others, and our willingness to perceive a 'canonical' collection with fresh eyes – the artist's and our own.

MODULE CCCXX

MODULE CCCXXI

Denkmal 11, Museum of Modern Art, 11 West 53 Street, New York, 2008. Triptych 8, Module CCCLXXV, Module CCCLXXVI, Module CCCLXXVII, 2008.
Chromogenic prints, 133 x 79 cm (each).

MODULE CCCLXXV

MODULE CCCLXXVI

MODULE CCCLXXVII

Anne Collier

Born in Los Angeles, USA, 1970; lives and works in New York. Collier has been the subject of solo exhibitions at ArtPace, San Antonio, Texas; Bonner Kunstverein, Bonn; and Presentation House Gallery, Vancouver. She has also exhibited at galleries in London, Madrid, Berlin, Los Angeles and San Francisco, and was included in the 2006 Whitney Biennial. Her works are represented in public collections including those of the Museum of Contemporary Art, Los Angeles; Walker Art Center, Minneapolis; and Tate Modern, London.

True to its title, Anne Collier's photograph *Open Book #1 (Crépuscules)*, 2009, shows a book being held open almost flat against a plain background. On the volume's right-hand page, surrounded by white space, is a lush colour shot of a sunset (the work's parenthetical French subtitle is another word for twilight); the left-hand page has been left blank. We are not given any further information about the book – the only other part of it we can see is a thin strip of the inside cover – and we know nothing about the person holding it, though their hands look feminine. Despite the romantic connotations of the image in the book, the photograph as a whole appears almost clinically objective; it could be documenting an artifact from an archaeological dig, or evidence from the scene of a crime.

The matter-of-fact visual style of *Open Book #1*, and of other entries in the series it inaugurates, provides a useful point of entry to Collier's larger project. What it suggests is that her interest lies as much in the traditions and conventions of the photographic medium as it does in any particular subject that might end up in front of a lens. By emphasizing the object qualities of the book, she also highlights the illusory nature of the reproduction therein: this is not a sunset, she reminds us, but rather a photograph of a photograph of a sunset that has also already been filtered through the complex processes of editing and printing. By directing attention to the way in which the photograph it depicts is contextualized by its system of presentation, *Open Book #1* prompts us to understand it as both image and artifact.

By emphasizing the object qualities of the book, Collier also highlights the illusory nature of the reproduction therein.

Collier's highly systematic approach to picture-making is rooted in the fondness shown by Conceptual artists for wielding the camera as a documentary tool, but is further informed by the commercial and technical photography of the 1960s and 1970s. Many of the objects she depicts, which include printed matter such as album covers and posters, as well as magazines and books, have immediate pop-cultural associations and are often tinged with nostalgia. *May 1968 (Playboy)*, 2012, for example, shows a calendar page featuring a grinning nude model posed by a swimming pool. The choice of date not only fixes the image in time but also reminds us of the student protests and general strike that took place in Paris that month. Others show pieces of darkroom equipment, using them to comment on the extent to which images are both the products and agents of manipulation.

Given Collier's focus on the *ways* we see, and on how photography mimics the mechanics of vision, it seems entirely appropriate that images of eyes should also crop up frequently in her work. *Developing Tray #1 (Grey)*, 2008, for example, reveals an unexpected formal similarity between container and organ, while *Cut*, 2009, pays sly homage to an infamous scene in Luis Buñuel's surrealist film *Un Chien Andalou*, 1929. The 'human element' of *Open Book #1*, which asks that we put ourselves in the place of its unnamed bibliophile, is quieter but equally insistent.

May 1968 (Playboy), 2012.
Chromogenic print, 147.3 x 122 cm (framed).

Developing Tray #1 (Grey), 2008. Chromogenic print, 106.7 x 130.2 cm.

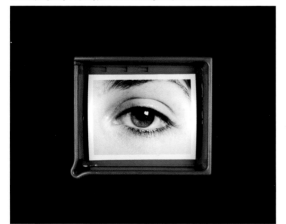

Cut, 2009. Chromogenic print, 116.4 x 139.7 cm.

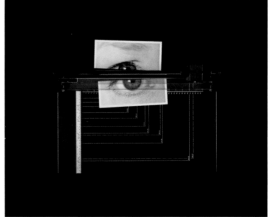

Tony Conrad

Born in Concord, New Hampshire, USA, 1940; lives and works in New York and Buffalo. Conrad has exhibited at venues including the Museum of Modern Art and MoMA PS1, New York. In 1991, the Kitchen, New York, staged a retrospective of his videos, and his film *The Flicker*, 1966, was featured in the Whitney Museum of American Art's 1999 exhibition, 'The American Century'. Conrad's first published recording was *Outside the Dream Syndicate*, 1972, a collaboration with Faust; more recently, he performed at the 2011 All Tomorrow's Parties festival.

Tony Conrad is something of an avant-garde legend in New York. Achieving notoriety early on with his 1960s 'anti-art' demonstrations with Henry Flynt and Jack Smith, he was indirectly responsible for naming the Velvet Underground (Lou Reed and John Cale unearthed a book of the title on moving into Conrad's old Manhattan apartment), and continues to exercise an active influence on the current scene in his seventies. Best known as a composer and performer associated with the development of minimalism in academic music, Conrad is also an artist and filmmaker with a consistent interest in breaking down the boundaries between the producer of a work – in whatever medium – and its audience. What Conrad seeks in all his diverse projects is a productive dismantling of established forms and relationships.

In 1966, Conrad made *The Flicker*, a half-hour film constructed entirely from rapidly alternating frames of black and white. His aim was to provoke a physical response, and in this he unarguably succeeded; several viewers at the work's premiere complained of sickness and fled the room. *The Flicker* is feted as a Structuralist classic for its uncompromising focus on the filmic medium, but Conrad soon moved on to the creation of 'film objects', sculptural works made by cooking and pickling unprocessed stock, and to 'Yellow Movies'. This latter series, produced in 1973 for a one-night 'screening', consisted of large sheets of paper inscribed with rectangular 'screens' and tinted with household paint. Conrad presented these surfaces' gradual yellowing as a kind of ultra-slow-motion movie, one made entirely without the form's conventional technology.

The Flicker, 1966. Black-and-white 16 mm film with sound, 30 minutes.

In the later 1970s and 1980s, Conrad began to concern himself increasingly with the theme of power and control in contemporary culture and society, an emphasis bolstered by his teaching position in the Department of Media Study at SUNY, Buffalo. He made community-based videos for public cable television stations (hosting the shows 'Studio of the Streets' and 'Homework Helpline') and collaborated with younger artists including Mike Kelley and Tony Oursler. In the 1990s, Conrad returned to his foundational interest in mathematics by making sculptures that explore the field's intersection with musicology. Most recently, he has continued to redefine the possibilities of live performance; July 2008 saw him stage *Unprojectable: Projection and Perspective* in the Turbine Hall at Tate Modern in London.

Yellow Movie, 1973. Mixed media, 320 x 270 cm.

Featuring an amplified string quartet (in which Conrad himself played violin) alongside various items more often associated with industrial music – or simply industry – such as electric drills and motors, the epic *Unprojectable* riffed on the museum's former life as a power station. Using the hall's central bridge as a stage, Conrad also incorporated films and shadows into the work, projecting them onto loose fabric sheets hung high above the audience's heads. Secreted behind these, the artist and his collaborators peppered an extended musical performance with restagings of some of his more violent filmic manipulations. Juxtaposing the retrospective character of these actions with the immediacy of intense sound and the mercurial nature of cast image, *Unprojectable* formed a unique composite portrait of its polymath maker.

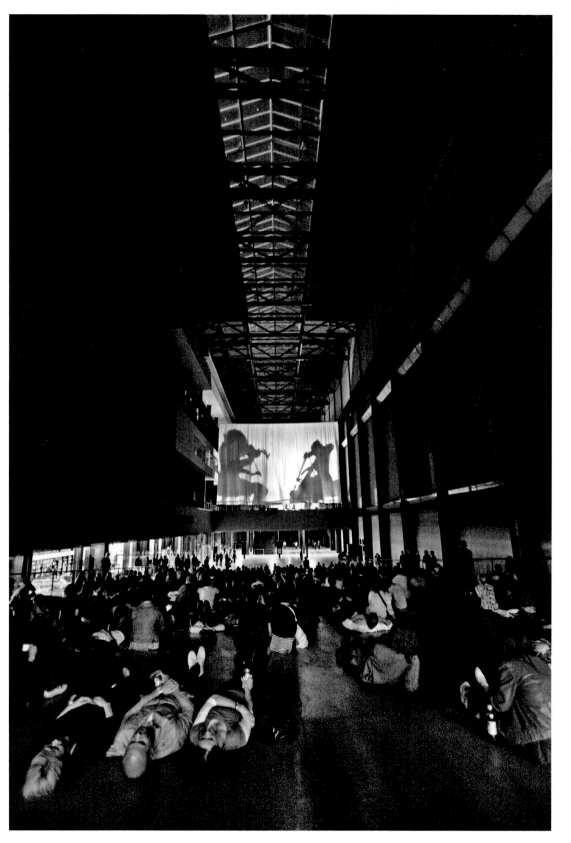

Russell Crotty

Born in San Rafael, California, USA, 1956; lives and works in Ojai and Upper Lake, California. Crotty has been the subject of solo exhibitions at La Criée centre d'art contemporain, Rennes; Kemper Museum of Contemporary Art, Kansas City; Miami Art Museum; and numerous other venues. His work is represented in the collections of the Centre Pompidou, Paris; the Museum of Modern Art, New York; and the Museum of Contemporary Art, Los Angeles. He has received fellowships from the Peter Reed Foundation and the National Endowment for the Arts.

Russell Crotty is a curious mix of artist, scientist and adventurer. A long-time amateur astronomer and dedicated surfer, he combines rigorous observational drawing with 'bad poetry' (his own term) in formats ranging from conventional sketches to books, charts and globes. Crotty's approach is both conceptual and highly romantic, combining a drive to record the information he obtains through the lens with a more subjective impression of the universe and our place within it. The owner and user of an array of optical telescopes – he is a traditionalist in this regard, eschewing digital technology – Crotty studies the night sky and renders what he sees in a manner that feels at once precise and oddly primitive.

Crotty's globes are constructed from fibreglass and covered with archival paper. The artist paints a translucent wash of watercolour onto the surface before drawing on it with ballpoint pen. The spheres vary in size – the largest are almost two metres across – but are generally shown suspended from the ceiling by wires, allowing viewers to see them from every angle. *M11 Galactic Cluster in Scutum*, 2002, shows only the white points of an obscure star system against a uniform dark ground, but other examples depict more familiar celestial forms like the Milky Way, or include elements of earthly landscape in the shape of horizon lines dotted with mountains and trees. And not all of Crotty's skies are nocturnal; *Venus Over High Glade*, 2006, is lightened by a crepuscular radiance, while *The Cape*, 2010, could have been made at midday.

Russell Crotty is a curious mix of artist, scientist and adventurer.

The prose that many of Crotty's works incorporate is characterized by exhaustive description derived in part from scrupulous field notes, in part from hazily remembered experience. While this hybrid writing reflects the artist's personal feelings about the locations he visits, it also sometimes incorporates extracts from local publications that cast the area in a different, cooler light. And the lettering itself, which fills the images' outlined landscapes like stratified rock, additionally becomes a textural component. There is even a hint of psychedelic poster design in the way that Crotty distorts his letterforms in order to fit the text into its allotted space – a remnant, perhaps, of his upbringing in the San Francisco Bay Area, birthplace of hippie culture in the 1960s.

Crotty's landscape drawings are similar in scale and ambition to his astronomical works and occupy many of the same formats, but here the artist narrates a more intimate experience of the natural world, also offering comment on the negative impact of human intervention. His surf works – seascapes of a kind – document in drawings, watercolours and monoprints a succession of real and imagined spots. Many of these idealized sites, rendered with the tireless fascination of a true obsessive, are derived from an extended series of sketchbooks titled 'California Homegrounds'. In this on-going project, Crotty intersperses doodles of perfect waves and beaches with lines of existing and invented surfer slang. As are the astronomical works, these books are labours of love, the fruits of a dedication to communicating a joy in nature rare in contemporary practice.

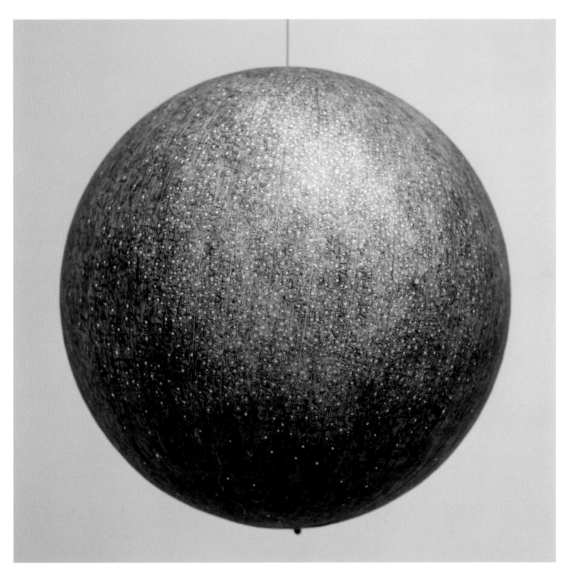

The Cape, 2010.
Ink and watercolour on paper on fibreglass sphere,
91.4 cm diameter.

Field Guide to Selected Surf Breaks II (detail), 2007.
Ink and watercolour on paper and vellum on 37 pages in linen-covered book,
62.2 x 62.2 x 3.8 cm (closed).

Keren Cytter

Born in Tel Aviv, Israel, 1977; lives and works in Berlin, Germany. Cytter's work has been the subject of solo exhibitions at venues including Tate Modern, London; X Initiative, New York; Witte de With Center for Contemporary Art, Rotterdam; Museum Moderner Kunst Stiftung Ludwig, Vienna; and KW Institute for Contemporary Art, Berlin. She has been included in several important thematic exhibitions including 'Fare Mondi/Making Worlds' at the 53rd Venice Biennale, and 'Television Delivers People' at the Whitney Museum of American Art, New York.

Rattled by the loud music blasting from her neighbour's apartment, a woman makes her way inside only to find the guilty party laid out bleeding in the aftermath of a suicide attempt. Bonded by this traumatic incident, the two enter into an ill-defined relationship, though their deadpan delivery makes it difficult to accept the connection as sincere. *Four Seasons*, 2009, a video by Keren Cytter, concludes with a kitchen-table banquet that descends into confusion when the wine is transformed into blood and the man causes various objects to spontaneously ignite, apparently through the application of psychic force. The work's characters and plot borrow freely from those of other films, and from the conventions of cinematic, televisual and literary genre, but the results are entirely Cytter's own.

The dramas around which Cytter's work revolves are frequently drawn from personal experiences, or from those of friends, and *Four Seasons* – for all its seeming absurdity – is reportedly no exception. Returning again and again to timeless themes of love, loss and friendship, the artist's videos are distinguished by their layered, meandering progression; they explore the dynamics of human interaction via a complex intermingling of the partially real and the fully imaginary. Further incorporating reminders of her medium's structural components – sets, props, camerawork, editing – Cytter never lets us forget that the object of our gaze is the product of a system of rules. Yet by combining this procedural candour with spoken narratives that detail her character's inner worlds, she draws us in ever deeper.

Cytter never lets us forget that the object of our gaze is the product of a system of rules.

The litany of references in *Four Seasons* reveals Cytter as a confirmed cineaste, equally absorbed by the output of mainstream Hollywood and of the European avant-garde, and as a devotee of modernist theatre. So while the video's extended climax echoes popular film's love affair with over-the-top special effects, its looping, stylized dialogue reflects the subtler influences of Samuel Beckett and Bertolt Brecht. Certain scenes are also twinned with existing scenes – the interrupted suicide, for example, is a restaging of one in Roman Polanski's 1976 psychodrama *The Tenant* (a film that was, coincidentally, also the inspiration for Brazilian artist Rivane Neuenschwander's eponymous video of 2010). But while *Four Seasons* is peppered with such references, it doesn't wholly depend on them for its strange and memorable impression.

Other works by Cytter trade in a similar blend of allusion and directness. *Les Ruissellements du diable* (The Devil's Streams), 2008, for example, takes as its starting point the Julio Cortázar short story on which Michelangelo Antonioni's iconic movie *Blow-Up*, 1966, was based. Cytter mines the text for a postmodern exercise in fragmented narrative shot not around Paris but in her own Berlin apartment. In thus combining elements still reflexively thought of as incompatible – fiction and autobiography, fantasy and realism, psychological portraiture and formal experiment – she encourages us to look closer at the ways in which life is increasingly overlaid with the deliberate patterning of art. That the artist is also a published novelist and the head of a theatrical dance company only enriches this project.

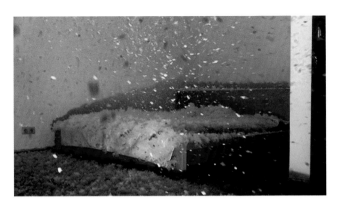

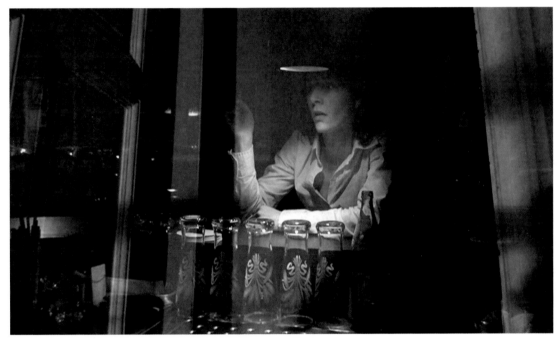

Les Ruissellements du diable (The Devil's Streams), 2008. Colour video with sound, 10 minutes 43 seconds.

Der Spiegel, 2007.
Colour video with sound, 4 minutes 30 seconds.

Something Happened, 2007.
Colour video with sound, 7 minutes.

Tacita Dean

Born in Canterbury, England, 1965; lives and works in Berlin, Germany. Solo exhibitions of Dean's work have been organized by institutions including Tate Britain, London; Museum für Gegenwartskunst, Basel; Dia:Beacon, New York; and Sprengel Museum, Hanover. She has also been featured in biennials in Venice, Berlin, São Paulo and Sydney, and a comprehensive retrospective was held at Schaulager Basel in 2006. Dean was a Turner Prize nominee in 1998, and has since been awarded the Aachen Art Prize, Hugo Boss Prize and Kurt Schwitters Prize, among others.

Maritime imagery has been a significant presence in the work of Tacita Dean since the early 1990s, providing an evocative backdrop for lyrical explorations of history, biography and myth. In one sequence of films and drawings, she relates the story of Donald Crowhurst, an English sailor whose aim of entering a race to circumnavigate the globe ended in deception and tragedy. And in *Roaring Forties: Seven Boards in Seven Days*, 1997, she again employs a simple chalk-on-blackboard technique to construct an epic narrative in which sailors struggle against an ocean storm. The series' sequential composition and the instructions marked on its surfaces forge a link with early cinema that resonates with Dean's vision of the sea as an inspiration for romantic – and frequently doomed – adventure.

In *Amadeus (swell consopio)*, 2008, made for the Folkestone Triennial, Dean revisits this theme – and her childhood home. The 50-minute film portrays a crossing of the English Channel undertaken by the titular fishing boat, tracing its journey from Boulogne-sur-Mer in France to the English town in which the exhibition took place, and in which Dean grew up. Once a busy ferry port, Folkestone is now used less frequently, and the elegiac feel of the artist's portrayal reflects this gradual change. Dean frames the Channel as a slice of national history: 'We have fished it, reclaimed land from it, smuggled across it, tried to keep it out or traversed it to lands beyond,' she writes. 'We are an island people who have become too content with looking in and have let our seaport citadels rot.'

That *Amadeus* is silent is meaningful, as is the incremental shift it records from pre-dawn darkness to early-morning light.

That *Amadeus* is silent is meaningful, as is the incremental shift it records from pre-dawn darkness to early-morning light. The film unfolds in the exact time it takes to make the cross-Channel journey on a modern ferry, thereby rooting the viewer in the present. But the trip it actually depicts takes rather longer, and a link is thus forged with times past. The whirring of the projector replaces the lapping of waves, hinting at a displacement of one technology by another – perhaps ironic given the artist's ongoing preference for traditional film over digital media. *Amadeus*, like all Dean's films, hinges on the unique qualities of celluloid, especially its quasi-painterly sensitivity to natural colour. Eschewing the linear narrative we are accustomed to from the medium, the artist wields her camera like a brush, sketching the scene's unique atmosphere and resonance.

In her project for the Turbine Hall at Tate Modern in London, Dean continued to reflect on the particularity – and the threatened status – of her favoured material in a work simply titled *Film*, 2011. The 11-minute 35 mm piece, again silent, was projected onto a 13-metre high slab at the end of the otherwise darkened space. A free-form montage of black-and-white, colour and hand-tinted images, the content ranges across various subjects – figurative and abstract, interior and exterior, natural and artificial. *Film* recalls the experiments of Structuralist filmmakers like Stan Brakhage who emphasized the medium's physicality, and makes a quietly powerful case for the rescue of a dying form.

Disappearance at Sea (Cinemascope), 1996. 16 mm anamorphic colour film with optical sound, 14 minutes.

Film, 2011.
35 mm colour anamorphic film, without sound, 11 minutes.

The Battle of Orgreave, 2001

35 mm-colour film with sound, directed by Mike Figgis, 60 minutes. The Modern Institute, Glasgow.

Jeremy Deller

Born in London, England, 1966; lives and works in London. Deller has exhibited internationally at important venues including the Hayward Gallery, London; Art Pace San Antonio, Texas; Palais de Tokyo, Paris; Bard College, New York; and Carnegie Museum of Art, Pittsburgh. He won the Turner Prize in 2004 and was appointed a Trustee of the Tate in 2007. In 2010, Deller was awarded the RSA Albert Medal by the Royal Society for the Encouragement of Arts, Manufactures and Commerce, in recognition of his 2009 work *Procession*.

On 18 June 1984, Orgreave in South Yorkshire was the site of a violent confrontation, as five thousand coal miners clashed with nearly eight thousand riot police in a field outside the local coking plant, before a cavalry charge stormed through the village. The miners, members of Arthur Scargill's National Union of Mineworkers, were on strike in protest at a series of pit closures instituted that year by Margaret Thatcher's Conservative government. This programme, part of a broader and ultimately successful push to weaken the unions in general, proved highly divisive and dominated the national political landscape as the strike dragged on into the following year. The Battle of Orgreave, as it became known, was a symbolic victory for the government.

Seventeen years to the day after this emblematic skirmish took place, Jeremy Deller reimagined it as a performance. *The Battle of Orgreave*, 2001, was staged on the site of the original event, and among the more than eight hundred participants were veterans from both sides. Enlisting Howard Giles, an expert in historical re-enactment, Deller researched his subject in detail and styled cast and setting to look the part. 'On the day it seemed no detail was missing,' recalls critic Alex Farquharson, 'right down to the "Rock on Tommy" ice cream van still selling its wares in the thick of the action, or the comic prelude of miners performing mock inspections of the police front line and applying "Coal not Dole" stickers to their riot visors.'

By resurrecting the battle – or at least its appearance – with such uncanny thoroughness, Deller not only reinvestigated a bitter dispute and its highly charged socio-political context, but also examined the extent to which an influential event and its representation diverge. Most re-enactors focus on encounters without living survivors; by adopting a more recent model and employing individuals with first-hand experience thereof, Deller produced something closer to a rematch – it was almost as if his combatants had emerged from hiding to pick up where they had left off. The artist also made some telling discoveries about the media's role, finding out that the BBC had reversed the order of events in its news footage to make it appear that the miners provoked the police charge.

The Battle of Orgreave, which was filmed by director Mike Figgis, hinged on collaboration, and this emphasis colours much of Deller's oeuvre. *Acid Brass*, 1997-2004, for example, involved the performance of acid house tracks by a traditional brass band, while 'Folk Archive', begun in 1999, was an exhibition of contemporary British 'popular' art organized in partnership with Alan Kane. In these and other projects, Deller explores aspects of culture and class that are habitually sidelined by academia and officialdom. Initially focused on his homeland, he now casts a wide net; *Memory Bucket*, 2003, for example, is a Texas-set, quasi-documentary film that visits the site of the Branch Davidian siege in Waco and George W. Bush's hometown of Crawford. Here again, the political meets the personal and 'reality' is revealed to be a highly elastic construction.

From Jeremy Deller and Alan Kane, Folk Archive, 1999-2005.
Tom Harrington, Cumberland and Westmoreland Wrestling Champion, Egremont, Cumbria, 1999.

The History of the World, 1997. Wall painting, dimensions variable. The Modern Institute, Glasgow.

Wim Delvoye

Born in Wervik, Belgium, 1965; lives and works in Ghent. Delvoye has been the subject of solo exhibitions at the New Museum, New York; Manchester City Art Gallery; Musée d'art contemporain de Lyon; Centre Pompidou, Paris; and Musée du Louvre, Paris. His exhibition 'Wim Delvoye: Knockin' on Heaven's Door', which opened at Bozar, Brussels, in 2010–2011, featured a monumental 17-metre lattice-cut steel tower, installed on the roof of the building.

'For me it's life. This is a human being without a soul.'[1] Wim Delvoye's notorious installation *Cloaca*, which has gone through several incarnations since it was unveiled in 2000, is a machine that mimics the processes of digestion and excretion. Designed and constructed with the help of scientists at the University of Antwerp, the work confronts viewers with a room-filling array of vats, pumps and tubing that suggests a bioengineer's laboratory or an industrial production line. Equipped with a garbage disposal system that pulps its intake, and stocked with chemicals and bacteria to replicate the contents of the stomach, *Cloaca* must be 'fed' twice a day. The final result of this process is entirely predictable but somehow still shocking: solid waste that is identical in appearance and odour to its traditional organic counterpart.

Curator Dan Cameron recalls *Cloaca*'s American debut at the New Museum, New York, in 2002: 'At the work's inauguration, Delvoye himself ascended the ladder carrying a tray laden with a tasty and substantial Belgian meal of mushroom soup, filet of fish, and a rich pudding, which he dropped in the funnel a dollop at a time.'[2] Following this ceremonial dinner, the machine was busy for some twenty-seven hours, computers maintaining the temperature of the food at 37.2 degrees while monitoring the action of each component. Viewers' responses to this process ranged from disgust to fascination, most reporting a combination of both. *Cloaca* hits a nerve, engendering something akin to the 'uncanny valley' effect in robotics – an instinctual feeling of revulsion elicited by machines that seem to be encroaching on human territory.

Calliope, 2001–2002.
Steel, X-ray photographs,
lead, glass, 200 x 80 cm.
Studio Wim Delvoye.

Delvoye has stirred up strong reactions before and since *Cloaca*, often through a similarly provocative focus on the human and animal form. In 1997, for example, he began a series of terrazzo tiles featuring sandwich meats and arrangements of his own faeces, while *Art Farm*, 2004–2008, saw him establish a tattoo workshop for pigs. Such projects, while coloured by the artist's mordant wit, also reflect his serious interest in the disjuncture between natural physicality and its codification according to the rules of society and culture. Delvoye's practice has also frequently seemed to cross the line between art and science, employing technology to absurdist ends that call the roles of both disciplines into question. In a set of 'SexRays' that form part of 2002's 'Gothic Works' series, for example, the artist borrows the format of the medieval stained-glass window to present X-ray photographs of friends performing a variety of explicit acts.

The same unsettling objectification of an intimate occurrence is a defining feature of *Cloaca*. More than just a crude joke aligning art and shit – both arguably useless 'products' – the work lays bare our persistent anxiety over the body and its everyday functions. In this it forms part of a lineage of 'abject' art that pointedly confronts us with our own embarrassment. And by encouraging us to reconsider how we as people might intersect with our creations, it makes us doubly uncomfortable.

1 The artist quoted on the website of Berlin gallery Arndt and Partner. http://www.arndtberlin.com/website/artist_1922
2 Dan Cameron, 'Wim Delvoye: *Cloaca*', New Museum, New York, 2002.
 http://www.newmuseum.org/exhibitions/360

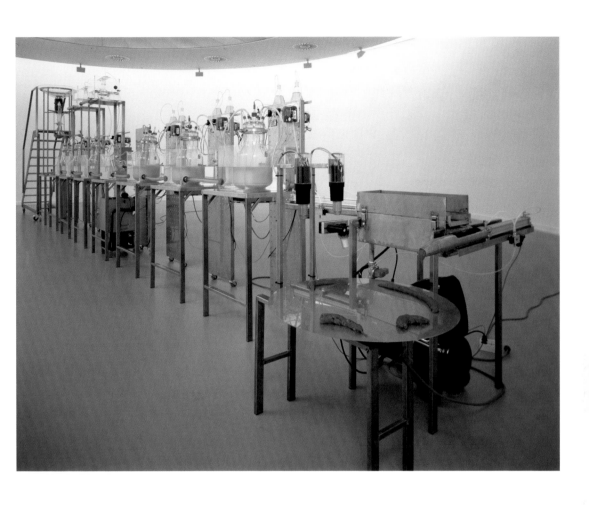

Art Farm, 2007. Live tattooed pigs. Studio Wim Delvoye.

Suppo (scale model 1:2), 2011. Laser-cut stainless steel, 620 x 75 cm. Studio Wim Delvoye.

Thomas Demand

Born Munich, Germany, 1964; lives and works in Los Angeles, USA, and Berlin. Demand has been the subject of solo exhibitions at the Museum of Modern Art, New York, and Neue Nationalgalerie, Berlin, and has represented Germany at the Venice Biennale and the São Paulo Biennial. He has participated in group exhibitions including 'Midnight Party' at the Walker Art Center, Minneapolis; 'Precarious Worlds: Contemporary Art from Germany' at the Kemper Art Museum, St. Louis, Missouri; and 'Haunted: Contemporary Photography/ Video/Performance' at the Solomon R. Guggenheim Museum, New York.

Thomas Demand trained as a sculptor and initially used a camera simply to record his work. Gradually, he became interested in the possibility that these documentary snaps might function as art in their own right, and eventually began to produce three-dimensional models exclusively as subjects for two-dimensional images. Starting with a found photograph – often from the popular press and depicting a historically or culturally significant (though not often immediately recognizable) location – Demand uses paper and card to build a large-scale replica. Eschewing digital manipulation, he makes physical adjustments to ensure a fairly convincing, though never entirely flawless, result. Careful lighting then allows him to create an appropriate atmosphere before he shoots – and then finally destroys – each simulation.

Landing, 2006, was first shown in Demand's 2007 survey exhibition at the Irish Museum of Modern Art in Dublin. Appearing to show the pieces of a shattered vase strewn across the stairwell of an institutional interior, it has a strange sense of airlessness that is common to all of the artist's work, and which prompts us to track down the artifice of the image. What is it about this scene that isn't quite right? Firstly, there is an incongruous cleanliness to the building's surfaces, and the illumination appears curiously flat. Viewers familiar with the location – the Fitzwilliam Museum in Cambridge, England – might also be able to pick out other small inaccuracies. But in spite of this disconnectedness from observable reality, the photograph still seems to describe an actual event – a crime, perhaps?

Landing's true subject is the aftermath of a widely reported accident in which three Qing Dynasty vases were destroyed by a museum visitor who tripped over his shoelaces and fell down the stairs, knocking the priceless artifacts to the floor. Here, Demand performs his own kind of 'reconstruction', not putting the vases back together (as was achieved by conservators) but recreating the scene of their breakage from one of several photographs distributed at the time. The work's title succinctly describes both the incident and (in generic terms) its location, while the mishap's destructive element is mirrored in the paper model's fate at the hand of the artist. This play with the intersection of image, language and idea is consistent with Demand's self-description as a conceptual artist making use of photography, rather than a photographer *tout court*.

Demand communicates an acute sensitivity to the ways in which fact and reportage exist in a state of flux.

Demand exercises a similarly self-reflexive wit in other works, referring to famous artists and influential or notorious figures from other spheres without ever representing them directly. *Barn*, 1997, for example, is based on a Hans Namuth photograph of Jackson Pollock's studio, while *Zimmer (Room)*, 1996, depicts the hotel suite in which L. Ron Hubbard composed *Dianetics*, the foundational text of Scientology. 'Presidency', a 2008 series commissioned by *The New York Times*, depicts the Oval Office following the election of President Barack Obama. In such works, and in his recent film projects, Demand communicates an acute sensitivity to the ways in which fact and reportage, visual memory and the photographic image exist in a state of flux, none ever quite consistent with the other.

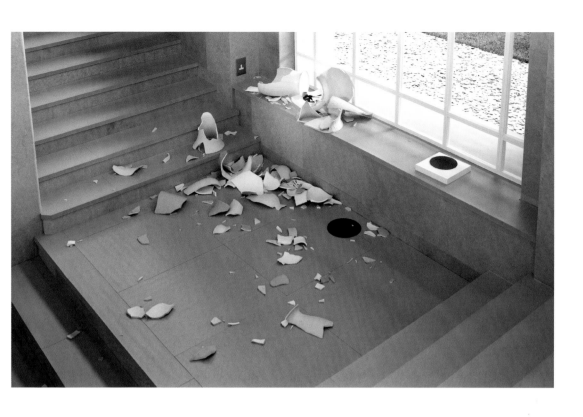

Presidency I, 2008.
Diasec-mounted chromogenic print, 310 x 223 cm.

Barn, 1997. Diasec-mounted chromogenic print, 183.5 x 254 cm.

Zimmer (Room), 1996. Diasec-mounted chromogenic print, 172 x 232 cm. The Museum of Modern Art, New York.

Rineke Dijkstra

Born in Sittard, the Netherlands, 1959; lives and works in Amsterdam. Dijkstra studied at the Gerrit Rietveld Academy, Amsterdam, and has been the subject of solo exhibitions at the Rudolfinum, Prague; Stedelijk Museum, Amsterdam; and San Francisco Museum of Modern Art. Her work is represented in the collections of Tate Modern, London, and the Museum of Modern Art, New York. She is the recipient of awards including the Kodak Award Nederland; the Art Encouragement Award Amstelveen; the Werner Mantz Award; and the Citibank Private Bank Photography Prize.

'I can see a woman crying…and loads of different shapes.' 'I can…I can see a woman with, like, part of a mouth, a chin, and around the chin there's fingers.' 'I can see her hair…in different colours.' The observations come from a group of English schoolchildren who appear in a triptych of projected videos by photographer Rineke Dijkstra. What the uniformed teenagers are responding to is Picasso's famous painting *The Weeping Woman*, 1937, a reproduction of which has been attached to the tripod of one of the three cameras used to film the work. This positioning means that the group looks us almost, but not quite, in the eye, as if we ourselves were the canvas. And its members do not address us directly but seem to be talking to themselves, then to each other as they riff on their friends' remarks.

Dijkstra's work was made in collaboration with Tate Liverpool and filmed in a special studio constructed inside the galleries. Inspired by school visits to the museum, it has the look of a documentary portrait but ultimately functions, as critic Rudi Fuchs points out, as something closer to a 'conversation piece' in painting. We begin by looking at the children, noting their distinctive faces and gestures, the way they tilt their heads in the universal pose of concentrated looking. Then, as they begin to speak, our attention shifts to their voices with their distinctive accents and inflections, and a sketch of nine individuals becomes a broader study of region and social class. Finally, as the discussion gains momentum and we are fully absorbed by the kids' speculations and insights – 'Looks like she's seen something she'd never wanna see again'; 'Like…she has just seen a ghost or something'; 'She looks like she has just disobeyed someone and then she regrets it' – we recall the image that is their focus.

Dijkstra adopts an approach at once sympathetic and unsentimental, highlighting the resilience of individual character.

The situation that *I See a Woman Crying* records was obviously contrived by the artist but, once filming commenced, the protagonists were not directed. This partial freedom is common to all of Dijkstra's subjects, and allows her to capture people as they choose to present themselves within a given context. Whether she is using video or (as has more often been the case) still photography, the artist adopts an approach that is both sympathetic and unsentimental, highlighting the resilience of individual character. To this end, she has most often worked in series, employing a systematic methodology to direct attention away from formal structure and toward human diversity. A well-known set of portrait photographs from the 1990s depicts young boys and girls at the beach, standing alone with the ocean at their backs, their postures strangely evocative of classical painting or statuary. Another presents three young mothers, each holding their baby, shortly after having given birth. In these works, and in *I See a Woman Crying*, Dijkstra shows herself to be at once tough and tender. Far from exploiting her subjects' flaws and differences, she celebrates them as badges of humanity.

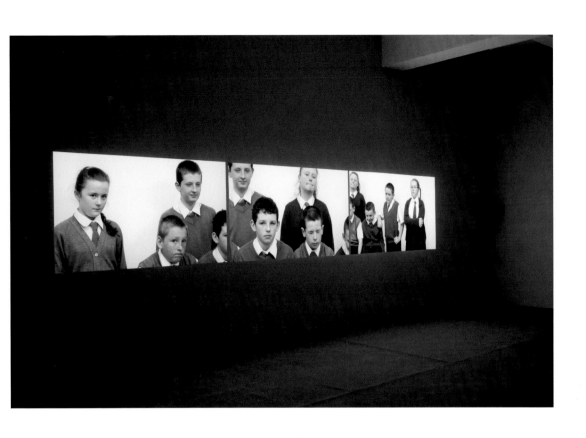

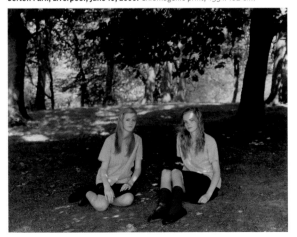

Sefton Park, Liverpool, June 10, 2006. Chromogenic print, 135 x 162 cm.

Kolobrzeg, Poland, July 26, 1992, 1992. Chromogenic print, 121 x 101 cm. The Metropolitan Museum of Art, New York.

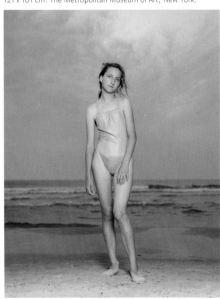

PASSAGE, 2006

Single screen colour video with sound, 7 minutes 52 seconds.

Willie Doherty

Born in Derry, Northern Ireland, 1959; lives and works there. Doherty's work has been the subject of solo exhibitions in, among other cities, Zurich, Dublin, Berlin, Madrid, New York and London. He was shortlisted for the Turner Prize in 1994 and 2003, and has represented Ireland at the Venice Biennale in 1993, Great Britain at the 2002 São Paulo Biennial, and Northern Ireland at the 2007 Venice Biennale. Also in 2006, seven of his video installations were the subject of a travelling survey exhibition organized by Laboratorio Arte Alameda, Mexico City.

As a child growing up in Derry, Northern Ireland, Willie Doherty witnessed 1972's Bloody Sunday massacre, in which twenty-six civil rights protesters and bystanders were gunned down by British troops. This event boosted the size and status of the Irish Republican Army, which had begun campaigning against the division of Ireland two years before, and remains emblematic of the Troubles. Many of Doherty's works reference Bloody Sunday and its repercussions, and employ its visual and linguistic markers to explore ideas around conflict, identity and the political mediation of images and words. Using video, photography and text, Doherty conjures darkly atmospheric scenarios in which the alignment of a given individual is never clear-cut, and the significance of a location shifts with the viewer's expectations.

In Doherty's video *PASSAGE*, 2006, two men are shown walking beside a road at night. Silent and severe, they seem at first to be heading toward one another, and there is an implication of imminent violence. We see one, then the other, in a rhythmic exchange that heightens the brooding tension. Occasional glimpses of the video's wider setting, a stretch of anonymous urban waste ground, provide no specific information, but the anticipation of a clash persists. Then, just as we begin to suspect that the pair may not occupy the same space and time after all, they pass each other. Neither man stops, but each casts a quick look back as he heads off into the gloom. In terms of mystery and quiet surprise, it is a moment akin to the fleeting instance of movement in Chris Marker's film *La Jetée*, 1962, a 'photo-roman' otherwise composed of still images.

Doherty conjures darkly atmospheric scenarios in which the alignment of a given individual is never clear-cut.

In the space of just under eight minutes, this apparent non-event in a seeming non-place is repeated several times. But while each encounter comes outwardly to nothing, the sense of threat is undiminished. And though no words are exchanged, there is an implication of mutual understanding, even if the two men still seem antagonistic toward one another. That their purposes are not made clear renders their mutual *purposefulness* all the more unsettling, but without the customary filmic cues of music and dialogue, we are left to construct our own details of character and plot. A familiarity with Doherty's background and oeuvre suggests one possible narrative, but even if we read *PASSAGE* as an allegory for the culture of secrets and division engendered by the Northern Irish situation, motivations are fuzzy and it is impossible to take sides.

PASSAGE, then, is a study in indeterminacy and assumption. It reminds us that meaning is constructed only through context, which, while necessarily diverse, is often controlled by those in positions of power and influence. In other works, Doherty underlines this point by using captions to openly manipulate our reading of an image. In doing this, he suggests that the process of emphasizing one meaning while suppressing another occurs even, or especially, when it goes unacknowledged. The theme of his 1990 installation *Same Difference*, in which two portraits of a woman from a TV news broadcast are superimposed with a sequence of terms – DERANGED, VOLUNTEER, MURDERER – chosen to evoke specific perceptions of their subject, thus also informs his current work, and remains intensely relevant.

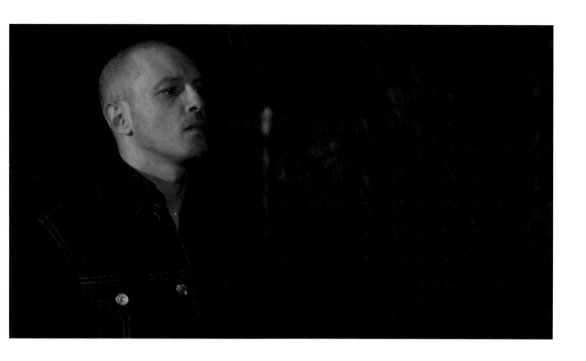

Mended Fence, Belfast, 2005.
Plexiglas and laminated chromogenic print
on aluminium, 122 x 152 cm.

Same Difference, 1990. Installation with two 35 mm slide-projected images
and changing text. Installation view, Matt's Gallery, London.

Music of the Future, 2002–2007

Oil on linen, 200 x 330 cm. Louisiana Museum of Modern Art, Humlebaeck, Denmark.

Peter Doig

Born in Edinburgh, Scotland, 1959; lives and works in Port of Spain, Trinidad. Doig won the John Moores Painting Prize in 1993 and was nominated for the Turner Prize the following year. In 2005, he was included in 'The Triumph of Painting' at the Saatchi Gallery, London, and in 2008, he was the subject of a major retrospective organized by Tate Britain, London, in cooperation with ARC/Musée d'Art moderne de la Ville de Paris and Schirn Kunsthalle, Frankfurt. His work has been featured in the Santa Fe Biennial, Tate Triennial and Venice Biennale.

'Last night I drove up from downtown, up George Street I think, and there was this eerie feel of semi-clothed people in a state of delirium, drug-infused, hunger-infused, or just plain drunkenness. It felt like a film set just before the camera's rolling, people in mid-flow, not sure where they are.'[1] Interviewing Peter Doig in 2007, fellow British painter Chris Ofili conjures up the woozy feel of a Trinidadian night – and Doig does the same in his canvas *Music of the Future*, 2002–2007, a river scene painted 'at that dusky time of day with no illumination other than what comes from the sky or is reflected off the water. There's only shadow and traces of colour.'[2] Both artists moved to the Southern Caribbean island in the 2000s, and their conversation reveals a mutual appreciation for the peculiarities of its atmosphere and light.

Music is not, however, the direct representation that this description might seem to imply. It was painted not from life, nor even from a photograph, but rather using a postcard from London showing a landscape in southern India that reminded Doig of his adopted home. Noting that the artist spent time in Trinidad as a child, critic Lisa Turvey has remarked that this tendency to blend found sources with personal recollection has become a more prominent feature of his work since he left the UK. While he has always painted from photographs and film stills, here he introduces yet another layer of dislocation. The painting is also marked by visual ambiguities that cause it to hover on the verge of abstraction. Superficially, *Music* is a social scene in the tradition of Georges Seurat, but there is an uncanny, almost hallucinogenic quality to it that distinguishes it from the Post-Impressionist's sunny vistas.

The intersection of rural landscape and psychological space has long been Doig's central theme. And while some earlier works such as *Ski Jacket*, 1994, which is based on a newspaper photograph of beginner skiers on a mountain in Japan, also depict crowds, he has most often concentrated on solitary figures. In doing this, he employs a variety of techniques, applying paint in translucent, veil-like washes as well as in small dabs of more opaque colour. Compositionally, he has shifted gradually from complex arrangements in which separate elements overlap one another to occlude a clear or unified view toward simpler, more iconic designs. But what finally makes his paintings memorable is their mood, a dreamlike blend of melancholia and tranquility that accords people and places the same subtly disquieting aura.

Georges Seurat, Sunday Afternoon on the Island of La Grande Jatte, 1884.
Oil on canvas, 207.6 x 308 cm.
Art Institute of Chicago.

Doig is a highly successful artist whose paintings have commanded extraordinary prices at auction in recent years, a fact that has led some to criticize his relocation to Trinidad as a badge of elite touristic status. But the fact that his practice continues to develop in and beyond its new context gives the lie to such easy dismissals. This is an art that draws on the past but – as *Music of the Future*'s title reminds us – does not reside there.

1 Peter Doig and Chris Ofili in conversation, *BOMB*, issue 101, Fall 2007.
2 Ibid.

Ski Jacket, 1994.
Oil on canvas, two parts: (right) 295.3 x 160.4 cm (left) 295 x 190 cm.
Tate, London.

Ping Pong, 2006-2008.
Oil on canvas, 240 x 360 cm. Barrie and Emmanuel Roman Collection.

Jimmie Durham

Born in Washington, Arkansas, USA, 1940; lives and works in Berlin, Germany. Durham has exhibited at venues and events around the world, including the Venice Biennale; Whitney Biennial, New York; Documenta 9, Kassel; Institute of Contemporary Arts, London; Exit Art, New York; and the Museum of Contemporary Art (M HKA), Antwerp. He is also is the author of numerous essays, many of which were anthologized in 1993's *A Certain Lack of Coherence*. In 1995, Phaidon published a comprehensive monograph, *Jimmie Durham*, and in 2005, Durham co-edited and wrote *The American West*.

Initially immersed in theatre and literature related to the US civil rights effort, Jimmie Durham was also a prime mover in the American Indian Movement from 1973 until the organization's dissolution at the end of the decade, co-founding and directing the International Indian Treaty Council. Only after this important political initiative did he redirect his energy toward the making and exhibiting of art, producing sculptures that challenge conventional representations of North American Indian identity. Since moving to Europe in 1994, Durham has focused on exploring the relationship between monumental architecture and national myth. Now working in performance and video as well as object making, he uses a wide variety of materials but concentrates on those associated with the crafting of tools, especially wood and bone. Currently, he is also interested in the uses and meanings of stone, experimenting with ways of liberating the material from its weighty but limiting evocation of authority and permanence.

Durham often animates his chosen material as a tool of violent intervention, combining blunt physical impact with an incisive sense of humour. In the performance *A Stone from François Villon's House in Paris*, 1996–2009, for example, he uses a pebble purportedly stolen from the 15th-century poet's abode to shatter a museum vitrine, while the photograph *Encore Tranquillité* (Still Tranquillity), 2008, depicts a light aircraft laid low by a massive boulder. In *Stoning the Refrigerator*, 1996, meanwhile, a battered 1950s-style refrigerator (named St. Frigo in recognition of its pure, all-white 'innocence') is paired with a video of the eponymous assault. Attacking the fridge in his local town square, Durham re-enacts a primitive but still-extant public punishment, employing an ancient material to erode a ubiquitous mod con. While such actions and images appear provocative, even insurrectionary, the artist himself takes a broader view: 'Throwing stones at man-made objects, or dropping boulders on them, is not like May '68,' he argues. 'It's not even an echo. For me, it is more like a mimetic re-enactment of nature.'

Durham often animates his chosen material as a tool of violent intervention.

For 'Rocks Encouraged', a 2010 exhibition at Portikus in Frankfurt, Durham displayed an array of objects that have a distinctly stone-like appearance but are in fact composed of 200-million-year-old petrified wood. Lining the gallery with foam tiles and dark carpeting, Durham quieted the space both visually and aurally in order to focus viewers' attention on the scattered prehistoric trunks – a move that echoes Joseph Beuys's use of rolls of insulating felt in his installation *Infiltration homogen für Konzertflügel* (Homogeneous Infiltration for Piano), 1966. Durham also decided to admit only one visitor to the exhibition at a time, facilitating an unusually individualized experience 'without jabber, without comparisons, without distractions'. Paired with the pale, trunk-like 'rocks' was a short meditative poem by the artist, displayed as a large wall text. (Books juxtaposing literary and theoretical essays with original drawings and photographs have long been a key component of Durham's oeuvre.) The arrangement, while less confrontational than *Stoning the Refrigerator* and other similar pieces, has a contemplative richness and power that counters the stasis of its antediluvian components.

Stoning the Refrigerator, 1996. Performance view.

A Stone from François Villon's House in Paris, 1996.
Smashed display case, stone, 100 x 100 x 70 cm.
Musée d'Art moderne de la Ville de Paris.

Nicole Eisenman

Born in Verdun, France, 1965; lives and works in New York, USA. Eisenman has been the subject of solo exhibitions at the Kunsthalle Zürich; Museo de Arte Carrillo Gil, Mexico City; Herbert F. Johnson Museum of Art at Cornell University, Ithaca, New York; Centraal Museum Utrecht; and San Francisco Art Institute. Her work is represented in the collections of the Museum of Modern Art, New York, and San Francisco Museum of Modern Art. In 2006, Eisenman co-curated the group exhibition 'Ridykeulous' with A. L. Steiner at Participant, Inc., New York.

Nicole Eisenman's painting *The Triumph of Poverty*, 2009, presents a complex arrangement of mismatched characters and artifacts. Oscillating between extreme stylization to relative naturalism, it also alternates between apparent expressions of social concern and a more distanced, academic investment in abstract formalism and art-historical reference. At the heart of the composition is a broken-down car 'driven' by a naked woman with a bulbous red nose. Around her is gathered an unhappy assortment of figures that includes a weirdly moss-green girl holding out a begging bowl; a vaguely reptilian man clad in top hat and tails with his trousers pulled down to reveal a reversed bottom; an emaciated man with his pockets turned out; and a naked African child with a distended stomach.

In the foreground is a procession of stumbling figures borrowed from Pieter Bruegel the Elder's allegorical canvas *The Blind Leading the Blind*, 1568. In Eisenman's rendering, this sorry crew is miniaturized and shown collapsing head first into a pack of scurrying rats. The rest of the painting's subjects seem entirely static, as if waiting for a sign – or a hand-out. But while facing in the direction of the vehicle, their hopes appear similarly stalled. Eisenman's theme is timeless and her basic method traditional, but *The Triumph of Poverty* does not feel dated or conservative. By employing a range of approaches and allusions within a single painting, she fends off complacency on the part of the viewer, challenging us to reconcile visually disparate components, whether or not we are aware of their origins.

Eisenman is comfortable depicting social situations and local characters alongside more ostensibly weighty subjects.

'There's a whole genre of paintings,' notes Eisenman, 'particularly French ones, of people eating and drinking, and the beer garden seems to be the equivalent, for certain residents of twenty-first-century Brooklyn, of the grand public promenades and social spaces of the nineteenth century. It's where we go to socialize, to commiserate about how the world is a fucked-up place and about our culture's obsession with happiness.'[1] In paintings like *Beer Garden with Ulrike and Celeste*, 2009, she explores this theme via a similar diversity of approach, making pointed use of clashing colours and awkward forms to conjure up a chaotic milieu. (As critic John Yau, considering these works, observes, 'Brooklyn is a teeming hodge-podge. There is no common language or even patois that everyone can agree on, no bedrock [and this includes style] upon which to stand.'[2])

Slothy, 2006. Oil on canvas, 25.4 x 25.4 cm.

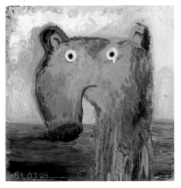

That Eisenman is comfortable depicting social situations and local characters alongside more ostensibly weighty subjects reveals an underlying playfulness and wit; what her oeuvre conveys most of all is a restless, joyful energy that prevents even the most conventional or serious themes from feeling exhausted or pessimistic. In a recent series of 'Large Heads', she borrows freely from artists including Picasso, Emil Nolde, Keith Haring and Philip Guston to arrive at monumentally scaled portraits with the quicksilver lightness of cartoons. There are many painters who like to rope in multiple allusions, skipping across periods and methods in the manner officially sanctioned by postmodern theory, but few do so with Eisenman's naturalness and approachability.

1 The artist quoted in a press release, Leo Koenig Inc., New York, 2009.
2 John Yau, 'Nicole Eisenman', *Brooklyn Rail*, December 2009/January 2010.

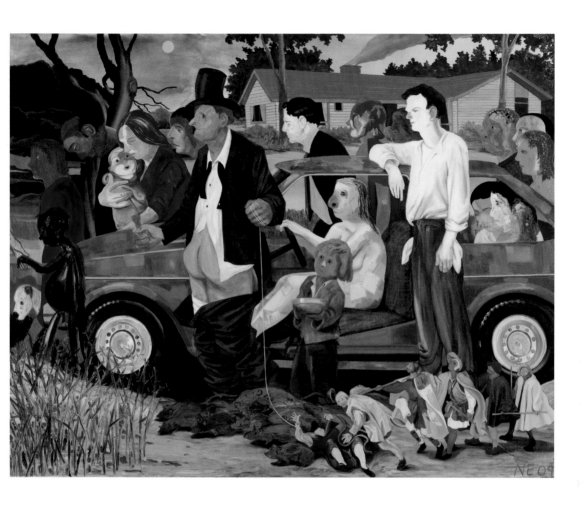

Beer Garden with Ulrike and Celeste, 2009. Oil on canvas, 165.1 x 208.3 cm.

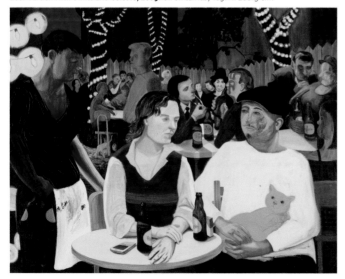

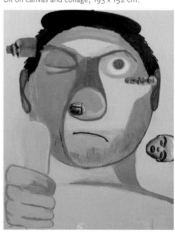

Guy Artist, 2011.
Oil on canvas and collage, 193 x 152 cm.

The Weather Project, 2003

Mixed media, 26.7 m x 22.3 m x 155.4 m. Installation view, Tate Modern, London.

Olafur Eliasson

Born in Copenhagen, Denmark, 1967; lives and works in Berlin, Germany. Eliasson has participated in numerous exhibitions worldwide and his work is represented in public and private collections including those of the Solomon R. Guggenheim Museum, New York; Museum of Contemporary Art, Los Angeles; DESTE Foundation for Contemporary Art, Athens; and Tate Modern, London. He has been the subject of major solo exhibitions at Kunsthaus Bregenz, Austria and Musée d'Art moderne de la Ville de Paris. Eliasson represented Denmark at the Venice Biennale in 2003.

The English famously love to talk about the weather, but many visitors to *The Weather Project*, Olafur Eliasson's 2003 installation at Tate Modern, found themselves struck dumb by the work's spectacular scale and extraordinary, quasi-mystical atmosphere. Commissioned as the fourth entry in the annual Unilever series for the London gallery's cavernous Turbine Hall, the work confronted viewers with a huge, sun-like semi-circle of orange light mounted high on the wall facing the building's entrance. Produced using several hundred coloured lamps, this imposing form was reflected in a mirrored ceiling, creating a sun-like disc. The light was also diffused by a vapour of water and sugar that filled the air, compounding the sense of a meteorological phenomenon.

The Weather Project is consistent with Eliasson's interest in basic environmental elements, and in understanding those elements more completely via their recontextualization in museum, gallery, and occasionally exterior public settings. The form of his work is also shaped by a focus on human perception – in looking at his installations, objects and images, we also observe ourselves in relation to a wider world. Nonetheless, an Olafur Eliasson exhibition is often a surprising experience that seems to employ a kind of natural magic in the service of art. 'The Mediated Motion' in 2001, for example, saw him fill the interior of Kunsthaus Bregenz, Austria, with soil, water, fog and a variety of plants. Other shows have revolved around outwardly simpler elements, the work's true complexity emerging only through interaction; 'Multiple Shadow House' at New York's Tanya Bonakdar Gallery in 2010, for example, featured a basic shelter-style structure that sprang to life with coloured silhouettes when visitors stepped inside.

The Weather Project, which was on display for six months and attracted an estimated two million visitors, prompted a similarly multipartite involvement. One popular approach was to lie flat on the museum's floor and observe one's own tiny, distant reflection subsumed by the radiant wash of orange. The mono-frequency bulbs that Eliasson used to make his artificial sun rendered colours other than yellow and black effectively invisible, turning the entire space into a duotone environment and giving documentary photographs of the work a peculiarly vintage look. *The Weather Project*, while concerned with our experience of the fundamental physical elements of landscape, thus also functioned as an ethereal zone of imagination and fantasy, a space visually apart and oddly out of time.

Olafur Eliasson and Günther Voght, 'The Mediated Motion', 2001. Installation view, Kunsthaus Bregenz, Austria.

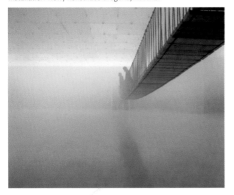

This fusion of the immediate and the ethereal is a thread that runs throughout Eliasson's practice. *The New York City Waterfalls*, 2008, was a project commissioned by The Public Art Fund for which the artist erected four large artificial waterfalls in New York Harbour. Importing a signifier of the 'unspoiled' sublime into one of the world's busiest metropolises, the artist encouraged viewers to re-evaluate values and meanings assigned to the natural. Visual illusion also continues to be an important tool in Eliasson's kit; in 'Take Your Time', his mid-career retrospective at the city's MoMA PS1 Contemporary Art Center, he made repeated use of mirrors, projections, strobes and kaleidoscopes, prompting us to look harder by illuminating the mechanics of sight.

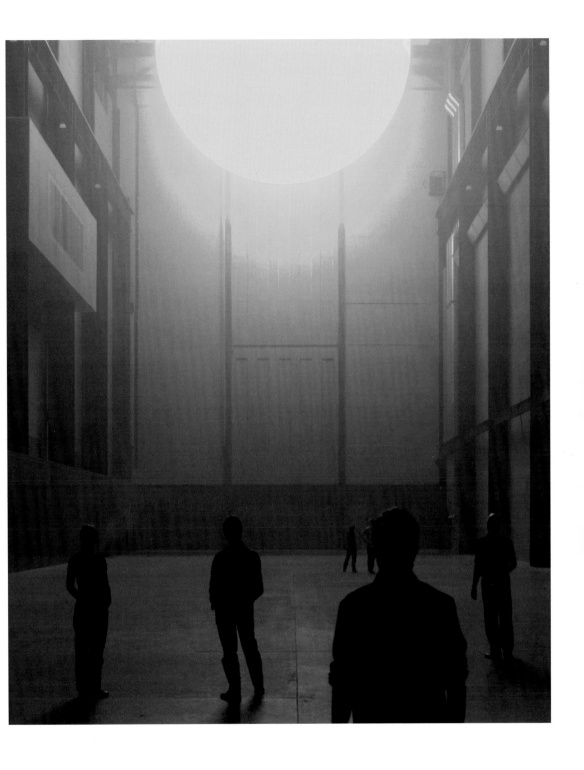

Olafur Eliasson, Take Your Time, 2008. Mixed media, dimensions variable. Installation view, MoMA PS1, New York.

Prada, Marfa, 2005

Mixed media, 7.6 x 4.7 x 4.8 m. Mock-up of a Prada boutique, Highway 90, Marfa, Texas.

Elmgreen and Dragset

Michael Elmgreen: born in Copenhagen, Denmark, 1961. Ingar Dragset: born in Trondheim, Norway, 1968. Both live and work in Berlin, Germany, and London, England. Elmgreen and Dragset have worked as a collaborative team since the mid-1990s and have exhibited at MUSAC, León, Spain; Malmö Konsthall, Sweden; Serpentine Gallery, London; and Kunsthalle Zürich. In 2003, they won the prestigious Preis der Nationalgalerie für Junge Kunst at Hamburger Bahnhof in Berlin. In 2009, they were awarded a Special Mention at the Venice Biennale for their presentation 'The Collectors'.

In a report for *artforum.com*, Adam E. Mendelsohn describes his encounter with an incongruous roadside structure on US Highway 90, outside the desert town of Marfa, Texas: 'There amidst the tumbleweeds,' he writes, 'in the very landscape where *Giant* was shot, was a boutique displaying accessories from Miuccia Prada's fall 2005 collection.'[1] But neither town nor building is quite what it seems. Marfa, while remote and sparsely populated, is famous for being home to the Chinati Foundation, a museum dedicated to the work of Donald Judd. And the building that Mendelsohn confronts does not represent the high-end retailer's attempt to exploit Chinati's success but is, rather, a work of art – specifically, Elmgreen and Dragset's public sculpture *Prada, Marfa*, 2005.

Produced by Ballroom Marfa and the Art Production Fund, *Prada, Marfa* is, Mendelsohn continues, 'more or less a perfect, if small, replica of a typical Prada emporium – except it will always be closed'. The faux-store was designed by architects Ronald Rael and Virginia San Fratello and, while constructed largely from adobe, was engineered to appear as pristine as if airlifted from Milan, hermetically sealed in the style of a Damien Hirst vitrine. The handbags and heels arranged inside are visible through windows and a (non-functioning) door, but remain otherwise inaccessible. (At least in theory – *Prada, Marfa* has been vandalized more than once, and has needed restocking after the theft of certain items.) But while they have been forced to perform some maintenance, Elmgreen and Dragset accept that the project will eventually return to the earth on which it stands.

Acknowledging *Prada, Marfa*'s heritage, the artists refer to it as a 'pop architectural land art project', while the work's location also makes an evocation of Minimalism in general – and Judd's iconic oeuvre in particular – impossible to avoid. The boxlike form of the building and the stripped-down style of its interior displays suggest a connection between the formal discipline of its sculptural precursors and the absorption of their aesthetic into the languages of design and marketing. Elmgreen and Dragset also make a provocative comment on Judd's rarefied market status, aligning one kind of exclusive, expensive product with another. And there is an echo too of other artists' outlets, from The Store, operated in New York by Claes Oldenburg in 1961, to The Shop, set up in London by Tracey Emin and Sarah Lucas in 1993.

Powerless Structures, Fig. 101, 2012.
Bronze cast, 430 x 410 cm.

The sheer unexpectedness of *Prada, Marfa* is characteristic of Elmgreen and Dragset's witty and subversive approach to collaborative situational art-making. In 2004, they transformed New York's Bohen Foundation into a replica subway station, while the 2009 Venice Biennale saw them convert the Nordic Pavilion into the art-filled abode of a fictional collector. And in 2011, they won the Fourth Plinth commission for London's Trafalgar Square with a proposal for a bronze sculpture of a boy on a rocking horse. Where *Prada, Marfa* flirts with outright cynicism to strike an overtly critical note, this last plan was clearly conceived in a spirit of optimism and offers a celebration of childhood and potential.

1 Adam E. Mendelsohn, *Stealing the Show*, Scene & Herd, artforum.com, 10 August 2005.

The Collectors, 2009.
Installation view, Danish and Nordic Pavilion, 53rd Venice Bienniale.

Death of a Collector, 2009.
Mixed media, 100 x 600 x 200 cm. Installation view,
Danish and Nordic Pavilion, 53rd Venice Biennale.

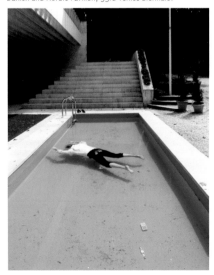

77 Million Paintings, 2006

Personal computer software. Installation view, Yerba Buena Arts Center, San Francisco, 2007.

Brian Eno

Born in Woodbridge, Suffolk, England, 1948; lives and works in London. Eno has exhibited internationally, including at events such as the Venice Biennale, and his album *Discreet Music*, 1975, is generally considered to be the first example of 'ambient' music. He was a co-developer of the SSEYO Koan generative music system, and of the Bloom, Trope and Air iOS applications. In 2008, he produced a soundtrack for Italian artist Mimmo Paladino's exhibition at the Museo dell'Ara Pacis, Rome, and in 2010 was guest curator of the Brighton Festival. Eno is also a founding board member of the Long Now Foundation.

Working at the prolific rate of five paintings per day, a conventional artist would need about 42,000 years to make 77 million paintings. Brian Eno has achieved this extraordinary number in a substantially shorter time by applying the theory of generative production. 'What I'm really doing when I work generatively is I'm making seeds,' he explains. 'Then I'm planting them, in the case of *77 Million Paintings*, in your computer. Then the seed grows into all the different kinds of flowers it can produce.'[1] Published as software for domestic use but also adapted to museum display, Eno's project is a program that creates a different combination of images and music each time it's launched, only ever potentially repeating itself when it reaches the titular figure.

The starting point for *77 Million Paintings* was a collection of around three hundred physical works, most of them made by scratching or drawing onto 35 mm slides. The majority of these feature abstract designs that emphasize pattern and light rather than representational imagery. Eno then worked with programmers to digitize each slide and incorporate it into a gradually shifting display that features one to four layers at any given time. The visual sequence is soundtracked by the artist's similarly non-linear ambient music, which is also built from a finite number of elements continually recombined into original forms. The slowly morphing result reflects its maker's interest in evolutionary theory – specifically, the idea of beginning with something simple and prompting it to become more complex – as a creative model.

Working at the rate of five paintings per day, a conventional artist would need about 42,000 years to make 77 million paintings.

The fusion of organic processes and emergent technology that informs *77 Million Paintings* runs throughout Eno's oeuvre as a visual and recording artist. Famous for his work as a musician and producer – first with seminal English art-pop band Roxy Music, then as an equally influential solo artist and collaborator with David Bowie, David Byrne, Robert Fripp and others – he has also made videos, light sculptures and audio installations, as well as digital and interactive works. Eno's first video was 1981's *Mistaken Memories of Mediaeval Manhattan*, which features lengthy impressionistic shots of the city's skyline. This reflects several defining features of his work, including a meditative pace and an acceptance of the value of chance. He later began using multiple slide projectors to create immersive animated environments.

Brian Eno and Peter Chilvers, Bloom, 2008. iOS application.

Eno conceived of *77 Million Paintings* in part as a way to enliven the blank spaces of users' switched-off computer and television screens, but the work has gained a second life as a mutable public presentation. In 2007, it was shown at the Yerba Buena Center for the Arts in San Francisco on a single 45-foot wide screen; elsewhere, it has appeared on up to twenty-four screens simultaneously. Yet even in venues that audiences are apt to walk through without devoting substantial time to any given exhibit, the work's unhurried, consciously 'unfocused' quality has not proven obstructive. 'I think people are really ready for very long, still experiences in a way that they haven't ever been before,' says Eno, 'or for a very long time, anyway.'[2]

1 Dustin Driver, 'Brian Eno: Let there be Light', apple.com, http://www.apple.com/pro/profiles/eno/index2.html
2 Sylvie Simmons, 'Brian Eno's "77 Million Paintings" is an artwork that won't sit still', *San Francisco Chronicle*, 27 June 2007. http://articles.sfgate.com/2007-06-27/entertainment/17250192_1_paintings-ambient-arts-forum/3

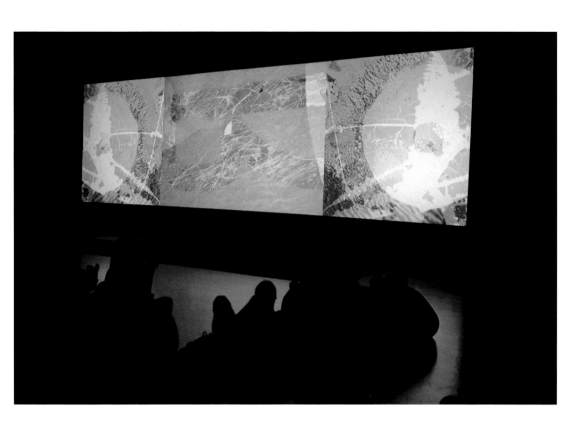

Luminous Festival, 2009. Sydney.

Mistaken Memories of Mediaeval Manhattan,
1981. Colour video with sound, 45 minutes.

Harun Farocki

Born in Nový Jičín, former Czechoslovakia, 1944; lives and works in Berlin, Germany. Farocki studied at the German Cinematic and Television Academy in Berlin, from which he was expelled in 1968 for political reasons, and from 1974 to 1984 was an editor and writer for *Filmkritik* magazine. His work has been exhibited at venues including the Beirut Art Center; Centre for Contemporary Arts, Glasgow; and Kunsthaus Bregenz, Austria, and was also included in Documenta 12. Since 2004, Farocki has held the position of Visiting Professor at the Akademie der Bildenden Künste in Vienna.

'Harun Farocki's film and video work is almost too interesting to be art.'[1] Critic Ken Johnson's assessment of the artist's 2011 exhibition 'Images of War (at a Distance)' at the Museum of Modern Art in New York bespeaks an oeuvre with an unusually direct and powerful connection to the world at large. Beginning his career alongside 'New German Cinema' directors such as Rainer Werner Fassbinder and Werner Herzog in the context of the late-1960s student protest movement, Farocki has more than ninety titles to his credit. He works in a wide variety of genres and formats, from short documentaries to feature films, digital animations to multi-screen video installations, offering, in Johnson's words, 'a self-reflexive, cinematic Cubism in which the medium itself, as a vehicle of truth, is subject to radical doubt.'[2]

Often, it is the role of filmic techniques and technologies in surveillance and propaganda that is the object of Farocki's critical gaze. Juxtaposing, intercutting and blending imagery and sound to interrupt narrative flow, he questions the authority of his sources, encouraging us to become more active, sceptical viewers of the heavily mediated material that is presented to us as unfiltered 'reality.' For example, in the two-screen video projection *I Thought I was Seeing Convicts*, 2000, he pairs CCTV footage from a Californian prison yard with abstracted shots derived from a computer program designed to track the movements of supermarket shoppers.

Through editing and narration, Farocki links one form of visual tracking with another.

Through editing and narration, Farocki links one form of visual tracking with another, connecting both to an overarching system of official control.

In the multi-screen video installation *Deep Play*, 2007, Farocki's focus is on the ostensibly more frivolous spectacle of the 2006 FIFA World Cup final between Italy and France. The work follows the action in real time from twelve different perspectives, juxtaposing the artist's own footage of the game with the television cameras' view, digital animations, statistical charts about the players and surveillance shots of the Berlin Olympiastadion. Commentators' assessments of the competition are heard alongside police radio messages about the security of the venue. The result is a sensory and informational overload that seems to confront us with the full complexity of this grand cultural event, an orchestrated matrix of performance and representation into which the individual viewer seems almost to vanish.

But while *Deep Play* seems to present a comprehensive portrait of its multidimensional subject, we are still left wondering where the truth (if any) of the event and its context resides. In 'Serious Games I-IV', the centrepiece of the exhibition that was the subject of Johnson's review, this question feels still more pointed. In a suite of four projected videos, we observe American soldiers using video-game technology and inhabiting simulated locations while in training for real-world battle, or apparently recovering from post-traumatic stress disorder – though in the latter case, the subjects turn out to be actors. There is more than enough material here for a captivating 'straight' documentary, but Farocki again foregrounds both the unreliability of his means and the inconsistency of our perception.

1 Ken Johnson, 'Unfiltered Images, Turning Perceptions Upside Down', *The New York Times*, 25 August 2011.
2 Ibid.

I Thought I was Seeing Convicts, 2000.
Two-channel colour video projection with sound, 23 minutes.

Serious Games I: Watson is Down, 2010.
Two-channel colour video installation with sound, 8 minutes.
The Museum of Modern Art, New York.

Vincent Fecteau

Born in Islip, New York, USA, 1969; lives and works in San Francisco. Fecteau's work appeared in the 2002 Whitney Biennial and has been exhibited at the Van Abbemuseum, Eindhoven, and UC Berkeley Art Museum. In 2008, he was the subject of a solo exhibition at the Art Institute of Chicago, and he received a fellowship from the John Simon Guggenheim Memorial Foundation in 2005. Fecteau's work is held in the collections of the Museum of Modern Art, New York, and the San Francisco Museum of Modern Art.

'Too often people think ideas generate the work; I think the work generates ideas.'

'I would love my pieces to seem "right" but without reason. Too often people think ideas generate the work; I think the work generates ideas.' Vincent Fecteau is unapologetic about maintaining an emphasis on form within a field still preoccupied by the legacy of conceptualism, comparing his approach to the injection of 'an anecdote or an awkward, off-colour joke' into a sculptural conversation habitually written off as closed or complete. Developing several works simultaneously in a slow, meticulous process of addition and subtraction, Fecteau shapes modelling materials like Foamcore and papier-mâché – sometimes also incorporating shells, paperclips, magazine clippings and other bits of everyday flotsam and jetsam – into abstract constructions that transcend their small scale to evoke monumental high-modernist sculpture, architecture and theatrical set design.

The part played by colour in Fecteau's work has grown more important as its material composition has become more pared down. The artist uses flatly applied and modulated coatings to work both with and against his sculptures' physicality, emphasizing or accentuating certain parts while softening or disguising others; here he makes quiet reference to the outside world, there he fosters a sense of self-containment. The tints, which range from black, white and muted earth tones to bright, even jarring shades of purple, blue and green, are drawn from the immediate environment but often have a private emotional resonance. And while Fecteau himself may disagree, it seems reasonable to speculate that his experience in the sphere of professional flower arranging may also have influenced his more unusual chromatic selections.

Yet, while idiosyncratic, Fecteau's work has a clear artistic heritage. Reviewing his 2008 exhibition at the Art Institute of Chicago, critic Michelle Grabner points out stylistic echoes of several key 20th-century Europeans, from Constantin Brancusi and Umberto Boccioni to Jean Arp and Picasso. The works in this show, all untitled, were made by applying papier-mâché to an inflated beach ball then cutting into and painting the resultant shell to produce a mismatched set of sculptures. These were then displayed on white pedestals of uniform size as a way to concentrate attention on their diversity of texture and tone. More recently, Fecteau has begun abandoning even this basic presentational support, hanging works on the wall in a move that, far from turning the works into paintings, emphasizes their curious objecthood.

From time to time, Fecteau engages more explicitly with the creative continuum of which he forms a part. In 2004, for example, he collaborated with painter Tomma Abts on a project at the Van Abbemuseum, Eindhoven, in which the pair displayed their own works alongside others drawn from the institution's collection. And in 2009, he curated an exhibition at the San Francisco Museum of Modern Art that exposed some rarely seen works to the light and allowed meaning to emerge through formal correspondence rather than historical context. 'I wondered whether it would be possible to construct a show as I did a sculpture,' he told critic Glen Helfand. 'Priority was given to the object over the concept, the poetic over the narrative, complexity over clarity.'

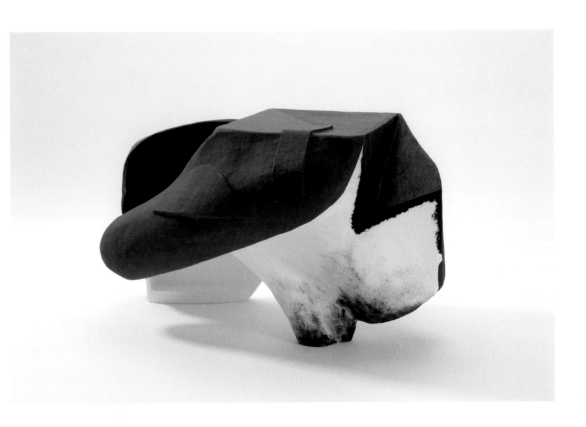

Untitled, 1999. Foamcore, collage, plastic, 10 x 43 x 38 cm.

Untitled, 2010. Papier-mâché, acrylic paint, 61 x 113 x 27.9 cm.

Untitled, 2003.
Papier-mâché, acrylic paint, balsa wood, 30 x 43 x 31 cm.

Urs Fischer

Born in Zurich, Switzerland, 1973; lives
and works in Zurich and New York, USA.
Fischer has been the subject of solo
exhibitions at museums including
the Kunsthaus Zürich; Museum Boijmans
Van Beuningen, Rotterdam; Centre
Pompidou, Paris; New Museum, New York;
and Fondazione Nicola Trussardi, Milan.
He was also included in the 2006 Whitney
Biennial, and has received several awards
including Zurich's Providentia-Preis for
Young Art.

In late 2007, visitors to Gavin Brown's Enterprise found the influential
New York gallery radically transformed. For once, however, the makeover
had been achieved not through creative addition, but rather by a striking
and labour-intensive removal. Urs Fischer's site-specific installation (or,
better, anti-installation) *You*, 2007, was essentially a hole in the ground,
a roughly 9-by-12-metre crater, 2.44 metres deep and surrounded by a
narrow ledge. Producing the work involved drilling into the concrete floor
and excavating the soil and rubble beneath before boxing in the room
with new walls. Fischer and his team of assistants also added a smaller-
scale reproduction of the main gallery, positioning it to function as an
introduction to the main event. *You* thus constituted a bracing physical,
psychological and conceptual reworking.

But startling as it was, *You* was not without precedent, having roots in both
Fischer's practice and in those of other artists. Fischer has often taken a
boldly irreverent approach to museum and gallery architecture, for example,
cutting holes through walls in works like *Kir Royal*, 2004, to highlight the
overlooked and unexamined mechanics of exhibition-making. In 1986,
Chris Burden took a similar approach in his *Exposing the Foundation of the
Museum*, an intervention at the Los Angeles Museum of Contemporary
Art's Geffen Contemporary in which three trenches dug inside the space
allowed visitors to observe and descend into the building's substructure.
Both Fischer and Burden's projects expose art-world institutions as far from
the permanent structures, either physically or ideologically, that they may
appear to be.

You also referenced the Earth Art movement of the late 1960s, in particular
the indoor projects of Michael Heizer and Robert Smithson, and has a local
relative in Minimalist sculptor Walter de Maria's long-term installation
The New York Earth Room, 1977. Both these works and Fischer's exploit the
sometimes-unexpected power of otherwise familiar materials, playing with
scale and context to reflect on the intersection of constructed spaces with
their various environments. *You* confronted viewers with their surroundings
in a strikingly direct manner, but also opened up a range of metaphorical
associations. Given the gallery's New York location, it was difficult not to
think about the city's continual and competitive cycle of
building and rebuilding, or its centrality in the art market
(from which, as it hints, the bottom may yet fall out).

**You confronted viewers with their surroundings
in a strikingly direct manner.**

In other works, Fischer employs a vast range of materials – everything from
steel to silicone, concrete to clay – to express the fundamentally mutable
nature of both objects and ideas. He is interested in duration and entropy,
sculpting figures designed to melt like candles during the course of a show,
and screwing the mismatched halves of two different fruits together to
produce a fast-decaying faux hybrid. Even his more outwardly resilient works
reveal a thoroughgoing interest in the ephemeral and a healthy sense of the
absurd: *Untitled (Lamp/Bear)*, 2005-2006, for example, is a 7-metre tall
bronze sculpture of a childhood teddy bear penetrated by an enormous desk
lamp. After being installed outside Park Avenue's Seagram Building, it sold at
auction in 2011 for just shy of seven million dollars.

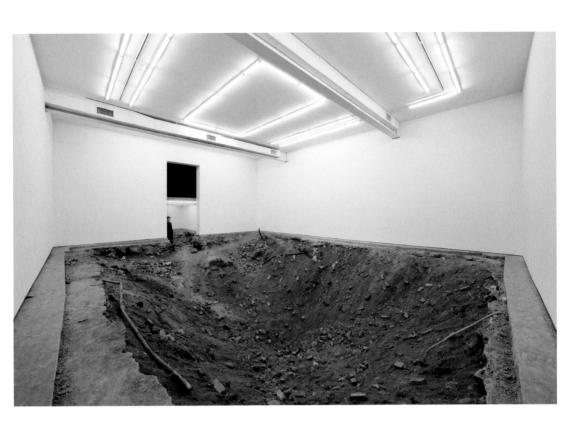

Untitled (Lamp/Bear), 2005–2006.
Mixed media, 700 x 650 x 749.9 cm. Private collection.

Untitled, 2000.
Apple, pear, screws, nylon, dimensions variable.
Gavin Brown's Enterprise, New York.

Learning to Love You More, 2002–2009

Website, book and series of non-Web presentations. Assignment 63. Make an encouraging banner. Sarah and Andrea, Brooklyn, Omaha, Nebraska.

Harrell Fletcher

Born in Portland, Oregon, USA, 1967; lives and works there. Fletcher has exhibited at the San Francisco Museum of Modern Art; UC Berkeley Art Museum; Drawing Center, New York; Seattle Art Museum; Signal, Malmö; and the National Gallery of Victoria, Melbourne. He was a participant in the 2004 Whitney Biennial and his work is represented in the collections of the Museum of Modern Art, New York; Berkeley Art Museum; and FRAC Bretagne, Châteaugiron, France. In 2002, he launched *Learning to Love You More*, a participatory website (and later a book) with Miranda July. Fletcher is a recipient of the Alpert Award in Visual Arts.

'1. Make a child's outfit in an adult size. 2. Make a neighbourhood field recording. 3. Make a documentary video about a small child.' These offbeat creative tasks are the first of seventy that form the backbone of Harrell Fletcher and Miranda July's interactive website *Learning to Love You More*, 2002–2009. Designed to inspire public participation, Fletcher and July's assignments gave rise to numerous 'reports' in the form of documentary photographs and texts submitted to the site by those who took up the challenge. 'Like a recipe, meditation practice, or familiar song,' writes Fletcher, 'the prescriptive nature of these assignments was intended to guide people towards their own experience.' Beyond the space of the website itself, which was later published as a book, the project also spawned many exhibitions, broadcasts and other presentations.

Learning's element of social engagement reflects an emphasis on the role of the artist not as sole author but instead as director-curator, collaborator-teacher or one of any number of other similarly open-ended designations. Fletcher studied organic farming at the University of California Santa Cruz, and while there joined forces with fellow artist Jon Rubin on a series of DIY exhibitions produced with assistance from local people. Since then, he has produced numerous projects that break with the art-world model of making, showing and selling, and which thrive even away from cultural and commercial centres. In Fletcher's practice, autonomy and originality (*Learning* itself takes up where artist Paul Thek's set of pedagogic directives

Fletcher has produced numerous projects that thrive away from cultural and commercial centres.

'Teaching Notes: 4-Dimensional Design' leaves off) are less significant than the ways in which a given idea or activity meshes with the world at large.

The decentralized archival impulse evident in *Learning* also shapes some of Fletcher's other projects. *The American War*, 2005, for example, is a travelling exhibition of snapshots taken by the artist depicting photographs in Ho Chi Minh City's War Remnants Museum. Fletcher's aim here is to bring the original images, which illustrate in graphic detail the impact of battle on Vietnam's people and landscape, to the attention of American audiences. Using readily available technology in the form of a cheap digital camera, Fletcher remakes and recontextualizes an entire existing display, cheekily bypassing the official machinery of museum tours and loans. And while it is debatable as to whether each 'copy' photograph qualifies as an independent work of art, as a group they fulfil the aim of more widely disseminating an overlooked perspective.

The format of the travelling exhibition continues to provide Fletcher with starting points for experiments in the democratization of art. 2011's 'The People's Biennial', for example, a collaboration with curator Jens Hoffmann, saw him visit five American cities that are not generally considered to be capitals of the art world. In each location, the pair selected residents' work for a show incorporating practices underrepresented in established surveys like the Whitney Biennial – among them 'folk' traditions of the kind that have also informed recent projects by other artists such as Jeremy Deller and Alan Kane. Many of their picks, which range from soap carvings to science videos, could easily have originated in *Learning*'s inspirational instructions.

'**The People's Biennial', 2011.** Exhibition view, Scottsdale Museum of Contemporary Art, Arizona.

Ceal Floyer

Born in Karachi, Pakistan, 1968; lives and works in Berlin, Germany. Floyer has been the subject of solo exhibitions at the Project Arts Centre, Dublin; Center for Contemporary Art, Tel Aviv; Museum of Contemporary Art, North Miami; and Palais de Tokyo, Paris. She participated in the Shanghai Biennale in 2006; the 53rd Venice Biennale in 2009; and the Singapore Biennale in 2011. Her work is represented in public collections including those of the San Francisco Museum of Modern Art; Museum für Moderne Kunst, Frankfurt; and Tate Modern, London.

'Objects should not touch because they are not alive. You use them, put them back in place, you live among them. They are useful, nothing more. But they touch me, it is unbearable. I am afraid of being in contact with them as though they were living beasts.' Antoine Roquentin, the anguished protagonist of Jean-Paul Sartre's existentialist novel *La Nausée* (Nausea), 1938, might have appreciated the apparent material economy of Ceal Floyer's installation *Things*, 2009. An array of plain white plinths occupying an otherwise empty room, images of the work suggest the apotheosis of Minimalist aesthetics, or the forlorn aftermath of a successful art heist.

But, as is the case with most of Floyer's work, there is more to *Things* than meets the eye. While the plinths constitute the installation's entire visual element, there is also an audio component. A visitor wandering among the plinths hears the title word repeated, at various intervals and in various different voices, by loudspeakers mounted flush with their tops and connected to CD players inside them. Floyer culled the assorted versions of 'things' in *Things* from pop songs, editing each recording so that nothing else remained. The result is a constant barrage of sound that fluctuates as the snatches of song remain distinct or overlap with one another, effectively transforming an outwardly placid space into a field of competing intonations and emphases.

In drawing attention to a convention of gallery or museum display, and by employing an 'extra' ingredient to cast an outwardly simple group of objects in an unexpectedly complex light, Floyer makes *Things* into more than just the sum of its parts. Like the Bruce High Quality Foundation's *Perpetual Monument to Students of Art*, 2010, a similar-looking installation derived from an exchange programme offering local art schools new plinths in exchange for old, *Things* plays on our assumptions about what constitutes an exhibition. Rather than present the gallery-goer with a roomful of crafted artifacts, Floyer emphasizes instead the value of looking more closely at the display context itself, and of thinking harder about the process of arriving at a work's final form. The 'things' in *Things* could be anything.

Floyer has often employed projected light as well as sound in her work, perhaps because both media offer a counterpoint to the more straightforward tangibility of images and objects. This unfixed, immaterial quality mirrors the artist's interest in highlighting differences between the actual and the expected or assumed. The absurd and contradictory situations with which her work presents us remind us that the senses are all too easily misled, and that our habits of looking and listening can be disrupted by the smallest and simplest of twists. That Floyer makes her point via a highly systematic approach inherited from the Conceptual artists of the 1960s and 1970s only makes it more humbling, and more irrefutable. She may not share Roquentin's disgust at tangible objects – far from it – but she does issue, in *Things* and in her work in general, a warning against taking them at face value.

The Bruce High Quality Foundation, Perpetual Monument to Students of Art, 2010.

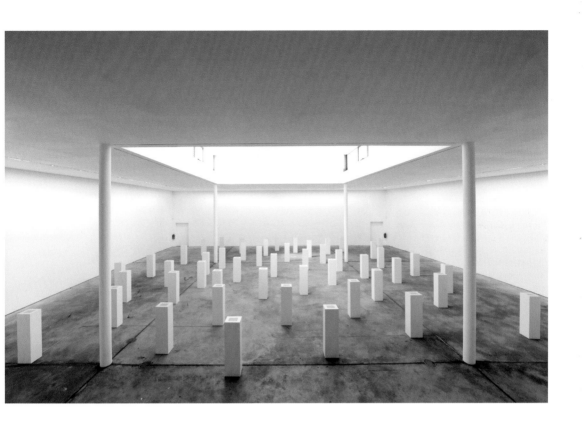

Scale, 2007. 24 wall-mounted speakers, computer, 12 stereo amplifiers, dimensions variable.

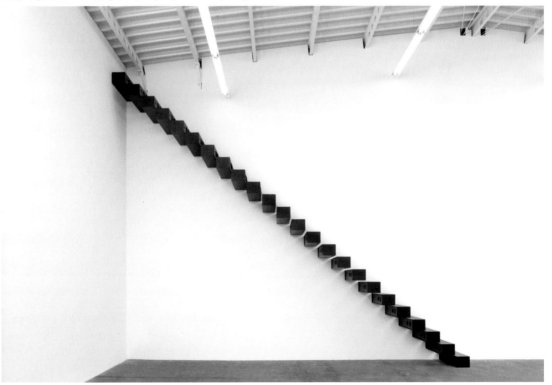

Andrea Fraser

Born in Billings, Montana, USA, 1965; lives
and works in New York and Rio de Janeiro,
Brazil. Fraser's work is represented in
the collections of De Hallen Haarlem;
Queensland Art Gallery, Brisbane; Tate
Modern, London; Thyssen-Bornemisza
Museum, Madrid; Whitney Museum of
American Art, New York, and elsewhere.
She is the recipient of fellowships and
awards from the National Endowment
for the Arts, Art Matters, Inc., and the
Franklin Furnace Fund for Performance
Art. Fraser has also taught and published
extensively around the world.

While it remains an important strand of contemporary practice, institutional
critique can seem as aridly theoretical as its name suggests. However,
Andrea Fraser's confrontational approach to this influential tendency
has proved capable of reinforcing and extending the vitality of its central
themes in a singularly engaging way. Typically adopting the context of the
museum as both her subject and her working arena, Fraser colours an acute
awareness of cultural politics with satirical wit to investigate the part played
by established hierarchies and modes of address in the presentation and
reception of art. And while she works in a variety of media, Fraser is at heart
a performance artist, often intervening directly in the art world's various
structures, rituals and routines.

One of Fraser's favoured roles is that of docent. Even more than a museum's
director or curatorial team, these guides-for-hire represent, for many
visitors, the voice of art-historical authority. By stepping into their shoes,
she thus adopts a position with enormous potential for critical subversion. In
her performances *Museum Highlights*, 1989, and *Welcome to the Wadsworth,*
1991, Fraser leads sometimes-baffled groups around the Philadelphia
Museum of Art and the Wadsworth Atheneum Museum of Art respectively,
describing their collections – not to mention sundry fixtures and fittings – in
purple or otherwise incongruous prose that undercuts the very notion of
canonical status. And in *Kunst muss hängen* (Art must hang), 2001, she again

**Fraser colours an acute awareness of
cultural politics with satirical wit.**

speaks in terms not quite her own, this time assuming the role of
another artist to re-enact with eerie precision a drunken speech
given six years earlier by Martin Kippenberger.

In her video *Untitled*, 2003, Fraser upped the ante by documenting a
hotel-room sexual encounter between her and an unnamed collector, who
paid almost $20,000 for his starring role. An uncompromising statement
about the roles of gender and sexuality in the production of and market
for contemporary art, *Untitled* was predictably divisive when first shown,
drawing fire for its supposedly exploitative aspects (though the exploited
party was not universally agreed upon) and for its seeming flirtation with
pornography and prostitution. 'All of my work is about what we want from
art, what collectors want, what artists want from collectors, what museum
audiences want,' the artist told journalist Guy Trebay at the time. 'By
that, I mean what we want not only economically, but in more personal,
psychological and affective terms.'

This complex system of desire is investigated in a less sensational though
equally compelling manner in some of Fraser's more recent works. In her
video installation *Projection*, 2008, the artist is seen performing monologues
based on transcriptions of her own psychoanalytic consultations. Displaying
two different recordings at opposite ends of the gallery space, she positions
the viewer between them to initiate another kind of dialogue, aiming to
tease out the psychological projections (the term also describes the work's
form) that shape the interaction of artist, art and viewer. Psychoanalytic
theory has been key to Fraser's artistic and critical practice since the 1980s;
in *Projection*, that significance is made explicit.

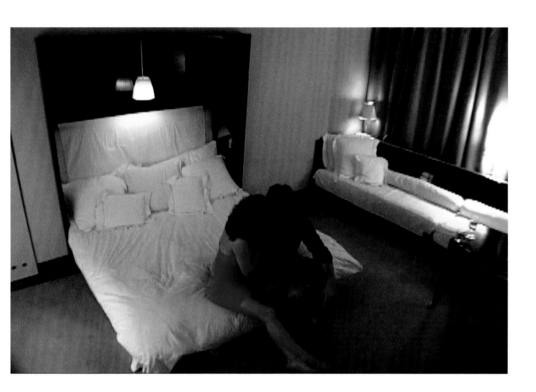

Projection, 2008. Two-channel video, 50 minutes.

Kunst muss hängen (Art Must Hang), 2001.
Single-channel video with sound, painting.

Museum Highlights: A Gallery Talk, 1989.
Performance view, Philadelphia Museum of Art.

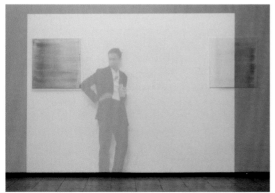

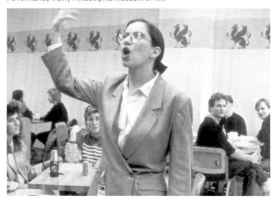

Katharina Fritsch

Riese (Giant), 2008
Polyester, paint, 195 x 95 x 70 cm.
4 Postkarte (Franken) / Postcard 4 (Franconia), 2008
Oil-based ink and acrylic on plastic panel, 280 x 405 cm.

Born in Essen, Germany, 1956; lives and works in Düsseldorf. Fritsch represented Germany in the 1995 Venice Biennale and has staged exhibitions at the Kunstmuseum, Basel; San Francisco Museum of Modern Art; Tate Modern, London; and K21, Düsseldorf. In 2009, Kunsthaus Zürich held a retrospective exhibition of her work that travelled to the Deichtorhallen, Hamburg. In 2011, she participated in 'Dreamscapes' at the Pulitzer Foundation for the Arts, St. Louis, and 'MMK 1991–2011: 20 Years of the Contemporary' at the Museum für Moderne Kunst, Frankfurt.

Posed in front of a green-tinted image of tree-covered cliffs and leaning on a fearsome-looking club, the larger-than-life figure of Katharina Fritsch's *Riese* (Giant), 2008, confronts us with a doleful stare. Painted an opaque pale grey, the loincloth-wearing caveman looks displaced, as if he has somehow wandered away from his own time and place to end up in the wide white space of the gallery. He is at once fantastical and familiar, the details of his all-too-human anatomy – a balding pate, a slightly protruding belly, the beginnings of a sagging chest – rubbing up against his apparently mythological origin. His downcast face has the unremarkable features of an anonymous passer-by, and the scene before which he stands, while lush and panoramic, is similarly difficult to identify.

Riese (which was in fact modelled on a 6-foot-4 Düsseldorf taxi-driver) is one of several sculptures by Fritsch paired with illustrative backdrops (here the separately titled *4. Postkarte (Franken) / Postcard 4 (Franconia),* 2008). As is the case with much of the artist's work, its power comes in part from incongruities of scale and colour, in part from a fusion of the banal, the unnerving and the seductive. The figure's matt coating gives it the look of a mass-produced object, a moulded mannequin or oversized toy, while its stiff posture adds to a feeling of soullessness. Yet the degree of detail makes it impossible to dismiss as a mere stand-in. Fritsch has applied the same treatment to a wide variety of subjects throughout her career, from the fluorescent totems of her 1981–1989 multiple *Madonnenfigur* (Madonna Figure) to the enormous black rodents of her terrifying *Rattenkönig* (Rat King), 1993, and the scarlet figure of her mischievous gallery-owner portrait *Händler* (Dealer), 2001.

Despite their machine-made look, most of Fritsch's sculptures are constructed via a time-consuming process of hand-moulding, plaster casting, reworking, recasting in polyester, and eventual painting. But while she constructed her earliest works herself, the artist now sends models to a factory for final industrial fabrication. This fusion of traditional hands-on craft techniques with depersonalized manufacturing links her practice to that of other post-Pop object-makers such as Jeff Koons and Takeshi Murakami. Fritsch's focus on well-known and iconic forms also gives her work an immediacy that allows it to play off viewers' expectations about art's contents and modes of display. Sculptures such as *Giant* seem to form part of a three-dimensional iconography, an archive of instantly recognizable yet strangely altered forms possessed of uncanny, primal power.

Yet while Fritsch's works are most often framed with reference to psychoanalysis (specifically the world of fears and phobias shaped by childhood experience), this is far from their only possible reading. Curator Jessica Morgan, for example, discovers in them an 'otherworldly', even 'hallucinogenic' effect, pointing to the way in which the opacity and intensity of their surfaces isolate them from their surroundings. When the sculptures coexist with pictorial backgrounds, she observes, this effect persists; the images seem to promise appropriate contexts, but finally suggest the obvious artifice of cinematic blue-screen projections. Like waking dreams, Fritsch's works straddle graspable reality and a floating world of fantasy and symbol.

Madonnenfigur (Madonna Figure), 1981–1989.
Multiple of plaster with pigment,
30 x 8 x 6 cm (overall).
The Museum of Modern Art, New York.

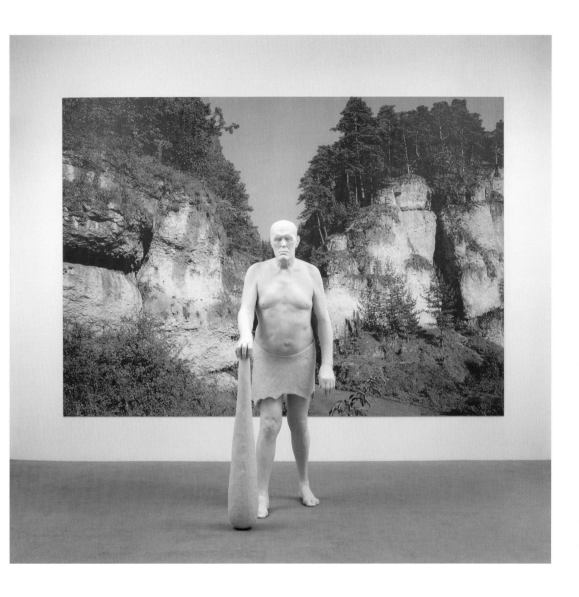

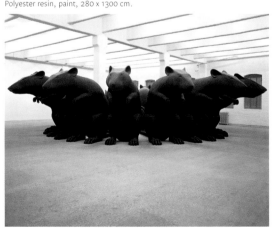

Rattenkönig (Rat King), 1993.
Polyester resin, paint, 280 x 1300 cm.

Händler (Dealer), 2001.
Polyester, paint, 192 x 59 x 41 cm.

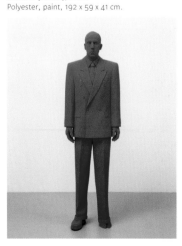

Ellen Gallagher

Born in Providence, Rhode Island, USA 1965; lives and works in Rotterdam, the Netherlands, and New York. Gallagher has exhibited at the Whitney Museum of American Art, New York; Museum of Contemporary Art, North Miami; St. Louis Art Museum; and the Institute of Contemporary Art, Boston. Her work is represented in public collections including those of Tate Modern, London; Centre Pompidou, Paris; Moderna Museet, Stockholm; and the Museum of Modern Art, New York. Gallagher has received the Arts and Letters Award of the American Academy of Arts and Letters and a Joan Mitchell Foundation Fellowship.

'They were manifestos in a way. They had an urgency and a necessity to them, but also a whimsy.' In the early 2000s, painter Ellen Gallagher assembled a vast archive of material drawn from popular magazines published between the 1930s and the 1970s and aimed at African-American readers, with titles such as *Ebony*, *Our World* and *Sepia*. Focusing on advertisements for hair products, she began arranging the ads into often very large compositions, adding her own rogue elements in the form of yellow Plasticine wigs, plastic googly eyes, and painted-on tongues and lips. Retaining the functional gridded composition of her original sources, the artist uses repetition to emphasize specificities of visual and verbal language, excavating buried narratives, identities and characters, both fanciful and concrete.

eXelento, 2004, is one such canvas, a panoramic array of printed images and text in black-and-white embellished with the familiar coloured putty. From a distance, the work looks almost abstract, but seen close to it becomes an encyclopedia of variations on a theme. Gallagher's opaque wigs emphasize the ads' basis in pretence and performance, while the panel's oscillation between figurative and non-figurative also hints at a possible connection between historical formulations of the 'New Negro' and concurrent innovations in modernist painting. Thus while *eXelento* is plainly concerned with questions around racial identity and division, stereotyping and

Gallagher's opaque wigs emphasize the ads' basis in pretence and performance.

caricature, it also invites a more purely formal reading, in which the vintage found images and their minutely crafted additions represent a broader exploration of visual modification and detail.

In another series, 'Watery Ecstatic', Gallagher uses watercolour (often in conjunction with other materials) and carved paper (a variant on 'scrimshaw', the objects made by American whalers from the bones or teeth of their prey) to picture creatures from Drexciya, a mythical Black Atlantis. The artist speculates that the interest in water and travel that inspired these works may have originated in the voyages made by her ancestors – her father's family arrived in the United States on whaling ships from Cape Verde. And while aware that the project thus reveals an element of nostalgia, she refuses to frame this as a wholly escapist tendency. It is rather, she counters, an ongoing search for home that keeps one moving through and observing the world at large.

Gallagher has also used the moving image to investigate ideas around the sequencing and layering of icons and stories. 'Murmur', a suite of six films made in collaboration with Edgar Cleijne, sees the artist revisit Drexciya alongside a variety of other lost and lawless worlds. The filmmakers employ a range of techniques that mirror Gallagher's painting, using found footage, for example, and augmenting images by painting directly onto the celluloid. At times, the action also contains a suggestion of *eXelento*'s grid format, presenting still images in rapid succession as if the painting's component parts had been made into a flip-book.

eXelento (detail)

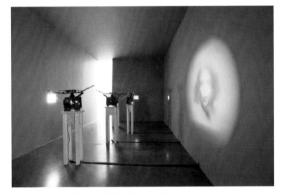

Ellen Gallagher and Edgar Cleijne, 'Murmur', 2003.
Five 16 mm animated film projections (Watery Ecstatic, Kabuki Death Dance, Blizzard of White, Monster and Super Boo), dimensions variable. Installation view, Gagosian Gallery, New York, 2004.

Watery Ecstatic, 2007.
Ink, watercolour, crushed mica and cut paper on paper, 140 x 190 cm.

IGBT, 2008.
Gesso, gold leaf, ink, varnish and cut paper on paper, 201.9 x 188 cm.

You Walk into a Space, Any Space, or Poor Little Girl Beaten by the Game, 2010

Bronze figurine, wooden plinth and 37 painted metal objects of varying sizes.

Ryan Gander

Born in Chester, England, 1976; lives and works in London. Gander has been the subject of solo exhibitions at the CCA Wattis Institute for Contemporary Arts, San Francisco; Villa Arson, Nice; MUMOK, Vienna; Museum Boijmans Van Beuningen, Rotterdam; Stedelijk Museum, Amsterdam; and Daiwa Radio Factory Viewing Rooms, Hiroshima. In 2007, he won the Paul Hamlyn Award for Visual Arts, and in 2008 his exhibition 'Heralded as the New Black' toured venues in the UK and Europe. An extensive monograph on Gander's work, *Catalogue Raisonnable Vol.1*, was published in 2010.

'There is some art for which you need to know a whole back-story in order to understand it. Gander recognizes that some back-stories need art in order to understand them.'[1] Experimenting with ways to introduce the work of Ryan Gander, critic Dan Fox finds that the artist's love of creation myths and convoluted anecdotes is as integral to his practice as his witty and sophisticated application of diverse materials and methods. 'In Gander's art,' writes Fox, 'form is not just a vehicle for content but springs forth as the direct, logical conclusion of his work's subject matter and, in some dizzying cases, delivers a meta-critique of the work itself.'[2] Informed by the self-referential antics of Conceptual art, Gander's primary aim is to trace connections between images, objects, ideas, people and moments in time.

This intention is made clear in Gander's illustrated lecture *Loose Associations*, 2002–, which links together a multiplicity of subjects that might otherwise seem to have little to do with one another, also fuelling a vast number of other projects in formats as diverse as painting and jewellery, sculpture and performance, typography and installation. Many of these works delve into the early history of modernism; others call attention to more immediate precedents and contexts. 'Alchemy Boxes', 2007–, for example, is a series of containers based on sculptures by other artists – or, in some cases, on just these objects' bases – that house various personal artifacts. These items remain unseen but are listed in accompanying wall texts, resulting in a curious tension between observed exterior and envisaged interior, historical value and everyday utility.

In a 2010 exhibition at London's Lisson Gallery, Gander presented a similar referential mash-up with *You Walk into a Space, Any Space, or Poor Little Girl Beaten by the Game*. In this installation, also part of a series, he imagines the subject of Edgar Degas's sculpture *The Little Fourteen-Year-Old Dancer*, 1881, abandoning her plinth. In Gander's take, she holds a pyramid, a sphere and a cube, extrapolations of three basic shapes associated with the Bauhaus school of art and design. More of the same primary-coloured objects are scattered around her. The implication is of an encounter between an impressionist aesthetic still hidebound by classical tradition and a more contemporary perspective inspired by geometrical abstraction. Gander translates a stylistic and theoretical transition into the endearing form of a drama in real time and space.

Gander takes a playful, even subversive approach to the authority of cultural forms and forums.

In other works, Gander shifts this kind of conflict into the present by manipulating the conditions under which we experience an exhibition or other display. *This Consequence*, 2005, for example, consists of a set of customized Adidas tracksuits to be worn by gallery guards. Each all-white outfit is embroidered with a small bloodstain, a highly crafted intervention designed to lend the already incongruous look an unsettling extra uncertainty and cast the status and authenticity of the whole enterprise into doubt. This playful, even subversive approach to the authority of cultural forms and forums is, to Gander, the very essence of art.

1 Dan Fox, 'Where to begin?', *frieze*, issue 116, June–August 2008, 172–177.
2 Ibid.

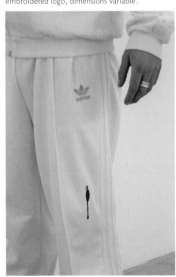

This Consequence (detail), 2005.
An 'All White' Adidas Tracksuit with golden embroidered logo, dimensions variable.

Nail Your Colours as You Will (Alchemy Box #21), 2010.
Two exhibition plinths, articles sealed inside, wall text.

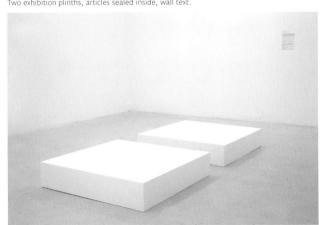

Gelitin

The group Gelitin was established in 1978. Its members all live and work in Vienna, Austria. The group has been the subject of solo exhibitions at venues including the Musée d'Art moderne de la Ville de Paris; Kunsthaus Bregenz, Austria; Kunsthalle St. Gallen, Switzerland; and MoMA PS1, New York. Gelitin has participated in the Venice Biennale and the Liverpool Biennial, and has staged performances and lectures internationally.

The collaborative group Gelitin is comprised of four artists who claim to have first met on a summer camp in 1978, and who began exhibiting together under their collective moniker (changed from the more conventionally spelled Gelatin in 2005) around 1993. Since then, Ali Janka, Florian Reither, Tobias Urban and Wolfgang Gantner have signed off on numerous outlandish and often confrontational projects, including a font design based on photographs of their own excrement, and a colossal pink stuffed rabbit 'installed' on a remote hillside in Italy, which they designed to remain in place for twenty years. They have made sculptures out of Plasticine, cheese and frozen urine, reproduced the entire contents of the Louvre in miniature, and constructed a functional rollercoaster inside a gallery space.

In 2005 at Leo Koenig Inc. in New York, Gelitin presented *Tantamounter 24/7*. Outwardly nothing more than a large crate, this object was in fact inhabited by the artists, and functioned as a kind of machine for creating replicas of whatever objects were placed inside it by visitors. But far from being perfect copies of their sources, the articles that eventually emerged from this concealed production line, which was stocked with materials and basic supplies, were more often radical reinterpretations. And nothing was turned away: a small child accepted into the box emerged some hours later along with its own 'copy', a set of Elmo dolls. Five years later, at New York's Greene Naftali Gallery, Gelitin revisited this model of 'live' collaborative manufacture with 2010's performance installation *Blind Sculpture*.

Gelitin has signed off on numerous outlandish and often confrontational projects.

Here, the artists were visible to their audience but reversed the situation of the earlier project by blindfolding themselves. In an arena surrounded by wooden bleachers, the group laboured over eight afternoons to produce a rambling construction that none of them got to see before its completion. As was the case with *Tantamounter 24/7*, *Blind Sculpture* was not solely the product of the group, but depended on outsiders' contributions. At Greene Naftali, Gelitin's helpers were not the viewing public but a pre-selected group of artists that included Rita Ackermann, Jim Drain, Liam Gillick, Adam McEwen, K8 Hardy and many others. These volunteers, with help from two additional assistants, arranged themselves into groups of between four and nine to organize the available materials – mostly surplus odds and ends – into a necessarily eccentric whole.

Blind Sculpture represents a playfully subversive approach to art-making in which the roles not only of the artists and their helpers, but also of their output and its audience are open to question. By restricting their own control over the work and allowing others to help shape it, Gelitin encourage us to consider ideas of authorship and reception. And in seeming to assign the visual a secondary status – though as critic David Velasco points out, both the installation's final form and the environment in which it evolved (a 'nutty, lubricious atmosphere' he dubs 'Gelitin-space'[1]) still had an identifiable look and feel – they suggest too that we think again about what art's defining ingredients might be.

1 David Velasco, 'Gelitin, Greene Naftali Gallery', *Artforum*, April 2010, 198.

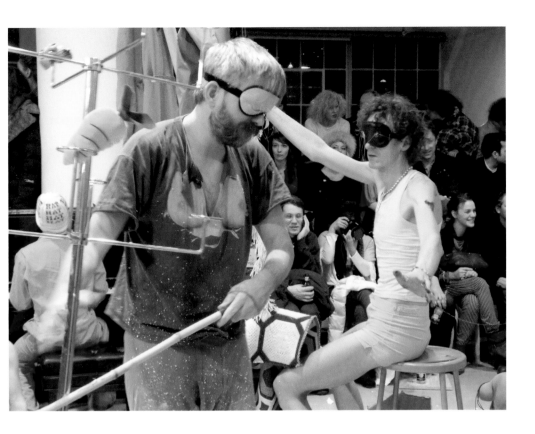

Hase / Rabbit / Coniglio, 2005–2025. Public sculpture, 60 x 40 x 3 m, Artesina, Italy.

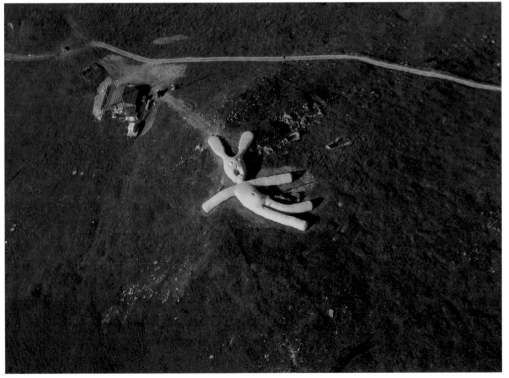

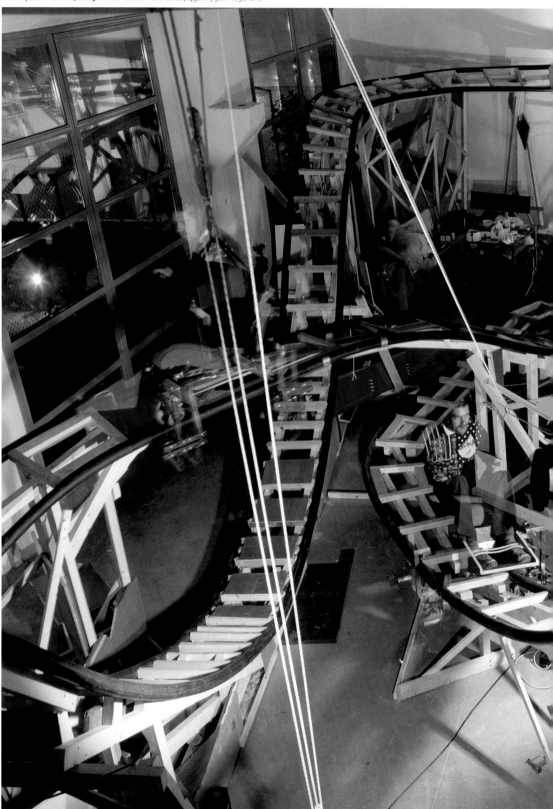

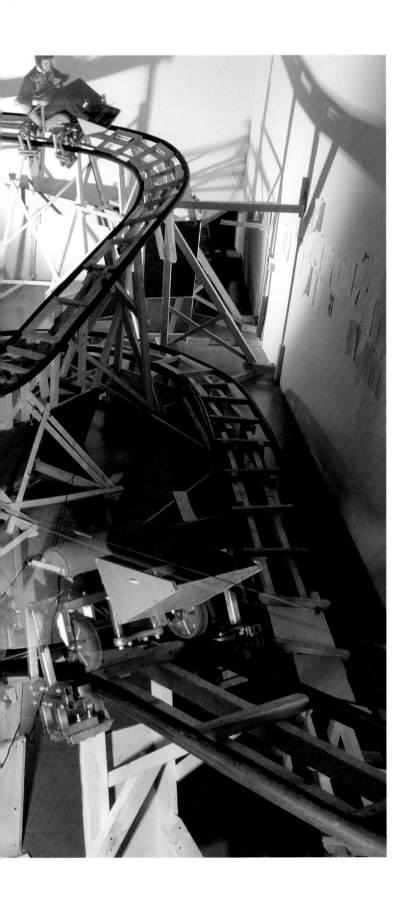

Isa Genzken

Born in Bad Oldesloe, Schleswig-Holstein, Germany, 1948; lives and works in Berlin. Genzken represented Germany at the Venice Biennale in 2007 and was the subject of a retrospective in 2009, organized by the Museum Ludwig, Cologne, and Whitechapel Gallery, London. She has also been the subject of solo exhibitions at Malmö Konsthall; Camden Arts Centre and The Photographers' Gallery, London; Kunsthalle Zürich; and Lenbachhaus, Munich. Her work is included in the collections of the Museum of Modern Art, New York, and Carnegie Museum of Art, Pittsburgh.

'There is nothing worse in art than, "You see it and you know it". Many artists seem to work from a theory that they invent, so to speak, and which accompanies them through life, a theory they never deviate from. That's a certainty I don't like.' If there is anything that Isa Genzken cannot be accused of, it is this kind of deadening rigidity. Emerging in mid-1970s Germany, Genzken set out to distinguish herself from the Minimalist aesthetic that dominated sculpture at that time by developing a thrillingly experimental and unpredictable practice inspired in part by Joseph Beuys. Art historian Benjamin H. D. Buchloh further characterizes the artist's approach as 'programmatically antimasculinist', a consciously anarchic alternative to the geometric fixity of her mostly male contemporaries. The oppositional nature of this stance meant that Genzken went under-recognized until quite recently, but the past few years have seen her achieve much greater visibility and influence.

In her 2007 solo exhibition at David Zwirner in New York, Genzken showed a number of works that, taken together, seemed to describe a scenario resulting from violent disorder, the aftermath of conflict, crime, or disaster. One gallery was dominated by a set of nine wall-mounted aluminium panels, collaged with various materials to suggest an abstracted cityscape. In another room, ragged beach umbrellas and sofas encrusted with foil sprawled alongside rough standing figures – tellingly described by the artist as 'soldiers' – formed from large bent coat hangers. Other works in the show were based around walking frames or wheelchairs. In *Untitled*, 2006, Genzken has partially wrapped a wheel chair in sheets of fabric and plastic, and balanced two ceramic bowls on its footrests. Streaks of white lacquer crisscross the haphazardly applied covering, while peering out from beneath is the printed image of a cat. The arrangement has an undeniable poignancy, a sense of abandonment that is all the more affecting for the seemingly incongruous, even arbitrary nature of its ingredients.

Geschwister, 2004. Plastic, lacquer, mirror foil, glass, metal, wood, fabric, 220 x 60 x 100 cm.

But Genzken's use of materials is of course far from indiscriminate. Rather, it presents a vision of the world as a place in which objects, images, ideas and feelings that do not immediately seem to 'belong together' are perpetually forced into close mental or physical proximity. When Buchloh characterizes the artist's present methodology as hovering on 'the brink of psychosis', his suggestion is not that Genzken is literally going mad, but that she is engaged in an ongoing confrontation with the impossibility of assessing the true value of material things in a world obsessed by their simple consumption. This mode, which reflects an overarching interest in modern and contemporary architecture as well as in material culture at large, also characterizes Genzken's work in film, photography, video, painting and collage. Across all these media, she makes reference to the legacies of Constructivism and other utopian currents in art and design en route to the creation of 'contemporary ruins'. These visions of collapse are at once uncomfortable and liberating, signalling a profound melancholia but also shot through with surprising optimism.

Abendmahl, 2008. Aluminium plate, mirror foil, spray-paint, tape, colour print on paper, 194 x 138.5 cm.

'Mona Isa', 2010. Exhibition view, Galerie Chantal Crousel, Paris.

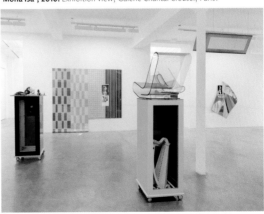

Rescinded Production, 2008

Powder-coated aluminium, transparent coloured Plexiglas, 200 x 240 x 240 cm.

Liam Gillick

Born in Aylesbury, England, 1964, lives and works in London and New York, USA. Gillick has exhibited at venues including the Whitechapel Gallery, London; Palais de Tokyo, Paris; Stedelijk Museum, Amsterdam; and Kunstverein, Munich. In 2008, his touring retrospective, 'Three perspectives and a Short Scenario', opened at the Witte de With, Rotterdam. In 2009, he represented Germany at the Venice Biennale and *All Books*, an anthology of his publications, was published by Book Works. Gillick was shortlisted for the Turner Prize in 2002 and for the Vincent Award in 2008.

The art of Liam Gillick is characterized by an elusiveness and complexity that some find wilfully obscure and self-regarding, while others see it as an instructively open-ended diagram of real-world ambiguity and fragmentation. Gillick makes objects, images and texts for gallery and museum display, but has also produced music, books, films, animations and various forms of design. He embraces the possibilities of collaboration in general, and of the artist-as-curator in particular. Closely associated with the notion of *relational aesthetics* – a term coined by French critic and theorist Nicolas Bourriaud in reference to art that hinges on a social context – he is interested in the many ways that physical and visual phenomena reveal the ideological and economic systems and structures that underpin them.

Gillick's sculpture *Rescinded Production*, 2008, was first shown in his exhibition 'The State Itself Becomes a Super Whatnot' at Casey Kaplan Gallery in New York. An open box form built from coloured aluminium and Plexiglas, it was presented as part of a larger body of work titled 'Construcción de Uno (Construction of One)'. This project revolves around a multipartite investigation into the political and interpersonal circumstances surrounding industrial production – here with particular reference to Brazilian research on Scandinavian car manufacture. The web of circumstances within which *Rescinded Production* is thus couched identifies it as more than just the exercise in Minimalist formalism it initially resembles (Donald Judd in particular made extensive use of an outwardly similar format). Instead, Gillick offers up his sleek but permeable 'corral' as an arena for experiment and debate.

Gillick offers up his sleek but permeable 'corral' as an arena for experiment and debate.

While *Rescinded Production* exists as an autonomous object, it functions most fully in conjunction with other works by the same artist. In its original installation, the sculpture was juxtaposed with others in a physically similar format tinted red, suggesting a potential standoff between rival schools of thought. Adjacent wall-mounted sculptures and a large vinyl wall text added to the sense of ideas and forms acting in concert or opposition (and perhaps both). Gillick's practice is heavily invested in this kind of internal connectedness, his projects often referring to one another to form their own 'community' while also proposing a critique of more familiar organizations in the wider world. *Rescinded Production* also forms part of a longer line of sculptures in which architectural forms such as the platform, the screen, the shelf and the canopy are lent alternative inflections and emphases.

Gillick has referred to art as a 'convenient mid-space location', and places equal emphasis on activities that other artists might dismiss as overly tangential, distracting or provisional. His aim in doing so is often less to 'master' a new medium or method than it is to research a particular process and its implications. To this end, he has scored films by Sarah Morris, devised a cocktail recipe for Ryan Gander, and penned several books that blur the line between historical reconstruction and speculative fiction. In these and other narratives, Gillick demonstrates a fascination with both utopian visions of shared life and the diversity of renegotiations to which they are subject.

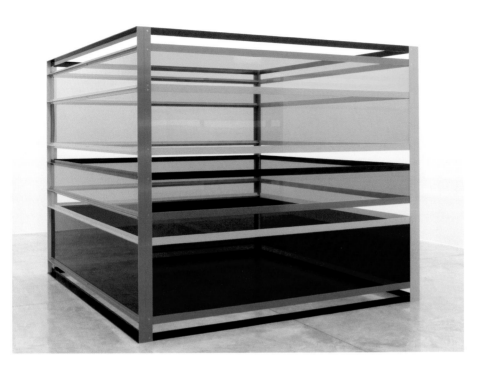

Discussion Island Resignation Platform, 1997.
Anodized aluminium, opaque Plexiglas, 142 x 95 x 2 cm.
Installation view, Documenta 10, Kassel, 1997.

Theanyspacewhatever Signage System, 2008.
Installation view, Solomon R. Guggenheim Museum, New York.

Discussion Island Double Exit Rig (detail), 1997–2010.
Aluminium, light fittings, white bulbs, cables, clamps,
wiring, two rigs, 20.3 x 120 x 120 cm (each).

Play Dead; Real Time, 2003

Three-channel colour video, silent, two screens, one monitor, 19 minutes; 15 minutes 22 seconds.

Douglas Gordon

Born in Glasgow, Scotland, 1966; lives and works in New York, USA. Gordon was the winner of the 1996 Turner Prize, the 1997 Venice Biennale's Premio 2000 award, the 1998 Hugo Boss Prize awarded by the Solomon R. Guggenheim Museum, and the 2008 Roswitha Haftmann Prize. His work has been the subject of exhibitions at the Museum of Contemporary Art, Los Angeles; the Fundació Joan Miró, Barcelona; and the Museum of Modern Art, New York. His film *Zidane, un portrait du 21e siècle*, co-directed with Philippe Parreno, premiered at the Cannes Film Festival in 2006.

'We had a very simple premise, which was that the elephant would be asked to roll over and play dead,' says Douglas Gordon, recounting the making of his video installation *Play Dead; Real Time*, 2003. 'We would ask the animal to do something she wasn't used to doing and see how she behaved.' The elephant to which Gordon refers is Minnie, a four-year-old Indian brought, with her trainer, from Connecticut to New York's Gagosian Gallery in the middle of the night to act out for the artist's camera. In addition to lying down and getting up, Minnie was directed to perform a range of simple movements such as walking forward and backing up while her movements were recorded on video, often at close range.

'We wanted to straddle a nature film and a medical documentary,' Gordon explains, 'to observe the subject in a way that could be used for a practical purpose but that also had a certain aesthetic.' The conception of a hybrid form in which divergent filmic genres are brought together is central to much of the artist's work. Colour, silent and punctuated by regular fades to black, *Play Dead; Real Time* has the coolness of a clinical document, but also a focus on formally beautiful details that connotes a more subjective undertaking. Projected onto two elephant-sized freestanding screens and a small monitor installed in a darkened interior (originally the same one in which it was filmed), it has an imposing physical presence of the kind more often associated with cinema.

While the footage used in *Play Dead; Real Time* is original, Gordon frequently makes use of existing material to examine film's methodologies, meanings and effects. In the breakout *24-Hour Psycho*, 1993, he slowed down Alfred Hitchcock's iconic horror movie to last the full day and night of the title, utterly transforming our experience of a narrative familiar in its broad arc but less so in its frame-by-frame minutiae. He has also pushed technical boundaries to present events from otherwise unseen perspectives: in 2006, he collaborated with Philippe Parreno on a feature-length film about footballer Zinédine Zidane, *Zidane, un portrait du 21e siècle*, in which footage from seventeen synchronized cameras was assembled into a composite study of the player's movements over the course of a match.

In *Play Dead; Real Time*, Gordon deconstructs his medium both as a way to more closely examine the uniqueness of the creature at hand, but also to establish and enhance an exchange between content and context. The installation positions not only Minnie and her image, but also the artist, gallery and viewer as interlinked players in a drama about the gaps between nature and nurture, performance and presentation. Critic Jerry Saltz also discerns a sly satirical edge: 'Staging a circus-like event in this conspicuously circus-like environment can't help but make you think of alpha males like Richard Serra, Anselm Kiefer, Damien Hirst and Julian Schnabel, all of whom have thrown their weight around this same space,' he writes. 'This charges the atmosphere with something caustic.'[1]

Douglas Gordon and Philippe Parreno, Zidane, un portrait du 21e siècle, 2006.
Colour video with sound, 91 minutes.

1 Jerry Saltz, 'Elephant Man', *Village Voice*, 25 March 2003. http://www.villagevoice.com/2003-03-25/art/elephant-man/

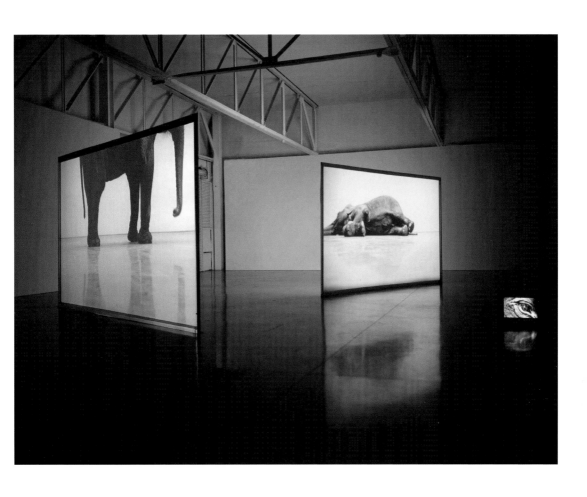

k.364, 2010. Installation view, Gagosian Gallery, London.

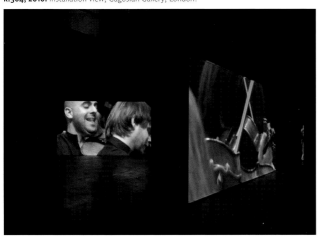

24-Hour Psycho, 1993.
Single-channel black-and-white video, silent, 24 hours.
Installation view, Le Méjan, Arles, 2011.

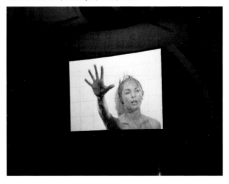

Paul Graham

Born in Stafford, England, 1956; lives and works in New York, USA. Graham's work has been exhibited at the Venice Biennale, in the inaugural exhibition at the Fotomuseum Winterthur, Switzerland, and at the Museum of Modern Art, New York. He was included in Tate Modern's landmark 'Cruel + Tender' survey exhibition of 20th-century photography, and was the subject of a mid-career survey exhibition at Museum Folkwang, Essen, that toured to the Deichtorhallen, Hamburg, Germany, and Whitechapel Gallery, London. In 2009, Graham won the Deutsche Börse Photography Prize.

'There remains a sizeable part of the art world that simply does not get photography. They get artists who use photography to illustrate their ideas, installations, performances and concepts, who "deploy" the medium as one of a range of artistic strategies to complete their work. But photography for and of itself – photographs taken from the world as it is – are misunderstood as a collection of random observations and lucky moments, or muddled up with photojournalism, or tarred with a semi-derogatory "documentary" tag.'[1] Paul Graham characterizes the pursuit of 'straight' photography in a contemporary art world grown desensitized to its unique qualities as something of an uphill battle, but his commitment to its ongoing potential as a subtle and complex medium in its own right remains undiminished. In series such as 'Television Portraits', 'American Night' and 'End of an Age', Graham makes a sophisticated case for photography as embodying a critical challenge to artist and viewer alike.

Graham makes a sophisticated case for photography as embodying a critical challenge to artist and viewer alike.

In 2004, Graham, who moved from London to New York in 2002, set out on a succession of exploratory journeys around the United States, following a tradition established in 1958 by Robert Frank with *The Americans*. Graham published his own road-trip photographs in 2007 as a set of twelve books under the title 'a shimmer of possibility'. The collection is comprised of groups of images that focus on lives lived on the margins of society, and on fleeting moments of ordinary beauty. Graham's presence as observer is reserved and benign – his shots feel intimate but never intrusive – and his deceptively casual compositions display an acute sensitivity to the effects of light and shade, hour and season. Very little can be said to 'happen' in most of these images – people wait for buses, mow the lawn, eat fast food – but the details of their postures and dress are quietly revelatory.

The sequences in 'a shimmer' vary in length; some longer sections are comprised of more than twenty photographs, while one slim volume houses just a single image. When exhibited as framed prints, they are arranged in non-linear fashion, though the suggestion of a narrative inevitably persists. But while the 'story' that Graham's photographs tell has no clearly defined beginning, middle or end, it does have a theme – the ubiquity and persistence of poverty. Again and again, figures that appear at first glance to be simply going about unremarkable business are distinguished, on closer inspection, by a careworn, weather-beaten aspect, or by the vacant desperation of their activities and accoutrements. In *California (Sunny Cup)*, 2005–2006, Graham focuses on a white styrofoam cup clutched to the chest of a middle-aged man. But what might once have held coffee now looks a little too battered for that – it seems more likely to be a receptacle for small change. Graham has cited Chekov's short stories as an inspiration, but this image seems closer to a haiku. As a fragment of observed reality, it has all the import of those 'decisive moments' regarded by Henri Cartier-Bresson as the ultimate quarry of the intuitive photographer.

1 Paul Graham, 'The Unreasonable Apple', presentation at first MoMA Photography Forum, February 2010. http://www.paulgrahamarchive.com/writings_by.html

California (Dark Cup), 2005-2006. Colour photograph, from the series 'a shimmer of possibility'.

Rodney Graham

Born in Abbotsford, Vancouver, Canada, 1949; lives and works in Vancouver. Graham has been the subject of solo exhibitions at the Sprengel Museum, Hanover; BAWAG Foundation, Vienna; Musée d'art contemporain de Montréal; Bergen Kunsthall; Institute of Contemporary Art, Philadelphia; Art Gallery of Ontario; Museum of Contemporary Art, Los Angeles; and the Whitechapel Gallery, London. His work was featured in the Whitney Biennial in 2006, and in 2008, JRP Ringier published *The Rodney Graham Songbook*, which collects the music and lyrics of the artist's five rock albums.

In April 2008 at the Abrons Arts Center, the Public Art Fund hosted a performance titled *The Rodney Graham Band live, featuring the amazing Rotary Psycho-Opticon!*. The first New York concert by the Canadian artist and musician and his six-man folk rock group, the event also showcased its title's 'amazing' device. *Rotary Psycho-Opticon*, 2008, is a freestanding sculpture inspired by the set of an early 1970s Belgian TV show in front of which Black Sabbath performed their classic 'Paranoid'. Five circular holes cut out of a metal backdrop patterned with black-and-white Ben-Day dots reveal other designs that move when power is applied. The effect is similar to that of a kaleidoscope, also recalling Marcel Duchamp's Rotoreliefs and other early works of kinetic art.

Graham also produced a smaller version of the work, *Mini Rotary Psycho-Opticon*, 2008, which is powered by a modified exercise bike. Both sculptures derive from their maker's interest in the cultural and physiological ramifications of psychedelia, making reference not only to the intimate association of popular music with mind-altering drugs, but also to a 1943 bicycle ride taken by Dr Albert Hofmann under the influence of LSD. Having first synthesized the drug in 1938 with the intention of producing a respiratory and circulatory stimulant, the Swiss chemist had set it aside for years, realizing its effect only when he absorbed some accidentally through his fingertips and found his perception unexpectedly and radically altered (Graham's film installation *The Phonokinetoscope*, 2001, reimagines this incident in detail).

Cultural and social happenstance has often inspired Graham's highly varied and carefully researched art.

Cultural and social happenstance has often inspired Graham's highly varied and carefully researched art. Initially associated with Vancouver's conceptual photography scene of the 1970s, he quickly began to explore a far wider range of themes and formal strategies, drawing on literature and philosophy, psychology and psychoanalysis, high and popular culture. Graham is also intrigued by antique technologies, shifting for example between video and various types of film, and often making the cumbersome display mechanisms of the latter an integral part of the finished work. In the film installation *Rheinmetall/Victoria 8*, 2003, the image of a 1930s typewriter emerges from an enormous 1961 projector, and as a thick layer of flour is shown accumulating on the keyboard, both machines become the subjects of a peculiar archaeology.

Graham often appears in his own work, though usually playing the role of someone else. In addition to his portrayal of Hofmann in *The Phonokinetoscope*, he has transformed himself into a shipwrecked pirate in the maddeningly elliptical video *Vexation Island*, 1997, and a roaming cowboy in the similarly inconclusive *How I Became a Ramblin' Man*, 1999. A more recent series of lightbox photographs pictures him as a card shark, a lighthouse keeper, a performer of early music, and an outsider in a Western saloon. As in all of the artist's works, these images are marked by a sophisticated interplay between the real and the recreated, between history and myth. Even when Graham appropriates recognizable archetypes or manipulates familiar narratives, his wry sense of humour gives them an unpredictable spin.

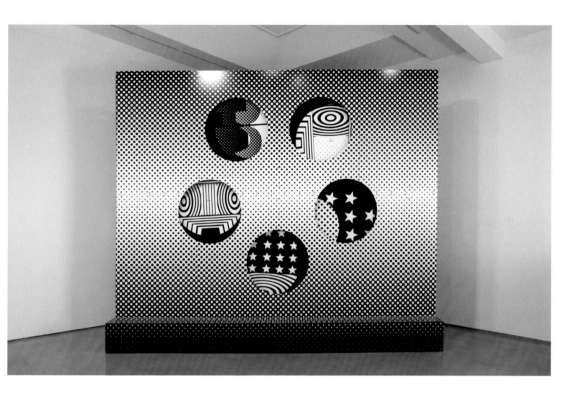

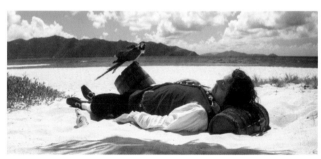

Vexation Island, 1997. Colour 35 mm film with sound, 9 minutes.

The Phonokinetoscope, 2001.
Colour 16 mm film, modified turntable and vinyl record.

Rheinmetall/Victoria 8, 2003.
Installation with colour 35 mm film, Cinemeccanica Victoria 8 film projector,
10 minutes 50 seconds. The Museum of Modern Art, New York.

One Floor Up More Highly, 2010
Soil, wood, acrylic, Styrofoam, clothing, acrylic on glass-fibre-reinforced plastic and acrylic on canvas.
Installation view, Massachusetts Museum of Contemporary Art.

Katharina Grosse

Born in Freiburg, Germany, 1961; lives and works in Düsseldorf and Berlin. Grosse has been the subject of solo exhibitions at the Hammer Museum, Los Angeles; Arken Museum for Moderne Kunst, Copenhagen; Queensland Art Gallery, Brisbane; Galerie Sfeir-Semler, Hamburg; and Artsonje Museum, Gyeongju-si, South Korea. She has also participated in group exhibitions including 'Space as Medium', Miami Art Museum, and 'Extreme Abstraction', Albright-Knox Art Gallery, Buffalo. In 1999, she was the artist in residence at the Chinati Foundation in Marfa, Texas.

'Very strong and raw colours tend to attract or even repulse the viewer,' observes Katharina Grosse. 'They tend to create certain reactions in a very direct way and that's what I want, to be *over*explicit.'[1] Grosse makes flowing installations that use bright acrylic spray-paint to transform viewers' experience of a given space with the aim of breaking down our habitual ways of seeing ourselves, our environment and each other. She typically applies pigment directly to the walls, floor, ceiling, even the doors and windows of an interior, radically destabilizing our ingrained perceptions of its form and function. Many of her recent works also incorporate objects, recognizable items that are lent a strange new cast by their reconfigured surroundings and incongruously tinted surfaces.

For *One Floor Up More Highly*, 2010, a temporary site-specific installation located in the hangar-like Building 5 gallery at Massachusetts Museum of Contemporary Art in North Adams, Grosse juxtaposed clusters of tall, carved white Styrofoam shards with four immense heaps of spray-painted soil. She also painted walls and floors on the hall's mezzanine, adding several shaped canvases and a single more conventionally proportioned abstraction. As viewers circumnavigated the work to observe it from different vantage points, this sprawling tableau remained, in spite of its artificial elements, powerfully organic in its intimations of geography and geology. 'My knowledge of how my installations function is very precise; they're about expanding small experience,' Grosse elaborates. 'By making something small really large, you slow the information, and time, down, like slow motion.'[2]

But while the foam had an iceberg-like quality and the mounds of earth suggested hills, Grosse's intention was not to create a literal representation of landscape. Rather, she aimed at an abstract setting in which colour and texture were ambiguous, even dissonant, and resonated with their context in unforeseen ways. The artist describes the foam, which was cut to shape with hot wire, as being 'like crystallized light, which connects with the white walls of the building.'[3] And far from being 'pure' earth, the soil piles contained fabricated boulders in a conscious play on ambiguities of scale and meaning. 'In this installation,' related Grosse, 'the soil looks a bit like raw pigment, or like it could be contaminated, or like coloured light is hitting it.'[4]

There is a strongly gestural quality to Grosse's painting in this and other works that betrays the influence of Abstract Expressionism. But while the artist appreciates the movement as a vital development, she also regards it as having had a proscriptive effect by focusing attention on flat surfaces with clearly delineated borders. Grosse aims not to paint according to any predetermined system, even one that seems to embrace improvisation, but instead to treat her medium as a way of thinking beyond extant modes. She dismisses even a similarity to street graffiti, which she regards as closed and territorial, characterizing her own use of spray paint as an invitation to trespass. 'There are no limits to painting,' she concludes, 'that's why I am involved in it.'[5]

Untitled, 2000. Acrylic on canvas, 200 x 284 cm.

1 http://www.youtube.com/watch?v=rJkSs5EQ7nk
2 The artist in Anthony Byrt, '500 Words: Katharina Grosse', *artforum.com*, 1 March 2011.
 http://artforum.com/words/id=27257
3 Ibid.
4 Ibid.
5 The artist in Ati Maier, 'Katharina Grosse', *BOMB*, issue 115, Spring 2011.

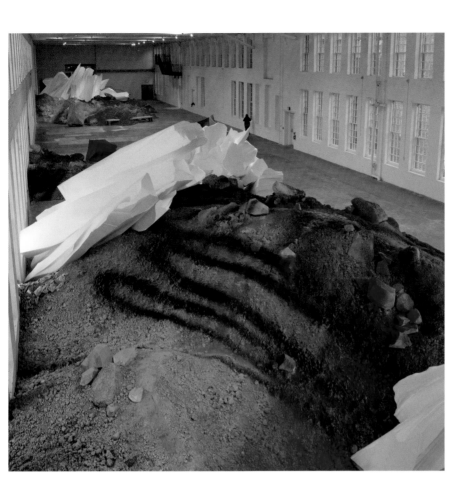

Pigmentos Para Plantas y Globos, 2008. Acrylic on balloons,
soil, walls, floor, 636 x 727 x 1450 cm. Installation view, Artium,
Museo Vasco de Arte Contemporáneo, Vitoria-Gasteiz, Spain.

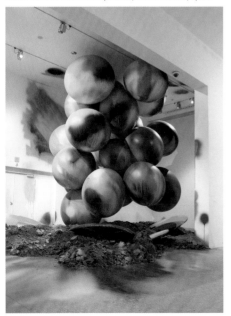

Cincy (detail), 2006. Acrylic on wall, floor, glass,
Styrofoam and soil, 480 x 740 x 1180 cm.
Installation view, Contemporary Arts Center, Cincinnati.

Line of Control, 2008

Stainless steel and steel structure, stainless steel utensils, 1000 x 1000 x 1000 cm. Installation view, Tate Britain, London, 2009.

Subodh Gupta

Born in Khagaul, Bihar, India, 1964; lives and works in New Delhi. Since 1997, Gupta has exhibited in Delhi, Mumbai, Amsterdam, London and New York. He has participated in group exhibitions including 'The Tree from the Seed' at Henie Onstad, Kunstsenter, Oslo; 'Under Construction' at the Japan Foundation/Tokyo Opera City Art Gallery; and 'Post Production (Sampling, Programming and Displaying)' at Galleria Continua, San Gimignano, Italy.

French curator and critic Nicolas Bourriaud defines the portmanteau term *altermodern*, which he employed as the title for the fourth Tate Triennial in 2009, as a 'reloaded' version of modernism based on the translation of shared values in the context of a global network. 'Altermodernism' is, he proposes, 'a movement connected to the creolization of cultures and the fight for autonomy, but also to the possibility of producing singularities in a more and more standardized world'. One of the artists featured in Bourriaud's exhibition was Subodh Gupta, whose sculptural installation *Line of Control*, 2008, filled a rotunda in the museum's Duveen Galleries. Gupta, who uses objects associated with the Indian subcontinent in tableaux informed by the Duchampian readymade, is perhaps the 'altermodern' artist par excellence.

Line of Control takes the form of a mushroom cloud of polished stainless-steel pots, pans and utensils that reaches for the ceiling. As a universally recognized symbol of mass destruction, the image is chilling enough. But knowing that the title refers to contested borders (which for an Indian or Pakistani viewer automatically evokes Kashmir) adds a twist. The work's metallic components are common to the point of ubiquity in Gupta's homeland, so their integration into such a potent image makes for an intriguing conversation between the harmless and the apocalyptic, the habitually overlooked and the wilfully ignored. 'Hindu kitchens are as important as prayer rooms,' says Gupta, and the meeting of fundamentals – nutrition and destruction, life and death – in *Line of Control* takes on a quasi-spiritual gravity.

Gupta makes frequent use of the kinds of objects from which *Line of Control* is constructed. The tiffin lunch box in particular often stands in both for the artist's memories of home and childhood, and for the encroaching transformation of rural Indian society along hyper-capitalist lines. Gupta plays with materials, scale and accumulation to render such items anew. In *U.F.O.*, 2007, he fuses hundreds of brass cups into the form of a flying saucer, creating an allusion to the fantastical 'other' rooted in issues of the here and now such as poverty, overpopulation and overproduction. In *Two Cows*, 2003-2008, he models a pair of milk-pail carrying bicycles in bronze, making them appear at once luxurious and impoverished, cutting across the class divide that they embody.

Some of Gupta's recent works make explicit reference to icons of modern and contemporary art. *Et tu, Duchamp?*, 2009, for example, is a sleek sculptural take on Duchamp's wittily altered Mona Lisa, *L.H.O.O.Q.*, 1919. *Jeff the Koons*, 2009, meanwhile, reproduces in painted aluminium fifty of the boxes designed to house a table-top edition of the American post-Pop master's *Puppy Vase*, 1998, evoking in the process Warhol's painted wooden *Brillo Boxes*, 1964. The increasingly diverse formal and referential palette that such projects represent reflects Gupta's increasingly international profile, but he continues, too, to reflect on his roots in works such as *Date by Date*, 2008. Here, a room stuffed with antiquated bureaucratic fixtures and fittings, dusty files and furniture parodies his country's administrative inefficiencies.

Date by Date, 2008.
Mixed media, dimensions variable.
Installation view, Serpentine Gallery, London.

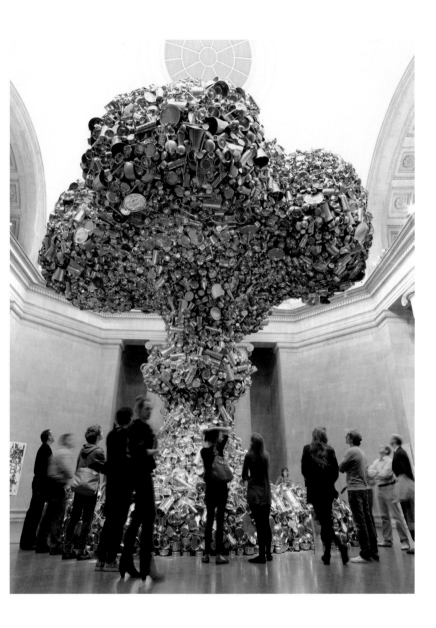

Two Cows, 2003–2008. Bronze, chrome, 98 x 252 x 118 cm.

Et tu, Duchamp?, 2009. Black bronze, 114 x 88 x 59 cm.
Marble plinth: 123 x 123 x 122 cm. Overall height: 237 cm.

David Hammons

Born in Springfield, Illinois, USA, 1943; lives and works in New York. Hammons's work is featured in the collections of the Albright-Knox Art Gallery, Buffalo; Fogg Art Museum, Cambridge, Massachusetts; Museum of Contemporary Art Chicago; Museum of Contemporary Art, Los Angeles; Museum of Modern Art and Whitney Museum of American Art, New York; and Stedelijk Museum voor Actuele Kunst, Ghent. Hammons received a MacArthur Fellowship in 1991.

'I can't stand art actually. I've never, ever liked art, ever.'[1] As the quote suggests, David Hammons has a wide contrarian streak, but the artist's fiercely maintained independence has only strengthened his influence over the course of a lengthy career. Moving from Los Angeles to New York in 1974, Hammons made his name with a succession of works that took a caustic approach to racial and cultural stereotyping. Combining a provocative wit with an approachable aesthetic informed by Dada, Outsider art and Arte Povera, Hammons stresses the communicative and ritualistic potential of objects and materials commonly associated with urban poverty and the African-American experience. Producing sculptures, videos, performances and mixed-media works, he also continues to dictate to an unusual extent the terms on which his work may be exhibited.

In his infamous early performance *Bliz-aard Ball Sale*, 1983, Hammons occupied a slot alongside other downtown Manhattan street vendors to sell snowballs, arranging and pricing them according to size. An absurdist critique of the inequities of commerce and the 'whiteness' of the American art world – still a prevalent condition – the action is typical of the artist's barbed humour. It also reflects his ongoing commitment to the use of public space, the city street in particular. In a similarly iconoclastic action from the same period, *Pissed Off*, 1981, he urinated against a monumental abstract public sculpture by Richard Serra, while for *Higher Goals*, 1986, he transformed a series of telegraph poles around Brooklyn's Cadman Plaza into unusably lofty basketball hoops, decorating them with bottle-tops.

The work that Hammons makes for gallery display tends to be similarly mischievous. In the early 1970s, for example, he produced 'Body Print' self-portraits by pressing his greased form onto paper to generate a delicate silhouette. Around the same time, he began creating found-object sculptures in which 'dirty', 'non-art' materials including elephant dung, chicken bones, strands of dreadlocked hair and bottles of cheap wine become talismans that suggest a contemporary equivalent to tribal shamanism (several other artists, from Joseph Beuys to Jimmie Durham, have attempted something similar). More recently, Hammons worked with New York gallery L&M Arts on two exhibitions that exploited the venue's aura of uptown exclusivity, subverting the expectations of even those most familiar with his approach.

At his L&M debut in 2007, Hammons presented, hanging on dressmaker's dummies, five brand-new full-length fur coats, the backs of which are singed with a blowtorch and slathered with paint and varnish. It was a characteristically provocative gesture that played on the dealership's moneyed look and feel, recalling the strategic 'wastefulness' of an infamous 1994 performance by the K Foundation in which the duo burned a million pounds. In a 2011 follow-up, Hammons presented a dozen splashy abstract paintings overlaid with blankets, bags and rough-cut sheets of plastic resembling used tarpaulins. But while more formally conventional than the earlier installation, the new project was still something of a disturbance in the usual order of things; critic Holland Cotter, after describing the work's echoes of Robert Rauschenberg, defines it as 'exalted trash'.[2]

Untitled, 2010. Mixed media, 152.4 x 109.2 cm.

1 The artist in Kellie Jones, 'David Hammons', *Real Life*, no. 16, Autumn 1986.
2 Holland Cotter, 'The Upper East Side Goes Grungy in David Hammons's Gallery Show', *The New York Times*, 1 March 2011.

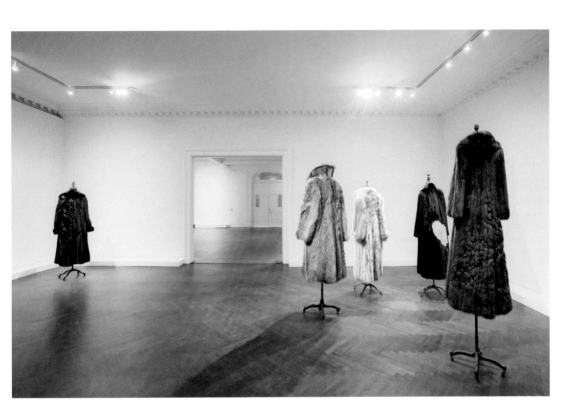

Higher Goals, 1986. Basketball nets, bottle-tops, mixed media.
Installation view, Cadman Plaza, Brooklyn, New York.

Bliz-aard Ball Sale, 1983. Performance, Cooper Square, New York.
Black-and-white photograph, 56 x 42 cm.
Migros Museum für Gegenwartskunst, Zurich.

Alexander the Great, 2007

Mixed media, 231.1 x 221 x 101.6 cm. The Museum of Modern Art, New York.

Rachel Harrison

Born in New York, USA, 1966; lives and works there. Harrison has been the subject of solo exhibitions at the Bard College, New York; Portikus, Frankfurt; Whitechapel Gallery, London; Le Consortium, Dijon; Migros Museum für Gegenwartskunst, Zurich; Los Angeles Contemporary Exhibitions; Transmission Gallery, Glasgow; and many other venues. Her work was featured in the Whitney Biennial in 2002 and 2008 and the Tate Triennial in 2009, and included in 'The Spectacular of Vernacular' at Walker Art Center, Minneapolis, in 2011.

'However chaotic her combinations may seem at first,' writes critic Jennifer Allen on the work of sculptor Rachel Harrison, 'each work is governed by a precise order, which is as much spatial as temporal: both filling the cream pie and hitting your moving target smack in the face.'[1] The allusion to slapstick comedy is surely intended, since Harrison makes frequent use of absurdist juxtaposition, revelling in an aesthetic of embarrassment. Interweaving gaudy handcrafted mini- or anti-monuments with pop-cultural found objects (the kinds of bits and pieces that are, in Allen's characterization, 'not worth stealing and not quite detritus'), the artist produces hybrid constructions and installations that gather an eclectic variety of materials and references while maintaining formal integrity and art-historical understanding.

Harrison's sculpture *Alexander the Great*, 2007, was first shown in her exhibition 'If I did it' at the Greene Naftali Gallery in New York. Named after Charles Darwin's research vessel the HMS *Beagle*, the display featured a series of photographs that meditate on the (real and imagined) evolution of three-dimensional portraiture, and a set of sculptures named after famous historical figures, Alexander among them. The work itself is composed of a mannequin perched atop a large boulder-like construction decorated in primary colours. The figure has two faces, one of which is a crude but instantly recognizable mask of Abraham Lincoln (variations on Janus appear in other of Harrison's sculptures too, suggesting an eye fixed simultaneously on past and future). Wearing a red cloak studded with gold stars, he carries a NASCAR souvenir bucket.

Harrison makes frequent use of absurdist juxtaposition, revelling in an aesthetic of embarrassment.

While some viewers might find Harrison's practice wilfully obscurantist or awkward, sculptures like *Alexander the Great* reveal it as in fact rather systematic, consciously hoping to reinvigorate age-old debates around the status of objects and the meaning of their presentation. What we are presented with in this work is a deliberate mixing of hierarchies, in which the different parts played by the found and the constructed are destabilized and interrogated. Even the mounting of the sculpture on a plain white pedestal at once acknowledges the continued resonance of classical style and nods to a specifically Minimalist trope. Like Harrison's work in general, *Alexander* is partially self-reflexive, offering comment on the entire history of making and finding, showing and seeing, as well as commenting - albeit obliquely - on its ostensible subject.

That *Alexander* incorporates photographs - the images on the bucket - as well as objects is also consistent with Harrison's methodology. Many of the artist's sculptures act almost as distended frames, again suggesting a shift in relative significance and allowing for dynamic play with scale and focus. In *Alexander*, the colours of the pictured cars are picked up in the irregular 'base', a simple echo that helps unite the sculpture's otherwise disparate parts. Such strategies have earned its maker comparison with artists as removed from one another as Alexander Calder and John Baldessari. But while she is a serious student of her heritage and milieu, Harrison's approach to lineages and orthodoxies - sculptural and photographic, historical and contemporary - is finally one of joyful irreverence.

1 Jennifer Allen, 'Moving Targets', *frieze*, issue 110, October 2007.

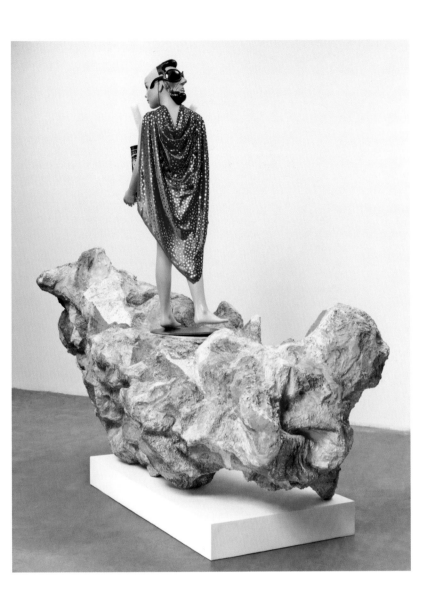

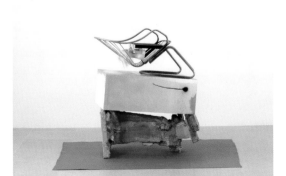

The Spoon Bender, 2011. Mixed media, 135.9 x 149.9 x 195.6 cm.

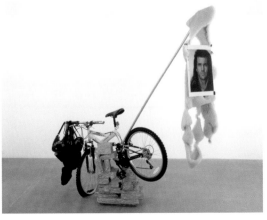

Huffy Howler, 2004. Mixed media, 213.4 x 213.4 x 76.2 cm.

Sharon Hayes

Born in Baltimore, USA, 1970; lives and works in New York. Hayes's training includes studies in anthropology at Bowdoin College in Maine, and in performance art at Trinity/La MaMa Performing Arts Program in New York. Her work has been seen at national and international exhibition spaces including the Generali Foundation, Vienna; MoMA PS1, New York; Museum Moderner Kunst, Vienna; Warhol Museum, Pittsburgh; and Tate Modern, London. She has also participated in events including the Istanbul Biennial and Auckland Triennial.

The diffuse format of Sharon Hayes's video installation *Parole*, 2010, reveals an artist with a complex, multivalent relationship to her fields of interest. A set of four video projections partially housed inside a makeshift plywood enclosure, the work requires viewers to shift their position several times over the course of more than half an hour in order to see and hear it in its entirety. This can feel at first like a disorienting and difficult experience, but ultimately succeeds in directing attention toward the nuanced intersection of related events and ideas separated by distance, time and context. *Parole*'s imagery depicts a variety of sites connected by their adopted function as settings for public speech, while its soundtrack is drawn from readings of historical texts that may be given some new context or understood differently by contemporary audiences.

If *Parole*, with its highly fragmented narrative, can be said to have a protagonist, it is perhaps the unspeaking female sound recordist who reappears from scene to scene, microphone perpetually in tow. We first meet this character (played by New York artist Becca Blackwell) listening and taking notes in an audio archive, recording the sound of her own pen as it moves across the page. In her subsequent movement through scenes of domestic, public, academic and artistic life, she is haunted by the sounds of various significant speeches, including early lesbian activist Anna Rüling's 1904 address 'What Interest Does the Women's Movement Have in the Homosexual Question?' and a college lecture by feminist cultural theorist Lauren Berlant about the role of sentimentality in cultural discourse.

The title of *Parole* refers to the word used by Swiss linguist Ferdinand de Saussure to refer to individual acts of speech (*parole*) within a greater linguistic system (*langue*). In focusing on individual examples of discussion around issues of civil rights and gender identity, the installation prompts a consideration of the ways in which protest and polemic continue to resonate beyond their original contexts, and how the act of documenting them invariably alters their meaning. An exploration of the interplay between politics and emotion, the broad and the intimate, *Parole* is consistent with a practice in which current concerns are rendered in terms of universal allegory. It also reflects the use of methods appropriated from cinema, anthropology and journalism.

For Hayes, documentation and demonstration, thought and expression are inseparable.

Parole also shares with Hayes's other work its element of performance. In her 1998 action *The Lesbian*, the artist parodied a conventional documentary format to produce a tongue-in-cheek attempt at 'explaining' the current state of lesbian culture in the United States, while *In the Near Future*, 2009, saw her take to the streets of international capital cities with a range of incongruous protest signs. These placards were either out of place or unplaceable, their messages subtly or drastically at odds with the surrounding environment. While fully public, Hayes's action was also photographed by friends and associates alerted in advance, complicating its reception both on site and in subsequent exhibitions and publications. For Hayes, documentation and demonstration, thought and expression are inseparable.

Parole (detail), 2010.

In the Near Future, 2009. Thirteen 35 mm slide projections.

Revolutionary Love 2: I am Your Best Fantasy, 2008.
Performance view, Republican National Convention, St. Paul, Minnesota.

Mary Heilmann

Born in San Francisco, USA, 1940; lives and works in New York. Solo exhibitions of Heilmann's work have been presented at the Institute of Contemporary Art, Boston; San Francisco Art Institute; Museum Ludwig, Cologne; Camden Arts Centre, London; Secession, Vienna; and the Douglas Hyde Gallery at Trinity College, Dublin. In 2008, her work was featured in the Whitney Biennial and was also the subject of a major retrospective organized by the Orange County Museum of Art, Newport Beach, that travelled to the New Museum, New York.

Recalling Mary Heilmann's early creative development in the context of a way of working – painterly abstraction – that in late 1960s and early 1970s New York was 'sinking into a worn-out slump', art historian Anne M. Wagner describes the artist's dogged concentration on issues beyond mere conceptual or aesthetic fashion thus: 'She relied on coming to terms, as all serious abstractionists must, with the most basic issues art presents. What world can a painting summon? What does it offer the mind and senses? Should it aim to disclose the contingencies of its making, or strive for an effect of presence so complete, so vivid, as to seem foreordained?'[1] In pursuing her own distinctive variant on post-Minimalism, Heilmann continues to address such fundamental concerns through the interplay of colour and shape, surface and objecthood, the spontaneous and the systematic.

Having trained as a sculptor and ceramicist, Heilmann brings a sophisticated spatial awareness to her deceptively simple grids, squares, spots and stripes, often using eccentrically shaped canvases and bringing the glaze-like properties of pigment to the fore. As Wagner writes, the artist's paintings 'accrue their features – depth, colour, volume, substance – over time, in steps or layers'. Heilmann further emphasizes each work's physicality by wrapping the paint around the canvas's edges, reminding us that these are not simply flat surfaces but fully three-dimensional. She applies the paint with a loose, easy hand that lends the results a relaxed, casual air, but which also evokes precedents in geometric and colour field painting. In this, and in their evocative titles, Heilmann's paintings thus take their place in an art-historical lineage. But there is a personal side to them too.

Heilmann employs a palette that speaks of possibility and risk-taking.

'Each of my paintings can be seen as an autobiographical marker,' Heilmann states, 'a cue, by which I evoke a moment from my past, or my projected future, each a charm to conjure a mental reality and to give it physical form.' Drawing on the surf culture of her childhood in the area around Los Angeles, the beatnik scene of her teenage years in San Francisco, and the punk, new wave and no wave scenes of 1970s and early 1980s New York, Heilmann employs a palette that speaks of possibility and risk-taking, a bright, bold and experiential approach to living in the moment. And while the works do not lean on verbal props, the artist's titles often provide clues as to specific points of origin.

Rainbow Kachina, 1982.
Watercolour on paper, 76.2 x 55.88 cm.

In the diminutive but typically exuberant *Pink Trace*, 2010, Heilmann employs both canvas and wood in constructing the support for an oozing candy-coloured layer-cake of pink and green. Extending the pattern on the canvas onto the otherwise monochrome panel, she playfully suggests a 'leak' from one surface to the other. This movement beyond the bounds of painting's conventional rectilinear format – the use of wood and the interlinked structure also echo her work in furniture design – implies an open-ended reconsideration of the medium's sensory and emotional limits. But however insistently Heilmann tests the possibilities of medium and format, sheer visual pleasure remains at her project's heart.

1 Anne M. Wagner, 'Field Trips', *Artforum*, November 2007.

Blue Hydrangia, 1995. Oil on canvas, 101.6 x 81.9 cm.

Broken, 2005. Oil on canvas, 106.7 x 73.7 cm.

Charline von Heyl

Born in Mainz, Germany, 1960; lives and works in New York, USA. Heyl has been the subject of solo museum exhibitions at Le Consortium, Dijon; the Dallas Museum of Art, and the Secession, Vienna. She participated in 'Make Your Own Life: Artists In and Out of Cologne', which travelled from the Institute of Contemporary Art in Boston to the Power Plant Contemporary Art Gallery, Toronto, the Henry Art Gallery, Seattle, and the Museum of Contemporary Art, North Miami. Her works are in the collections of the Musée d'Art moderne de la Ville de Paris; the Museum of Contemporary Art, Los Angeles; and the Museum of Modern Art, New York.

Charline von Heyl is a painter whose work inhabits a zone beyond the reductive classifications of figurative and abstract, presenting an exploration of the lingering potential of the art object to become an autonomous visual event. Her paintings are at once questions and answers, puzzles and solutions, never rejecting reference outright, but seeking to transcend it and confront the viewer with something never seen before. The artist's early works, made by painting over and gradually obliterating recognizable motifs, have given way to multi-layered canvases in which several different styles of painting appear to be competing for the same space. And while reflecting the influence of her teachers Jörg Immendorff and Fritz Schwegler, and her experience of the highly experimental Cologne painting scene of the 1980s, Heyl's approach remains distinct.

In addition to her paintings, and sometimes displayed alongside them, Heyl makes prints and collages. While not framed as studies, these often feed into the larger works on canvas. Predominantly black and white, they incorporate photographic and other imagery as well as fragments of text and pattern, providing the artist with an extended vocabulary of forms that she can continue to make use of without compromising the individuality of her vision as a whole. Heyl has also used the book format to generate original elements; in *Sabotage*, 2008, she again plays with the possibilities of layering, printing images onto sheets of clear plastic as well as paper, so that the act of turning a page generates a fleeting superimposition.

In an essay published to accompany Heyl's solo exhibition at the Secession, Vienna, in 2004, critic John Kelsey identifies the active engagement with time that *Sabotage* implies as a key component of all the artist's work, arguing that she causes the act of painting to 'oscillate between a before and an after' by refusing to let its meaning solidify. He further characterizes Heyl's practice as intensely self-aware in its continued re-enactment of a gestural vocabulary associated with tendencies dating back to Abstract Expressionism. 'The painting knows that it is a stage,' he writes, 'and that performance is its highest power.'

Untitled, 2007.
Woodcut on paper, 76.5 x 57.2 cm.

The drama that Kelsey outlines remains clearly and thrillingly evident in recent paintings by Heyl such as *Pink Vendetta*, 2009. Enclosed almost entirely within a camp starburst silhouette reminiscent of a comic-book explosion or a bargain-basement price tag is a cluster of geometric-biomorphic shapes punctured, Swiss-cheese-style, by several large round holes. Through and around these apertures we glimpse a backdrop of smeared red lines and handprints set against a sickly pink ground. The combination feels at once carefully staged and on the verge of erupting violently from its jagged frame, a group of individually placid painterly elements goaded by the artist into bloody battle. There is a sense of depth to the composition, but its background and foreground have been deliberately confused. And while the painting's element of 'action' seems to refer to the story of its making, this narrative is – consistent with Kelsey's characterization – both non-linear and exhilaratingly high-key.

It's Vot's Behind Me That I Am (Krazy Kat), 2010.
Acrylic and oil on linen and canvas, 208.3 x 182.9 cm.

Woman, 2005.
Charcoal, acrylic and oil on canvas, 208.3 x 198.1 cm.

Susan Hiller

Born in Tallahassee, Florida, USA, 1940; lives and works in London, England, and Berlin, Germany. Hiller has been the subject of solo exhibitions at venues including Castello di Rivoli, Turin; Kunsthalle Basel; and Wexner Center for the Arts, Columbus. She has also participated in group exhibitions including 'Monuments for the USA' at CCA Wattis Institute for Contemporary Art, Oakland, California, and White Columns, New York; and 'Outside of a Dog' at the BALTIC Centre for Contemporary Art in Gateshead. Hiller was the recipient of a John Simon Guggenheim Fellowship in 1998 and the DAAD Fellowship, Berlin, in 2002.

Characterizing her practice as a series of 'investigations into the "unconscious" of our culture', Susan Hiller is widely acknowledged as a key influence on generations of younger British artists. A pioneer of 'archival' installation and participatory performance, Hiller has also continuously embraced the potential of new and expanded media, including video and sound. Her work displays traces of her own early studies in Mesoamerican anthropology and archaeology, taking as its point of departure neglected or denigrated aspects of cultural production – most strikingly elements of the supernatural and the unexplained or inexplicable. Strongly influenced at different stages of her career by Minimalism, Surrealism and Conceptual art – she has dubbed her own approach *paraconceptual* – Hiller is also associated with a feminist sensibility directed in particular at the rehabilitation of repressed and 'irrational' impulses.

In mapping out this territory, Hiller has considered dreams and horror films, narratives of near-death experiences and the history of psychoanalysis, looking always for what the mythical, mysterious or uncanny might reveal to us about everyday life. For *An Entertainment*, 1990 – one of the earliest artistic uses of projected video – she edited together her own footage of Punch and Judy shows, creating a nightmarish environment that illuminates the full strangeness of its subject, a theatrical form shaped by ritual violence. But she has also followed quieter routes, working with postcards, for example, in her extended series 'Rough Seas', 1982-2009. Gathering cards from around the United Kingdom that illustrate stormy weather, the artist annotates grids of related examples with texts that interrogate disjunctions between verbal and visual description.

Hiller's installation *Witness*, 2000, consists of several hundred tiny speakers suspended by wires from the ceiling of a darkened gallery. Positioned at various heights, the dangling array suggests a swarm, cloud or constellation, while the design of its component parts resembles that of the archetypal flying saucer. The last connection is particularly appropriate given that *Witness* addresses the UFO phenomenon; holding any given speaker up to his or her ear, the listener hears a voice relating – in one of many languages – the story of a different more or less close encounter with purportedly alien technology. Heard en masse as they necessarily are as one moves around and through the work, these testimonies blur together into a hubbub of competing accounts, none of them comprehensible.

An Entertainment, 1990.
Four-channel video projection with quadrophonic sound, 25 minutes 59 seconds. Tate, London.

The texts from which *Witness* is constructed were gathered online and originate from many different times and places, and while some of their sources are named, others remain anonymous. At intervals, the collective babble dies away so that only one voice remains audible, but our understanding of these isolated examples still depends on an understanding of the particular language in which they happen to be delivered. What persists even when the details of a story are obscured is a feeling for its teller's conviction. It is thus especially affecting that several begin by admitting that they do not expect to be believed. Hiller describes the extraordinary collection as an archive of modern visionary experience equivalent to the reporting of angels associated with an earlier age.

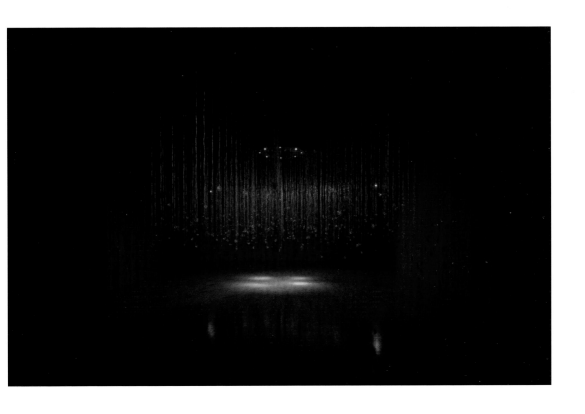

Nightwaves, 2009. Nine archival digital prints, 52.7 x 78.5 cm.

Susan Hiller, Wild Talents, 1997.
Dual-channel video installation with two projections, one monitor, lights and chair.

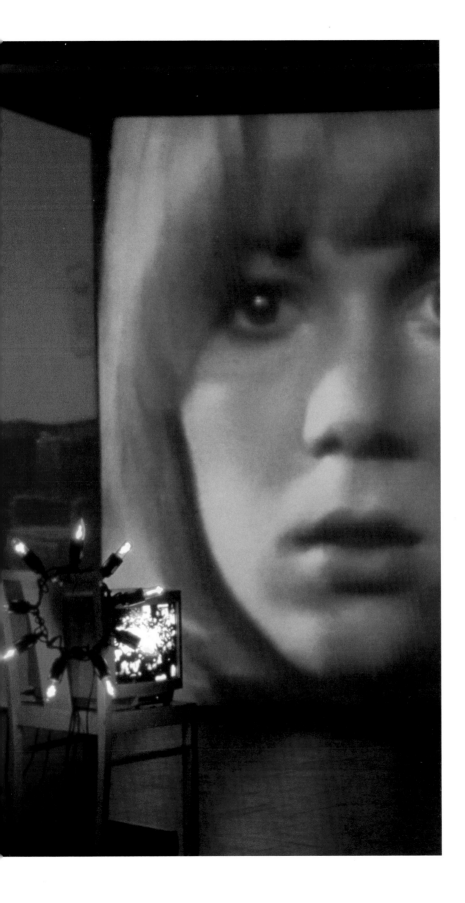

Cavemanman, 2002

Mixed media installation, dimensions variable. Installation view, Carnegie Museum of Art, Pittsburg, 2008.

Thomas Hirschhorn

Born in Bern, Switzerland, 1957; lives and works in Paris, France. Hirschhorn has been the subject of solo exhibitions at the Institute of Contemporary Art, Boston; Art Institute of Chicago and Renaissance Society, University of Chicago; Palais de Tokyo, Paris; and Pinakothek der Moderne, Munich. His work is represented in the collections of the Museum of Modern Art, New York; Walker Art Center, Minneapolis; and Tate Modern, London. He is a recipient of the Marcel Duchamp Prize and the Joseph Beuys Prize, and represented Switzerland at the 54th Venice Biennale in 2011.

A claustrophobic network of cardboard-and-packing-tape caves occupied by groups of mannequins covered in silver foil and stacked with books reproduced at giant size, Thomas Hirschhorn's installation *Cavemanman*, 2002, transforms the space it fills into an environment fizzing with conflicting forms and ideas. The curving walls, built over a sprawling plywood armature, are plastered with clippings from popular magazines and newspapers and photocopies of philosophical and political texts. Empty beer and soda cans and cardboard 'rocks' litter the uneven floor, multiple images of clocks are tagged with the names of different international cities, and the slogan 1 MAN=1 MAN is sprayed here and there in black paint. Stark fluorescent lights buzz overhead while inset video monitors display footage of what appears to be the famous Lascaux caves but turns out to be Lascaux II, its theme-park-like recreation.

'I wanted to make a space in which it was possible to feel outside of the real,' says the artist of the characteristically maximalist project, which was first installed at New York's Gladstone Gallery and has been remade around the world. 'I was interested in making a space that awaits discovery; a space in development – indefinite, perhaps infinite – and a space in which someone has been living.'[1] Hirschhorn frames *Cavemanman* as the abandoned home of a hermit who has withdrawn from society in order to confront his obsession with the achievement of equality – hence his idealistic motto. This hoped-for condition is also represented by the mannequins' interconnection via ropes of foil that also lead to what look like homemade bombs, each taped to a volume of incendiary thought. Hirschhorn is a passionate believer in the power of radical theory to counteract the deleterious effects of unchecked consumerism, and while declining to present *Cavemanman*'s library as a perfect syllabus, he does make a case for informed resistance.

The establishment of loci for intellectual debate is a key part of Hirschhorn's practice, as is the use of commonplace materials. 'I am against work of quality,' he states. 'Energy, yes! Quality, no!'[2] In sculptures that frequently take the form of temporary kiosks or pavilions, he takes a 'more is more' approach that eschews specialist techniques and privileges ready accessibility over potentially intimidating displays of craft or value. But he does not shy away from confrontational subject-matter. Another exhibition at Gladstone Gallery, 2006's 'Superficial Engagement', generated controversy by incorporating gruesome photographs of war casualties into a walk-through assemblage that delivers an uncompromising statement about our collective unwillingness to accept the realities of human violence. In such projects, Hirschhorn continues to draw on his experience as a graphic designer with the politically driven Grapus collective, refuting exclusive ideology but still aiming to communicate a 'message' about the human condition. In 'Crystal of Resistance', his contribution to the 2011 Venice Biennale, the artist again used images of the suffering generated by conflict, integrating them into an interior modelled in part – like *Cavemanman* – after a timeless geological form. As before, the effect was both congruent with and removed from the world we know.

'Crystal of Resistance', 2011.
Installation view, Swiss Pavilion, Venice Biennale.

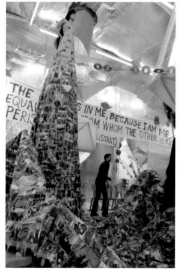

1 The artist in Michael Wilson, 'Caves of New York', *Artforum*, vol. 41, no. 6, February 2003, 110-15.
2 Okwui Enwezor, James Rondeau and Hamza Walker, *Jumbo Spoons and Big Cake*, exhibition catalogue, Art Institute of Chicago and Renaissance Society of the University of Chicago, 2000, 32.

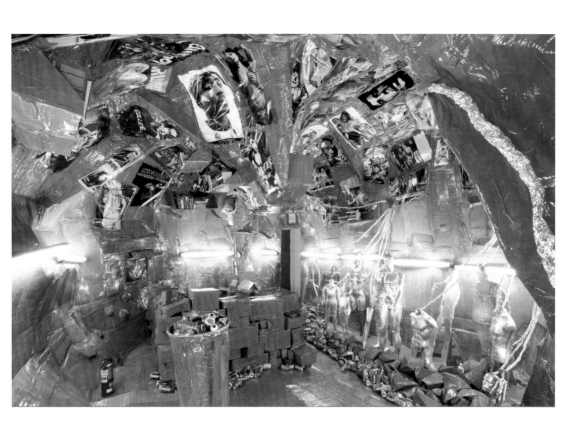

Saddam/Schwarzenegger, 2004.
Paper, plastic sheet, prints, felt pen, ball-point pen, 42.5 x 59 cm.

'Superficial Engagement', 2006.
Installation view, Gladstone Gallery, New York.

Damien Hirst

Damien Hirst was born in Bristol, England, in 1965. He lives and works in Devon, England, and Baja, Mexico.

Love him or loathe him, Damien Hirst has established himself as a figure of unique influence since his rise to near-ubiquity in the 1990s. If any individual has been responsible for transforming public perception of what it means to be a contemporary artist, it is surely this brash, business-minded figurehead of the YBA (Young British Artist) generation. Hirst is routinely lambasted as a mere publicity-seeker and his work attacked for its perceived lack of subtlety, but even the most strident critic would be hard-put to deny the artist's achievement in imprinting his most famous works on the popular imagination. To an incomparably greater extent than any of his peers – and most of his elders – Hirst has 'crossed over' to become a household name.

Hirst's abiding themes – life and death, beauty and horror – are universal, and his treatment of them is direct and confrontational, increasingly with religious overtones. Since the 1991 debut of his much-parodied shark-tank sculpture, *The Physical Impossibility of Death in the Mind of Someone Living*, and in the almost viral spread of his spot, spin, and butterfly paintings, Hirst has pursued a fascination with blood-and-guts physicality while evincing a designer's instinct for striking, easily reproduced images. And although some recent undertakings have made a lesser impression – critic Adrian Searle described a 2010 exhibition of 'self-painted' canvases at the Wallace Collection in London as 'a momento mori for a reputation' – Hirst continues to diversify, presiding over a brand that reaches to furniture and clothing, skateboards and cars.

It would be disingenuous, then, to overlook the fact that Hirst's triumph has also been financial. His career arc has coincided with and to some extent driven a boom in the international contemporary art market over the last fifteen years. And while his prices have declined in tandem with the global economic downturn, he remains the richest artist in Britain – a feat accomplished with the help of some judicious alliances, particularly those forged in his formative years with his Goldsmith's College tutor Michael Craig-Martin, dealer Jay Jopling and patron Charles Saatchi. Hirst's sculpture *For the Love of God*, 2007, demonstrates with especial clarity his mastery of the entrepreneurial artist-as-facilitator model espoused by Craig-Martin, and his positioning of wealth as a creative medium in its own right.

N-Chloroacetyl-l-phenylalanine (PFS)
Crystalline, 1997.
Household gloss on canvas, 91.4 x 114.3 cm.

A platinum cast of an 18th-century human skull encrusted with 8,601 flawless pavé-laid diamonds, *For the Love of God* trades in high drama of a typically Hirstian kind. The work reportedly cost £14 million to produce and was priced at a staggering £50 million when first exhibited – spotlit, in a darkened chamber – at the White Cube in London. Confusion surrounding its eventual sale – apparently to a consortium that included the artist himself – encouraged some commentators to locate the work's true artistic value in the waves of misinformation that this event sent through the media.

The Physical Impossibility of Death in the Mind of Someone Living, 1991
(three-quarter view). Glass, painted steel, silicone, monofilament, shark and
formaldehyde solution, 217 x 542 x 180 cm.

Deckchair (red), 2008.
77.5 x 121.9 x 58.4 cm.

Carsten Höller

Born in Brussels, Belgium, 1961; lives and works in Stockholm, Sweden. Höller's work has been the subject of solo exhibitions at the Fondazione Prada, Milan; Institute of Contemporary Art, Boston; Musée d'Art contemporain, Marseille; Massachusetts Museum of Contemporary Art; and Museum Boijmans Van Beuningen, Rotterdam. In 2005, he represented Sweden (with Miriam Bäckström) at the 51st Venice Biennale. Höller won the Enel Contemporanea Award in 2011, and was the subject of a retrospective at the New Museum, New York.

Until his career as an artist took off in the mid-1990s, Carsten Höller was employed as a research entomologist, and a scientific approach – he holds a doctorate in biology – continues to pervade his current work. Höller's immersive installations are experiments in emotion, perception and physiology that demand viewers' participation, confronting them directly with aspects of their own humanity. But while the artist pursues a serious agenda, his work retains a playfulness that ensures its broad accessibility. All kinds of unusual materials and contexts have been grist to the mill; he has designed vehicles and architectural interventions as well as toys and games, and used animals and plants alongside high technology to enhance our perceptions of ourselves, and of the world around us.

Höller's best-known works are his series of slides built inside museums, galleries and other interiors. Attracted to the playground staple's combination of visual spectacle and personal thrill, the artist produced several of these on a modest scale before accepting a commission to transform the vast Turbine Hall at London's Tate Modern in 2006. Höller's *Test Site* was made up of five slides that spiralled down from upper levels, allowing visitors to take an alternative – and speedy – route through the building, or simply to stand and watch as a succession of riders launched themselves down the partially enclosed metal-and-plastic tubes. The work's title suggests that it might be a prototype for a still more ambitious scheme in which sliding becomes an everyday method of negotiating built space.

While the irresistible impact of Höller's slides hinges on the phenomenon of an unusual kind of movement occurring in an unexpected context, other works by the artist act on our brains and bodies by mining the strangeness of the natural world. *Solandra Greenhouse*, 2004, was a garden habitat for the *Solandra Maxima* vine, a plant that releases pheromones, chemicals associated with feelings of sexual attraction and love. And *Soma*, 2010, installed at the Hamburger Bahnhof in Berlin, was a pen housing twenty-four canaries, twelve reindeer, eight mice and two flies – plus a mushroom-shaped platform bed available for nightly rental. Half the reindeer had been fed mushrooms that made their urine hallucinogenic, and since all the urine was collected and made available to paying guests for consumption, *Soma* offered up a truly unique gamble.

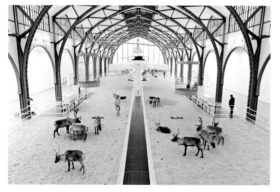

Soma, 2010. Installation view, Hamburger Bahnhof-Museum für Gegenwart, Berlin.

Höller is fascinated by the idea of duality, and many of his projects incorporate physical or visual doubling or division. In his 2003 exhibition 'One Day One Day' at the Färgfabriken in Stockholm, two works shown opposite each other were exchanged for alternatives on a daily basis, the shifts going slyly unannounced. 2005's *Mirror Carousel* is one of a long line of sculptures in which reflective surfaces simulate the multiplication of objects and spaces. And in *The Double Club*, 2008-2009, Höller designed and built a temporary installation that took the form of a working London bar, restaurant and nightclub split into two halves. A distinct mix of music, food and drink characterized each part, the layout prompting dialogue between the two cultures – Congolese and Western – represented therein.

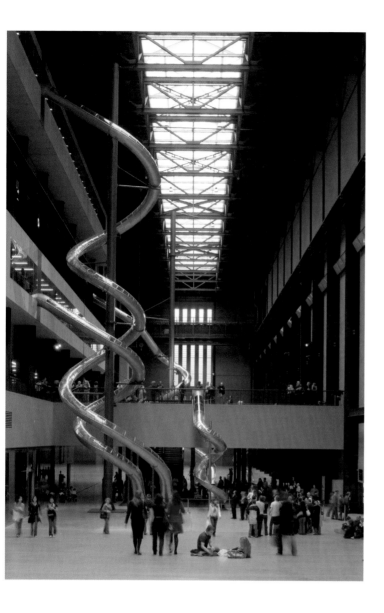

The Double Club, 2008–2009.
Installation view, London.

Mirror Carousel, 2005. Aluminium, mirrors, lights, motor, 5 x 7.5 x 7.5 m.

Roni Horn

Born in New York, USA, 1955; lives and works in New York and Reykjavik, Iceland. Horn has been the subject of solo exhibitions at the Centre Pompidou, Paris, and the Dia Center for the Arts and Whitney Museum of American Art, New York. She has exhibited at the Whitney Biennial, Documenta and the Venice Biennale. Horn is a recipient of the CalArts/Alpert Award in the Arts and a Guggenheim fellowship. 'Roni Horn aka Roni Horn', a comprehensive overview of her work to date, opened at the Whitney Museum of American Art in 2009.

'Big enough to get lost on. Small enough to find yourself. That's how to use this island,' writes Roni Horn. 'I come here to place myself in the world. Iceland is a verb and its action is to center.'[1] On a promontory overlooking the coastal town of Stykkishólmur stands a modest art deco building with a semicircular arc of windows that faces the western fjords. This structure, a former lending library, is now home to Horn's *Vatnasafn/Library of Water*. Commissioned and produced in 2007 by the Artangel agency in association with local authorities, this long-term project corrals three singular collections – of 'water, words and weather reports' – that reflect the artist's close and ongoing relationship with the work's site. Combining the roles of museum and community centre, *Vatnasafn* juxtaposes the artist's work with an archive and multi-use space.

Vatnasafn's primary 'exhibit' is *Water, Selected*, a striking array of twenty-four floor-to-ceiling clear glass tubes filled with water derived from the ice of nearby glaciers, set into a rubber floor on which are inscribed adjectives relating to the subject of weather (OPPRESSIVE; DULL; SERENE). The otherworldly image of the translucent columns exists in a state of extraordinary tension with the raw physicality of their contents, while the verbal fragments that surround them, rooted in culture and emotion, interject a human element. In an adjoining room, copies of a sequence of photographic books titled 'To Place' that Horn made in and about Iceland in 1991 and 1992 are available for visitors to peruse. Accompanying these volumes is *Weather Reports You*, a set of conversations with local residents concerning the same apparently universal human preoccupation, recorded in 2005 and 2006 by writer Oddný Eir Ævarsdóttir, her brother, archaeologist Uggi Ævarsson, and their father, broadcaster Ævar Kjartansson. Finally, on the building's lower floor is a studio where local and visiting writers are invited to live and work.

Horn has been visiting Iceland regularly since 1975, and describes herself as a 'permanent tourist' in this strikingly elemental place.

Horn has been visiting Iceland regularly since 1975, and describes herself as a 'permanent tourist' in this strikingly elemental place. Her interest in meteorology is equally long-standing, and the two facets of her work now dovetail intimately. In Horn's oeuvre, weather carries a host of associations, providing access to ideas around light and heat, people and place, the everyday and the eternal. For *You are the Weather*, 1994-1996, for example, she photographed an Icelandic woman a hundred times, creating a kind of frieze that wraps around all four walls of a room. Minute differences between one image and the next align the endless shifts of climate with the subtle fluctuations of an individual identity. Water is a recurrent motif too; the artist's 1999 series 'Still Water (The River Thames, for Example)' depicts the surface of the river in photographs footnoted with her own wildly diverse thoughts on the material's history and significance. *Vatnasafn* thus unites ideas and images that Horn has explored throughout her career in the very spot that is their nexus. An extraordinary personal and climatic document, it is also a unique monument to the permanence of change.

1 Roni Horn, 'Island and Labyrinth', *Pooling Waters / Vatnamot* (Vol. 4 of 'To Place'), 1991, revised 1997.

You are the Weather (detail), 1994–1996. 64 Chromogenic prints and 36 gelatin-silver prints, 26.5 x 21.4 cm (each).

Untitled (Aretha), 2002–2004. Optical glass, 33 x 76.2 x 76.2 cm. The Museum of Modern Art, New York.

Still Water (The River Thames, for Example), 1999. 15 offset lithographs, 77.5 x 105.4 cm (each). The Museum of Modern Art, New York.

Tehching Hsieh

Born in Nan-Chou, Taiwan, 1950; lives and works in New York, USA. Since 2000, Hsieh has exhibited in North and South America, Asia and Europe, including at the Museum of Modern Art and in 'The Third Mind: American Artists Contemplate Asia, 1860–1989' at the Solomon R. Guggenheim Museum, both in New York. In 2010, Hsieh was included in the Liverpool Biennial and the Gwangju Biennale in South Korea. *Out of Now: The Lifeworks of Tehching Hsieh*, a book documenting the artist's oeuvre, was published in 2008.

I KEPT MYSELF ALIVE. I PASSED THE DECEMBER 31ST, 1999. Assembled from letters cut out of a magazine and stuck onto a piece of paper, ransom-note style, the statement is signed TEHCHING HSIEH and date-stamped JANUARY 1, 2000. Humble, even throwaway, in its homemade look and apparently simple declaration, the collage in fact 'reports' the end of thirteen years' creative activity. On Hsieh's 36th birthday, 31 December 1986, the artist issued a terse statement outlining his intentions for a period lasting until the final year of the 20th century: WILL MAKE ART DURING THIS TIME. WILL NOT SHOW IT PUBLICLY. True to these words, *Tehching Hsieh 1986–1999 (Thirteen Year Plan)* saw Hsieh withdraw completely from exhibiting for the stated period, and he has made no work since.

To appreciate the thinking behind this extraordinary gesture – one that might seem to contradict the whole purpose of being an artist – it helps to know something about Hsieh's background, and about the creative currents that underpin his method. Initially a painter, Hsieh abandoned the medium after his first solo exhibition in favour of a radical brand of performance art centred on extremes of discipline and duration. Beginning in New York in the late 1970s, he completed five year-long actions that came closer to the 'blurring of art and life' described by artist Allan Kaprow than the work of any of his predecessors or contemporaries. The series also reflected the difficulty of Hsieh's relocation from Taiwan to the United States; he was an illegal immigrant for fourteen years until gaining amnesty in 1988.

Thirteen Year Plan followed on the heels of *One Year Performance 1985–1986 (No Art Piece)*, during which Hsieh avoided all artistic activity. Not only did he take a break from making art, he also refused to discuss it, read about it, or look at it in museums and galleries. Previously, he had spent consecutive years locked in a bare wooden cell (*One Year Performance 1978–1979 [Cage Piece]*); punching a time clock every hour (*One Year Performance 1980–1981 [Punching the Time Clock]*); subsisting entirely outdoors (*One Year Performance 1981–1982 [Outdoor Piece]*); and living physically tethered to another artist, Linda Montano (*Art / Life: One Year Performance 1983–1984 [Rope Piece]*). Each action was monitored and documented through photographs and related ephemera.

'My influences were Dostoevsky, Kafka, Nietzsche, Camus's *Myth of Sisyphus*, and my mother.'

Despite the almost unimaginable stamina that these works surely demanded, Hsieh does not frame them as demonstrations of physical or mental strength; rather they are, he says, about 'wasting time and freethinking'. They also illustrate a degree of cultural and personal isolation: 'I don't think I'm part of Asian contemporary art,' he tells critic Barry Schwabsky. 'Certainly I come from Asia, but my influences were Dostoevsky, Kafka, Nietzsche, Camus's *Myth of Sisyphus*, and my mother.'[1] Yet neither are *Thirteen Year Plan* and the works that preceded it strictly 'autobiographical'. Rather, they reflect Hsieh's realization that an artist could *contain* his work; that the very stuff of life could become both subject-matter and raw material.

1 The artist in Barry Schwabsky, 'Live Work', *frieze*, October 2009.

TEHCHING HSIEH

DEC 31 **1986 - 1999** DEC 31

I KEPT MYSELF ALIVE. I PASSED THE DEC 31, 1999.

Tehching Hsieh JANUARY 1, 2000.

1986 1987 1988 1989
1990 1991 1992 1993
1994 1995 1996 1997
1998 1999

EARTH

One Year Performance 1980–1981 [Punching the Time Clock]. Performance documentation.

One Year Performance 1978–1979 [Cage Piece].
Performance documentation.

One Year Performance 1981–1982 [Outdoor Piece].
Performance documentation.

Untitled, 2006

Aluminium, glass, rubber and plastic letters, 100 x 75 x 4.5 cm.

Bethan Huws

Born in Bangor, Wales, 1961; lives and works in Paris, France, and Berlin, Germany. Huws's work was featured at the 2003 Venice Biennale and in 2006 she won a BACA Europe Laureate prize, which recognizes outstanding artists at mid-career. Huws has been the subject of solo exhibitions at venues including Tate Modern, London; Kunsthalle Düsseldorf; Chapter Arts Centre, Cardiff; and Henry Moore Institute, Leeds. In 2011, Huws's exhibition 'Black and White Animals' opened at Limousin's Centre international d'art et du paysage de l'Île de Vassivière.

WHAT'S THE POINT OF GIVING YOU ANY MORE ARTWORKS WHEN YOU DON'T UNDERSTAND THE ONES YOU'VE GOT? The question is spelled out neatly in small, white, plastic capital letters on a black, metal-framed notice board of the kind traditionally used in schools and offices for prosaic, factual communiqués. But despite the formal, deadpan appearance of Bethan Huws's *Untitled*, 2006, its tone is provocative, even accusatory. Viewers are likely to feel slighted at the implication that they have demanded more from the work's maker than they are really able to comprehend. They may also be unnerved at the strangely direct inquiry; Huws here transforms the experience of interacting with a work of art into something much closer to a literal conversation than we are entirely comfortable with.

Huws grew up speaking both Welsh and English, thus it seems fitting that she should explore the vicissitudes of language so extensively in her art. Her practice ranges across painting, sculpture, installation and film, as well as various kinds of work using written text, and is as likely to hinge on discreet interventions as it is on autonomous images or objects. Drawing on linguistics and psychology as well as art history, it makes frequent reference to influential figures of the past, focusing in particular on the long shadows cast by Ludwig Wittgenstein and Marcel Duchamp. Yet while Huws's approach is informed and analytical, it is coloured too by her upbringing, reflecting a personal engagement with Welsh cultural identity (her 2011 exhibition at the Whitechapel Gallery in London was titled 'Capelgwyn', a Welsh translation of the venue's name).

Despite the formal, deadpan appearance of Bethan Huws's *Untitled*, 2006, its tone is provocative, even accusatory.

Untitled is one of a number of works by Huws that employ the same format, stripping away aestheticized presentation to hone in on questions around the role and value of art. By wondering aloud about the necessity for 'more artworks', it presents a critique of the art world as an *acquisitive* arena, one shaped as much by the power of the market as it is by intellectual curiosity. Other 'word vitrines' confront the Duchampian legacy (one reading PISS OFF I'M A FOUNTAIN evokes the challenge thrown down by his famous readymade of 1917), while texts installed in specific sites refer to literary and other figures (for 2009's *False Teeth*, the artist stencilled the titular phrase on the windows of a seaside shelter where T.S. Eliot is believed to have written part of *The Waste Land*).

Running parallel to such allusive investigations are objects such as Huws's reed boats, tiny model craft that she has been producing since 1983 in meditative tribute to those made with her father as a child. And on a larger scale, though similarly quiet, are architectural interventions that alter the ways in which we experience built spaces by, for example, raising part of the floor. Huws is that rare breed of artist adept at balancing a thoroughgoing excavation of her creative forebears (both celebrated and familial) against a transformative but immediately accessible approach to the here and now as commonly seen and felt.

Argon, 2006. Clear glass tubing with argon-neon gas mounted on Perspex, 50 x 50 x 55 cm.

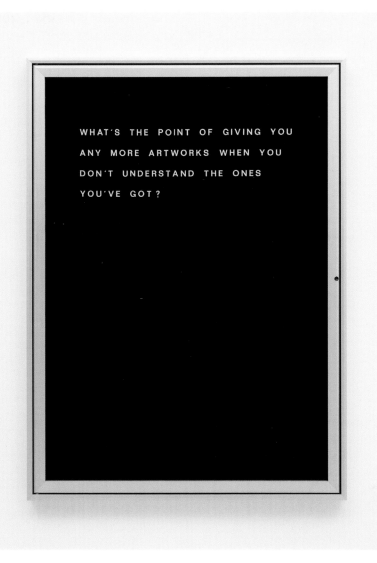

Boats, 1983–2006. Rush, glass, wood, dimensions variable.
Installation view, Kunstmuseum St. Gallen, 2007.

False Teeth, 2009. Vinyl on Plexiglas, dimensions variable.
Installation view, Nayland Rock Shelter, Margate, Kent, England.

Pierre Huyghe

Born in Paris, France, 1962; lives and works in New York, USA. Huyghe has exhibited at the Solomon R. Guggenheim Museum, New York; the Van Abbemuseum, Eindhoven; the Museum of Contemporary Art, Chicago; and the Musée d'Art moderne de la Ville de Paris. He has also participated in the Istanbul Biennial; Carnegie International; Johannesburg Biennale; and Biennale d'art contemporain de Lyon. He was a recipient of a DAAD Artist in Residence grant in Berlin and received a Special Award from the Jury of the Venice Biennale in 2001.

Marshalling considerable human and material resources, Pierre Huyghe stages elaborate performances that repeatedly cross and re-cross the boundary separating fact from fiction. In terms of both production values and duration, the videos that document these events have come to resemble full-length, big-budget movies. Yet even when he plays on cinematic genres, the artist consciously omits many of the characteristics with which we associate filmed entertainment. Huyghe's approach to his medium (one that involves multiple disciplines and techniques) is exploratory and elliptical; he tends to aim not at conventional linear narrative, but rather at the bringing together of whole constellations of activity.

The Host and the Cloud, 2010, which was filmed over the course of a year in the former home of the Musée national des Arts et Traditions populaires in Paris, is no exception. Huyghe himself characterizes the work as a drama in which the central character appears only in the form of an alter ego, a 'white rabbit' lost in his own mental landscape, and conceives of it as part of a cycle that also includes *A Forest of Lines*, 2008, and *La Saison des Fêtes*, 2010 – videos filmed in Sydney Opera House and the Palacio de Cristal, Museo Nacional Centro de Arte Reina Sofía, respectively. All three of these highly ambitious works revolve around a conflation of the real and the constructed, and incorporate allusions to the artist's earlier work.

One group, clad in masks and capes, stages a trial or meeting; another assembles to carve pumpkins.

Framing *The Host* as an experimental game, Huyghe placed a group of individuals in situations designed to prompt improvisation. In front of an on-site audience, group members performed the roles of museum staff by interacting with displays, and with each other, in response to both Huyghe's direction and their own unplanned inclinations. As experienced by the gallery visitor, *The Host* becomes an evocative drift through a loose-knit sequence of rituals and routines, each with its own internal logic. As the actors riff off the holidays on which the filming took place – Halloween, Valentine's Day and May Day – they become embroiled in a series of peculiar tableaux. One group, clad in masks and capes, stages a trial or meeting; another assembles to carve pumpkins. Allegorical connections may be forged between these and other events, but these are only ever suggested, never forcefully imposed.

Other videos by Huyghe plough similar furrows. *This is Not a Time for Dreaming*, 2004, for example, stars a set of specially made puppets that also appeared in a one-off live show. It celebrates the fortieth anniversary of the Le Corbusier-designed Carpenter Center for the Visual Arts at Harvard University via a whimsical dramatization of the tensions that reportedly bedevilled the building's construction. *A Journey That Wasn't*, 2005, is on a very different scale, recording an expedition to the Antarctic undertaken by the artist and friends, supposedly with the aim of tracking down a mythical creature living on an unnamed island. Footage from the trip is interspersed with shots of an extravagant musical recreation mounted by the artist in Central Park, one featuring a black ice set and a forty-piece orchestra.

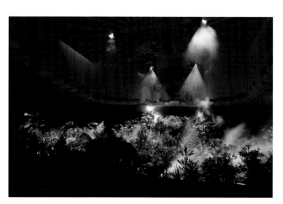

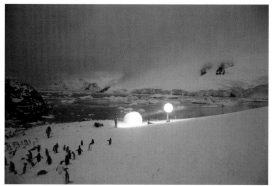

A Forest of Lines, 2008.
Installation and performance view, Sydney Opera House.

A Journey That Wasn't, 2005.
Colour 16 mm film with sound transferred to video.

La Saison des Fêtes, 2010.
Installation view, Palacio de Cristal, Madrid.

This is Not a Time for Dreaming, 2004. Live puppet play and
colour 16 mm film with sound transferred to video. 24 minutes.

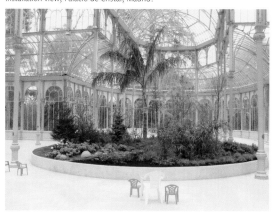

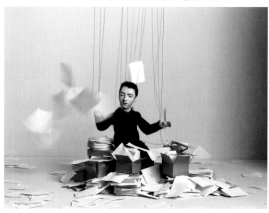

Pierre Huyghe, The Host and the Cloud, 2010. Colour video with sound, 2 hours 1 minute 30 seconds.

Ryoji Ikeda

Born in Gifu, Japan, 1966; lives and works in Paris, France. Ikeda has exhibited at the Museum of Contemporary Art, Tokyo; Bangkok Art and Cultural Centre; and the Garage Centre for Contemporary Culture, Moscow. He has also collaborated with artists including Carsten Nicolai and Hiroshi Sugimoto. Ikeda won the Ars Electronica 'Golden Nica' prize in 2001, and was short-listed for a World Technology Award in 2003 and 2010. His music releases include *1000 Fragments*, 1995; *Matrix*, 2001; and *Dataphonics*, 2010.

'As an artist/composer,' writes Ryoji Ikeda, 'my intention is always polarized by concepts of the "beautiful" and the "sublime". To me, beauty is crystal: rationality, precision, simplicity, elegance, delicacy; the sublime is infinity: infinitesimal, immensity, indescribable, ineffable.' *test pattern (enhanced version)*, 2011, an installation commissioned for Ikeda's 2011 exhibition 'The Transfinite' at the Park Avenue Armory in New York, represents one attempt to resolve these timeless artistic concerns using the 'material' of pure mathematical data and the immersive capabilities of audiovisual technology. Constructing an immersive environment from hypnotic abstract animation and hard-hitting electronic sound, Ikeda translates the spectral immateriality of the digital realm into a visceral looking and listening experience.

Walking into the Armory's Wade Thompson Drill Hall, which at 5,100 square metres is one of the largest unobstructed spaces in New York, visitors to 'The Transfinite' were confronted by a 12-metre tall screen that also extended 24 metres across the floor toward them. Onto these connected surfaces was projected a sequence of white fields and stripes, the frenetic movement of which was choreographed according to a soundtrack incorporating seemingly erroneous noises evocative of skipping CDs or bursts of static interference into a propulsive, at times almost danceable, rhythm. Free to walk across the installation's horizontal section, many viewers lay down flat, allowing *test pattern*'s matrix to surround and subsume them.

The work, which also references the familiar diagnostic tool identified in its title, is punctuated by abrupt shifts from light to dark, hard to soft, noise to silence, all of which contribute to an immediate and powerful sensory impact. Ikeda's mastery of composition, programming and editing (he was assisted on *test pattern* by Tomonaga Tokuyama) gives his work a satisfying exactitude that mirrors his fascination with binary code. If all hard information may be conveyed via zeros and ones, he asks, might not that communicative economy extend to more poetic or speculative ideas? Along with the other works in 'The Transfinite', *data.tron*, 2007, and *data.scan (1x9 linear version)*, 2009-2011, *test pattern* forms part of a 'symphonic' project that poses just such a question.

Ikeda evinces a sense of wonder at the ways in which even apparently chaotic events are underwritten by mathematical perfection.

If the austere, colourless look of Ikeda's work is informed by Minimal and Conceptual art – especially that which features adaptations of existing repetitive, serial or informational structures – its sound generates a different, albeit related, set of echoes. The artist's use of pure sine tones, for example, harks back to the quasi-scientific experiments of early academic computer musicians, while his fusion of metronomic pulse and 'fuzzy' distortion signals an affinity with contemporary 'glitch' and minimal techno labels such as Raster-Noton (founded by Carsten Nicolai) and Mille Plateaux. Sometimes introducing frequencies that drift toward the outer limits of human hearing, Ikeda exercises a canny awareness of the ways in which our perceptions may be tested and stretched. His careful rearrangement of sonic and visual interruptions and accidents into fully coherent patterns is thus allied to a sense of wonder at the ways in which even apparently chaotic events are underwritten by mathematical perfection.

Matrix (5h version), 2009. Sound installation.

data.tron, 2007. Audiovisual installation.

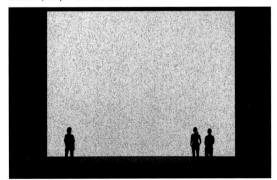

Ann Veronica Janssens

Born in Folkestone, England, 1956; lives and works in Brussels, Belgium. Janssens has exhibited at venues including the Musée d'Art contemporain, Marseille; Middelheim Museum, Antwerp; CIVA, Fondation pour l'Architecture, Brussels; Kunstverein München; Museum of Contemporary Art, Los Angeles; and the Museum of Contemporary Art (M HKA), Antwerp. Janssens's work has also been featured in the Venice Biennale, Sydney Biennale, ImPulsTanz International Dance Festival, Vienna, and Art Basel.

'I am interested in what escapes me, not in order to arrest it, but on the contrary, in order to experiment with the "ungraspable".' Ann Veronica Janssens employs projected light and colour to destabilize perception, radically altering our experience of three-dimensional space by constructing immersive 'springboards towards the void'. Often eschewing autonomous objects and images in favour of ambient atmospheric effects, Janssens's projects are experiments in the loss of control. Yet while primarily sensorial and abstract, they are more than just formal exercises. In transforming solid, permanent structures into shifting, ephemeral environments, Janssens dislocates us from our own sense impressions and proposes a concomitant deconstruction of social, cultural and political context.

Janssens's *Blue, Red and Yellow*, 2001 – the title is a nod to Piet Mondrian, and to Barnett Newman's late 1960s series 'Who's Afraid of Red, Yellow and Blue' – takes the form of a pavilion that was first installed on the terrace of the Neue Nationalgalerie in Berlin. The polycarbonate structure's translucent walls are coated with films in the colours of the title, while the interior is continually suffused with a dense mist. This gives the effect of an environment that shifts according to the viewer's position, the colours merging where the walls intersect. Moving through the room, the impression is one of light becoming tactile as the solidity of the architecture melts away. The lack of any other features adds to the feeling of an unbounded space from which form, function and even time have been excised, leaving only a kind of purgatory.

In *Chambre Anéchoïque* (Anechoic Chamber), 2009, Janssens adopts a similarly immersive approach to exploring the physical and psychical resonance of sound. By cladding an interior with acoustically absorbent polymeric foam dihedrals, the artist produces a space from which reverberation has been almost completely eliminated. Far from experiencing a tranquil silence, however, visitors soon discover that their attention is redirected inwards toward an ever-present but oddly unfamiliar set of internal sounds. The focus becomes the noise of the human body itself: the beating of the heart, the flow of blood and the operation of the nervous system. Here, Janssens's 'ungraspable' is shown to be within each of us, as our own individual presence is brought disconcertingly to the fore.

Untitled, 2003. Balloon, helium, halogen, wire, 200 cm diameter. FRAC Bourgogne, Dijon.

Janssens also uses video, film and freestanding sculpture to explore sensorial experience within a cultural-historical framework. In *Side*, 2006, made with Guillaume Bleret in the eponymous Turkish city, a filmic record of a total solar eclipse is presented as a tribute to cinema pioneer Joseph Plateau, who injured his eyes by staring directly at the sun. And in *Aquarium*, 1992–2005, a perfect sphere floats in the centre of a cubic glass box filled with water and alcohol, reflecting the viewer's own inverted image. In these and other projects, Janssens continues the work of artists such as Larry Bell, James Turrell and others associated with the Light and Space movement that emerged in late 1960s California. She also echoes the quasi-scientific explorations of European contemporaries like Olafur Eliasson and Carsten Höller.

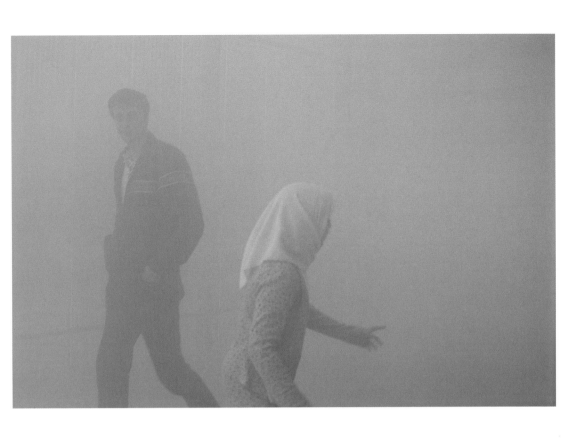

Aquarium, 1992–2005.
Glass, water, methanol, silicone oil, 38.1 x 38.1 x 38.1 cm.

Freak Star, 2004.
8 light projectors, artificial mist, dimensions variable.

Sergej Jensen

Born in Maglegaard, Denmark, 1973; lives and works in Berlin, Germany. Jensen's work has been featured in the Berlin and São Paulo Biennials, and has also been shown in solo exhibitions at venues including: Portikus, Frankfurt; the Aspen Art Museum; Bergen Kunsthall; Malmö Konsthall; Douglas Hyde Gallery at Trinity College, Dublin; Kunstverein Bremerhaven; and (with Stefan Müller) Kunstverein Braunschweig. Jensen has also performed internationally with artists including Claus Richter, Oliver Husain and Michaela Meise.

While all kinds of materials have found their way into the work of Sergej Jensen, the artist's own description of his practice as 'painting without paint' holds true. Jensen typically employs a conventional rectilinear fabric panel, but allows that which is customarily assigned a supporting role to take centre stage. Not only stretched canvas but also cashmere, silk, wool, jute, burlap and a range of other found textiles form the substance of his works as much as does anything he applies to them. The resultant abstractions – and occasional loose figurations – clearly allude to modernist painting but avoid any obvious irony or pastiche. As critic Lisa Pasquariello writes, 'This thoroughly digested and largely tainted legacy appears in his work as a kind of inescapable given. His quotations are neither arch nor disillusioned.'

Digging deeper for the origins of Jensen's highly tactile but chromatically muted aesthetic, Pasquariello recounts the artist's recollection of having spent hours staring at featureless ceilings as a sickly bedridden child. Perhaps, she speculates, this experience influenced his spare compositional style as much as anything produced by often-cited forebears and contemporaries such as Blinky Palermo, Rosemarie Trockel or Jensen's former teacher at the Städelschule in Frankfurt, Thomas Bayrle. Jensen's early exposure to video games – he is the son of a computer programmer – can also be traced in his use of patterns resembling simple digital graphics. Yet his work never has a machine-made appearance; the wear and tear suffered by his chosen materials remains visible in each finished work, and his use of sewing, gluing, dyeing and bleaching encourages happy accident.

The readymade functions in Jensen's work in various different ways. His predilection for weathered materials alludes to the passage of time and assigns him an accepting role, one that runs counter to the macho physicality historically associated with formalist abstraction. By recycling off-cuts and focusing on seemingly insignificant details like stains, rips and frayed edges, Jensen also engages in a continuing investigation into the role of chance and the residual possibilities of improvisation and the decorative. But while works such as *Untitled*, 2009, with its suggestions of painterly brushstrokes rendered in different-coloured lengths of string arranged against a raw canvas ground, seem more-or-less autonomous in their play on technique and the space of the picture, other of Jensen's works make explicit reference to the larger world with which art intersects.

Some of these allusions are rather shocking in their deliberate bluntness – a bluntness that seems at first to run counter to the delicacy of Jensen's aesthetic. *Untitled (Binary Zero)*, 2005, and *Untitled (Money Bags)*, 2007, for example, forge an explicit link with the art market by using money as a medium. In the first, a squared-off nought is rendered in colourful banknotes affixed to an all-black canvas; in the latter, the titular sacks have been sewn together into a dun-coloured grid. Jensen also integrates his paintings-without-paint into installations that import domestic accoutrements into the space of the gallery, and augments them with collaborative projects in performance, music and film.

Untitled (Binary Zero), 2005.
Money on canvas, 130 x 120 cm.

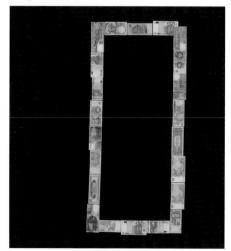

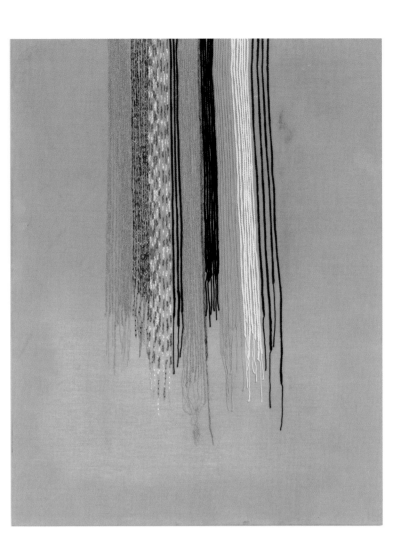

The Last Hang Man, 2006.
Dyed burlap, 185.2 x 155.2 cm.

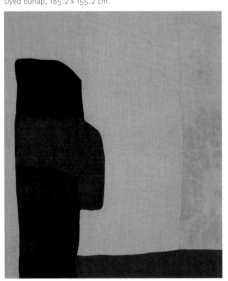

Untitled (Money Bags), 2007.
Money bags, 280 cm x 220.5 cm.

Jodi

Jodi are Joan Heemskerk (born in Kaatsheuvel, the Netherlands, 1968) and Dirk Paesmans (born in Brussels, Belgium, 1965). They live and work in Dordrecht, the Netherlands. Jodi has been the subject of solo exhibitions at Museo Tamayo, Mexico City; Spacex, Exeter; and Eyebeam, New York. The pair have also been included in group exhibitions at the New Museum, New York; Nam June Paik Art Center, Gyeonggi-do, South Korea; Arnolfini, Bristol; and the Stedelijk Museum, Amsterdam. Jodi won a Webby Award in the Arts category in 1999.

www.sod.jodi.org, 2000.

'With a computer there is no white page; you are always reacting to something or involved in some process.'[1] Dirk Paesmans's characterization of digital media as inherently fluid and interactive underpins his practice as a member, along with fellow artist Joan Heemskerk, of Jodi, also known as jodi.org. Drawing on its members' backgrounds in video and photography, Jodi makes work for and with the World Wide Web, also producing software and modified electronic games. Key players in the net.art movement that emerged in the mid-1990s, Jodi uses formats and systems associated with the Internet in ways that disrupt or subvert the expectations of their creators, hosts and users. Often, the usually invisible internal structure of extant projects is exposed, becoming the substance of a new work.

Jodi's performance *The Folksomy Project*, 2009, which has been presented in several exhibition venues including Eyebeam in New York and the Arnolfini in Bristol, draws on the popular video-sharing website YouTube. Using specially designed software in a live setting, Jodi selects and manipulates a succession of clips that reveal new technology as the object of both love and hate: viewers watch as the owners of laptops, cellphones and iPods are shown either singing their gadgets' praises (sometimes literally) or destroying them in frustration. At Eyebeam, two pairs of 'live-respondents' posted their own responses to these videos as they appeared on a large screen overhead. The always-moving, always-changing clash of image and sound, live, recorded and remixed action made for an exhilarating loop of destruction and creation.

Revealing our relationship with new devices as swinging between two extremes, *The Folksomy Project* pits the strengths and weaknesses of recent innovation against timeless human quirks. It also does something similar for YouTube itself – and for the Web as a whole – reminding us that every successful design or smooth operation is shadowed by the possibility of failure or dysfunction. There is a clear echo of Marshall McLuhan's famous dictum 'the medium is the message' here too: in Jodi's feverish accumulation and continual reworking of anonymous 'content', information is rapidly eclipsed by the sheer volume of material. The duo's early projects often make use of glitches, viruses and other erroneous or malignant phenomena, and something of this focus lingers in *The Folksomy Project* and other 'screen grabs'.

In 2000, Jodi published a website, *www.sod.jodi.org*, that reproduces the source code for a modified version of the video game Wolfenstein 3D, displaying readable elements within an otherwise abstract-looking text. Other game modifications followed, including *www.untitled-game.org*, 2002, *http://jetsetwilly.jodi.org*, 2003, and *http://maxpaynecheatsonly.jodi.org*, 2006. Paesmans describes how the duo attempted to make all the mistakes they could in concocting these sites, but found that even impossible requests were in some way allowed for: 'The computer keeps working. Something wrong still works. There is nothing wrong with something wrong.'[2] Thus while Jodi's oeuvre is rooted in critique, it is also underpinned by a sense of discovery, admiration, even sympathy. 'I feel really sorry for computers that just display information,' Paesmans admits. 'They can do so much more.'[3]

1 The artist interviewed in 'Something Wrong is Nothing Wrong', *Mother Board TV*, http://www.5min.com/Video/Jodi-Art-Collective-Interview-51714014
2 Ibid.
3 Ibid.

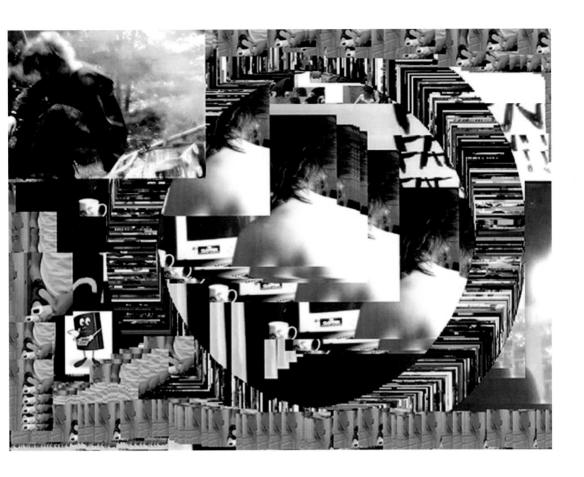

My%Desktop, 2002.

Raoul De Keyser

Born in Deinze, Belgium, 1930; lived and worked there; died in his hometown in 2012. De Keyser has been the subject of regular exhibitions in Antwerp, Frankfurt, Berlin, Vienna and elsewhere, and has been featured in international group exhibitions including 'Unbound: Possibilities in Painting' at the Hayward Gallery, London, in 1994. A 2004 retrospective of his paintings travelled from the Whitechapel Gallery, London, to the Musée de Rochechouart; De Pont, Tilburg; Fundação Serralves, Porto; and the Kunstverein St. Gallen.

A late bloomer (he didn't start exhibiting until he was in his thirties and only achieved wide recognition in his sixties), Raoul De Keyser seems at first glance to stand apart from the dominant themes and currents of the 21st century. Yet while his subtle, idiosyncratic work may pose a challenge to curators and collectors in search of a topical fix, it is an enduring favourite among other artists, making this unassuming but influential figure a consummate 'painter's painter'. De Keyser's canvases are neither entirely representational nor fully abstract, often suggesting incomplete plans, disassembled components or scattered debris. 'Remnants', his 2003 exhibition at David Zwirner in New York, for example, was based in part on fragments of a ten-year-old linocut that resurfaced by chance in the artist's studio.

Like another celebrated Belgian painter, Luc Tuymans, De Keyser habitually works on a modest scale and with conventional materials, employing a bruised palette of blues and greens, greys and browns. Yet while his work may be visually understated, it exudes a quiet conviction that betrays a deceptively rigorous engagement with subject, mood and method. Allowing chance elements to play a critical role in the work's genesis, and ensuring that the stages of a given painting's construction remain visible in the finished piece, De Keyser engages in an unhurried investigation of what critic Hans Rudolf Reust has called 'nonfigurative narration' - a silent sequence of painterly 'events'. Yet for all its introspective craft, De Keyser's work is not insulated from the world at large; in fact, its implicit concerns with fragility, dissolution and impermanence align it with much recent art and writing.

In *Untitled*, 2006, a series of irregular shapes in muted blue drift across a field of washed-out grey. Lines of darker grey divide the surface into two unequal halves in a vague suggestion of a brick wall. The shapes themselves are more sharply defined - almost diagrammatic - and resemble pieces of cut paper or shards of broken glass. There is scant suggestion of depth or scale however, and little in the way of modelling or texture. Only the translucent quality of the pigment's application and its flickering hues lend the painting 'organic' vitality. In the 1960s, De Keyser was a member of *Nieuwe Visie* (New Vision), a group that sought to reinvigorate the tradition of formalist

Surplace no. 2, 2002. Oil on canvas, 70 x 80 cm. Museum Dhondt-Dhaenens, Deurle, Belgium.

painting in Europe by concentrating on prosaic subjects and simplified imagery. *Untitled* shows him continuing to pursue a personal variant of this methodology, reducing forms to their essence and refusing any extraneous embellishment. De Keyser's work is plainly informed by a raft of historical precedents including Abstract Expressionism and Minimalism, and the ghosts of artists from Joan Miró to Paul Klee seem to haunt his formal lexicon. Yet his work never feels like rehash or pastiche, and it has been cited as inspirational by contemporary painters such as Tomma Abts and Rebecca Morris - other artists for whom the relationship of painted surfaces to the images, designs and spaces they describe remains at issue.

Drift, 2008. Oil on canvas, 34 x 44 cm.

Kimsooja

Born in Taegu, South Korea, 1957; lives and works in New York, Paris and Seoul. Kimsooja has been the subject of major exhibitions at San Francisco Art Institute; Hirshhorn Museum and Sculpture Garden, Washington, D.C.; Museo Nacional Centro de Arte Reina Sofía, Madrid; and the MIT List Visual Arts Center, Cambridge, Massachusetts. She has participated in international exhibitions, including the Venice Biennale, Yokohama Triennial and Whitney Biennial, and in 2002 received the Anonymous Was a Woman Award.

A figure stands in the middle of a busy street, remaining motionless as people hurry past. Clad in a plain grey jacket, with her straight, black hair in a long ponytail, she is a silent, monochromatic interruption in a world of noise and colour. Seen only from behind, her expression and identifying features are hidden to us but, from time to time, a passer-by will turn and stare, puzzled by this steadfast refusal to go with the flow. For the most part, however, the throng simply ebbs and flows around her. The figure is Kimsooja's and the scene is from *A Needle Woman*, 1999-2001, a suite of videos in which the artist becomes 'an individual and an abstraction, a specific woman and every woman, instrument and actress, motionless and purposeful, balancing between presence and absence.'

Across up to eight separate screens, the scene shifts from Tokyo – the work's first sequence was filmed there in 1999 – to New York, London, Mexico City, Cairo, Delhi, Shanghai and Lagos. But while the location is different in each case, Kimsooja's position, and the central framing of her impassive head and shoulders, remains consistent throughout. Slowing her footage down until the pedestrians' bustling motion becomes a kind of lethargic ballet, the artist emphasizes her own isolation. She becomes, as the title suggests, a needle threaded through the fabric of the world, a pin stuck in a map. Through her incongruous stasis and anonymity, she both distinguishes and erases herself, allowing us to imagine ourselves in her place, bound to other people but always separate from them.

The practice of sewing that informs *A Needle Woman* recurs throughout Kimsooja's oeuvre as both metaphor and hands-on skill.

The practice of sewing that informs *A Needle Woman* recurs throughout Kimsooja's oeuvre as both metaphor and hands-on skill. Focusing on everyday activities and their aesthetic likeness to transcendent ritual, the artist explores the human condition in a global context. In actions, images and objects, she examines human traits and motivations, aiming not to highlight conflict or contrast, but rather to achieve a kind of harmony. For example, in a series of sculptures made with *bottari* – the traditional Korean bed coverings also used to wrap and carry personal belongings – she transforms a prosaic object into a symbol of common structure with roots in her own family history, since as the daughter of a military officer her childhood was marked by frequent relocation.

Other works by Kimsooja make explicit reference to spirituality and religion, again seeking to identify a shared ground of meaning. *Lotus: Zone of Zero*, 2008, for example, is a large-scale installation that combines a suspended mandala of red Buddhist lotus lanterns with a multi-channel soundtrack that weaves together Tibetan, Gregorian and Islamic chants, the titular 'zone' being a central spot where all three merge. Originally made for Galerie Ravenstein in Brussels, which shares a large space with the entrance to a railway station, it implicates – as did the original durational performances filmed for *A Needle Woman* – a diverse crowd in continual, repeated motion. And as did the earlier work, it elevates a populous environment into an arena for individual contemplation.

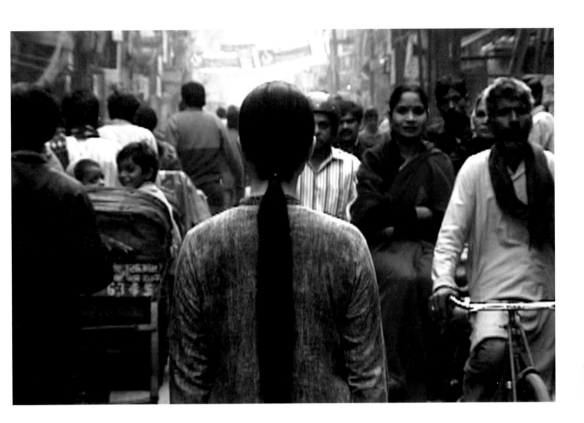

Bottari Truck – Migrateurs, 2007.
Truck, bottari, cords, 470 x 170 x 200 cm. Installation view, FIAC, Paris.

A Beggar Woman – Lagos, 2000–2001.
Silent colour video, 6 minutes 33 seconds.

Lotus: Zone of Zero, 2008.
Lotus lanterns, six-channel sound, dimensions variable.
Installation view, Galerie Ravenstein, Brussels.

Harmony Korine

Born in Bolinas, California, USA, 1973; lives and works in New York. Korine's films have won prizes at the Rotterdam Film Festival, Gijón International Film Festival, Venice International Film Festival, and Copenhagen International Documentary Festival. The screenplays for *Gummo*, *Julien Donkey-Boy* and the unfinished *Jokes* were published by Faber and Faber in 2002. Korine has also directed music videos for Sonic Youth, Will Oldham and Cat Power, and has exhibited at Taka Ishii Gallery, Tokyo; Vanderbilt University Fine Arts Gallery, Nashville; and Galerie du Jour Agnès B., Paris.

Harmony Korine is one of those artists who are loved and reviled in equal measure for their unapologetic embrace of ugliness, irritation and shock as legitimate, even necessary components of meaningful work. Occupying that awkward territory between the merely hip and the genuinely avant-garde (a distinction that is, arguably, drawn more sharply in his primary medium of film than in any other), Korine exposes himself to criticism from all sides by refusing to explain away his aesthetic decisions. He courts controversy too by flirting with exploitation; the sensational elements of his oeuvre serve to attract relatively broad attention, but ultimately alienate as many viewers as they convince. Yet Korine's uncomfortable, uncompromising approach continues to resonate, in large part by circumventing narrative and conceptual logic to communicate on a gut level.

Trash Humpers, 2009, a 35 mm feature film presented as a found VHS videotape, follows a group of four geriatric buddies as they kill time in a seemingly aimless round of petty destruction, nonsensical 'conversation', and simulated sex acts with inanimate objects. Clad in mismatched clothes and grotesque burn-victim masks, the unnamed protagonists lapse periodically into singing and dancing in a style that most people abandon as toddlers: unskilled, loud and repetitive. Drifting through a suburban no-man's-land of desolate parking lots and abandoned houses, they behave more like mental patients or drug-addled teenagers than fragile pensioners. One vignette shows them cavorting with overweight prostitutes; in another, they abduct a baby then break into a house and force its resident to consume a stack of pancakes doused in liquid soap.

Korine exposes himself to criticism from all sides by refusing to explain away his aesthetic decisions.

Korine first made his name as the prodigious screenwriter of Larry Clark's 1995 film *Kids*, later directing his own movies *Gummo*, 1997, *Julien Donkey-Boy*, 1999, and *Mister Lonely*, 2007, all of which polarized critical opinion but cemented their auteur's reputation as a poet of post-white-trash Americana. Korine's charisma and personal mythology have also been contributing factors to his notoriety: a lover of slapstick and vaudeville, skewed jokes and anecdotes, his early appearances on *The Late Show with David Letterman* are slyly subversive gems. Other enterprises have also taken their place in the Korine universe. *Fight Harm*, for example, a proposed follow-up to *Gummo*, was pitched as a document of his own street fights with strangers. The project was abandoned when, after six encounters, he wound up in hospital.

Korine has collaborated with artists including painter Christopher Wool, with whom he produced the book *Pass the Bitch Chicken*, 2002, and Rita Ackermann, another painter, with whom he made a cycle of mixed-media panels for a 2010 exhibition at New York's Swiss Institute. Between 1992 and 1999, Korine also co-published a fanzine with artist and skateboarder Mark Gonzales, and he is the sole author of the montage novel *A Crackup At The Race Riots*, 1998. But it is in films like *Trash Humpers*, with its queasy, distorted beauty and immersion in the self-indulgent id, that Korine's vision emerges most affectingly. 'I never cared so much about making perfect sense,' he has stated. 'I wanted to make perfect nonsense. I wanted to tell jokes, but I didn't give a fuck about the punch line.'

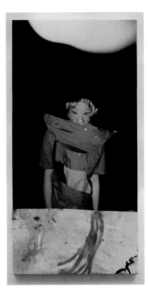

**Rita Ackermann and Harmony Korine,
Trouble is Comin, 2010.**
Acrylic medium on vinyl, enamel spray
paint and ink on canvas, 297 x 152 cm.

Devils and Babies (detail), 2009.
Photocopied artist's book, 20.3 x 14 cm. Published by Iconoclast Editions.

Gummo, 1997. Colour 35 mm film with sound, 89 minutes.

Michael Krebber

Born in Cologne, Germany, 1954; lives and works there. Krebber has exhibited widely throughout Europe and the United States. Solo exhibitions of his work have been held at Galerie Buchholz, Berlin; Greene Naftali Gallery, New York; Richard Telles Fine Art, Los Angeles; and Maureen Paley, London. Krebber was included in 'Painters without Paintings and Paintings without Painters' at Orchard, New York, in 2005, and in 'Make Your Own Life: Artists In and Out of Cologne' at the Institute of Contemporary Art in Boston; Power Plant, Toronto; Henry Art Gallery, Seattle; and the Museum of Contemporary Art, North Miami, in 2006–2007.

A consummate contemporary artist's artist, Michael Krebber makes work that is at once consciously defined by what has gone before, and freed by this knowledge to transcend established formal and conceptual limits. A former student of Markus Lüpertz and assistant to Georg Baselitz and Martin Kippenberger – pivotal figures in post-war German painting – Krebber is hyper-informed about his creative forebears and contemporaries and readily admits (albeit with tongue somewhat in cheek) that anything he may wish to contribute has already been done. Thus he prefers the subtle gesture to the grand statement, the hermetic allusion to the obvious reference. He is, in the words of critic John Kelsey, 'less a painter than a strategist', an artist whose methodology 'underlines the fact that artists are readymades too, and that readymades can be unmade'.

Krebber makes, manipulates and recontextualizes paintings, books, posters and objects, also incorporating materials that surround his work's production, exhibition and reception. Critic and curator Daniel Birnbaum characterizes the artist's practice as 'a space for conversation rather than a mode of producing objects'; he has, for example, exhibited sections of his studio floor as if they were pictures, and incorporated empty galleries into self-reflexive presentations. Krebber is most closely associated with painting – he turned to it via a series of monochromes in the early 1990s, progressing to stylistic extrapolations of the oeuvres of Sigmar Polke and Albert Oehlen – but his canvases tend to look unfinished, suggesting fundamental doubts about the medium's ongoing validity.

Krebber prefers the subtle gesture to the grand statement, the hermetic allusion to the obvious reference.

Comprehensively networked into the historically important scene around his native Cologne, Krebber is an influential teacher and the locus of a powerful personal myth. He has his favourite points of reference - the novelist Herman Melville, poet Paul Valéry and artist Marcel Broodthaers crop up repeatedly in various forms - but makes few concessions to widely shared knowledge, seemingly content with obscure sources if he judges them to be relevant. Linked to a 'New Formalist' tendency, Krebber forges connections that seem to have a logic all their own, one that may be as much to do with the purely visual or experiential as with any apportioning of ideational clues or keys. His works are profoundly open-ended, trusting the viewer to unravel - or simply accept - their enigmatic propositions.

The One with the Roses, 2004.
Ink, emulsion and newspaper on fabric, 180 x 120 cm.

For 'Connecting Sugar with Hollywood', his 2006 exhibition at Greene Naftali Gallery in New York, Krebber attempted to trace a link between German painter Gerhard Richter and filmmaker Jack Smith, highlighting the unexpected in each artist's output (the association itself, between two utterly different sensibilities, inspires curiosity). Characteristically, the title is borrowed - it was reportedly an alternate name of Smith's for his cult feature *Flaming Creatures*. The title work itself is a diminutive watercolour doodle hung on top of a poster advertising the project (a rendering of a female torso drawn by artist Richard Hawkins) so that only the edge of the printed sheet emerges from behind the painting's frame. The combination of formats emphasizes the qualities and associations of both while subverting conventions of visual display, and the delicacy of Krebber's painterly hand is allied again to the uncompromising individualism of his intent.

Miami City Ballet IV, 2010.
3 primed canvases, acrylic lacquer on fabric, 90 x 90 x 7 cm.

INT (green), 2010.
Surfboard (6 parts), lacquer, styrofoam, plastic, metal, 58 x 395 x 14 cm.

Christina Kubisch

Born in Bremen, Germany, 1948; lives and works in Hoppegarten, Germany. Kubisch has been the subject of solo exhibitions in the USA, Europe, Australia, Japan and South America, and she has participated in the Venice Biennale; Documenta; and Sónar festival, Barcelona. Her music has been released by labels including Cramps Records, Edition RZ, ampersand and semishigure. Kubisch has lectured in Maastricht, Paris and Berlin, and is a professor of sound art at the Academy of Fine Arts, Saarbrücken, as well as being a member of the Akademie der Künste, Berlin.

'Nothing looks the way it sounds,' says Christina Kubisch, 'and nothing sounds the way it looks.' Trained as a composer, flautist and painter, Kubisch was among the first artists to use sound in installations, working most notably with electromagnetic induction and ultraviolet light. Her abiding interest is in exploring the synaesthetic interrelationship of time, space and materials through imagery, music and noise. To this end, she not only performs in concert settings (often collaborating with other musicians and dancers), but also produces 'Electrical Walks'. Begun in 2003, these remarkable experiential projects require participants to don wireless headphones that amplify the sound produced by ambient electrical currents. The ongoing series evolved from works dating back to the 1970s for which Kubisch encircled rooms with wire induction coils, also installing them inside headphones to create sounds that alter with the wearer's movements.

For the 2010 Ars Electronica festival in Linz, Austria, Kubisch developed several new projects including two interrelated 'Electrical Walks', *Walk the Factory* and *Walk the City*. In the first of these, headphone-clad participants are led on a tour through Tabakfabrik Linz that reveals the secret sounds generated by this imposing industrial building and its contents. In the second, a map indicating points of particular interest also functions as a set of directions to resident electroacoustic phenomena that punctuate a circuit of downtown Linz. A more contained counterpoint to these paired works appeared in the form of *Ruhrlandschaften*, a display of forty photographs depicting locations around the Ruhrgebiet district. Each image is designed to be viewed while listening to a museum-style personal audio guide loaded with corresponding electromagnetic 'soundscapes' recorded on site.

Kubisch's journeys, whether undertaken alone or in a group, alter our perceptions of an environment by foregrounding one of its ever-present but usually imperceptible aspects. Tellingly, the series emerged from a perceived shortcoming of the artist's earlier electroacoustical works – the hum of background noise. Once she abandoned attempts to edit out the interference, it became a focus. 'The palette of these noises, their timbre and volume, vary from site to site and from country to country,' she observes. They are, however, ubiquitous: 'Light systems, transformers, anti-theft security devices, surveillance cameras, cell phones, computers, elevators, streetcar cables, antennae, navigation systems, automated teller machines, neon advertising, electric devices' – all are surrounded by an aura that, once decoded, has an extraordinary, almost physical power.

The immediacy and uniqueness of *Walk the Factory* and *Walk the City* reside in their harnessing of an elemental effect.

Kubisch notes that the interactive element of 'Electrical Walks' is not dependent on computers, and thus has an 'almost archaic' quality. It may seem strange to describe a work of this kind in terms of antiquity, but the artist has a point. The immediacy and uniqueness of *Walk the Factory* and *Walk the City* reside in their harnessing of an elemental effect, and in their reliance on the timeless acts of walking and basic navigation. In this, Kubisch's practice also resonates with a host of other artists', from the Situationists' 'psychogeographic' remappings of late 1960s Paris to Janet Cardiff's audio walks with their layering of uncovered narrative over visible place.

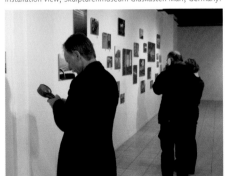

Ruhrlandschaften, 2010.
Installation view, Skulpturenmuseum Glaskasten Marl, Germany.

Break, from the series 'Emergency Solos', 1975.
Performance view.

Gabriel Kuri

Born in Mexico City, Mexico, 1970; lives and works in Mexico City and Brussels, Belgium. Kuri's work has been shown at the Berlin Biennale and Fundación/ Colección Jumex, Ecatepec, Mexico. It has also been featured in 'Brave New Worlds' at the Walker Art Center, Minneapolis, and 'Unmonumental' at the New Museum, New York. Some of Kuri's recent solo exhibitions include 'Gabriel Kuri: Soft Information in Your Hard Facts' at Museion, Bolzano, Italy, and 'Gabriel Kuri: Nobody needs to know the price of your Saab' at the Blaffer Art Museum, University of Houston.

Many of us keep and store receipts – some more diligently than others – but few apply the same organizational principles as Gabriel Kuri. 'I have a whole section in which I put receipts that end in a terminating phrase, like "Thank you for your consumption",' he tells critic Scott Indrisek. 'Then there's another category: receipts that come with a little magenta stripe that indicates that the roll is coming to an end. They do not have a diaristic significance; it's a different type of taxonomy.' Kuri, who maintains a fascination with everyday economics, has mined this archive of prosaic commercial documents repeatedly to make a number of surprisingly imposing works of art.

Trinity (Voucher in triplicate), 2004, is a triptych of hand-woven Gobelin wool tapestries in white, yellow and pink that reproduces three printed receipts issued by the same shop in Mexico. Each part records, on an incongruously monumental scale, a purchase of the same few items, each set of purchases having been made twelve months apart. The work's sumptuous material and banner-like format gives it a heraldic quality that contrasts with the humble nature of its source. *Trinity* also nods toward Conceptual art in its use of a rule-based production process, and to Minimalist aesthetics in its reliance on serial repetition. Kuri has been making similar tapestries since 2001, employing assistants in the craft's traditional home town of Guadalajara in Mexico.

While his tapestries invest the humble slips of paper on which they are modelled with a certain grandiosity, Kuri also makes more direct use of everyday materials and objects, from newspapers and soap to cigarette butts and aluminium cans. In another triptych, *Untitled Fridge Trinity*, 2004, he sets plastic bags hovering in mid-air inside three glass-fronted illuminated fridges, while *Quick Standards*, 2006, sees him reconfigure some wooden poles and silver insulating blankets into a mute set of all-purpose protest banners. As such works suggest, Kuri's overarching focus is on the ways in which throwaway artifacts may be endowed with spiritual or political significance – though generally with an undercurrent of poetic irony.

Kuri's overarching focus is on the ways in which throwaway artifacts may be endowed with spiritual or political significance.

Bolstering Kuri's project is his talent for making unexpected juxtapositions. In his hands, formal combinations that may sound jarring make sense, and found objects acquire new meanings in conversation with one other. In *Hanging Rainbow*, 2006, for example, a curled strip of multicoloured acetate hangs inside two see-through mesh rubbish bins. One container has been inverted and stacked atop the other, creating an enclosed space that functions, in conjunction with its colourful content, as a throwaway vision of the sublime. In *Concomitancia*, 2007, meanwhile, a pair of coat-check stubs project from between slabs of black and brown marble that suggest off-the-peg tombstones. Such juxtapositions convey a sympathy with the make-do-and-mend school of improvisation and wittily acknowledge the beauty of the thrown-together and the impermanent. In this, Kuri's approach can be traced to the clashes of permanence and ephemerality that characterized Arte Povera as much as to the everyday appeal of Pop art. *Trinity*, in its fusion of the prosaic and the luxurious, forms part of an ongoing dialogue concerning labour, consumption, time and money.

The Recurrence of the Sublime, 2003.
Bowl, avocados, newspaper, dimensions variable.

Quick Standards, 2006.
Emergency blankets taped on wooden sticks, dimensions variable.

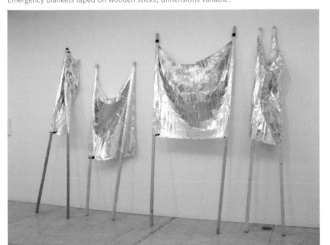

Complimentary Cornice and Intervals, 2009.
Marble slabs, courtesy cosmetics, 149.5 x 182 x 8 cm.

Sean Landers

Born in Palmer, Massachusetts, USA, 1962; lives and works in New York. Landers's work has been shown in numerous solo exhibitions at Andrea Rosen Gallery, New York; Taka Ishii Gallery, Tokyo; and greengrassi, London. He has participated in group exhibitions including 'Defamation of Character' at MoMA PS1, New York, and 'Happiness' at the Berlin Biennale for Contemporary Art. A comprehensive catalogue of Landers's work was published in conjunction with his solo exhibition at the Kunsthalle Zürich in 2004.

'MY PAST FAILURES ARE NOW MY MOST POPULAR WORK; I'M NOT AFRAID TO FAIL, IT'S SUCCESS THAT FRIGHTENS ME; OF COURSE I'M A FRAUD.' The multicoloured fragments of boldly painted text that swim in and out of view in Sean Landers's canvas *Luck, Fear, Regret*, 2003, verge on the embarrassing in their apparent admissions of inadequacy and self-doubt. It is unsettling to see the private torment of creativity spelled out – literally, and sometimes badly – in this way, but such cringe-inducing confessionals are Landers's stock-in-trade. Since he came to prominence in the mid-1990s, the artist has repeatedly made himself the butt of his own jokes about artistic and personal ambition and status, appearing to alternate between extremes of self-deprecation and self-aggrandizement.

Landers has employed various media including sculpture, photography and video, as well as painting, to plumb the depths of what critic Jane Harris has dubbed 'loser chic'. Along with a number of other artists identified with the 'slacker' tendency, such as Mike Kelley, Cary Leibowitz and Cady Noland, Landers mines a seam of low comedy that consciously undermines idealized notions of the artist as spiritual or moral exemplar. Also denying any expectation of a consistent voice or standpoint, and playing mercilessly on our tendency to align artists' autobiographies directly with their output, Landers makes for a compelling but utterly unreliable narrator. His 1995 book *[sic]*, to take one notorious example, is a 454-page handwritten tirade described by its author as 'a stinking open wound that mercylessly exposes people whom I love and care about.'

It is unsettling to see the private torment of creativity spelled out – literally, and sometimes badly – in this way.

As *Luck, Fear, Regret* demonstrates, the use of text, particularly in the form of actual or simulated stream-of-consciousness rants, continues to play an important role in Landers's work. Sometimes, as in paintings like *Career Ego*, 1999, it is combined with figurative imagery. Elsewhere, it constitutes something like an image in itself, or becomes a sort of ambient texture – a pervasive buzz of language that is often, deliberately, as irritating as that word implies. Landers has even branched out into sound recording: his 2001 exhibition at Andrea Rosen Gallery in New York was accompanied by the artist reading aloud his own *Dear Picasso*, in which, while Samuel Barber's soaring music plays, he compares himself – ironically? – to the titular modern master.

When not aping his heroes, Landers is more likely to populate his art with a cast of monkeys, monsters and comedians. 'Around the World Alone', the artist's 2011 exhibition at New York's Friedrich Petzel Gallery, for example, featured a suite of paintings depicting seafaring circus clowns. But *Luck, Fear, Regret*, along with the series to which it belongs, again makes words do all the work. Even when appearing to strip his methodology down to verbal essentials, however, Landers evinces a love of painterly technique. Using the simple but effective device of varying the lettering's size and sharpness, he suggests a spatial depth that exists in fascinating tension with the text's commentary on artistic profundity. 'I SEEK AUTHENTICITY AND BUEATY', he assures us, and somehow we can't help but believe him.

Career Ego, 1999. Oil on linen, 142 x 119 cm.

[sic], 2010. Glenn Horowitz Bookseller, East Hampton, New York, third edition. Originally published 1995, based on a work on paper from 1993 consisting of 454 sheets, ink on paper, 27.9 x 21.6 cm (each).

John Latham

Born in Livingstone, Northern Rhodesia (now Maramba, Zambia), 1921; died in London, England, 2006. Latham founded the Institute for the Study of Mental Images in 1954 and co-founded the Artists Placement Group with Barbara Steveni in 1965. His work has been included in many important group exhibitions including 'Blast To Freeze' at the Kunstmuseum Wolfsburg, Germany, and 'John Latham: Anarchive' at the Whitechapel Gallery, London, in 2010. Flat Time House, London, the artist's former home and studio, was opened to the public in 2008.

In many contemporary artists' work, science only makes an appearance in the form of 'topical' reference or formal device; for a far smaller number, it is fundamentally integral to their practice. John Latham was a member of the latter group, his imaginative investigation of theoretical physics and co-development, with Barbara Steveni, of the notion of 'flat time' transcending anything attempted by his predecessors or peers. The complexity of Latham's ideas, the diversity of his output and the uncompromising approach he adopted meant that the world of art schools, museums and galleries sometimes found it difficult to accommodate him, and he was generally under-appreciated. Yet this genuinely radical figure's influence is still strongly felt, especially in post-Conceptual and performance art that engages directly with ideological and technological issues.

God is Great #4, 2005 – part of a series begun in 1990 – is one of Latham's final works. Into a pile of broken glass are inserted copies of three sacred texts, the New Testament, the Koran and the Torah. David Thorp, co-curator of the exhibition 'John Latham: Time Base and the Universe' that was held at John Hansard Gallery in Southampton, and MoMA PS1 in New York, in 2006 and 2007, writes that across the 'God is Great' cycle as a whole, Latham pursues 'a compatible relationship between the ethical goals of humanity and the dominant scientific theories of the universe.' This gives some idea of the scale of the artist's ambition, and the seriousness with which he took his polymathic role.

God is Great #2, 1991, which also incorporates the three books – here embedded in a single sheet of glass – became the subject of controversy following its withdrawal from Latham's retrospective at Tate Britain. In the wake of recent terrorist bombings in London, the museum was worried that the work might incite a violent response; the artist condemned this act of censorship as a cowardly overreaction. The furore recalled an incident from earlier in Latham's career: in 1966, while a lecturer at Saint Martin's School of Art, he borrowed a copy of Clement Greenberg's *Art and Culture* from the college library and mischievously invited students to chew its pages. Latham distilled the resulting pulp and attempted to 'return' a phial of liquid. It was rejected, and Latham lost his job.

Art and Culture, 1966.
Leather case containing book, letters, photostats and labelled vials filled with powders and liquids, 7.9 x 28.2 x 25.3 cm. The Museum of Modern Art, New York.

That Latham's career can be bracketed by works featuring books is entirely appropriate; he made repeated use of them as signifiers of belief systems, vital but fallible containers of knowledge and conjecture. As well as using books more-or-less whole in sculptures and installations, he also slashed and burned them, evoking destruction as an element of creativity, in collages and mixed-media works. But Latham also made paintings and drawings, most notoriously 'one-second' drawings produced using a spray-gun filled with ink. These super-fast splatters – which make Pollockian Abstract Expressionism look positively laboured – were presented by the artist as frozen moments in time, 'least events' containing the essence of a greater whole. The absurdist wit that permeates such projects only reinforces the iconoclastic purposefulness with which they were conceived.

One Second Drawing, 1971. Enamel on wood panel, 20.6 x 19.4 cm.

Cluster No. 11, 1992. Plaster, book fragments, 44 x 54 x 50 cm.

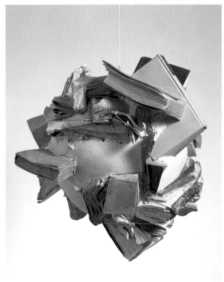

An-My Lê

Born in Saigon (now Ho Chi Minh City), Vietnam, 1960; lives and works in New York, USA. Lê has had solo exhibitions at Dia Beacon, New York; the Henry Art Gallery, Seattle; San Francisco Museum of Modern Art; Museum of Contemporary Photography, Chicago; and MoMA PS1, New York. She was the subject of a feature on the PBS television series 'Art 21' in 2007, and was the recipient of a Louis Comfort Tiffany Foundation Award in 2009. She is an associate professor of photography at Bard College, New York.

The role and status of the military in the 21st century is perhaps more ambiguous than ever before, since the nature and purpose of warfare have become increasingly fraught with ethical and practical contradictions. Military activity is debated fiercely and continually, yet our understanding of its on-the-ground reality remains clouded by politics, mythology and misinformation. At once attracted to and repelled by the complexity of modern conflict and the preparations made for it, Vietnamese photographer An-My Lê follows the movements of American and other forces around the world. The images that she makes reveal a concern with history on multiple levels and scales, from the interactions of individual human beings to the relationship of their activities to landscape.

Lê fled Saigon with her family in 1975, the last year of the Vietnam War, and settled in the United States as a political refugee. This experience led her to examine what it means to live in turbulent times and places, often via a focus on the processes of memory and simulation. In the 'Viêt Nam' series, 1994-1998, for example, Lê juxtaposes records of the jungle she recalls from childhood with shots of its post-war development, while in 'Small Wars', 1999-2002, she documents the curious hyper-reality of Vietnam War re-enactments in North Carolina. These and other works examine the disjunction between war as a personal and collective truth, and as a vocabulary of images that stand in for received ideas in the culture at large.

Manning the Rail, USS Tortuga, Java Sea, 2010, is a photograph that feels indebted to both landscape and history painting in its naval subject-matter and panoramic sweep. The sight of so many ships in close proximity is startling, and it takes an effort to accept the image as contemporary. Yet the shot is intimate as well as grandiose, and our eye is drawn to the servicemen's clasped hands in the foreground as they perform the titular manoeuvre. The choreographed formality of their stance acts as a reminder of the hierarchical and ritualized nature of their working lives. *Manning the Rail* is impressive, yet a certain flatness and stillness about it serves to remind us that, for the individuals involved, this subject is rather unremarkable.

The sight of so many ships in close proximity is startling, and it takes an effort to accept the image as contemporary.

Lê uses an old-fashioned – and cumbersome – medium-format film camera, and her work reveals the influence of 19th-century photographers such as Roger Fenton, Timothy O'Sullivan and Gustave Le Gray, who were as interested in the medium's utility for detailed record-keeping as they were in its potential for creative expression. Even when she depicts fast-moving action, Lê tends to concentrate on the broader settings in which events take place, and the people who feature are often rendered visually insignificant by their surroundings. The images' crisp focus signals that this is not from-the-hip reportage but something more reflective, which acknowledges the parts played by construction and mediation. And whether black-and-white or colour, skilful 'drawing' - composition - remains key to Lê's depiction of war as a confounding, but nonetheless persistent human phenomenon.

Small Wars: Explosion, 1999–2002.
Gelatin silver print, 67.3 x 96.5 cm.

29 Palms: Combat Operations Center Guard, 2003–2004.
Gelatin silver print, 67.3 x 96.5 cm.

Portrait Studio, USS Ronald Reagan, North Arabian Gulf, 2009.
Archival pigment print, 67.3 x 96.5 cm.

Teenage Room, 2009

Mixed media, 270 x 435 x 430 cm. Installation view, Danish Pavilion, Venice Biennale.

Klara Lidén

Born in Stockholm, Sweden, 1979; lives and works in Berlin, Germany. Lidén has participated in numerous international group exhibitions including 'Concrete and Imagination' at the Urban Art Info, Berlin, and 'When Humour Becomes Painful' at the Migros Museum für Gegenwartskunst, Zurich, as well as in the Berlin and Moscow Biennales. She has also been the subject of solo exhibitions at venues including Moderna Museet, Stockholm, and the Serpentine Gallery, London. Lidén got financial support from The Swedish Arts Grants Committee for exhibitions abroad 2007, 2008 (twice) and 2010.

The desire for an all-black bedroom is a classic expression of self-conscious teenage angst. In its over-the-top gothic theatricality, it typifies the wilful contrarianism of adolescent rebellion; if the house in which it festers is bright and welcoming, then the teenager's lair must be the sinister opposite. In Lidén's installation *Teenage Room*, 2009, however, it is not the interior's walls that are blackened, but its contents. Bunk beds, a tower of boxes packed with clutter, a computer, a portable stereo and a classroom globe – all have been sprayed to become dense shadows of themselves. Even a shelf of books and CDs is obscured under a layer of paint. And in a final melodramatic touch, an axe hangs from a string by the door.

But in spite of its familiar tropes, *Teenage Room* offers more than a straightforward parody of youthful folly. The carpet underfoot is white – black pigment bleeds onto it wherever objects make contact – and a small hatch at floor level stands open, suggesting a recent escape. Just as we go through many phases en route to adulthood, there is, it appears, more than one side to this story. *Teenage Room* also reflects a broader interest in built living spaces on the part of its creator, who originally trained as an architect. Lidén has constructed a house using discarded materials, and moved the entire contents of her apartment into a museum. In such works, she questions the functions and meanings of public and private structures by reworking or undermining established forms.

Just as we go through many phases en route to adulthood, there is, it appears, more than one side to this story.

While her installations explore an undercurrent of disaffection that becomes visible through the destabilization of built space, Lidén's videos deal in a tension that periodically finds more violent release. In *Bodies of Society*, 2006, the artist repeatedly prods a bicycle in her apartment with an iron bar before beating it to a pulp, while *Kasta Macka (New York, Frankfurt, Zurich)*, 2009, sees her hurl a succession of objects into the rivers that run through each titular city. While such acts seem to paint the artist as a perennial outsider acting out futile rites of frustration, *Myth of Progress (Moonwalk)*, 2008, illustrates a differently alienated relationship with the urban milieu. Here, Lidén glides backwards through a succession of nocturnal streetscapes. Always moving, she never quite arrives.

Precedents for Lidén's practice range from the romantic-conceptual short films of Bas Jan Ader to the confrontational early performances of Vito Acconci, while her recycling of found and domestic matter resonates with a broad swathe of modern and contemporary artists. *Teenage Room* in particular also seems to acknowledge the currency of gothic imagery and style in much art of the past decade or so, especially by young Americans such as Sue de Beer and Banks Violette. Lidén has characterized her aim as being to 'divert materials or spaces from their prescribed functions, inventing ways of making these things improper again.' *Teenage Room* achieves this in a particularly stratified way by reclaiming an already 'subverted' site and exploring what still bubbles beneath its surface.

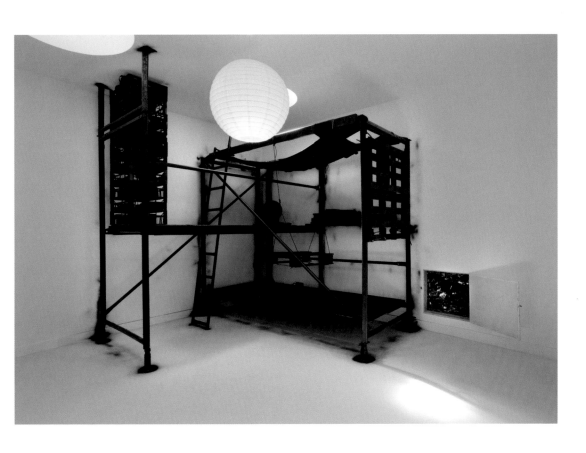

Untitled (from the 'Poster Paintings' series), 2010.
Found posters, blank poster paper, wheat paste, 90 x 62 x 14 cm.

Bodies of Society, 2006. Colour video with sound, 3 minutes.

Rückenfigur, 2009

Neon and paint, 61 x 369.6 x 12.7 cm. Whitney Museum of American Art, New York.

Glenn Ligon

Born in New York, USA, 1960; lives and works there. Ligon has been the subject of solo exhibitions at the Hirshhorn Museum and Sculpture Garden, Washington, D.C.; Brooklyn Museum, New York; and Power Plant, Toronto. He has participated in the Whitney Biennial, the Venice Biennale and Documenta, and his work was included in 'Moving Pictures' at the Solomon R. Guggenheim Museum, New York, and Guggenheim Museum, Bilbao. Ligon won the Skowhegan Medal for Painting in 2006.

Best known for the text-based paintings that he began making in the late 1980s, Glenn Ligon employs a range of mediums – drawing and printmaking, photography and video, sculpture and installation – to examine aspects of the cultural history of the United States from the perspective of a gay African-American man. Ligon's 2011 mid-career retrospective at the Whitney Museum of American Art in New York surveyed the full range of his practice and featured several works rendered in neon, three of which occupied the exhibition's final room. Each of these spells out the word AMERICA in outlined capital letters, though the text, while always legible, has been tinted or altered in various simple ways. In the first work, *Untitled*, 2006, Ligon has painted the glass tubing black, so that light emerges from it only through tiny cracks in its surface. In the second, *Untitled*, 2008, the word's front side is darkened, a pale halo radiating onto the wall from its unpainted back. In the third, a black-painted back prevents the halo effect and each letter is reversed left to right – though since *A*, *M* and *I* are symmetrical, only *E*, *R* and *C* appear changed.

The title of the last work, 2009's *Rückenfigur*, was derived from a German word that translates literally as 'back figure'. Associated with a mode of 19th-century German Romantic painting exemplified by Caspar David Friedrich, it describes a viewpoint that includes an individual pictured from behind contemplating a scene, usually a landscape. As used by Ligon, the word refers directly to his text's reorientation (it is as if we were 'behind' it, perhaps even excluded from it), and also to the idea of America as containing multitudes. Another inspiration for *Rückenfigur* was the famous opening of Charles Dickens's *A Tale of Two Cities*: 'It was the best of times, it was the worst of times.' The image that Dickens evokes – of a country at once wise and foolish, rich and poor, hopeful and despairing – is echoed by Ligon in his unification of the seeming opposites that constitute present-day America: strength and fragility, clarity and ambiguity, black and white.

Malcolm X, #1 (small version #2), 2003.
Silkscreen and Flashe paint on canvas, 121.9 x 91.4 cm.

When American artists began using neon in the 1960s, they were attracted to its contradictory associations with the gaudy brashness of high-street commercial display and the cool authority of machine-made signage. Artists such as Joseph Kosuth and Bruce Nauman played on this dichotomy, the former reproducing deadpan texts from dictionaries and philosophical treatises, the latter jokes and absurdities. Ligon's use of neon, which began in 2005 with his *Warm Broad Glow*, comments on and extends this tradition, turning it to more explicitly socio-political ends. Ligon has incorporated references to other art before. In his landmark work *Notes on the Margin of the Black Book*, 1991–1993, for example, he annotated a set of ninety-one photographs of black men by Robert Mapplethorpe with comments and quotations that together express his conflicted response to the work. *Rückenfigur*'s art-historical allusion is broader, but contributes nonetheless to a powerful and formally elegant fusion of aesthetic investigation, autobiographical reflection and state-of-the-union address.

Warm Broad Glow, 2005.
Neon and paint, 10.2 x 121.9 cm.

Notes on the Margin of the Black Book, 1991–1993.
91 framed offset prints and 78 framed text pages, respectively 27.9 x 28.6 cm and 13.3 x 18.4 cm (each). Solomon R. Guggenheim Museum, New York.

Above and Below, 2007

Installation, epoxy-coated aluminium tubing, 6 x 30 m. Indianapolis Museum of Art.

Maya Lin

Born in Athens, Ohio, USA, 1959; lives and works in New York and Colorado. Lin has been the subject of solo exhibitions at the Des Moines Art Center; Contemporary Arts Museum, Houston; and Carnegie Museum of Art, Pittsburgh. Her work is represented in numerous public collections. She is the recipient of the Presidential Design Award, and is a member of the American Academy of Arts and Letters and the American Academy of Arts and Sciences. In 1994, a documentary on the artist, *Maya Lin: A Strong Clear Vision*, won the Academy Award for Best Documentary.

Chinese-American artist Maya Lin divides her practice between the production of interior and exterior artworks, and the execution of architectural projects commissioned by public and private clients. Consistent to all her work is a focus on our experience of landscape, especially as marked by human influence. Often employing high technology to survey and represent the environment in startling new ways, Lin maintains a commitment to social and political issues alongside a thoroughgoing concern with ecology. Having achieved early prominence as a student at Yale University with her contest-winning and hugely popular design for Washington D.C.'s Vietnam Veterans' Memorial in 1981, Lin has gone on to produce numerous sculptures for museum and gallery display, as well as earthworks, monuments and other structures.

'Maya Lin: Systematic Landscapes', an exhibition that opened at Seattle's Henry Art Gallery in 2006, brought together many of the artist's interior installations, including *2x4 Landscape*, 2006. Constructed from more than 50,000 fir and hemlock boards cut to different lengths and arranged into a hill form, the imposing 30-ton structure occupies a curious territory between a model landscape and the real thing. Loosely based on the lava-formed Palouse hills of eastern Washington, its fragmented surface evokes the look of a digital image via natural materials and age-old techniques. Another work in the exhibition, *Water Line*, 2006, represents an underwater landmass in the southern Atlantic Ocean as a topographical grid formed from wire. Derived from a computer rendering, it reveals and activates a usually hidden terrain.

Consistent to all Lin's work is a focus on our experience of landscape, especially as marked by human influence.

Above and Below, 2007, was produced for another institutional space – the Indianapolis Museum of Art – but is not displayed within a gallery. Instead, it occupies a terrace outside the IMA's relocated Asian galleries. Thinking again about water, Lin based this project on the patterning of local underground river systems. *Above and Below* was designed using photographs, plans and statistics describing formations in Bluesprings Caverns to recreate them in tinted aluminium tubing. Lin and a team of assistants also descended into the caverns to collect additional information using acoustic beam equipment. The first part of the work, which is suspended above head height, represents the upper part of the cavern; the remainder describes underwater portions. The net-like structure echoes the simplicity of Minimalist aesthetics.

In addition to these autonomous installations, Lin continues to work on highly ambitious multi-site undertakings such as the Confluence Project. Since 2006, she has drawn on all the different aspects of her practice to make works for locations scattered along the path taken by the Lewis and Clark expedition through the Columbia River Basin in the states of Washington and Oregon. This extended set of public situations combines interpretive study with an aspect of commemoration, examining historical discoveries and conflicts by, for example, juxtaposing elements of Native American tradition with extracts from explorers' journals. The artist has also collaborated with landscape architects to restore part of each site's natural surroundings, demonstrating once again the possibility of a constructive intervention into an existing terrain.

The Wave Field, 1995. Earth and grass, 30 x 30 m. Commissioned for the François Xavier Bagnoud Aerospace Engineering Building, University of Michigan, Ann Arbor.

Vietnam Veterans Memorial, 1982. Black granite, 3 x 75 m. Washington, D.C.

Maya Lin, 2x4 Landscape, 2006. Installation, SFI certified wood, 3 x 16 x 10 m.

The Diving Stage (1928) after Paul Nash, 2007

Installation, mixed media including 1976 Russian diving suit, headphones, audio excerpts. Tate Britain, London.

Goshka Macuga

Born in Warsaw, Poland, 1967; lives and works in London, England. Macuga has been the subject of solo exhibitions at the Project Arts Centre, Dublin; Fundacja Galerii Foksal, Warsaw; Transmission Gallery, Glasgow; and Tate Britain and Bloomberg Space, London. She has participated in group exhibitions at Museum of Contemporary Art (M HKA), Antwerp; Frankfurter Kunstverein; Neue Nationalgalerie, Berlin; Kunsthalle Basel; and the Museo de Arte Contemporánea de Vigo, Spain. She has also participated in the São Paulo Biennial, and was nominated for the Turner Prize in 2008.

For 'Objects in Relation', her 2007 exhibition in Tate Britain's 'Art Now' series, Goshka Macuga delved into the museum's collection to produce an installation that proposes an alternative history of British Surrealism. But Macuga's presentation is not, strictly speaking, museological. Rather, it takes a subjective, poetic approach to its subject, focusing on the spirit of a particular moment rather than on a sequence of innovation and influence. Macuga is just as interested in the potential for the mechanisms of display to themselves produce meaning as she is in excavating a period or tendency. Thus while she undertook extensive archival research in planning the work, looking especially at personal correspondence, she presents her findings as a kind of assemblage, recontextualizing existing artworks, artifacts and documents to produce a work that also reveals something of her own identity.

Among the objects in Macuga's display is the seated figure of a deep-sea diver, around which is arranged a cluster of chairs with headphones hooked over them. *The Diving Stage (1928) after Paul Nash*, 2007, makes reference to a performance by Salvador Dalí at the International Surrealist exhibition in London in 1936, for which the notorious provocateur gave a lecture dressed as if about to descend beneath the waves (a shot of the prank later appeared on the cover of *Time* magazine). Through the headphones plays a set of audio clips, including excerpts from Herbert Read's 'The Freedom of The Artist', Paul Éluard's 'Poetic Evidence', André Breton's 'Limits Not Frontiers of Surrealism' and an anonymous text from the International Surrealist Bulletin with the run-on title 'The situation in England, the intellectual position with regard to Surrealism the formation of an English group immediate activities'.

Macuga's presentation takes a subjective, poetic approach to its subject, focusing on the spirit of a particular moment.

Standing behind the diver is a wooden tower based on Nash's painting *The Diving Stage*, 1928. Not only does this resonate formally with the trees that Macuga scatters throughout the exhibition, but it also helps establish a dialogue in the work between the different ways in which Surrealism evolved in Britain and in continental Europe. While Nash's British Surrealism was often marked by a romantic, pastoral air, the continental strand espoused by Dalí (at least until his official expulsion from the movement in 1939) tended to have a more openly insurrectionary flavour. Macuga juxtaposes the two artists' (coincidental?) use of diving imagery to playfully suggest the possibility of subconscious communication between them, positioning herself as an intellectual explorer in the process.

The Diving Stage (1928) after Paul Nash, and 'Objects in Relation' as a whole, speak of their maker's immersion in an open-ended process of investigation through which the traces of past thought and activity are reanimated in new and unexpected ways. Macuga's practice suggests that of a curator freed from the requirement to establish hierarchies of value or spell out objective significance. But her intention is not to attack the authority or veracity of established accounts; rather, she makes use of them as raw material, reordering the fragments of creative history into original narratives and prompts to further speculation and debate.

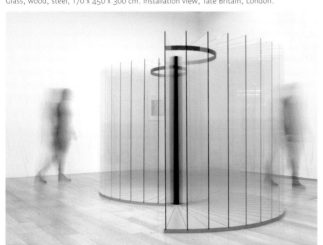

Deutsches Volk – Deutsche Arbeit, 2008.
Glass, wood, steel, 170 x 450 x 300 cm. Installation view, Tate Britain, London.

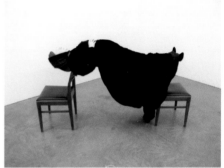

Madame Blavatsky, 2007.
Carved wood, fibreglass, fabric clothes, chairs, 114 x 190 x 74 cm.

Picture Room, 2003.
Mixed media. Installation view, Gasworks, London.

Barry McGee

Born in San Francisco, USA, 1966; lives and works in there. McGee has been the subject of solo exhibitions at the Walker Art Center, Minneapolis; Brandeis University's Rose Art Museum, Waltham, Massachusetts; Deitch Projects, New York; and the Watari Museum of Contemporary Art, Tokyo. His work has also been shown at the San Francisco Museum of Modern Art; Hammer Museum, Los Angeles; and on streets and trains across the United States.

'Compelling art, to me, is a name carved into a tree.' A prime mover in the Bay Area graffiti scene ever since its mid-1980s explosion, painter Barry McGee graduated from the San Francisco Art Institute in 1991 and has since become an international cult figure. Additionally working under a variety of colourful pseudonyms including Ray Fong, Lydia Fong, Bernon Vernon and (most famously) Twist, McGee has developed a rich and deeply felt practice influenced by the Beat poets, the Mexican muralists, and the itinerant tradition of hobo art. A founding member of his hometown's Mission School, McGee has also been – along with his late wife Margaret Kilgallen – instrumental in providing a context for work by other artists similarly fascinated with 'American retro' aesthetics.

Concerned with the complexities and frustrations of life in a modern city, McGee repeatedly employs the image of a sad-eyed male figure, rendered with a sympathetically delicate line. This abject character often winds up adorning empty liquor bottles, or playing a bit part in rambling installations pieced together from spray-paint cans, signage and scraps of metal or wood. Wandering lost through environments embellished with bright colour and repeating pattern, he represents a melancholic and introverted counterpoint to the demonstrative razzmatazz commonly associated with street art. The artist sees his avatar as an everyman, albeit one 'specific to San Francisco, where there's a huge homeless population that everyone wants to be free of, a bit like graffiti'.

McGee repeatedly employs the image of a sad-eyed male figure, rendered with a sympathetically delicate line.

For McGee, illegal graffiti continues to represent a necessary way of working, one that he pursues alongside museum and gallery commissions and argues in favour of as a relevant, albeit risky, iteration of contemporary folk art. 'I love graffiti because it enables kids from every social extraction to do something that brings them closer to art,' he explains. 'It's an important introduction to form and writing, storytelling and colour.' Furthermore, he regards it as a helpful corrective to his otherwise similar 'indoor' work, one that allows him to reach a wider and more diverse audience: 'Whenever I do stuff indoors,' he admits, 'I always feel like I have to do 110% more stuff outdoors to keep my street credibility.'

McGee's 'street' smarts are further reinforced by his incorporation of objects such as battered dumpsters, salvaged television sets and overturned vehicles into large-scale set-ups that also house clusters – 'communities' – of framed drawings and photographs. In immersive exhibitions like 2005's 'One More Thing' at Deitch Projects in New York – arguably the now-defunct gallery's defining moment – and in his contribution to the 2009 Biennale de Lyon, McGee stakes out a critical territory between the studied and the spontaneous, between the theoretically legitimized and the 'merely' popular. A striking feature of both displays was a piggybacking trio of hooded dummies, the upper member of which was mechanized so that he appeared to be spraying a tag. In thus linking these planned and orchestrated shows with their guerrilla counterparts, and in alluding directly to his work's performative aspect, McGee's silent 'helpers' made a vociferous statement.

Untitled, 2011. Acrylic on wood panel, nine elements, 105.4 x 101.6 cm.

Barry McGee and Josh Lazcano, Untitled, 2010. Mural, Houston Street and Broadway, New York.

Ryan McGinley

Born in Ramsey, New Jersey, USA, 1977; lives and works in New York. McGinley has been the subject of solo exhibitions at Galerie Gabriel Rolt, Amsterdam; MoMA PS1, New York; Ratio 3, San Francisco; and MUSAC, León, Spain. His work is featured in the collections of the Solomon R. Guggenheim Museum and Whitney Museum of American Art, New York; San Francisco Museum of Modern Art; and the Saatchi Gallery, London. In 2007, McGinley was awarded the Young Photographer Infinity Award by the International Center of Photography.

Not long after curator Sylvia Wolf first picked up Ryan McGinley's debut book of photographs, 2002's *The Kids Are Alright*, the artist found himself, at twenty-five, among the youngest ever subjects of a solo exhibition at the Whitney Museum of American Art. Such is the immediacy of his work. McGinley's 2003 display introduced a wider audience to a view of youth and youthfulness that runs counter to its darker, more pessimistic interpretation by the likes of Nan Goldin and Larry Clark. Yet while McGinley's images celebrate an uninhibited sexuality and a joyful immersion in nature, they initially came close to being overshadowed by the artist's association – alongside fellow artists Dan Colen and the late Dash Snow – with a downtown New York milieu generally portrayed as not just hedonistic but nihilistic.

In his early photographs, McGinley takes a deceptively casual approach to documenting the lives of his close friends, producing intimate quasi-snapshots perfectly attuned to a blossoming culture of image sharing on websites and blogs. Over time, however, he has concentrated less and less on his own immediate circle and made greater use of hired models, also adopting an increasing degree of technical orchestration and printing in a greater range of sizes. In preparing his current projects, McGinley spends a long time selecting small groups of people with which to travel to carefully selected – though generally unidentifiable – rural locations. He then shoots his subjects unclothed, allowing them to improvise but only within staged scenarios and according to a predetermined stylistic menu. The results thus occupy a middle ground between spontaneity and calculation.

McGinley is unabashed in his use of studio lighting and digital enhancement, aiming not for realism but simply for the most affecting result. This 'directorial' approach is clearly visible in works like *Brandee (Midnight Flight)*, 2011, a large-scale photograph of four figures in a nocturnal forest. Two young men and a young woman watch as another woman appears to hurl herself from a muddy bank, perhaps toward an unseen pond or river. Framed by a twinkling flurry of leaves, the diver's heedless pose looks all the more dramatic. The lighting of the shot adds to its impact too, as the figures' pale skin is picked out against the dense blackness of their surroundings. The striking contrast evokes both painting and cinema, recalling a host of precursors from Caravaggio to film noir in its atmospheric extremes of tonality.

To depict naked young people cavorting in an outdoor location is to question the control and ownership of shared space.

Brandee's collapsing of the differences between the real and the constructed is enmeshed with a blurring of the lines between myth and reality, public and private. To remove clothes, buildings and other manufactured items from a photographic or filmic image is to render it virtually timeless, investing it with an aura of fantasy and magic. And to depict naked young people cavorting in an outdoor location is to question the control and ownership of shared space and the possibility of genuine freedom. McGinley's work has travelled far from its urban roots, but has confronted such questions since the artist first picked up a camera.

Dash & Agathe (Black Leather Couch), 1999.
Chromogenic print, 76 x 101.6 cm.

Dakota (Hair), 2004.
Chromogenic print, 76 x 101.6 cm.

Coco & India (Cascade), 2008–2009.
Chromogenic print, 25.4 x 17.8 cm.

After G. Hobe, Salon Library for the Great Exhibition, 1902, Turin (detail), 2006

Ink and acrylic on canvas, 450 x 267 cm. Installation view, Talbot Rice Gallery, Edinburgh.

Lucy McKenzie

Born in Glasgow, Scotland, 1977; lives and works in Brussels, Belgium. In addition to her own work, McKenzie is known for curatorial and collaborative projects including the record label Decemberism and Nova Popularna, a temporary salon and performance space in Warsaw. She has exhibited at the Museum Ludwig, Cologne; San Francisco Museum of Modern Art; Arnolfini, Bristol; Institute of Contemporary Art, Boston; and Van Abbemuseum, Eindhoven.

Memorably described by critic Elizabeth Schambelan as 'embodying a persona that seems part Edith Sitwell, part Lydia Lunch', Lucy McKenzie is a painter who also works with other artists, designers, writers and musicians on publishing initiatives, curatorial projects and public events. These diverse undertakings explore aspects of the 20th-century avant-garde, borrowing from their distinct aesthetics in a wilfully subjective reordering of European cultural history. Rather than simply appropriating her chosen styles, or offering studies of their various rises and falls, McKenzie reworks and recombines selected elements of them according to her own creative agenda. The precise nature of this agenda can be hard to pin down, but its idiosyncratic social and political bent ultimately renders secondary the need to identify exact periods or iconographies.

McKenzie's points of reference run the gamut from East European propaganda imagery to 1980s pop music graphics.

McKenzie's points of reference run the gamut from East European propaganda imagery to 1980s pop music graphics, but tend to have in common an association with the tarnished utopianisms and worn-thin ideals of high modernist thought. Often drawing on painters of the 1920s and 1930s, the artist also alludes to figures such as German artist Käthe Kollwitz and beloved Belgian comic-book illustrator Hergé. The latter's most famous creation, the intrepid Tintin, was a central motif in McKenzie's 2005 exhibition at Metro Pictures in New York. 'SMERSH' included portraits of the boy reporter sketched as if he were a real flesh-and-blood individual, and mural-like paintings in which other characters – this time rendered in the cartoonist's iconic *ligne claire* graphic style – inhabit well-known urban sites.

Some of McKenzie's collaborative enterprises include launching a record label, Decemberism, and teaming up with Polish artist Paulina Olowska to run Nova Popularna, a salon and performance venue in Warsaw inspired by earlier artists' societies and meeting-places. As part of her 2008 exhibition in the Museum of Modern Art's 'Projects' series, McKenzie also enlisted illustrator Beca Lipscombe and designer Bernie Reid – the trio collaborate as interior design group Atelier – to reconfigure a gallery in fin-de-siècle style. Atelier makes 'rugs' by stencilling directly onto interior and exterior floors, and produces textiles with mismatched designs 'sampled' from different eras. Embracing the fact that art is most often seen in private homes, McKenzie and company weave a narrative around the interplay of art and design, functionality and decoration.

Depeche Mode, Party, 1999.
Acrylic on found canvas, 113 x 82 cm.

McKenzie's own paintings and drawings also often feature *trompe-l'oeil* techniques, in which architectural imagery is rendered onto unstretched canvases or freestanding panels. *After G. Hobe, Salon Library for the Great Exhibition, 1902, Turin*, 2006, for example, depicts part of the titular room on a scale large enough to again blur the boundaries between painting, installation and stage set. But while McKenzie habitually works in this immersive mode, intimate editions also form an important part of her oeuvre. A retrospective of these at Cologne's Museum Ludwig in 2010 featured fifty prints and posters, record covers and accessories. Consistent with the artist's inclusive modus operandi, many of these artifacts relate to readings, concerts and parties organized by herself. For McKenzie, art, craft and life thus prove joyfully inseparable.

TinTin 1, 2005.
Coloured pencil drawing on paper, 49.4 x 42 cm.

Cheyney and Eileen Disturb a Historian at Pompeii, 2005.
Acrylic and ink on paper, 254 x 345.4 cm.

Cloud Canyon No. 14, 1963/2011

Mixed media. Installation view, New Museum, New York.

David Medalla

Born in Manila, the Philippines, 1942; lives and works in London, England. Medalla's work has been included in several landmark exhibitions including 'In Motion', an Arts Council of Great Britain exhibition; 'Live in Your Head: When Attitudes Become Form', curated by Harald Szeemann for, among others, the Institute of Contemporary Arts in London; 'Chance and Change' at the Auckland City Art Gallery, New Zealand; 'L'informe' at the Centre Pompidou, Paris; and 'Out of Actions: Between Performance and the Object, 1949–1979' at the Museum of Contemporary Art, Los Angeles. In 1998, he founded and directed the London Biennale.

Medalla is physically and conceptually nomadic and has been associated with some of contemporary art's most radical and elusive currents.

'A crazy old charismatic bat of the first order, oblivious to fads and trends.' Photographer Miroslav Tichý's affectionate summation of David Medalla is difficult to argue with, but it barely scratches the surface of this unique artist's idiosyncratic and visionary practice. Medalla is physically and conceptually nomadic: he was born in Manila but has also lived in London, New York and Paris, and has been associated, over the course of a career spanning more than forty years, with some of contemporary art's most radical and elusive currents. An innovator in the early days of kinetic art and (especially when involving viewers' active participation) performance art, he has also produced paintings and drawings, indoor and outdoor installations, and what he terms 'impromptus' and 'ephemerals'. If there are distinct threads running through his oeuvre, they are perhaps the universality of change and the primacy of experimentation.

Medalla's encounters with such luminaries as Gaston Bachelard, Lionel Trilling and Marcel Duchamp, as well as his remarkable erudition – he was admitted to New York's Columbia University as a 'special student' at the age of 12, and has lectured at the Sorbonne in Paris and the Universities of Oxford and Cambridge – have sometimes been overshadowed by his identification with the hippie counterculture. Yet while multimedia collaborative projects such as the Exploding Galaxy, which he initiated in London in 1967, are dated by their psychedelic air, other initiatives of this Filipino 'national treasure' have proven flexible and enduring. Among these are his signature 'bubble machines'.

Designed for installation at the New Museum in New York as part of its 'Stowaways' series of projects, *Cloud Canyon No. 14*, 1963/2011, is one such device. These kinetic sculptures – Medalla characterizes them as 'auto-creative' – generate coils of white foam that resemble the titular vapour formations. The earliest instalment in the series takes the form of a plain wooden box, the simplicity of which led artist Gavin Jantjes to dub Medalla's approach 'practical minimalism' for its roots in the use of basic equipment and materials to explore complex and varied ideas. 'It is doing the most with the least,' he observed, 'and that is so much part of what artists from the so-called periphery have to do.'[1] Later versions are structurally more complex but adhere to the same core idea.

As Jantjes's account suggests, the bubble machines took some time to find an audience. First appearing in the early 1960s, they remained obscure until one was featured in 'The Other Story' at London's Hayward Gallery in 1989. Yet the series exerted an influence nonetheless: critic Richard Dyer notes its powerful impact on artists such as Hans Haacke (Roger Hiorns is one example from a younger generation) and outlines some of the works' implications: 'By positing an interrelated series of opposites – dynamic/static; authored/auto-generated; monumental/ephemeral – Medalla disputes the parameters of what constitutes sculpture,' he writes. 'In choosing a medium that self-destructs as it is created, the stability of the work is undermined and the validity of the concepts of solidity and permanence in sculpture are brought into question.'[2]

1 Gavin Jantjes in conversation with David Medalla. 'Dialogues with Artists on Internationalism', Institute of International Visual Arts (INIVA), London, 29 May 1997, http://tinyurl.com/28gur40
2 Richard Dyer, 'David Medalla, 55 Gee Street', *frieze*, issue 21, March-April 1995.

David Medalla with Cloud Canyon No. 2, London, 1964.

Cloud Canyons (1997) Cosmic Propulsions 'another vacant space.', Berlin, 2011.

Hellen van Meene

Born in Alkmaar, the Netherlands, 1972; lives and works in Heiloo. Van Meene has exhibited at venues including Huis Marseille, Amsterdam; Museum Folkwang, Essen; and Pump House Gallery, London. She has taken part in numerous group exhibitions, including 'Me, Ophelia' at the Van Gogh Museum, Amsterdam, and 'Family Pictures' at the Solomon R. Guggenheim Museum, New York.

Hellen van Meene began taking photographs of young people in her hometown of Alkmaar in northern Holland, but has increasingly pursued the subject around the world, travelling to far-flung destinations from Japan and Russia to the American South. Her specific focus is on adolescents – especially girls – possessed of an awkward, androgynous beauty (though latterly she has branched out into interior scenes and formal animal portraits). Her images are calm and contemplative, yet are also haunted by an unsettling, even sinister air. Their subjects' subtly off-kilter appearance ultimately hints at a broader disjunction between individuals and their environments, expectation and reality. Van Meene's stated aim is to produce 'photographs of adolescent situations and attitudes, which represent the type of "normality" we don't usually share with others, but keep to ourselves'.[1]

Untitled #372, 2010, depicts a dark-haired girl kneeling in a clearing. Clad in a shiny, clinging pink dress, she holds her hands at her side in a position that feels at once casual and defensive, and looks out beyond the frame to her left with the pensive expression that characterizes so many of van Meene's subjects. She also has that not-quite-adult look to which the artist is particularly sensitive; her body seems very slightly ill-proportioned, as if her frame has not quite kept pace with her height, and her pale skin stands out against the dark forest floor, exposed and vulnerable. The dress, wrinkled and pulled tight between her legs, furthers the uncomfortable impression of a fish out of water (it even looks like a swimsuit).

Van Meene aims to create an atmosphere, a scenario, and treats her subjects as actors.

Perhaps surprisingly, van Meene does not consider such photographs to be portraits per se, or even studies of a particular age. Rather, she aims to create an atmosphere, a scenario, and treats her subjects as actors. 'As a matter of fact,' she admits, 'I treat my models as objects which you can direct and guide. They are simply material for me.'[2] This consciously distanced approach helps her to concentrate on formal aspects – 'the lightfall on a white skin, bruises on an arm, hands which disfigure in water, and starting goose-pimples in frosty weather.'[3] To highlight these details, she arranges each shoot with great precision, paying as much attention to composition, posture, and colour relationships as any painter would. Yet even within this careful methodology, she makes room for improvisation and development.

Untitled #331, 2008. Chromogenic print.

While adolescence remains van Meene's primary focus, a recent series of photographs taken in Saint Petersburg sees her revisit one young subject as a grown woman. *Untitled #366*, 2010, depicts the unnamed figure wearing nothing but a long black wig and scarlet lipstick. She confronts the camera with an icy, blue-eyed stare, her absolute directness at odds with the dreamy evasiveness of so many of the artist's images. Yet while the shot seems to hold out the promise of psychological insight, there is still a powerful, perhaps impenetrable strangeness about the image. It could be called a documentary shot, but is transparently staged; it strips its subject physically bare, but leaves the mystery of her situation intact.

1 The artist interviewed by Karel Schampers.
2 Ibid.
3 Ibid.

Untitled #61 (Knee Over), 1999. Chromogenic print.

Untitled #366, 2010. Chromogenic print, 29.2 x 29.2 cm.

Jonathan Meese

Born in Tokyo, Japan, 1970; lives and works in Berlin, Germany. Meese has been the subject of solo exhibitions at the Staatsschauspiel, Dresden; Conceptual Art Center Bukovje, Postojna, Slovenia; and the Museum of Contemporary Art, North Miami. He designed the sets for Wolfgang Rihm's opera 'Dionysos' at the Westergasfabriek in Amsterdam, and recently erected a permanent sculpture at the Alte Nationalgalerie in Berlin. A retrospective, 'Totalzelbstportrait', opened at the GEM Museum voor Actuele Kunst in The Hague in 2011.

'To produce art is to produce toys for the world, for the revolution.' Jonathan Meese takes a stridently ambitious, uncompromising and demonstrative stance when it comes to making and exhibiting his gleefully energetic work. A maximalist installation artist, performance artist, painter, sculptor and provocateur, Meese imprints his distinctive likeness and personality firmly and repeatedly on everything he produces. Central to his project are ideas about the autonomy or, in his preferred term, the 'dictatorship' of art. His persona has a suitably commanding, even messianic air, but one that is consciously and continually undermined by its self-consciously over-the-top flamboyance. Meese's approach is thus at once serious and self-mocking, borrowing from the potentially burdensome history of German modernism only to revel in its pretensions and absurdities. Informed by the legacies of cult artist-pranksters identified with a previous generation - Joseph Beuys, Sigmar Polke, Martin Kippenberger and A. R. Penck among them - Meese is unusual in today's art world for the totalizing range of his vision.

Meese explores his tongue-in-cheek totalitarian aesthetic via a confrontational sense of humour.

Meese explores his tongue-in-cheek totalitarian aesthetic via a confrontational sense of humour that is perhaps most clearly apparent in his chaotic performances. *Noel Coward Is Back - Dr. Humpty Dumpty vs. Fra No-Finger*, staged at Tate Modern in London in 2006, saw him made up like a geisha, enacting a drunken breakdown to the accompaniment of vintage film clips. And in a 2011 action at Bortolami in New York, *War 'Saint Just (First Flash)'*, he parodied a Nazi dictator, posturing, ranting and *Sieg Heil*-ing from behind a towering podium. In Meese's worldview, however, no single artist or other individual may exercise absolute authority, only art itself. Meese's self-portrait paintings also reflect the curious blend of egoism and obfuscation that he seems to embody, as various characters stand in for the artist himself. Given this predilection for role-play, it is unsurprising that Meese has a strong interest in drama and film; he has designed theatrical sets, and wrote and starred in a play, *De Frau: Dr. Poundaddylein - Dr. Ezodysseusszeusuzur*, that was presented at Berlin's Volksbühne theatre in 2007.

Noel Coward Is Back - Dr. Humpty Dumpty vs. Fra No-Finger, 2006.
Performance view, Tate Modern, London.

True to his conception of art, not individual artists, as the guiding light and governing force, Meese often merges his identity with others in collaborative projects. In one such undertaking - described, with self-deprecating wit, as 'a courtly affair of awkward politeness punctuated by artistic embarrassment' - he teamed up with pioneering 'bad painter' Albert Oehlen. Taking turns riffing on Oehlen's collaged photographic elements, the duo arrived at a set of images that, while they explore a fascination with ugliness and abjection common to both artists, could not have sprung from isolated individual effort. *The Greeting*, 2003, is typical, a grotesque hermaphroditic figure improvised around an up-skirt porn shot. In 2006, Meese's collaboration with another painter, Tal R, resulted in *Mother*, a multipart installation on the titular subject that was contained by a large pink fortress built inside the gallery. If the cutesy, childlike setting felt incongruous given Meese's quasi-macho predilection for grand narratives and weighty expressionism, the collaborative approach again resulted in an unpredictable and counterintuitive success.

Jonathan Meese and Tal R, Mother, 2006. Installation view, Bortolami Gallery, New York.

Empirical Construction, Istanbul, 2003

Ink and synthetic polymer paint on canvas, 304.8 x 457.2 cm. The Museum of Modern Art, New York.

Julie Mehretu

Born in Addis Ababa, Ethiopia, 1970; lives and works in New York, USA. Mehretu has exhibited in several important group exhibitions including 'Poetic Justice' at the Istanbul Biennial; 'Automatic Cities' at the Museum of Contemporary Art, San Diego; and Prospect 1, New Orleans. She has been the subject of solo presentations at venues including the Walker Art Center, Minneapolis; REDCAT, Los Angeles; Albright-Knox Art Gallery, Buffalo; and St. Louis Art Museum. Mehretu was a MacArthur Foundation Fellow in 2005.

Julie Mehretu is one of a group of young American artists responsible for injecting new life into abstract painting over the past decade, drawing on the innovations of past movements to kick-start a range of possible futures. Mehretu's primarily large-scale canvases and drawings are exhilarating maelstroms of colour, shape and line that embody an experience of organized chaos centred on the postmodern city. The places she depicts, while in large part imaginary, feature recognizable elements of real-world architecture, topography and history. And despite the artist's use of traditional materials – paint, ink, and pencil – her practice suggests an approach to image-making that feels particular to the digital age, employing techniques of layering and translucency in a style that recalls computer manipulation and the hyper-complexity of the Internet.

Mehretu's painting *Empirical Construction, Istanbul*, 2003, is a subjective portrait of the titular city that reflects its storied past and hectic present. Juxtaposing graphic icons derived from the Islamic decorative and architectural traditions with symbols from flags and fragments of contemporary signage, the canvas frames its subject as a point of intersection between old and new, East and West, marked by European and Asian influences. The work's combination of epic size and intricate detail envelops the viewer in a frenzied whirl of motion that is at once attractive and unnerving; we feel both the excitement of a busy global capital and the spiralling danger of a contested territory. The sheer amount and diversity of activity hints at a society losing touch with itself, in which the individual is swept along by events and the possibility of contemplation is buried beneath a mass of data.

Empirical Construction reveals a range of well-known antecedents, from the Italian Futurists' attempts to represent the speed and violence of modern life to the embrace of painterly gesture and all-over composition that were distinguishing features of American Abstract Expressionism. Mehretu wields pens as well as brushes to construct a dense matrix that feels three-dimensional despite its deliberate paucity of conventional modelling. While perspective in the painting appears to shift – the artist exploits multiple points of view, visually and conceptually – the result maintains a suggestion of depth. Orbital and radiant lines of force and shards of flat, bright colour intermingle with more delicately drawn passages, the two working in tandem to pull the eye in.

Orbital and radiant lines of force and shards of flat, bright colour intermingle with more delicately drawn passages.

Mehretu's work is often discussed in terms of mapping, and there is a diagrammatic superstructure to her images that anchors each tumultuous surface in an originating vision. The artist uses plans of institutional and public sites as readymade frameworks on which to hang personal narratives. In *Empirical Construction*, a city that was at the heart of several extinct empires is thus pictured according to still-current experience. Ultimately, Mehretu's interest is in social space and common ground, in the myriad ways that built environments reflect the individual and collective identities of their makers and inhabitants, whether still living or long-gone. There is a dynamism to her pictures that signifies constant change: developmental, regressive, cyclical and entropic.

Black City, 2007. Ink and acrylic on canvas, 304.8 x 487.7 cm.

Gustav Metzger

Born in Nuremberg, Germany, 1926; lives and works in London, England. Metzger organized the international Destruction in Art Symposium (DIAS) in London in 1966. He has exhibited, performed and lectured internationally, at venues including Transmission Gallery, Glasgow; Whitechapel Gallery, London; Modern Art Oxford; Museum für angewandte Kunst (MAK), Vienna; and the Museum of Contemporary Art, Tokyo. A retrospective of his work, 'Gustav Metzger: Geschichte Geschichte', was staged at the Generali Foundation, Vienna, in 2005.

The centrepiece of Gustav Metzger's 2009 retrospective at the Serpentine Gallery in London – and exhibited again two years later at the e-flux project space in New York – *Mass Media: Today and Yesterday,* 2009, is an installation based around an archive of several thousand daily newspapers. The papers, accumulated by the artist since 1995, are stacked in a large block. Viewers are invited to cut out articles relating to topics designated by the artist (the themes at e-flux were 'extinction', 'credit crunch' and 'the way we live now'). The clippings are then attached with magnets to an adjacent wall. The result is a continually updated narrative of contemporary ills edited by its readers to illustrate a growing disillusionment with mainstream thought.

Mass Media forms part of Metzger's 'Historic Photographs' series, in which he deconstructs widely disseminated visual representations of significant global events. Other entries in the series feature enlarged reproductions of newspaper images partially obscured from view by rubble or other material, emphasizing our distance from the realities they purport to illustrate. Newspapers have long been a touchstone for the artist as flexible signifiers for the increasingly intrusive presence in our lives of corporate-controlled 'reportage', and for the capacity of science and government to assume a progressive role on one hand and a damaging one on the other. Metzger is committed to political activism, critical in particular of unchecked industrial development and capitalist excess, and supportive of ecological campaigns.

Newspapers have long been a touchstone for the artist as signifiers for the increasingly intrusive presence of corporate-controlled 'reportage'.

Metzger has incorporated such concerns into his art throughout a long and iconoclastic career. He achieved early notoriety around 1960 as a pioneer of 'auto-destructive art', spraying acid onto hanging sheets of nylon and canvas to produce works that consumed themselves, challenging established ideals of preservation and permanence. His development of this radical process led to two landmark symposia; it also influenced artists such as John Latham and, more famously, musician Pete Townshend, who cited Metzger as the inspiration for his guitar-smashing antics during concerts by The Who. Metzger went on to make other works whose effect hinges on their own physical instability; *Liquid Crystal Environment*, 2005, for example, immerses viewers in a projection that gradually and continually changes colour like a giant lava lamp.

Other works by Metzger have made use of humble found objects including plastic bags and cardboard boxes (a sack of refuse that constituted part of a 2004 recreation of 1960's *First Public Demonstration of Auto-Destructive Art* was mistakenly thrown away by a cleaner at Tate Britain in London). And consistent with his interest in environmentalism, the artist has also incorporated natural forms into several projects; also on display at the Serpentine exhibition was *Flailing Trees*, 2009, for which he embedded fifteen inverted willows in a concrete block as a comment on the destabilizing effects of global warming. Metzger has weathered numerous creative storms over the years, but as *The New York Times* critic Ken Johnson's sharply sceptical response to his 2011 exhibition at the New Museum indicates, his work can still polarize and provoke.

Historic Photographs: No. 1: Liquidation of the Warsaw Ghetto, April 19 -
28 days, 1943, 1995.
Black-and-white photograph, bricks. Installation view, Musée départemental
d'Art contemporain de Rochechouart, 2010.

Liquid Crystal Environment, 2005.
Five slide projectors, liquid crystal. Installation view, Musée départemental
d'Art contemporain de Rochechouart, 2010.

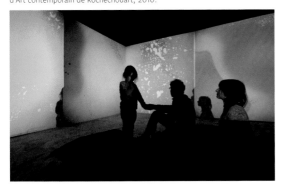

Vacuum Room, 2005

Six-channel colour video installation. Installation view, Kunstverein Hannover, 2007.

Aernout Mik

Born in Groningen, the Netherlands, 1962; lives and works in Amsterdam. Mik made his solo museum debut in 2000 at the Van Abbemuseum in Eindhoven, and has also exhibited at the Institute of Contemporary Arts and Camden Arts Centre, London; the Museum of Modern Art, New York; Kunstverein Hannover; and Hammer Museum, Los Angeles. In 1997, he won the Sandberg Prize for *Lick*, 1996, and *Fluff*, 1996, and was awarded the Heineken Art Prize by the Royal Netherlands Academy of Arts and Sciences in 2002. In 2007, Mik was selected to represent the Netherlands at the Venice Biennale.

In a 2009 exhibition at the Museum of Modern Art in New York, Aernout Mik used both gallery and non-gallery locations to explore the intersection of reality and fiction, turning viewers into unwitting performers and provoking reflection on the madness of crowds. In eight video installations scattered throughout the building, the artist – with assistance from curators Laurence Kardish and Kelly Sidley – exploited the peculiar resonance of transitional spaces in addition to galleries proper. *Middlemen*, 2001, for example, was projected onto a temporary wall in the institution's bustling lobby. Silent and looping, the footage's atmospheric depiction of what suggests the aftermath of a catastrophic incident in a commodities exchange was all the more unnerving for occupying a site of roughly comparable style and scale.

Also included in the MoMA exhibition was *Vacuum Room*, 2005, a six-channel video projected onto the walls of a freestanding enclosure. Where *Middlemen* traded on the free-flowing environment of the lobby, this installation features cushions and chairs, inviting viewers to rest while at the same time implicating them in its highly ambiguous action. Each of the work's screens, which are arranged so that it is impossible to see them all at once, depicts a different view of an unnamed official chamber, such as a legal or governmental assembly room. The setting appears to have been targeted by protesters, and we watch as they face off against a cadre of senior officials. The confrontation is almost entirely verbal and symbolic, but its motivation is unknown.

Whether we move from view to view or take up a seated position the semiotic deadlock persists.

Vacuum Room is also deliberately confounding in its refusal of escalation or climax. As the situation ebbs and flows, it soon becomes apparent that the images are not sequential, and that the motivations of each 'side' in the encounter will never be clarified. (That one of the occupiers is shown breaking eggs over a statue hints at an anti-authoritarian agenda, but nothing more specific emerges.) The editing and installation design fracture time and space, turning what resembles objective documentary footage into something far more open-ended. Whether we move from view to view or take up a seated position (the chairs are placed *between* the screens so that their occupants are the objects of others' observation, making this a more meaningful decision than it sounds), the semiotic deadlock persists.

In *Citizens and Subjects*, an installation at the 2007 Venice Biennale, Mik extends the themes of conflict, vulnerability and moral confusion addressed in *Vacuum Room* to reflect on the anxious condition of the contemporary Western nation state. Made up of three multi-channel videos – *Training Ground*, *Convergencies* and *Mock Up* – *Citizens and Subjects* is also housed within a quasi-architectural structure. Inside, the staged action of *Training Ground* and *Mock Up* follows the preparations for a large-scale emergency, while the mix of found and original footage in *Convergencies* traces the implementation of these contingency plans. By juxtaposing the 'factual' with the re-enacted in a dense and consciously disorienting flow, Mik further problematizes our understanding of representation, both as connoting a relationship between government and citizen, and as bound to the imaging of reality at large.

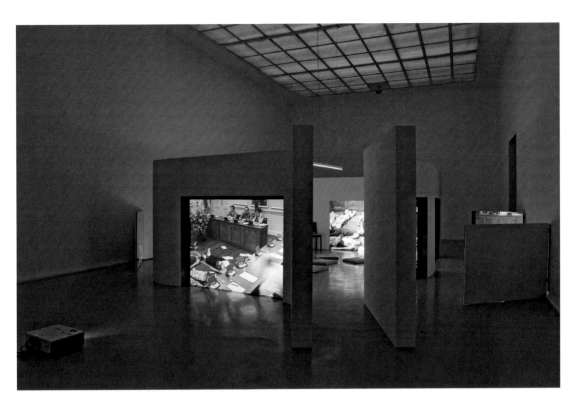

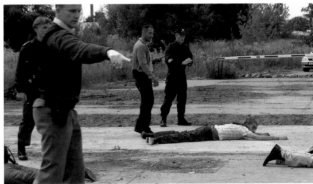

Training Ground, 2006. Two-channel colour video installation.

Communitas, 2010. Three-channel colour video installation.

Communitas, 2010. Three-channel colour video installation.

Middlemen, 2001. One-channel colour video installation.

Boris Mikhailov

Born in Kharkov, Ukraine (former USSR), 1938; lives and works in Kharkov and Berlin, Germany. Mikhailov has been the subject of solo exhibitions at the Kunsthalle Wien; Institute of Contemporary Art, Boston; National Center for Contemporary Arts, Moscow; Sprengel Museum, Hanover; Centre de la Photographie, Geneva; and the Finnish Museum of Photography, Helsinki. He won the Hasselblad Award in 2000 and the Citibank Photography Prize in 2001. Mikhailov was the subject of a retrospective at the Fotomuseum Winterthur in 2003, and represented the Ukraine at the 2007 Venice Biennale.

Now considered one of the most important photographers to emerge from the former Soviet Union, Boris Mikhailov initially trained as an engineer in the forbidding industrial town of Kharkov. He took up photography full-time only after being fired from his factory job in the late 1960s (when the KGB found nude photographs of his wife), and exhibited only rarely prior to the collapse of Communism at the end of the 1980s. Much of his work reflects the harshness of life for those cast aside in the country's economic rebirth, but there is a tenderness – and also a drama – to even his grittiest and most uncomfortable images. Combining the roles of journalist and director, Mikhailov confronts his environment but consciously shapes it too, interpreting, responding and adapting.

Mikhailov's best-known series is 'Case History', a set of more than five hundred colour shots taken in Kharkov between 1997 and 1998. This records, in unflinching detail, the lives of the city's homeless population, the so-called *bomzhes* that proliferated along with the rise of capitalism. Often upsetting in their frank depictions of poverty, dirt and disease, Mikhailov's pictures manage nonetheless to invest their subjects with a certain dignity. This is not, however, an entirely spontaneous effect; the artist asked his models to re-enact scenes from Christian and artistic iconography, resulting in a curious mix of documentary and painterly or theatrical modes. But this apparently willing involvement is disturbing too, the more so when those depicted are naked or otherwise exposed. Is this a kind of exploitation?

Combining the roles of journalist and director, Mikhailov confronts his environment but consciously shapes it too.

'Case History' may appear unremittingly dark, and it remains difficult to look at these images of pale, scarred and ageing bodies without flinching. But as critic Anne von der Heiden points out, it is the hints of complicity that make 'Case Studies' truly shocking. 'Most of all,' she writes, 'we are irritated that the *bomzhes* look at the man with the camera with an expression of trust and delight.'[1] Mikhailov refuses to make life easy for the viewer by serving up unambiguous shots that frame their subjects entirely as victims. Von der Heiden also reads the series' images of wounded flesh, which have obvious religious connotations, as an allegory for the tribulations undergone by a society seemingly in perpetual transition from one dysfunctional system to another.

While the individual works in 'Case History' are untitled and uncaptioned, leaving viewers to decide on their implications, Mikhailov's 1982 series 'Klebrigkeit' is sprinkled with explanatory notations, though these are often too personal or obscure to provide the hoped-for key to meaning. In the earlier 'Red Series', 1968-1975, some clarification is provided in the form of a scarlet tint, an allusion, perhaps, to the all-pervasive influence of the Communist party 'Yesterday's Sandwich', another time capsule from the early days of Mikhailov's career, was published only in 2006, having been a victim of Communist prudery for the previous half-century. In this playful series, the artist uses basic superimposition techniques to enliven his grimy images of daily life, transforming the mundane into a visionary and libidinous fantasy world.

1 Anne von der Heiden, 'Consumatum Est? "Case History" by Boris Mikhailov' in Herausgegeben von urs Stahel (ed.), *Boris Mikhailov: A Retrospective*, Fotomuseum Winterthur/Scalo, 2003, 170-172.

Untitled, from the series 'Red', 1968–1975. Chromogenic print.

Beatriz Milhazes

Born in Rio de Janeiro, Brazil, 1960; lives and works there. Milhazes has been the subject of solo and group exhibitions in a number of museums, including the Museum of Modern Art, New York, and the Musée d'Art moderne de la Ville de Paris. In 2009, the Fondation Cartier pour l'art contemporain in Paris presented a major survey of her work. Milhazes's paintings are in the permanent collections of institutions worldwide, including those of the Museum of Modern Art and Metropolitan Museum of Art, New York; the Banco Itaú, São Paulo; and the Museo Nacional Centro de Arte Reina Sofía, Madrid.

'I am interested in conflict, and the moment you add one more colour, you start a conflict.' Inspired by pioneers of modernist abstraction such as Mondrian and Matisse, as well as by the Brazilian master Tarsila do Amaral and – perhaps most visibly – Sonia Delaunay, Beatriz Milhazes uses a technique halfway between collage and painting to construct festive, rhythmic canvases and works on paper. In a studio fortuitously located next to Rio de Janeiro's lush Botanic Gardens, Milhazes juxtaposes floral shapes and patterns with designs and colour combinations borrowed from local folk art, Tropicalismo and the Colonial Baroque. The result is a blend of nature study and formal experiment that represents a uniquely Brazilian hybrid (Milhazes emerged alongside the country's *Geração de Oitenta* [1980s Generation]), additionally recalling the work of international contemporaries such as English painter Bridget Riley. Thus while Milhazes's work may deal with conflict of a sort, it does so in the most seductive, musical style imaginable.

Having begun by working with collage in various different materials – first paper, then fabric, and latterly the canvas of the support itself – Milhazes eventually became interested in also producing motifs of her own that could be juxtaposed and layered in a similar way. She discovered an effective way to do this by making drawings on sheets of clear plastic, painting on their reverse sides in acrylic, gluing the painted sides to a canvas, then peeling off the plastic alone to transfer the motif. The results of this method have the bold, graphic punch of a screen print - the artist's brushstrokes having been filtered through the smooth texture of the plastic - coupled with the intimate, 'crafted' feel of a hand-painted surface. And while Milhazes has often used her finished paintings to spark smaller 'real' collages on paper, as well as much larger public installations on architectural façades, some of her recent panels reverse the referential process by feeding off the unpredictable visual effects generated by her mix-and-match gatherings of printed ephemera.

Popeye, 2008, is a typically effervescent whirl of brightly coloured overlapping circles that feels spontaneous but is organized around what the artist describes as a 'rational' compositional system in which colour and shape are carefully aligned and balanced. Milhazes's post-painterly

Mulatinho, 2008.
Acrylic on canvas, 248 x 248 cm.

system of application here makes for a mix of flat and inflected or translucent areas of pigment, creating a feeling of depth without perspectival illusion. There is also a suggestion of the passage of time in the work's juxtaposition of fresh and weathered-looking paint. And there is unquestionably an evocation of the joyful chaos of carnival in the picture's bubbling activity. Reviewing the exhibition at New York's James Cohan Gallery in which *Popeye* first appeared, critic Roberta Smith observes that Milhazes's interlocking rings also display 'the precision of gears and wheels', a quality appropriate to work that recalls industrial designer Verner Panton as much as it does other painters. In celebrating both the flux of human society in her hometown and the parallel buzz of nature, Milhazes keeps one eye fixed on the structures that hold it all – just barely – together.

Aleksandra Mir

Born in Lubin, Poland, 1967; lives and works in London, England. Mir has been the subject of solo exhibitions at venues including Power Plant, Toronto; Saatchi Gallery, London; and Schirn Kunsthalle, Frankfurt. Her work has also been included in numerous important group exhibitions including 'GNS (Global Navigation System)' at the Palais de Tokyo, Paris, and 'The Shapes of Space' at the Solomon R. Guggenheim Museum, New York. Mir is represented in a number of collections including those of the Brooklyn Museum, New York, and the Nasjonalgalleriet, Oslo.

'Every day, there will be new art and old news on the walls.' For two months at the end of 2007, Aleksandra Mir transformed New York's Mary Boone Gallery into a combined studio and newsroom, working with a team of assistants to produce two hundred large drawings inspired by the lurid front pages of local tabloids the *New York Post* and *Daily News*. During the time she lived in the city – between 1989 and 2005 – Mir had honed a practice based on travel, communication and publishing, and on the production of events rather than images or objects. 'Newsroom 1986–2000' framed the space of the gallery as the artist's temporary headquarters, becoming not only a forum for the display of finished work, but also a base from which to operate.

In preparing the project, Mir and three helpers spent several months in the New York Public Library copying ten thousand covers – fifteen years' worth – before selecting the most striking for reproduction onto larger sheets. The drawings, rendered in black marker, have a raw, off-kilter appearance that suggests a public history reshaped by private emotion. In the installation at Mary Boone, they were grouped according to headlines: COWBOYS OR COPS?; COPS CAPTURE GRAFFITI KING; PSYCHO COP; MORE COPS ON THE WAY. Having published her own mock edition of the *Daily News* on the first anniversary of 9/11 with a headline celebrating her own birthday in a modest attempt to wrest the day back from its negative connotations, Mir again used the mass media as a template for personal expression.

This reframing of the link between common knowledge and subjective encounter is also apparent in *Hello*, a project begun by Mir in 2000 and expanded continually since. Described by the artist as 'a photographic daisy-chain', the endlessly lengthening strip of snapshots brings together individuals from wildly divergent circumstances with disarming effortlessness; a figure appearing on the right of one print crops up again on the left of its neighbour. In a visual take on the notion of six degrees of separation, the work reproduces the Web's radical connectivity in an immediate, physical form. The leaps made within the space of two or three images are often dizzying, spanning the globe and suggesting previously unconsidered associations between obscure and famous figures, familiar and unfamiliar milieux.

Hello, 2000– .
Colour photographs, dimensions variable.
Installation view, Curve Gallery, Barbican,
London, 2001.

Mir's performance *First Woman on the Moon*, 1999, also brought together previously separate physical and historical worlds by re-imagining the narrative of the space race according to an explicitly feminist agenda. Using bulldozers to remodel a Dutch beach into an ersatz lunar landscape, the artist orchestrated a ten-hour event that culminated at sunset, when she climbed a small hill to plant the stars-and-stripes, and claim for herself the titular honour. In acknowledgment of the fact that the audience for the original landing only ever observed it as a televised or printed image, Mir ensured that local news media were on hand to record the goings-on, and thus add to the mythical status of the event, which lives on in the form of a documentary video, photographs and relics.

First Woman on the Moon, 1999.
Colour video with sound and publicity stills, 12 minutes, originating from live event in Wijk aan Zee (the Netherlands) on 28 August, 1999.

Untitled (It is easy to forget, and sometimes we don't remember, but without memory a person is a snapshot, a two dimensional image, a ghost), 2007

Oil on canvas, 210 x 260 cm.

Muntean/Rosenblum

Markus Muntean: born in Graz, Austria, 1962; Adi Rosenblum: born in Haifa, Israel, 1962; both live and work in Vienna, and London, England. Muntean/Rosenblum have exhibited at the Essl Museum, Klosterneuburg bei Wien; Museo de Arte Contemporáneo de Castilla y León, Spain; and the Australian Centre for Contemporary Art, Melbourne. Their work has also appeared in exhibitions including 'The Triumph of Painting' at the Saatchi Gallery, London; 'Melodrama' at the Museo de Arte Contemporáneo de Vigo, Spain; and 'Fantasies and Curiosities' at the Miami Art Museum.

A popular toy with children in the 1970s and 1980s was the rubdown transfer. This consisted of a cardboard backdrop (usually a landscape or other panoramic illustration) and a sheet of transfers depicting figures, objects or other elements, printed onto special plastic. The activity, long-since rendered quaint by Photoshop, involved completing the scene by adding the transfers – in positions of one's own choosing – by rubbing the back of the sheet. The results typically had a strange, disjointed quality. Individual characters seemed lost in their own private dramas, caught up in physical action but oddly divorced from the big picture. Markus Muntean and Adi Rosenblum are best known as painters, but the relationship of their works' protagonists to the environments they occupy has a similar feeling of artificiality and alienation.

Untitled (It is easy to forget, and sometimes we don't remember, but without memory a person is a snapshot, a two dimensional image, a ghost.), 2007, is typical of the duo's oeuvre. A large canvas rendered in a clear but otherwise unremarkable, affectless and even slightly amateurish style, it pictures a group of young people loitering in a desolate car park shadowed by a motorway flyover. While the five figures share the space, they barely acknowledge one another's presence, instead staring off in different directions as if longing to be somewhere else. Their stiff poses and blank expressions reflect Muntean/Rosenblum's use of fashion magazines for source material, while the picture's dour atmosphere is reflected in its lengthy caption (an element common to most of these artists' work).

Giving the image a slightly comic-book appearance by framing it as a round-cornered vignette, Muntean/Rosenblum suggest, like the designers of those transfer kits, that this might be just one small part of a greater narrative. But what exactly is going on? The caption reads less like a line of dialogue than it does a collective thought expressed in the measured poetry of philosophical reflection. Is it an understanding of this melancholic observation that binds these people together, or do they somehow embody its truth unawares? If the painting depicts an existential crisis or conflict, it does so in a rigorously deadpan manner that seems to permit little in the way of 'personal' identification on the part of the viewer. The windswept car park feels as uninviting as its occupants are uncommunicative.

Yet in spite of its studied cool, there is something in Muntean/Rosenblum's project that provokes emotion. The less the works' unnamed stars seem prepared to give of themselves, the more they seem mere victims of postmodern ennui, and the more we are prompted to examine the extent to which their emptied-out predicaments mirror our own. That the artists' compositions periodically reveal an awareness of classical convention suggests that there is a history here, albeit one routinely suppressed in the scramble to consume and conform. Forcing contemporary visual styling (the term feels more apt than *style* given the paintings' mimicry of catalogue modelling) into confrontation with timeless – albeit ironic or elliptical – meditations on the human condition, Muntean/Rosenblum hold the here and now up to an unforgiving light.

It is never Facts that Tell, 2004.
Projection from a digital source.

IT IS EASY TO FORGET, AND SOMETIMES WE JUST DON'T REMEMBER, BUT WITHOUT MEMORY A PERSON IS A SNAPSHOT, A TWO-DIMENSIONAL IMAGE, A GHOST.

Untitled (There was no warmth...), 2005. Oil on canvas, 220 x 260 cm.

THERE WAS NO WARMTH BETWEEN US, AND WE HAD FEW INTERESTS IN COMMON, THOUGH EACH WAS A BELIEVER. NEITHER COULD CREDIT THE OTHER'S FAITH, BUT ANYWAY WHAT COMFORT DOES BELIEVE OFFER, WHEN IT CONTAINS WITHIN IT ITS OWN ANTITHESIS, THE GLISTENING DROP OF POISON AT THE HEART?

Untitled (Because there is no escape...), 2009.
Oil on canvas, 138 x 97 cm.

BECAUSE THERE IS NO ESCAPE FROM WHAT DOES NOT EXIST.

Takashi Murakami

Born in Tokyo, Japan, 1962; lives and works in Tokyo. Murakami has been the subject of solo exhibitions at the Serpentine Gallery, London; Museum of Contemporary Art, Tokyo; Museum of Fine Arts, Boston; and the Château de Versailles, France. In 2001, he organized the paradigmatic exhibition 'Superflat', and between 2007 and 2009 a retrospective of his work, '©Murakami', travelled from the Museum of Contemporary Art, Los Angeles, to the Brooklyn Museum, New York, the Museum für Moderne Kunst, Frankfurt, and the Guggenheim Museum, Bilbao.

In 2010, Takashi Murakami followed in the footsteps of a handful of other contemporary artists including Jeff Koons and Xavier Veilhan by exhibiting in the rarefied surroundings of the Château de Versailles, Louis XIV's opulent royal palace. 'Murakami – Versailles' featured twenty two works by the post-Pop icon distributed through fifteen rooms of the palace and its gardens, and made the most of the correspondences and contrasts between the art and its context. That such an exercise was even possible testifies to Murakami's international stature, and to an interest in his work that has long since transcended the art world to enter the realm of popular culture, style and commerce. In this respect, Murakami is clearly indebted to Andy Warhol, but presents a new and uniquely Japanese take on 'the business of art'.

Among the works at Versailles was *Flower Matango*, 2001–2006, a vast, polychrome fiberglass urn that occupied pride of place in the gilded Hall of Mirrors. Atop a goblet-like stem, two spherical forms covered with inanely grinning stylized flowers are topped and surrounded by a tangle of curling stems. The colours are opaque and saturated, the finish impenetrably high-gloss, and the overall feel something like a cartoon brought to life. The work is immediately identifiable as Murakami's for its self-consciously hyper-superficial appearance and attitude – an aesthetic that the artist has dubbed 'superflat' after the group exhibition of the same name he curated for the Museum of Contemporary Art, Los Angeles, in 2001. According to the artist, 'superflat' takes its cue from an innate Japanese predilection for two-dimensional imagery that has found its apogee in *manga* and *anime*.

'Superflat' takes its cue from an innate Japanese predilection for two-dimensional imagery that has found its apogee in *manga* and *anime*.

Extending his concept beyond the purely visual, Murakami suggests that 'superflat' also comments on the quasi-classless society of modern Japan, in which distinctions between high and low culture have been, for better or worse, largely 'flattened' or eradicated. This again makes Versailles a perfect frame for work that borrows extensively from popular culture. The building's ornate early Rococo design also emphasizes Murakami's apparent embrace of materialism and his fascination with infantilized kitsch. The latter appears in his oeuvre in a mutation of *kawaii*, the quality of 'cuteness' that has become an inescapable phenomenon in his home country and, with the international ubiquity of endlessly adaptable and marketable characters like Hello Kitty, far beyond it.

Manufacturing toys and T-shirts in his 'factory' under the Kaikai Kiki Co. imprint, and collaborating with fashion house Louis Vuitton on a series of handbags (he also installed a dedicated store inside his touring 2007–2009 retrospective), Murakami continues to push Warhol's entrepreneurial model to its very limits. He has also returned periodically to the exploration of exaggerated sexual imagery that characterizes sculptures such as *Miss Ko*, 1997, and *My Lonesome Cowboy*, 1998. A recent exhibition at Gagosian Gallery, London, juxtaposed remakes of canvases by fin-de-siècle Japanese painter Kuroda Seiki with *3m Girl*, 2011, a wide-eyed giantess with titanic breasts, in a contemporary take on the long-established Japanese tradition of *shunga*, or erotic art.

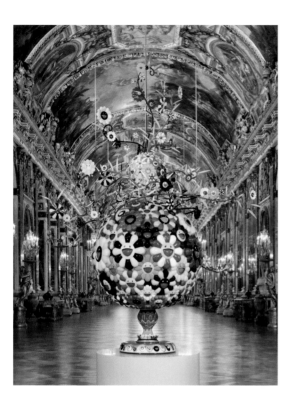

Oval Buddha, 2007-2010. Bronze and gold leaf. Water Parterre, Château de Versailles.

Tan Tan Bo, 2001. Acrylic on canvas mounted on board, three panels, 360 x 540 x 6.7 cm (overall).

Wangechi Mutu

Born in Nairobi, Kenya, 1972; lives and works in New York, USA. Mutu's work has been exhibited at galleries and museums worldwide including the San Francisco Museum of Modern Art; Miami Art Museum; Tate Modern, London; Studio Museum, Harlem, New York; Museum Kunstpalast, Düsseldorf; and the Centre Pompidou, Paris. Her work is included in the permanent collections of major institutions including the Museum of Modern Art, New York, and the Museum of Contemporary Art, Los Angeles.

Born into the Kenyan Kikuyu tribe, Wangechi Mutu was educated in Nairobi at Loreto Convent Msongari and later attended the United World College of the Atlantic in Wales. On moving to New York in the 1990s, she initially divided her studies between art and anthropology, and this interest in the structuring of human society, in conjunction with the artist's international background, continues to inform her work. Mutu's focus is on the portrayal of women's bodies, with specific reference to the ways in which they are imprinted with the skewed priorities of patriarchal culture. Her images, objects and environments address the influence of racial and sexual archetypes on the construction of personal identity, with particular reference to colonial history in general and African politics in particular.

Formally, Mutu's practice alternates between drawn or collaged works and installations that incorporate objects and videos, and which sometimes approach the gallery space itself as a blank canvas to be 'damaged' or otherwise transfigured. Using sources ranging from medical literature to pornography, motorbike journals to fashion magazines, the artist conjures up hybrid characters that critique the popular media's objectification and historicization of its female and non-Western subjects. Alluding to this process without reproducing its results, Mutu makes work that is both grotesque and seductive. Her intricate figures convey a powerful element of the fantastical even as they remain rooted in the familiar and contemporary; their allusions to mythology are filtered through a material palette that includes ribbons and glitter alongside paint and ink.

In *The Bride Who Married a Camel's Head*, 2009, Mutu presents an image of a dark-skinned woman kneeling in long grass. Butterflies hover about the figure's head as she holds aloft a bleeding jawbone. Her mane of serpentine hair is topped with an ornate floral headdress, and an opulent cluster of pearls dangles from one ear. The subject seems at once primordial in her apparent intimacy with raw nature, and majestic in her rich attire and attitude of triumph. *The Bride* reimagines signifiers of exoticism, combining the real with the otherworldly until the clichés surrounding 'blackness' are subsumed into an open-ended whole. Its lush detailing and texture thus not only reflect a labour-intensive technique, but also suggest a multiplicity of possible interpretations.

Mutu uses imagery of a similar stripe in her installations, but employs a variety of sculptural means to expand the experience of her work on paper into ambient space. In *Our lost mind finding a heart in dutty water*, 2007, which was included in the 10th Biennale de Lyon in 2009, she confronts the viewer with a long translucent curtain patterned with images of 'fallen heads' derived from her recent portraits. Behind the curtain, an array of light bulbs hangs above a floor soaked by water leaking from hoses plugged with high-heeled shoes. The danger of electrocution to which this combination alludes has, in concert with the portraits, a characteristic diversity of associations, centred on what the artist describes, tellingly, as 'the collapse and breakdown of a system.'

Sleeping Heads (detail), 4 of 8, 2006.
Mixed media collage on Mylar, 43.2 x 55.9 cm.

Our lost mind finding a heart in dutty water, 2007.
Mixed media, dimensions variable. Biennale de Lyon, 2009.

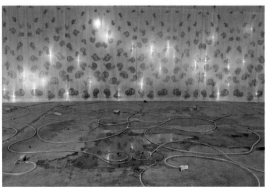

Stay the Same Never Change, 2008

Colour video with sound, 93 minutes. The Museum of Modern Art, New York.

Laurel Nakadate

Born in Austin, Texas, USA, 1975; lives and works in New York. Nakadate's work has been exhibited at MoMA PS1, New York; Yerba Buena Center for the Arts, San Francisco; J. Paul Getty Museum, Los Angeles; and Museo Nacional Centro de Arte Reina Sofía, Madrid. Her debut feature film, *Stay the Same Never Change*, premiered at the Sundance Film Festival in 2009. Her second feature, *The Wolf Knife*, premiered at the 2010 Los Angeles Film Festival and was nominated for a 2010 Gotham Independent Film Award and a 2011 Independent Spirit Award.

'In general, I wait to be approached. I want to be the one who's hunted, I want to be the one who they take interest in – because if they're not interested in me, they're probably not going to be interested in being in a video. I also like the idea of turning the tables – the idea of them thinking that they're in charge or that they're in power and they're asking me for something and then I turn it on them, where I'm the director and the world is really my world.' In a series of films begun when she was an MFA student at Yale University, Laurel Nakadate plays a seemingly dangerous game, allowing herself to be invited into the homes of anonymous single men. Once there, she poses for pictures, dances – even stages ersatz birthday parties. It is a routine that makes for profoundly uncomfortable viewing.

Muddying the distinction between empathy and exploitation, Nakadate's videos were immediately controversial, and raised discomfiting questions. Where did an artistic project, even one with intimations of anthropological study, shade into a problematic exercise in voyeurism? When did the staging and play-acting in the works end and an unscripted narrative of sexual power and fantasy begin? And how were artist and viewer implicated in the images' content? The narrative of trust and betrayal that shapes works such as *Oops!*, 2000, and *Don't You Want Somebody to Love You?*, 2006, also colours *Good Morning, Sunshine*, 2009, a video in which Nakadate enters the bedrooms of teenage girls (all respondents to a casting call), wakes them up, and instructs them to strip to their underwear. The footage, shaky in the manner of amateur pornography, seems to heighten the atmosphere of anxiety and interrupted innocence.

In the photographic series '365 Days: A Catalogue of Tears', 2011, Nakadate again turns the camera on herself, documenting an extended performance in which she wept every day for a year. The images, which picture her before, during and after each tearful episode, suggest that she was either alone and withdrawn from the world during this time, or else engaged in an endless round of travel that largely confined her to hotel rooms and airplane toilets. In many of the shots, her image is reflected in mirrors or windows, a reference to the act of looking in which she and us, her audience, is engaged. And as in Nakadate's earlier works, there is an unsettling intimation of the breach of personal privacy.

The girls are pretty – and prettily photographed – but the situations they place themselves in soon begin to feel dangerous.

In the feature film *Stay the Same Never Change*, 2008, Nakadate explores these themes in a form that she characterizes as 'both visual fact and narrative fiction'. The movie's teenage female protagonists, played by amateur actors, are seen drifting through Kansas City while men leer after them. The girls are pretty – and prettily photographed – but the situations they place themselves in soon begin to feel dangerous, and the setting veers all-too-easily from banal to unsettling. 'It's a strange little movie about the ways the world can disappoint or enthral us,' the artist says, 'and the things we do to be okay.'[1]

1 The artist in N. Rain Noe, 'Laurel Nakadate's Lens on the Lonely', *Theme*, issue 13, February–March 2008.

December 19, 2010. Chromogenic print, 101.6 x 127 cm.
From the series '365 Days: A Catalogue of Tears', 2011.

Don't You Want Somebody to Love You?, 2006.
Single-channel colour video with sound, 3 minutes 3 seconds.

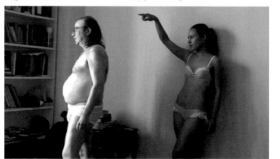

Good Morning, Sunshine, 2009.
Single-channel video with sound, 14 minutes 50 seconds.

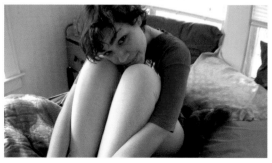

Rosalind Nashashibi

Born in Croydon, England, 1973; lives and works in London. Nashashibi has had solo exhibitions at Presentation House Gallery, Vancouver; Chisenhale Gallery and Tate Britain, London; and Fruitmarket Gallery, Edinburgh. She has also participated in Manifesta, the Venice Biennale and the British Art Show. In 2003, she was a winner of the Beck's Futures Award at the Institute of Contemporary Arts, London. In addition to working independently, Nashashibi maintains a collaborative practice with artist Lucy Skaer.

'I'm interested in the line between being and performing,' explains Rosalind Nashashibi, 'and I use observation as a starting point for talking about a layer of reality beyond the immediately obvious.' In *Jack Straw's Castle*, 2009, a short film commissioned by Bergen Kunsthall and the Institute of Contemporary Arts in London, Nashashibi explores these and other ideas via an unexpected convergence of people and pursuits. The title refers to a part of Hampstead Heath in North London that surrounds a former pub named in honour of one of the leaders of the English Peasants' Revolt of 1381 (the 'castle' was a hay wagon from which Straw would address his followers). This tract of public woodland, now better known as a cruising area for gay men, provides the work with its setting.

Jack Straw's Castle was shot during the day and at night, and interweaves real-life footage with staged scenarios. There are no professional actors in the film, but the artist's mother, Pauline Nashashibi, takes on the role of protagonist – and could also be described as a stand-in for the artist herself. She is shown strolling through the park at dusk and encountering a film crew setting up lights in a clearing, their aim to transform an outwardly natural space into an idealized arena designed with cinema audiences in mind. In the film's after-dark sequences, men walk around looking to meet others for the purpose of illicit al fresco sex. Filming the latter scenes was, Nashashibi admits, 'a tense experience'. But she also remembers her and her cinematographer Suzie Lavelle receiving 'knowing smiles' from some subjects, 'as if we were complicit in their act'.

***Jack Straw's Castle* suggests that the boundary between common ritual and unscripted action is permeable.**

Jack Straw's Castle suggests that the boundary between common ritual and unscripted action is permeable, and looks at how both strains of activity are filtered through the techniques and aims of cinema. In its concentration on all-male groups – the artist's mother provides the film's sole visible female presence – it directs viewers' attention to the shared characteristics of different homosocial environments. And in its focus on the performative nature of both the lighting crew's quest for aesthetic perfection and the cruising men's hunt for intimacy, it tracks the acting out of two different kinds of desire. Not much 'happens' here, but Nashashibi's foundational decisions – the presence of her mother alone raises numerous uncomfortable issues – and the gestures and instructions employed by her subjects, generate a complex meditation on voyeurism, the observer and the observed.

The Prisoner, 2008.
Two-screen colour 16 mm film with sound, 5 minutes.

Nashashibi's other films and photographs deal with closely related territory. In *Eyeballing*, 2005, accidental 'faces' found by the artist in objects and images around New York City are juxtaposed with shots of off-duty cops, who appear to scrutinize their observer with some suspicion. And in *The Prisoner*, 2008, the camera follows a woman around London's South Bank Centre to the strains of Rachmaninoff's *The Isle Of The Dead*, the sequence marked by a portentous atmosphere conjured from nothing more than well-worn filmic devices and the staggered distribution of imagery across two screens. But while the anticipated climax again remains elusive, Nashashibi does far more than merely set the scene.

Jack Straw's Castle, 2009.
Colour 16 mm film with sound, 17 minutes.

Eyeballing, 2005. Colour 16 mm film with sound, 10 minutes.

Mike Nelson

Born in Loughborough, England, 1967; lives and works in London. Nelson's work has appeared in exhibitions at the Institute of Contemporary Arts, London; Australian Centre for Contemporary Art, Melbourne; CCA Wattis Institute for Contemporary Arts, San Francisco; and the Statens Museum for Kunst, Copenhagen. His major installation *The Coral Reef* was acquired by Tate Britain in 2008. A recipient of Paul Hamlyn Award in 2001, Nelson was nominated for the Turner Prize in 2001 and 2007, and represented Britain at the Venice Biennale in 2011.

The title of Mike Nelson's installation *A Psychic Vacuum*, 2007, echoes that of science fiction writer Stanislaw Lem's book *A Perfect Vacuum*, 1971. Lem's text is a collection of reviews of non-existent books; Nelson's project suggests the set of an imaginary movie. Commissioned by public art agency Creative Time, *A Psychic Vacuum* occupied a disused warehouse in Essex Street Market on Manhattan's Lower East Side. Nelson transformed the tumbledown structure into a dense and forbidding labyrinth of rooms and corridors furnished with a range of locally sourced found objects. So while the work's enigmatic tableaux looked to have been assembled months or years ago by anonymous and long-gone individuals, they were in fact the products of the artist's own meticulous planning and construction.

Entering through what appeared to be the charred remains of a Chinese restaurant, visitors to *A Psychic Vacuum* were plunged into a meandering complex rife with intimations of clandestine, extremist and criminal activity. Dim and hot, the installation's claustrophobic cells suggested makeshift offices, drug dens or torture chambers. One resembled a closed-down bar, another a cluttered photographic darkroom. A range of props added to the work's general impression of secrecy and squalor; obscure books and old magazines were piled next to broken toys and rusted tools, strange religious artifacts rubbed up against what might have been terrorist or survivalist paraphernalia. Without evoking a specific narrative, Nelson's environment turned on an atmosphere of dread and an allusion to the permeable border between reality and simulation, public and private, the ordinary and the occult.

Without evoking a specific narrative, Nelson's environment turned on an atmosphere of dread.

The artist's first installation in the United States, *A Psychic Vacuum* employed a physical structure similar to that of earlier works such as *The Coral Reef*, which was first produced in 2000 at Matt's Gallery in London and later remade for Tate Britain, and *The Deliverance and the Patience*, which was shown in a former brewery during the 2001 Venice Biennale. These and other of Nelson's works revolve around an interweaving of fact and fiction that, while bolstered by literary and historical references, remains sensitive to the peculiar conditions of their sites. In its hallucinatory conjuring of 'unreal' places, the artist's practice finds formal parallels in those of Christoph Büchel and Gregor Schneider, but is equally indebted to the reality-bending games played by authors of genre fiction including Ray Bradbury, H. P. Lovecraft, and the aforementioned Lem.

The Coral Reef, 2000.
Mixed media, dimensions variable.
Installation, Tate Britain, London.

As the development of *A Psychic Vacuum* suggests, Nelson also directs his referential gaze inward, revisiting his own creative history as a strategy for moving forward. Returning to Venice in 2011 as Britain's national representative, he reworked *Magazin: Büyük Valide Han*, an installation made for the 2003 Istanbul Biennial, to produce *I, Imposter*. The earlier work featured a darkroom filled with shots of the surrounding area; its descendant was a remake from memory to which were added reproductions of parts of the 17th-century caravanserai (roadside inn) that housed *Magazin*. The result was a conflation of two divergent contexts that created a third arena both strangely familiar and entirely new.

I, Imposter, 2011. Site-specific architectural installation, dimensions variable. British Pavilion, Venice Biennale.

Games of Desire, 2009

Two-channel colour video installation with sound, 22 minutes 27 seconds.

Shirin Neshat

Born in Qazvin, Iran, 1957; lives and works in New York, USA. Neshat has been the subject of solo exhibitions at the Museo de Arte Moderno, Mexico City; Espoo Museum of Modern Art, Finland; Castello di Rivoli, Turin; Wexner Center for the Arts, Columbus; the Art Institute of Chicago; the Serpentine Gallery, London; and the Hamburger Bahnhof, Berlin. She was included in Documenta XI, the 1999 Venice Biennale and the 2000 Whitney Biennial. She has been awarded the First International Award at the 48th Venice Biennale, the Hiroshima Freedom Prize and the Lillian Gish Prize.

The striking photographs and videos of Shirin Neshat are dominated to a great extent by the juxtaposition and interrogation of binaries, whether cultural, sexual, ideological or religious. In several of her recent installations, the viewer is placed literally between two opposing views, seated in the middle of a pair of screens positioned so that it is impossible to watch them both simultaneously. Concerned in particular with the position of women in her native Islamic society, Neshat dramatizes the problems of inequality and miscommunication exacerbated by national circumstances. But while it addresses specific conditions, her work has a universal resonance in its appeal to feelings and ideas surrounding ritual and identity, love and loss in a world governed by rules and conventions that often seem to belong to a different era.

In Neshat's series 'Women of Allah', 1993–1997, which was made immediately after her first trip back to Iran since the 1979 Islamic Revolution, the artist overlays black-and-white portrait photographs with delicate Farsi calligraphy. The images feature women, many of them members of the artist's family, wearing veils and brandishing guns, gazing out at the viewer with confrontational directness. The texts are extracted from poetry and prose by contemporary Iranian women writers, and represent a wide variety of perspectives, some of them apparently incompatible. The combination of image and text problematizes the Western perception of Muslim women as mute and desexualized; Neshat herself traces the works' visual elegance to her early experiences of Koranic iconography, and their conceptual power to an implication of deep personal involvement.

Neshat dramatizes the problems of inequality and miscommunication exacerbated by national circumstances.

Passage, a video from 2001, was made in collaboration with American minimalist composer Philip Glass, and shows Neshat taking a comparatively pared-down approach. The film opens on a group of black-suited men carrying a body across a beach and into the landscape beyond, eventually arriving at an isolated burial site. In a separate scene, veiled women chant intently and dig at the ground with their hands while a young girl nearby plays at building a campfire out of stones. A final scene brings these elements together and shows the earth bursting into flames as body and soil also meet. Less didactic than 'Women of Allah', *Passage* is an open-ended meditation on the cycle of life and death, and the enduring value of symbolic ritual action.

Neshat's video installation *Games of Desire*, 2009, shows her making use of the twin-screen format, but shifts the scene from the Middle East to the Southeast Asian country of Laos. Here, the artist's twinned images present men and women reciting the traditional courtship songs known as *lam*. *Games of Desire* laments the gradual disappearance of its subject, a custom that allows participants to escape, albeit fleetingly, the confining bonds of everyday convention via a joyful and humorous exchange. Neshat separates the sexes to engineer a call-and-response-style face-off, turning the viewer into a silent interloper. She also pictures the crowds that gather to watch the performers, emphasizing the profound need for modes of expression that offer both participants and viewers an escape from the prescribed.

If I had wings like a crow,
I would have taken you and made you fly with me.

Passage, 2001. Colour video installation with sound,
11 minutes 30 seconds. Solomon R. Guggenheim Museum, New York.

Stories of Martyrdom, 1995. Ink on silver gelatin print,
101.6 x 152.4 cm. From the series 'Women of Allah'.

Rapture, 1999. 16 mm black-and-white film with sound, transferred to two-channel video installation, 13 minutes.

Rivane Neuenschwander

Born in Belo Horizonte, Brazil, 1967; lives and works there. Neuenschwander's work has been the subject of solo exhibitions organized by the New Museum, New York; Artpace Foundation, San Antonio; Portikus, Frankfurt; Walker Art Center, Minneapolis; St. Louis Art Museum; and the Carnegie Museum of Art, Pittsburgh. Her work has also been included in the Istanbul Biennial; São Paulo Biennial, and Venice Biennale. In 2004, she was shortlisted for the Hugo Boss Prize at the Solomon R. Guggenheim Museum in New York.

At just ten-and-a-half minutes long, the drama traced by Rivane Neuenschwander's video *The Tenant,* 2010, is brief, but unfolds with an eerie, suspenseful slowness. Named after a 1976 movie by Roman Polanski, the projected loop follows a large soap bubble's leisurely passage around the interior of a deserted house. As we watch, the bubble – real, not a digital simulation – rounds corners, bounces gently off walls and ceilings, and even appears to pause occasionally, hovering in space and generating an extraordinary tension. We constantly expect to see this fragile entity burst, but editorial cuts, which make it plain that several bubbles were used in the work's filming, extend its life indefinitely.

Made in collaboration with Cao Guimarães, *The Tenant* thus invests a sequence of quiet formal beauty with an edge of anxiety. Subtle sound effects and atmospheric music by O Grivo contribute to the work's moody ambiguity. The bubble survives its journey but never reaches any particular destination, leaving us to ponder its ultimate role and purpose. In Polanski's film, a psychological thriller based on Roland Topor's novel *Le locataire chimérique*, 1964, a filing clerk named Trelkovsky moves into a small apartment in Paris, the previous tenant of which has attempted suicide. Gradually, the building's other occupants, whom Trelkovsky suspects are responsible for the woman's eventual death, force him to assume his predecessor's identity. In Neuenschwander's video, this tale of isolation and madness is rendered mute, but its horror persists.

Neuenschwander's practice is not restricted to video; she also makes paintings, objects, collages and installations. Many of these have a collaborative, interactive or mutable dimension. The much-travelled installation *I wish your wish*, for example, is comprised of a colourful array of ribbons printed with pleas contributed by members of the public. Viewers are invited to take a ribbon of their choice and wear it around their wrist, replacing it with a piece of paper inscribed with their own desire. *Involuntary Sculptures (Speech Acts)*, 2001–2010, is an archive of casual constructions made and abandoned by the anonymous patrons of restaurants and bars. Three-dimensional doodles made from coasters and straws, sugar cubes and Champagne corks, these ephemeral objects evince an informal creativity and evoke, with gentle melancholy, good times long past.

Neuenschwander's practice, while formally diverse, is bound together by a fascination with reduction, erasure and absence.

As all these works suggest, Neuenschwander's practice, while formally diverse, is bound together by a fascination with reduction, erasure and absence. Conjoined with an interest in marking the passage of time, this endows it with an emotional heft often missing from concept-driven art. Her most successful projects display a fusion of sophistication and accessibility that has earned their maker comparison with other influential figures in Brazilian art such as Clark and Oiticica. In Neuenschwander's hands, images and objects are never autonomous, but function as powerful records of individual and (especially) social life. Her core concern is with the fleeting nature of human experience, whether physical or psychological; thus the vulnerability of the bubble in *The Tenant* strikes a chord even when its simple illusion becomes clear.

Involuntary Sculptures (Speech Acts), 2002. Mixed media, dimensions variable.

I wish your wish, 2003. Ink on fabric ribbons, dimensions variable. New Museum, New York.

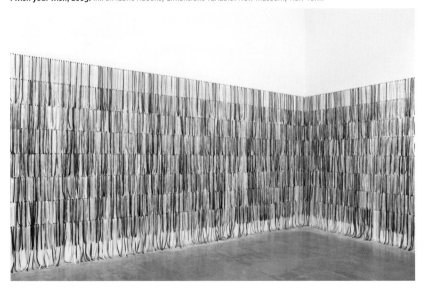

Misc. Spill, 1990

Mixed media, dimensions variable. Museum of Contemporary Art, Los Angeles.

Cady Noland

Born in Washington, D.C., USA, 1956; lives and works in New York. Noland's first solo exhibition was at White Columns, New York, in 1988. Other exhibitions have been organized by the Paula Cooper Gallery, New York; Museum Boijmans Van Beuningen, Rotterdam; and Wadsworth Atheneum Museum of Art, Hartford, Connecticut. Noland's work also appeared in 'Strange Abstraction: Robert Gober, Cady Noland, Philip Taaffe, Christopher Wool' at the Touko Museum of Contemporary Art, Tokyo, and 'Cady Noland & Olivier Mosset: MONO' at Migros Museum für Gegenwartskunst, Zurich.

In 2006, the mischievous (and now defunct) New York gallery Triple Candie, already notorious for mounting an unauthorized exhibition of photocopied reproductions of work by American sculptor David Hammons, presented 'Cady Noland Approximately: Sculptures & Editions, 1984-1999'. Again organized entirely without the artist's agreement, this strange quasi-survey consisted not of original works but of uncredited remakes by Taylor Davis, Rudy Shepherd and two other anonymous participants. Dubbed 'approximations' rather than copies, these objects and images, based on works made by Noland between the mid-1980s and the late 1990s, were derived from whatever information the makers could find. 'By deliberately falling short of its target,' they wrote, 'the exhibition is meant to incite the public's desire and curiosity to experience the real thing, which remains frustratingly elusive.'

What happened to this artist, and what is it about her that still attracts such fascination? A star of the early 1990s scene around New York gallery American Fine Arts, Noland, daughter of abstract painter Kenneth Noland, withdrew from the commercial art world after her first solo exhibition at Paula Cooper Gallery in 1994. Yet while she continues to exercise rigid control over the exhibiting of her oeuvre, and has never been the subject of an official retrospective or monograph, numerous active artists - Sarah Lucas, Josephine Meckseper, Seth Price and Banks Violette among them - acknowledge her as an influence. The sensational appeal of a 'disappeared' figure may have some bearing on this, but it is the uncanny contemporaneity of Noland's work that has secured her continuing cult status.

Misc. Spill, 1990, a scattered installation that incorporates aluminium awning frames, a car bumper, a shopping cart and a stars-and-stripes flag alongside pipes, cinderblocks and metal barricades, is typical of Noland's muscular and confrontational style. By selecting materials and forms associated with the spectacle, violence and waste of mainstream American culture, she infuses the strategies of Duchamp and Warhol with socio-political weight, offering viewers a jarring and still-pertinent state-of-the-union address. *Misc. Spill* also engages forcefully with the architecture of its display space to suggest a critique of institutional strictures. And while so many artists strive to invite the viewer in, Noland deliberately erects aggressive obstructions that prompt us to question the ways in which our own public roles and identities are mediated and controlled.

Untitled, 2008.
Metal basket, motorcycle helmets, film reel, subway straps, cast metal object, 34.3 x 64.8 x 33.7 cm.
Walker Art Center, Minneapolis.

In other works, Noland has used stock photography and reprinted cuttings from tabloid newspapers to address the myth-making power of mass culture still more directly. Some early examples make explicit reference to then-current events; others recycle and manipulate images long-since rendered iconic through notoriety. *Oozewald*, 1989, for example, features a famous shot of Lee Harvey Oswald and his assassin Jack Ruby, printed onto an aluminium cut-out. Oswald's face is peppered with white discs suggestive of bullet holes, while a crumpled American flag spews from his mouth. That the sculpture changed hands at a New York auction in 2011 for $6.57 million suggests that the appeal of Noland's tough-talking post-Pop aesthetic is as powerful as ever, even if the artist herself maintains a critical distance.

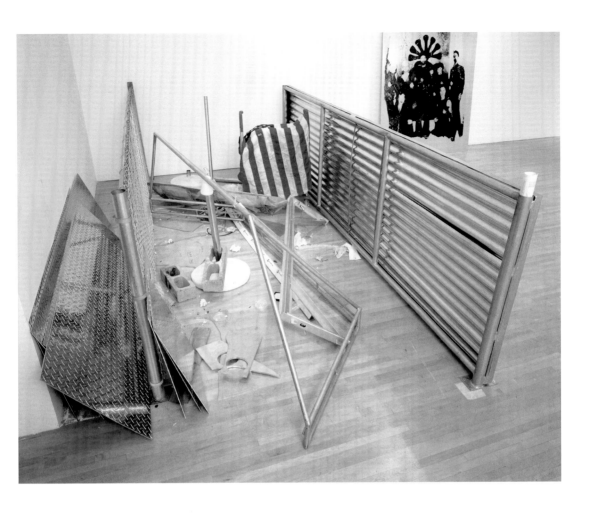

Mutated Pipe, 1989. Mixed media and chrome rod, 83 x 334 x 13.5 cm. Museum für Moderne Kunst, Frankfurt.

Talking with Bramante, Rope Drawing # 111, 2007

Rope, painted walls, dimensions variable. Installation, Grey Art Gallery, New York.

Brian O'Doherty

Born in County Roscommon, Ireland, 1928; lives and works in New York, USA. O'Doherty exhibited under the name Patrick Ireland for thirty-six years in numerous exhibitions, including Documenta and the Venice Biennale. Surveys of his work have been held at venues including the Smithsonian American Art Museum, Washington, D.C.; Elvehjem Museum (now Chazen Museum), Madison, Wisconsin; and MoMA PS1, New York. O'Doherty's art is held in numerous collections including those of the Metropolitan Museum of Art, New York, and Dublin City Gallery The Hugh Lane.

Commissioned for a major retrospective of his work at New York University's Grey Art Gallery in 2007, Brian O'Doherty's *Talking with Bramante, Rope Drawing # 111* used a system of stretched cords and painted wall surfaces to divide up an institutional interior. Part of an extended series of such installations begun in 1973, this 'drawing in the air' was an architectural disruption that intersected with O'Doherty's hugely influential collection of essays, *Inside the White Cube: The Ideology of the Gallery Space,* 1976. In *Talking with Bramante*, the room's perspective is distorted by geometric fields of colour that generate fleeting impressions of depth and proximity, while the slender coloured ropes that run from floor to ceiling and wall to wall partially dictate the viewer's route around the site.

O'Doherty is a figure of extraordinary range and erudition. Trained in Ireland and England as a physician, he emigrated to the United States in 1957. Moving to New York in 1961, he devoted himself to art and criticism, exploring in particular the possibilities offered by Conceptual practice and theory. In addition to exhibiting his own work, he has served as editor of *Art in America* and appeared on television as NBC's resident expert. Over the years, he has also held key positions in the National Endowment for the Arts, helping to facilitate the making of several important television documentary series, and is the author of the novels *The Strange Case of Mademoiselle P.,* 1992, and *The Deposition of Father McGreevy,* 1999, which was nominated for the Booker Prize.

O'Doherty is also known for inhabiting a number of alter egos. The longest-lived of these was Patrick Ireland, created in protest at the 1972 Bloody Sunday massacre in Derry, at which British troops shot and killed fourteen civil rights marchers. In 2008, the year after the British withdrew their military from Northern Ireland, O'Doherty ceremonially 'buried' his character at the Irish Museum of Modern Art in Dublin. But while the artist's practice thus demonstrates an overtly political component, it is perhaps more visibly indebted to the ideas and persona of Marcel Duchamp. O'Doherty has made repeated reference to the French provocateur, launching explorations of the Minimalist grid from variations on his beloved game of chess, for example, and basing a portrait of the luminary on his electrocardiogram.

Portrait of Marcel Duchamp: Mounted Cardiogram, 4/4/66, 1966.
Ink on paper, 27.9 x 21.6 cm.
Collection of the artist.

Through such works, O'Doherty demonstrates a playful spirit even as he engages with the complexities of art's history and language. *Talking with Bramante* showed a similar depth and breadth, toying with the viewer's visual perception while alluding to the artist's study of socio-economic and philosophical-aesthetic contexts. Stylistically, it also echoed the approaches of Sol LeWitt (the painted walls) and Fred Sandback (the stretched ropes). Just as *Inside the White Cube* articulates the absolute lack of 'neutrality' in even the clean, well-lit space of a typical modernist gallery, *Talking with Bramante* prompts a reassessment of our habitual ways of looking at and navigating an artwork, embodying the possibility of a more active and thoughtful response to any given situation – however materially or conceptually tangled it may appear.

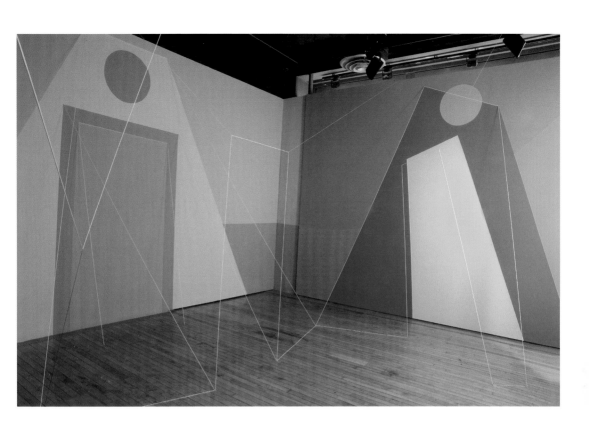

Five Identities, 2002.
Photograph on aluminium, 124.5 x 124.5 cm.
Collection of the artist.

Hello, Sam, 2011. Mixed media installation, dimensions variable.

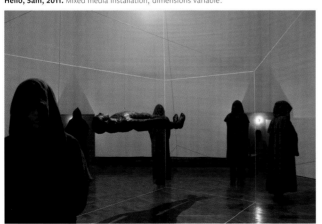

Hans Op de Beeck

Born in Turnhout, Belgium, 1969; lives and works in Brussels. Solo exhibitions of Op de Beeck's work have been mounted at GEM, The Hague; the Museum of Contemporary Art (M HKA), Antwerp; Galleria Borghese, Rome; Hirshhorn Museum and Sculpture Garden, Washington, D.C.; and Kunstverein Hannover. He has participated in group exhibitions including 'Breaking Away' at MoMA PS1, New York; 'All that Useless Beauty' at Whitechapel Project Space, London; and the Venice Biennale in 2011, among others.

Hans Op de Beeck made the first entry in his 'Location' series of sculptural installations while a student at Amsterdam's Rijksakademie, and it catapulted him to immediate visibility. *Location (1)*, 1998, is a large, meticulously rendered table-top model of an intersection at night. Housed in a darkened space, the wintry scenario features a set of diminutive traffic lights that turn dutifully on and off, but is otherwise static and silent. The dead trees that surround the crossroads and the simulated moonlight that illuminates it contribute to an almost post-apocalyptic sense of abandonment and desolation. Immersive in the manner of a theatrical set, *Location (1)* establishes one of the artist's central, recurring themes: alienation from a world of circular routine and failed communication.

The situation in *Location (7)*, 2011, is similar to this foundational work in that it confronts the viewer with a scenario at once familiar from everyday life and yet at the same time oddly removed from it. Seemingly frozen in time, its strangeness is emphasized via details of material, scale and setting. This recent work is not strictly speaking a model, more a life-size simulation, and the space it reproduces is, in a first for the series, private. From a living room based on the interior of a generic suburban home, viewers look out onto a nocturnal garden. The interior seems to have been recently vacated - a bed is unmade and objects are strewn about - and its contents are a uniform grey reminiscent of Pompeiian ash. Outside, the remnants of a barbecue are juxtaposed with a decorative fountain hung about with lights. Here, too, all is colourless.

Adding to the eerie mood are two soundtracks. Ambient noise emanating from the garden is paired with a more conventionally musical piece, specially composed by Serge Lacroix, heard in the interior, the combination adding a layer of cinematic atmosphere. In conjunction with the all-grey look - not a paint job but the result of every feature having been cast in concrete - the impression is one of absolute artifice and perfect futility, an exercise in control that leads nowhere. Highlighting the house-and-garden arrangement's innate theatricality, Op de Beeck lays bare the human drive to project an outward impression of security and normality, no matter what the underlying circumstance. The only thing that feels truly 'real' is the gradual return of nature, reasserting itself in the absence of human activity. It's a tragi-comedy worthy of Samuel Beckett.

Op de Beeck probes the cracks in 'reality', prompting us to question our own role in its construction.

Op de Beeck's aesthetic drifts between the minimal and the saturated, but his focus remains the ways in which our identities and relationships are strained and abstracted by the advance of technology and the rise of globalization. In films, photographs, sculptures, drawings and other kinds of what he refers to as 'proposals', Op de Beeck probes the cracks in 'reality', prompting us to question our own role in its construction. Sometimes, as in the 2010 exhibition 'Silent Movie' at Marianne Boesky Gallery in New York, the styling of his images and objects makes explicit reference to the history of film; in the 'Location' series, we are encouraged to project our own personal stories onto each disconcerting scene.

Location (1), 1998. Sculptural installation, mixed media, 3.2 x 4 x 5 m.

Hans Op de Beeck, Location (6), 2008. Sculptural installation, mixed media, mist and artificial light, 18 m diameter and 4 m high (cylinder).

Gabriel Orozco

Born in Jalapa, Veracruz, Mexico, 1962; lives and works in New York, USA; Paris, France; and Mexico City. Orozco has shown his work at distinguished venues including the Whitney Museum of American Art, the Museum of Modern Art and Solomon R. Guggenheim Museum, New York; Philadelphia Museum of Art; and the Venice Biennale. A major retrospective of his work was organized by the Museum of Contemporary Art, Los Angeles, in 2000, and later travelled to the Museo Tamayo, Mexico City, and the Museo de Arte Contemporáneo de Monterrey, Mexico.

The ragged forms of the rubber strips and coils reflect the action of explosive force.

Gabriel Orozco's installation *Chicotes*, 2010, was produced for the artist's 2011 survey exhibition at Tate Modern in London, but is based on a collection that he has been putting together for several years. Across the floor of one gallery were arranged dozens of scraps of black rubber car tyres found on the sides of Mexican highways. Some of these partially shredded remains have pools of aluminium melted into them, perhaps in allusion to the wheels that the rubber originally encased. Others are simply laid flat, suggesting the skins or skeletons of insects or reptiles. The singed waste is also still wreathed in a distinctive smell, described by critic Ben Street as 'redolent of escape, of exile' in its sensory evocation of life on the road.

Though static, *Chicotes* thus refers outside itself to a history of motion and place, and to the physical trauma that led to its main ingredient being discarded. The ragged forms of the rubber strips and coils reflect the action of explosive force, while the fossil-like relief effect produced by the aluminium's contact with their distinctively textured surfaces generates an impression of ancient, organic origin. As Street observes, there are links here to the natural forms of Land Art – especially as interpreted by Robert Smithson – and perhaps also to Joseph Beuys's *Lightning with Stag in Its Glare*, 1958-1985, which narrates the creation of primordial creatures not entirely dissimilar to Orozco's salvaged fragments. Orozco also owes a debt to Barry Le Va's scatter art for *Chicotes*'s all-over distribution.

Orozco often makes work at the site of an exhibition using local materials, but while this is not the case with *Chicotes*, he has adapted the form of the work in response to the architecture and location of its site. The work is also consistent with the artist's interest in reassessing everyday forms; he continually encourages the viewer to take a closer look at even the most seemingly banal and ephemeral objects and materials. Often, this involves radical physical transformations. To make the sculpture *La DS*, 1993, for example, he sliced a vintage Citroën DS into thirds and excised the central part, stripping the vehicle of its functionality to arrive at an exaggerated, caricature-like tribute to the car's aerodynamic design.

Elsewhere, Orozco makes smaller, subtler alterations to his source material. In addition to producing installations, sculptures and videos, he works extensively in photography, print and painting, and the use of a still camera in particular allows him to capture the beauty of passing moments. *Breath on Piano,* 1993, for example, records a momentary haze of condensation on the instrument's glossy black surface. In his graphic work, Orozco reveals a playful interest in games and sports, and a concomitant predilection for geometric devices. His series 'Samurai Tree Invariant Paintings', 2005, employs the L-shaped knight's move in chess to determine the positions of four different colours within a diagram-like composition. The results, while abstract, again retain a vital connection to the world as we know and negotiate it, but suggest that there are always alternative moves to be made if we know where and how to look.

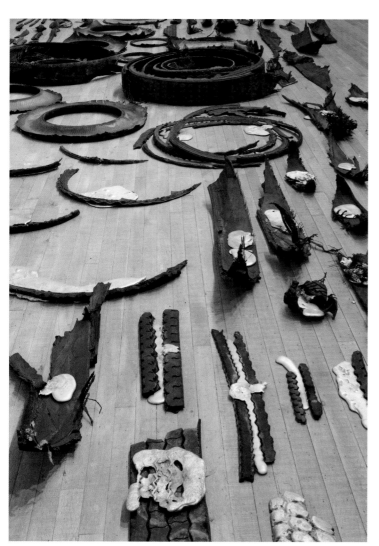

Samurai Tree (Invariant 6), 2005.
Acrylic on linen canvas, 120 x 120 cm.

La DS, 1993. Modified Citroen DS, 140.1 x 482.5 x 115.1 cm.
Collection Fonds national d'Art contemporain, France.

Breath on Piano, 1993. Colour photograph, 40.6 x 50.8 cm.

Tanja Ostojić

Born in Užice, Serbia, former Yugoslavia, 1972; lives and works in Berlin, Germany. Ostojić has exhibited and performed internationally at venues including the Rooseum Center for Contemporary Art, Malmö; KW Institute for Contemporary Art, Berlin; Brooklyn Museum, New York; MUMOK, Vienna; and the Museum of Contemporary Art, Zagreb. She has performed at events including the 2001 and 2011 Venice Biennale; Manifesta 2, Luxembourg; and Institute of Contemporary Arts, London. Her work is represented in numerous public collections including that of the Museum of Contemporary Art, Belgrade.

'I have a problem with what passes for "general awareness" in the world because politics consists in what the media doles out to readers, viewers and listeners. I'm interested in a constructive criticism of society in the widest sense. Politically engaged art is just a part of this criticism. But as I also insist on staying out of the world of politics, I am freer to express myself through the works "on my own head", like hairstyles. Posters, flyers, postcards, street actions, situational works, dinner discussions and artist statements allow me to construct informal platforms for discussion, within an exhibition space, on the Internet or wherever I am.'[1] Tanja Ostojić's characterization of her coruscating, mercurial and explicitly feminist practice describes a commitment to the integration of art into everyday life in the context of a redrawn map of Europe.

In 2000, Ostojić began *Looking for a Husband with EU Passport*, an interactive project in which she employed various media to initiate a critique of European power and bio-politics, emphasizing the impact of bureaucracy on the lives of women. After publishing an ad for a partner equipped with the titular document, the artist embarked on a correspondence involving several hundred applicants. Eventually, one of these, German citizen Klemens G., stood out, and Ostojić arranged a meeting. The rendezvous was staged as a performance outside the Museum of Contemporary Art in Belgrade in 2001, and a month later, the two married in New Belgrade. At this point, with the required documents in hand, the artist applied for a visa.

Ostojić recounts what transpired: 'After two months, I got one entrance family unification visa for Germany, limited to three months, so I moved to Düsseldorf where I was officially living for three-and-a-half years. In spring of 2005, my three-year permit expired, and instead of granting me a permanent residence permit, the authorities granted me only a two-year visa. After that K. G. and I got divorced, and on the occasion of my *Integration Project Office* installation opening at Project Room in Gallery 35 in Berlin on 1 July 2005, I organized *Divorce Party*.'[2] Critic Suzana Milevska writes that Ostojić's experience 'reveals and ironizes the truth about the traffic with women, prostitution, pragmatic marriages, and all the other "side effects" of transition.'[3]

'In such conditions,' Milevska argues, 'the economy of gendering is inevitably the economy of power over the body.'[4] This relationship is emphasized in *Looking for a Husband with EU Passport* by the image that Ostojić used in her advertisement, a stark shot of her thin, shaven figure looking closer to that of a concentration camp victim than a conventional object of desire. The artist has also exploited this kind of apparent contradiction elsewhere to highly divisive effect: a poster showing her crotch clad in underwear emblazoned with the EU flag - a riff on Gustave Courbet's *L'Origine du monde*, 1866, again targeted at legislative inequalities - triggered controversy. It was presented on rotating billboards in Vienna when Austria had taken over the 2006 presidency of the Council of the European Union. The work was removed after two days as a result of an enormous media scandal. 'Provocation', admits Ostojić, 'is a speciality of mine.'

1 From an interview with the artist: http://www.van.at/see/tanja/
2 From a statement by the artist:
 http://www.brooklynmuseum.org/eascfa/feminist_art_base/gallery/tanja_ostojic.php?i=1360
3 From an essay extracted on the artist's website: http://www.van.at/see/tanja/
4 Ibid.

Looking for a husband with EU passport

Please send your applications to hottanja@hotmail.com
Do not hesitate to contact me with any further questions or details

Tanja Ostojić and Marina Gržinić, Politics of Queer Curatorial Positions: After Rosa von Praunheim, Fassbinder, and Bridge Markland, 2003. Colour photograph, 100 x 100 cm.

I'll Be Your Angel, 2001–2002.
Colour video with sound documenting performance 'with' Harald Szeemann at the 49th Venice Biennale, 22 minutes.

Untitled/After Courbet (L'Origine du monde), 2004. Poster.

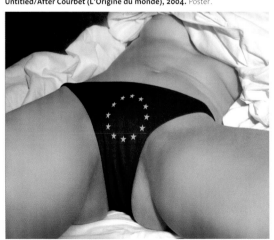

He Kōrero Purākau mo Te Awanui o Te Motu: Story of a New Zealand River, 2011

Wood, brass, automotive paint, mother of pearl, paua, upholstery, two parts, 103 x 275 x 175 cm and 85.5 x 46 x 41 cm.

Michael Parekowhai

Born in Porirua, New Zealand, 1968; lives and works in Auckland. Parekowhai was awarded an Arts Foundation of New Zealand Laureate Award in 2001. His work is featured in most major private and public collections in New Zealand and Australia, and in many across the Asia-Pacific region and Europe. Parekowhai has been included in numerous important exhibitions, including the Asia Pacific Triennial, Gwangju Biennale and Sydney Biennale. A major volume cataloguing his oeuvre was published by Michael Lett, Auckland, in 2007.

'Performance is central to understanding "On first looking into Chapman's Homer" because music fills a space like no object can.' Michael Parekowhai's project for the New Zealand pavilion at the 2011 Venice Biennale was centred on three concert grand pianos. Two of these, cast in bronze and topped by life-size metallic bulls, remain mute, but a third was played throughout the exhibition by a succession of young Kiwi performers. *He Kōrero Purākau mo Te Awanui o Te Motu: Story of a New Zealand River*, 2011, is an elaborately carved bright red-painted Steinway that refers to the artist's own Maori and Pakeha (non-Maori New Zealander) roots, and alludes to other works based on the same form (the first in a series conceptually, it was the fourth to be fully completed).

Parekowhai's exhibit as a whole was presented in tribute to the English romantic poet John Keats's titular sonnet, which describes a Spanish explorer scaling a hill in Darién (now Panama) and surveying the Pacific in awe of the myriad possibilities it seemed to offer. The verse's themes of discovery and the overlapping of old and new worlds are mirrored by the sculptor's awareness of his own country's geographical isolation – a position that he ultimately, and characteristically, frames as empowering. Keats's verse also communicates its author's admiration for the playwright George Chapman's translation of the Greek poet Homer, forming an argument for the transformative potential of art that is echoed in Parekowhai's practice. Here, by investing a historically European form with traditional Maori motifs, *He Kō rero Purākau mo Te Awanui o Te Motu* describes a singular creative rendezvous.

Parekowhai's practice as a whole has been characterized as a commentary on 'introduced' culture, but its explicitly political dimension is generally tempered by an interest in childhood and learning (his parents were progressive schoolteachers), and in the intersection of art history and everyday life. To this end, he often exploits popular and commercial forms, picturing or building them with critical alterations to material, scale and finish. For his first solo exhibition in 1994, 'Kiss the Baby Goodbye' at the Govett-Brewster Art Gallery in New Plymouth and the Waikato Museum of Art and History in Hamilton, Parekowhai remade an array of classic modernist works – including paintings by pivotal figures in New Zealand art such as Gordon Walters and Colin McCahon – as oversized metallic versions of snap-together plastic model kits, apparently awaiting construction.

Patriot: Ten Guitars, 1999.
Ten custom-made semi-acoustic guitars, with maple, spruce, rewarewa, kauri, ebony and paua and fittings,120 x 57 x 50 cm (each).

In later works like *Patriot: Ten Guitars*, 1999, Parekowhai makes reference to the realities of a mixed heritage in other ways. Inspired by an Engelbert Humperdinck song that was a hit in New Zealand in the 1960s, the work juxtaposes ten custom-built guitars made from native and imported woods with ten wall-mounted lightboxes that resemble *hiki* – the structural components of a traditional Maori meeting house. Each guitar has an individualized shell inlay, making each member of the group slightly different from its neighbours. Here, as in *He Kōrero Purākau mo Te Awanui o Te Motu*, apparently disparate elements are brought together under the banners of family and music.

Chapman's Homer, 2011.
Bronze, stainless steel, two parts, 251 x 271 x 175 cm and 56 x 87 x 37 cm.

The Moment of Cubism, 2009.
Installation view, Michael Lett, Auckland.

Subconscious of a Monument, 2003

Soil excavated from beneath the Leaning Tower of Pisa, wire, dimensions variable. Installation view, The Royal Institute of British Architects, London.

Cornelia Parker

Born in Cheshire, England, 1956; lives and works in London. Parker was nominated for the Turner Prize in 1997 and appointed Officer of the Order of the British Empire (OBE) in the Queen's 2010 Birthday Honours. Her work has been featured in numerous exhibitions, including solo appearances at the Serpentine Gallery, London; Institute of Contemporary Art, Boston; Kunstverein Stuttgart; and the Museo de Arte de Lima, Peru. Her work has been included in group exhibitions at venues including Tate Britain, London; the Museum of Modern Art, New York; and the de Young Museum, San Francisco.

In late 2005, visitors to the gallery at London's Royal Institute of British Architects (RIBA) were confronted by a room filled with small clay boulders hung from the ceiling by wires, the arrangement barring entry into the space. Suspended a uniform distance above the floor, the organized scatter of these otherwise anonymous-looking pale brown clumps hinted at a shared point of origin – and this is indeed the case; the whole array was excavated from beneath the Leaning Tower of Pisa in 2001 by engineers working on a restructuring project aimed at preventing the building's collapse. Cornelia Parker's installation *Subconscious of a Monument*, 2003, reflects on the counterintuitive strangeness of this act by introducing its own element of absurdity, making the heavy soil appear weightless.

Typically, Parker deals with objects, images and materials that, while outwardly prosaic, are distinguished by their potent histories and associations. Her work is populated by well-known figures, historic locations and extraordinary events, though these remain evident only through the subtlest or most utterly transformed of visual traces. The artist's basic process is one of rearrangement and recombination. Sometimes, this seems to occur at an almost molecular level, drawing out an unexpected and delicate beauty from even the most profane and brutal acts. Parker has a fondness for 'cartoon violence', subjecting objects to crushing or stretching, blowing them up or dropping them from great heights. The results of this mayhem tend, however, to be oddly quiet, the still centres of a succession of rapidly turning worlds.

Parker has a fondness for 'cartoon violence', subjecting objects to crushing or stretching, blowing them up or dropping them.

While Parker frequently works on a large scale, some of her most affecting works are relatively modest 'drawings' in which the medium turns out to have especial resonance. *Pornographic Drawings*, 1996-, for example, is a sequence of Rorschach-blot images made using a liquid solution of obscene videotapes confiscated by customs officers. The black-and-white tints in *Poison and Antidote Drawings*, 2004-, meanwhile, contain snake venom and anti-venom respectively. And the wire that forms a delicate lattice in *Bullet Drawing*, 2008, was manufactured from the projectile of the title. In these and other works, Parker undertakes a formal and conceptual alchemy that undermines preconceived notions of symbolic and functional value. Her work turns on the element of surprise, but retains its power even after the big reveal.

Physically, *Subconscious of a Monument* resembles several of Parker's earlier projects, including *Cold Dark Matter: An Exploded View*, 1991 – one of her best-known works – and especially *Edge of England*, 1999. The first of these is made from pieces of a garden shed that the artist had blown up by the British Army; the latter is comprised of chalk fragments from a cliff at Beachy Head, a notorious suicide spot on the south coast of England. In its 'hovering' composition, the installation for RIBA also recalls *Thirty Pieces of Silver*, 1988-1989, for which Parker had more than a thousand silver objects – dishes, candelabras, trombones – flattened by a steamroller. *Subconscious of a Monument*, its title a reflection of the artist's interest in Freudian psychoanalysis, again invests the commonplace with something like a mind of its own.

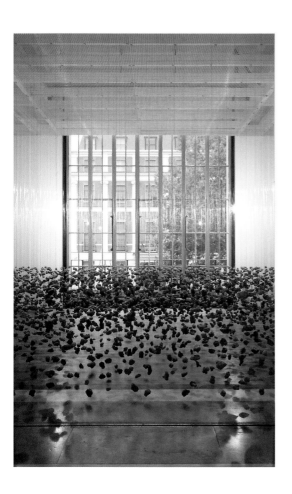

Bullet Drawing, 2009.
Lead from a bullet drawn into wire, 66 x 66 cm.

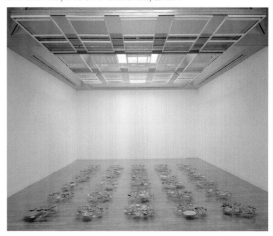

What Happens Next, is All in the Mind, 2008.
Pencil on acid-free notebook, text drawn
by Lily McMillan, 24.5 x 20.5 cm.

Cold Dark Matter: An Exploded View, 1991.
Mixed media, dimensions variable. Tate, London.

Thirty Pieces of Silver (detail), 1988–1989.
Silver and metal, dimensions variable. Tate, London.

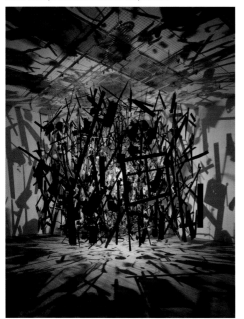

The Istanbul Drawing, 2005

Marker, chalk, pencil, multiple dimensions on walls. Installation view, Istanbul Biennial.

Dan Perjovschi

Born in Sibiu, Romania, 1961; lives and works in Bucharest. Perjovschi has been the subject of solo exhibitions internationally since the mid-1990s, at venues including the Museum Ludwig, Cologne; Kunsthalle Göppingen, Germany; Brukenthal Museum, Sibiu; and the Museum of Modern Art, New York. He participated in Manifesta 2 in Luxembourg in 1998, and represented Romania at the Venice Biennale in 1999. Perjovschi is a recipient of the George Maciunas Prize, the Henkel Art.Award and the Gheorghe Ursu Foundation Award.

The 2005 Istanbul Biennial took place not in a single formal exhibition space but was instead scattered across several specially repurposed venues. Among these was the Bilsar Building, a derelict warehouse given a coat of paint for the occasion but otherwise left rough around the edges. Covering the structure's interior walls was a rash of small drawings in marker, pencil and chalk, made directly onto their freshly whitened surfaces. Suggesting casual graffiti, these doodle-like cartoons and mottos were considered a single work by their maker, Dan Perjovschi, and far from representing an act of vandalism, constituted an officially sanctioned part of the exhibition. *The Istanbul Drawing*, 2005, ranged over a variety of subjects from local politics to the globalized art world, but was unified by its combination of deceptively artless drawing and wry satirical wit.

Perjovschi rose to prominence after representing Romania at the 1999 Venice Biennale with a floor piece that addressed perceptions of his homeland as a cultural backwater within a reconfigured Europe. This interest in representing the difficulties of life in a post-Cold War world from the perspective of one of its poorest nations remains among the artist's most important themes. Perjovschi demonstrates a sophisticated, sometimes angry, sometimes amused awareness of the contradictions and conflicts that Romania embodies as a country split between a ruling class in thrall to pan-European trade and an excluded general populace still nostalgic for the relative certainties of communism. But his art is not as inward- or backward-looking as this might suggest; instead, it reflects the attitudes and concerns of a broad contemporary audience for whom shifts in identity and status have become a constant.

Key to the effectiveness of Perjovschi's drawings is their visual economy and their masterful use of written language.

Key to the effectiveness of Perjovschi's drawings is their visual economy, which lends them an easy accessibility, and their masterful use of written language. Perjovschi is adept at interweaving puns and found phrases, applying his background in political journalism to the construction of acid punch lines. *The Istanbul Drawing* featured, for example, an image of two women wearing traditional Islamic hijabs, captioned SOME TIME AGO and TODAY. The only difference between the two was that the ostensibly more modern figure was pictured holding a cell phone to her ear. And in acknowledgment of the way in which the art world now mirrors the hierarchies of government and commerce, a stack of terms listed four players in apparent order of significance: SPONSORS, SMALL SPONSORS, CURATORS, ARTISTS.

For *WHAT HAPPENED TO US?*, his first solo project in the United States in 2007, Perjovschi took on a more conventional, albeit iconic, setting in the shape of the Donald B. and Catherine C. Marron Atrium at the Museum of Modern Art in New York. Here, the performative element of the artist's practice was more clearly apparent, as he drew on one of the interior's towering walls in front of visitors during public hours, also editing a giveaway pamphlet. Responding directly to events being reported in the news media at the time, Perjovschi made a partial return to his role as an illustrator with Romanian opposition newspaper *22*.

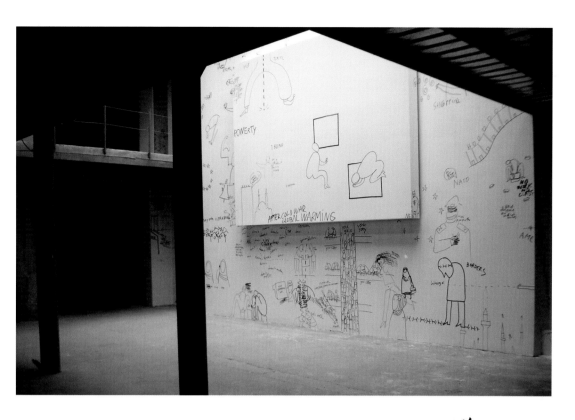

'Projects 85: Dan Perjovschi, WHAT HAPPENED TO US?', 2007.
Installation view, The Museum of Modern Art, New York.

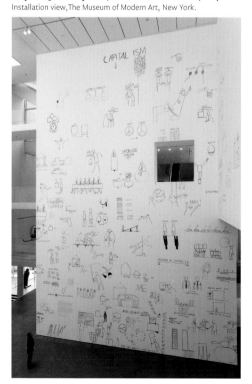

Do You Like Feng-shui?, 2003.
Variable techniques, dimensions variable.

Citizen-Consummer, 2004.
Variable techniques, dimensions variable.

Elizabeth Peyton

Born in Danbury, Connecticut, USA, 1965; lives and works in New York, and Berlin, Germany. Peyton's work is held by institutions including the Museum of Modern Art and Whitney Museum of American Art, New York; the Centre Pompidou, Paris; Kunstmuseum Wolfsburg; Kunstmuseum Basel; Museum of Fine Arts, Boston; Boros Collection, Berlin; and Walker Art Center, Minneapolis. In 2008 and 2009 a retrospective, 'Live Forever: Elizabeth Peyton', showed at the New Museum, New York; the Walker Art Center, Minneapolis; Whitechapel Gallery, London; and Bonnefantenmuseum, Maastricht.

'Celebrity itself is not that interesting to me,' says Elizabeth Peyton, whose paintings, prints and drawings often depict well-known 19th-century and contemporary figures – politicians, models, pop musicians and other artists. Peyton's real subject, she insists, is the creative role model, the individual who takes a stand for personal freedom by remaining imaginative in the face of everyday rigours. While celebrity is often portrayed as a negative or at best empty phenomenon, Peyton's works make the case for earned fame as something like a heroic achievement. 'I see it as a positive thing to reach so many people,' she says. It is apt, then, that the painter's work has itself, with the help of its intimate and approachable style, become so popular both in and to a certain extent beyond the art world.

Peyton rose to prominence in the early 1990s, a period when figurative painting in general, and portrait painting in particular, was widely considered a spent force. Beginning by working primarily from magazine photographs and television images, she developed a distinctive manner inspired less by the neo-Conceptual art fashionable at the time, and more by the stylish social portraiture of David Hockney and Alex Katz. Using brightly coloured oil paint brushed lightly onto primed boards and panels – she also works in watercolour and coloured pencil on paper – Peyton infuses her subjects with a radiance that speaks of innocence and experience, of virtue and notoriety. While she typically renders backgrounds and figures in loose, liquid strokes, facial features – lips and eyes in particular – are sharply picked out and her male subjects in particular acquire a childlike, even cherubic air.

Peyton infuses her subjects with a radiance that speaks of innocence and experience, of virtue and notoriety.

In her recent work, Peyton has moved away from using photographs as source material and now also draws from life, picturing people from her own social and professional circles. But while the rock stars and royals for which the artist became known now feature less often, the work's look is consistent; Peyton's paintings remain distinguished by the flat colour, high contrast and closely framed composition characteristic of snapshots. The androgynous delicacy of her subjects also persists, though it is increasingly combined with a subtler psychological acuity, taking them well beyond the realm of a fan's idealizing tributes.

JZ, 2009. Coloured pencil on paper, 21.9 x 15.2 cm.

This is notable, too, in the artist's self-portraits: *E.P. Reading (self-portrait)*, 2005, in which Peyton paints herself lost in a magazine, is infused with an atmosphere of introspective contemplation. Curator Iwona Blazwick notes that the condition of Peyton's portraits often approaches that of the still life, and here this quality is emphasized by the fact that close attention has been paid not only to the subject's face, but equally to the chair in which she reclines, the book and coffee cup that sit on a table next to her, even the bright emerald-green shoes she wears. It has an ambiguous, even guarded feeling – Peyton's gaze is downcast and her face is half in shadow – but still manages to convey something of her personality. Peyton has been called a successor to Andy Warhol, and in this blend of straightforwardness and evasion, she reminds us of his suggestion to 'just look at the surface of my paintings and films and me, and there I am.'

David Hockney, Powis Terrace Bedroom, 1998.
Oil on board, 24.8 x 17.8 cm. Kunstmuseum Wolfsburg.

Michael Clark, 2009. Oil on linen on board, 25.4 x 20.3 cm.

By My Side, 2009

Two-channel sound installation, 3 minutes 5 seconds. Installation view, Governors Island, New York.

Susan Philipsz

Born in Glasgow, Scotland, 1965; lives and works in Berlin, Germany. Philipsz's work has been included in the Melbourne Biennial, Tirana Biennial, Tate Triennial and the British Art Show. She has been the subject of solo exhibitions at the Museum of Contemporary Art, Chicago; Ludwig Forum für Internationale Kunst, Aachen; and Pro Arte Foundation, Helsinki. Philipsz was shortlisted for the Becks Futures award in 2004, and won the Turner Prize in 2010. Her work is represented in the collections of the Arts Council England and Museum Ludwig, Cologne.

'WHERE ARE YOU GOING? WHERE ARE YOU GOING? CAN YOU TAKE ME WITH YOU?' This heart-rending appeal is sung in a lilting Scots brogue that reaches out across the water toward the Statue of Liberty. Broadcast from speakers installed on Governor's Island's Lima Pier, the music is an unexpected and haunting addendum to an already curious place. Technically part of the Borough of Manhattan, the 172-acre land mass was given its name in British colonial times, when it served as a base for New York's royal administrators. Subsequently employed as a US Army post, then as a Coast Guard installation, it is home to three historic fortifications that now enjoy National Monument status. Much of the remaining portion is open to the public, and has latterly become a venue for cultural and sporting events. Still dotted with empty buildings, it retains a *Marie Celeste*-like aura of abandonment exacerbated by its separation from the city.

The disembodied female voice, which seems to express this sense of desolation in an appeal to passing ships, belongs to artist Susan Philipsz. Her audio installation *By My Side*, 2009, was commissioned by public art agency Creative Time for 'This World and Nearer Ones', the first instalment of its quadrennial PLOT exhibition series. Philipsz recorded herself singing the titular ditty, taken from the 1971 musical *Godspell*, in two-part harmony (she performed both parts). In its new context, the protagonist's outsider status seems to reflect that of the monument toward which the sound is directed. The lyric's intimations of yearning are still present, but have been repurposed according to the peculiarities of local topography and development. In this, *By My Side* is consistent with Philipsz's interest in using song to reflect on the psycho-social resonance of place, especially when that resonance has an undercurrent of melancholia. By using her own voice – which is pleasant but untrained – and eschewing effects and instrumentation, she avoids becoming a 'singer' per se, seeming instead to perform by and for herself.

The music is an unexpected and haunting addendum to an already curious place.

While Philipsz also makes work for gallery exhibition, her practice is at its most distinctive when it hinges on this kind of direct intersection with public space. At the Sculpture Projects Münster 2007 event in Germany, for example, she installed speakers under a bridge to broadcast a duet (she again sang both parts) based on Jacques Offenbach's *The Tales of Hoffmann*, which relates the story of the malevolent courtesan Giulietta and her theft of Hoffman's reflection. And in *SURROUND ME: A Song Cycle for the City of London*, 2010–2011, the artist's voice was heard across a number of sites in the capital's financial centre, an ancient labyrinth of streets that falls eerily silent outside of working hours. As does *By My Side*, such interventions combine specific cultural references with subjective emotional impressions, at once immersing us in the mental spaces of history and myth and making us more intensely aware of the observable here and now. Singing clearly and simply, Philipsz asks only that we sit – or stand, or walk – and listen.

SURROUND ME: A Song Cycle for the City of London, 2010–2011.
Audio installation, London.

Pathetic Fallacy, 2008. Four-channel sound installation, 3 minutes 24 seconds.
Installation view, Folkestone Triennial, England.

The Lost Reflection, 2007. Sound installation, 2 minutes 10 seconds.
Installation view, Skulptur Projekte Münster, Germany.

LAST CHANCE LOST, 2007

Metal, neon, wood and plastic, 61 x 122 x 8 cm. Los Angeles County Museum of Art.

Jack Pierson

Born in Plymouth, Massachusetts, USA, 1960; lives and works in Southern California and New York. Pierson has been the subject of solo exhibitions at venues including Centro de Arte Contemporáneo de Málaga; the Irish Museum of Modern Art, Dublin; Museum of Contemporary Art, North Miami; and the Museum of Contemporary Art, Chicago. His work is in the collections of the Seattle Art Museum; Walker Art Center, Minneapolis; and the Metropolitan Museum of Art, New York. In 2006, he curated 'The Name of This Show Is Not: Gay Art Now' at Paul Kasmin Gallery, New York.

'LAST CHANCE LOST.' The blunt phrase speaks of melancholia and regret, a painful awareness of opportunity irrevocably squandered, and is spelled out in mismatched metal and plastic signage letters that appear to have been salvaged from foreclosed convenience stores or abandoned roadside diners. Piled up on the floor in two groups and leaning against the wall as if awaiting resale or recycling, a few of them, seemingly unwilling to relinquish their original roles, are illuminated by neon. The rest are burned-out or faded, their paint beginning to flake as rust sets in. The letters' mixture of sizes and their slightly awkward arrangement not only emphasizes their objecthood but also slows down our reading, making the eventual realization of their meaning all the more poignant.

Jack Pierson began making text sculptures in 1991, and they soon became his calling card. Focusing on short slogans and single words, they trace an American landscape of love and longing, eroded fame and lost time that feels at once introverted and demonstrative. And while they often allude to a fascination with glamour and entertainment – FAME; SHOWBIZ; LOST IN THE STARS – they also refer to a parallel, private world of thought and emotion – PROMISES; PROVIDENCE; FAITH. The found letters' higgledy-piggledy arrangements suggest that the words they form might have come together by chance, and even

The found letters' higgledy-piggledy arrangements suggest that the words they form might have come together by chance.

that they might somehow express feelings felt by the objects themselves. Though they generally convey tantalizingly little in the way of 'information', these works, like contemporary haiku, can thus contain multitudes.

Pierson's other works – his practice spans painting, drawing, photography and installation – are similarly tinted by a wistful, nostalgic mood. In his 'Self Portrait' series of photographs, the artist employs 'body doubles', stand-ins that 'play' him at different stages of life from childhood through adolescence to adulthood. The obvious fiction that these images embody – no serious attempt is made to replicate Pierson's actual appearance – represents an exploration of the way in which personal identity slips between the real and the invented as we discover, emphasize or suppress different aspects of our personalities at different stages of life. In 'Self Portrait', Pierson also links this complex process of self-actualization to a negotiation of homosexual desire; many of the subjects pose flirtatiously in a blend of come-on and self-love.

In a more recent photographic sequence, Pierson makes use of more diverse imagery but maintains a gentle focus on the erotic. Printing on thin paper and folding his prints like posters ready for the mail, he moves across a range of subjects with the free-roaming scopophilia of a tourist. 'Go there now and take this with you', a 2010 exhibition at Bortolami in New York, featured several of these large 'portable' shots, including images of weathered statuary, ethereal sun-drenched landscapes, and delicate still-life arrangements. Some, including *God is Love*, *Eden Roc* and *Idols* (all 2010), allude to religious faith; others present abstract fields of colour and pattern. Imbued with the contemplative quality of Pierson's world-weary words, they convey a new and disarming optimism.

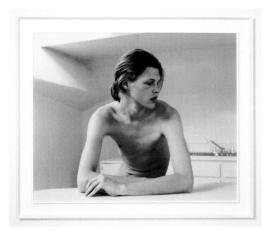

Self Portrait #4, 2003. Pigment print, 111.8 x 137.2 cm.

FAME, 2005. Plastic, metal, wood and neon, 406.4 x 114.3 x 10.2 cm.

Pyramid, Pink, 2010. Folded pigment print,108 x 144.8 cm.

Jack Pierson, LAST CHANCE LOST, 2007. Metal, neon, wood and plastic, 61 x 122 x 8 cm. Los Angeles County Museum of Art.

The Black Factory, 2004

Interactive installation/performance. Bates College Museum of Art, Lewiston, Maine.

William Pope.L

Born in Newark, New Jersey, USA, 1955; lives and works in Lewiston, Maine. Pope.L has exhibited in New York, London, Los Angeles, Vienna, Brussels, Montreal, Berlin, Zurich and Tokyo, at venues including the Art Institute of Chicago; Santa Monica Museum of Art, Los Angeles; Galerie Catherine Bastide, Brussels; Sammlung Falckenberg, Hamburg; and the Carpenter Center for Visual Arts at Harvard University, Cambridge, Massachusetts. He is a recipient of the Japan Exchange Fellowship for Creative Artists, and was selected as a USA Rockefeller Fellow in 2006. In 2010, Pope.L was appointed a member of the faculty at the University of Chicago.

'My work is not glamorous yet it is ambitious in its feeling,' states William Pope.L. 'It seeks a visceral, bodily, material "explanation" for human desire writ large in human action. Like the African shaman who chews his pepper seeds and spits seven times into the air, I believe art re-ritualizes the everyday to reveal something fresh about our lives. This revelation is a vitality and it is a power to change the world.'[1] In objects, images and participatory actions, Pope.L explores some of the myriad contradictions inherent to the treatment of racial identity, community and diversity in North America, aiming to establish new spaces for contact and dialogue. Styling himself (with tongue firmly in cheek) 'The Friendliest Black Artist in America', he plays on preconceptions about social status by any means necessary, moving from painting, sculpture and installation to photography, collage and performance.

Pope.L's most notorious works are his numerous 'crawls', begun in 1978. The most ambitious of these signature actions, 2002's *The Great White Way*, was enacted in stages over a five-year period and saw the artist, dressed as Superman and with a skateboard strapped to his back, traverse 22 miles (35 km) of New York City's Broadway on his hands and knees. The physically and mentally punishing ritual was framed as an act of sympathy with the city's homeless population, celebrating their courage and stamina in the face of enormous challenges. Other projects reflect a quieter approach: in 'Failure Drawings', 2003–, for example, a series made exclusively while travelling using immediately available materials, Pope.L meditates on the vagaries of his own life's journey.

I believe art re-ritualizes the everyday to reveal something fresh about our lives.

Originally featured in 'The Interventionists', a 2004 exhibition organized by the Massachusetts Museum of Contemporary Art, Pope.L's *The Black Factory* is an extended interactive performance that makes use of a recreational vehicle, a trailer and a three-person staff. Driving from town to town, the artist's helpers set up a series of roadside workshops, to which visitors are asked to bring objects that represent for them the idea of 'blackness'. These artifacts are then incorporated into provocative skits performed by the crew, then photographed and archived in the *Factory*'s virtual library. A few are retained for further use, or incorporated into souvenirs offered for sale in the *Factory*'s gift shop, with all proceeds going to local charities.

Failure Drawing #636: Far Above the Ocean, 2009–2010.
Ink, acrylic, ballpoint pen, oil stick, marker and correction fluid on map, 62.9 x 81.3 cm.

For Pope.L, the purpose of *The Black Factory* is not to confirm a restrictive conception of black identity but to identify and explore the positive value of difference within a framework of community. In presenting the work as a kind of informal laboratory, he encourages audiences to empower themselves as potential agents of cultural awareness and democratic change. And by incorporating, via the shop, elements of commerce and donation, he extends that possibility into the realms of economics and consumption. As is the case with the artist's practice in general, *The Black Factory* is thus directed at confronting and deconstructing stereotypes rather than simply ignoring them in favour of a more idealized or comfortable perspective.

1 Artist's statement, http://foundationforcontemporaryarts.org/grant_recipients/popel.html

The Great White Way: 22 miles, 5 years, 1 street, 2002.
Performance view, New York.

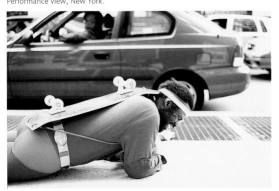

Bill Cosby with Bad Attitude, not dated.
Yarn, paper collage, glue, acrylic and tape, 15.2 x 38.1 x 17.8 cm.

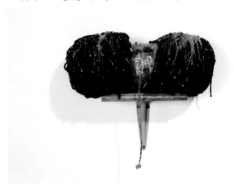

Genesis P-Orridge

Born Neil Andrew Megson in Manchester, England, 1950; lives and works in New York, USA. P-Orridge was a member of the kinetic action group Exploding Galaxy/ Transmedia Exploration from 1969 to 1970, and founded performance art group COUM Transmissions in 1969. S/he has exhibited at the Serpentine Gallery, London; Centre Pompidou, Paris; Contemporary Art Museum St. Louis; Barbican, London, and White Columns, New York, among many other venues, and performed internationally as a member of Throbbing Gristle, various incarnations of Psychic TV, and Thee Majesty.

For a figure identified more with unique and radical takes on music, sexuality and the occult than with visual work per se, and operating largely outside the market, Genesis Breyer P-Orridge enjoys something of a cult status in the contemporary art world. A founding member of the Dada-influenced performance group COUM Transmissions, which later morphed into the sporadically reunited 'industrial' bands Throbbing Gristle and Psychic TV, P-Orridge was also a participant in Fluxus and a practitioner of mail art. (A confrontational variant on the latter resulted in a charge of sending 'indecent and offensive material', including defaced photographs of the Queen.) S/he also collaborated extensively with artist Brion Gysin, who, along with William S. Burroughs, revived the 'cut-up' collage technique originally developed by the Surrealists.

Another early influence on P-Orridge was the work of artist Austin Osman Spare, in particular his notion of the 'sigil', a talismanic image directed at empowering the mind to affect reality through suggestive magic. This idea, which reinvests art with practical functionality, resonates with P-Orridge's philosophy in general, impacting his/her work across a range of media. In the late 1990s, P-Orridge again transcended the self-contained art world – and blurred the boundaries of selfhood – in a transgressive collaboration with performance artist Lady Jaye Breyer. This saw the couple 'cut up' their own bodies via surgery and cross-dressing, becoming ever more alike with the aim of merging into a single 'pandrogynous' unit called Breyer P-Orridge. Since Lady Jaye's death in 2007, Genesis embodies the 'joint' personality alone.

Two Into One We Go **documents P-Orridge's breast augmentation in a set of compare-and-contrast snapshots.**

'30 Years of Being Cut Up', a 2009 exhibition at Invisible Exports in New York, surveyed P-Orridge's collage work. And while many of the inclusions appeared deceptively unassuming, they formed an effective overview of the artist's myriad preoccupations. *Two Into One We Go*, 2003, for example, documents P-Orridge's breast augmentation in a set of compare-and-contrast snapshots (a rubber-stamped caption reads S/HE IS HER/E). *Assume Power Focus*, 1977, meanwhile, recalls the anarchic fury of P-Orridge's punk years by juxtaposing a close-up shot of penetration with a newspaper story about a rapist, snaps of the artist disrobing and a familiar royal portrait. (The title is also that of a 1982 Throbbing Gristle album, and would later be adapted by artist Eli Sudbrack, a.k.a Assume Vivid Astro Focus.)

While much of P-Orridge's work over the years has challenged convention, and while Scottish Conservative MP Sir Nicholas Fairbairn's notorious condemnation of COUM Transmissions as 'wreckers of civilization', a judgment handed down following the collective's controversial exhibition 'Prostitution' at London's Institute of Contemporary Arts in 1976, is hyperbolic, s/he has continually and unabashedly sought escape from restrictive norms in all areas of life. Yet despite his/her use of provocative imagery – 'Prostitution' featured assemblages made with used tampons and examples of group member Cosey Fanni Tutti's modelling work for pornographic magazines – P-Orridge cannot accurately be called nihilistic; Marie Losier's 2012 documentary film *The Ballad of Genesis and Lady Jaye* reveals the artist and his/her former partner as dedicated to the translation of love into a genuinely life-enhancing art.

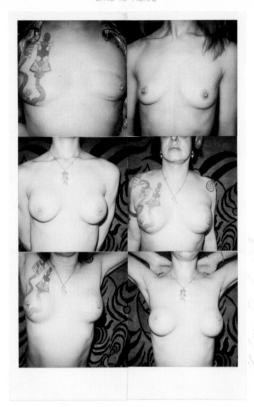

S/HE IS HER/E

TWO INTO ONE WE SO

English Breakfast, 2002–2009.
Mixed media, 35.6 x 27.9 cm.

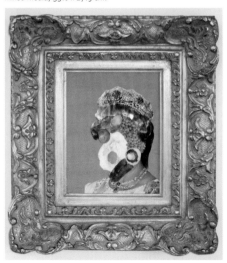

Cover of Throbbing Gristle '20 Jazz Funk Greats' (Industrial, 1979)

Tal R

Born in Tel Aviv, Israel, 1967; lives and works in Copenhagen, Denmark. R has been the subject of solo exhibitions at Kunsthalle Tübingen; Bonnefantenmuseum, Maastricht; Camden Arts Centre, London; Louisiana Museum of Modern Art, Humlebæk; and Kunsthalle Mannheim. He has also appeared in group exhibitions at Essl Museum, Klosterneuburg, and the Arken Museum for Moderne Kunst, Ishøj, Denmark. R currently holds a Guest Professorship at the art academies of Helsinki, Hamburg and Düsseldorf.

'They're very friendly and they're colourful, but there's something in there that's always on the edge of falling down, collapsing, like an ice-cream melting down your arm on a summer day.'[1] Thus Tal R characterizes his recent paintings (which represent something of a technical break from his previous work) as being freighted with an underlying instability. Shown at the Kunstverein Hamburg in 2010, then again at Berlin's Contemporary Fine Arts in 2011 under the title 'The Elephant Behind the Clown', R's newest canvases are made using rabbit-skin glue and flat layers of pure pigment. The mixture produces a slightly muted, fresco-like surface, to which the artist adds occasional touches of wax crayon. But even when he tones down the chromatic intensity of his work, the imagery R uses remains bold, accessible and wildly heterogeneous: 'I throw in whatever gets people on the dance floor,'[2] he grins.

Given this all-embracing attitude, it seems appropriate that R's aesthetic has been described as *kolbojnik*, a Hebrew word that translates literally as 'leftovers' but that in this context would be better interpreted as 'jack-of-all-trades'. His work may echo outsider art in its joyfully unencumbered look, but this apparent spontaneity is underpinned by a sophisticated understanding of painterly tradition. R's energetic brushstrokes, saturated colours and childlike motifs, his immersion in both popular culture and the legacy of high modernist abstraction, link him with precursors and contemporaries from 1980s neo-expressionists such as A. R. Penck and Georg Baselitz to younger painters like Martin Maloney and Jules de Balincourt. R moves fluidly from depictions of people and places like *New Quarter*, 2003, to formal designs like *Gimi, Gimi, Gimi after Midnight*, 2005–2006, avoiding any sense of contradiction or inconsistency. And in the likes of *Lord Tanger*, 2000, he allows the two to overlap via a signature compositional device based on three parallel bands of activity.

That R himself cites among his influences the short films of Bas Jan Ader and the history of the Holocaust – alongside the more expected comic books and children's doodles – speaks of a referential net cast unusually wide. Yet although he draws on a vast range of characters and symbols – some familiar, others modified or invented – the artist's aim remains, in his words, 'to make a painting that is completely itself on its own terms.'[3] *Man with Violine*, 2010, one of the works featured in 'The Elephant Behind the Clown', fulfils this ambition in that while it depicts an interior inhabited by a couple and their dog, and also functions as an abstraction in its flattening and fragmentation of the space around them into a pattern of coloured strips, it finally transcends both conventional roles to achieve an autonomous presence and value. R readily admits, however, to the impossibility of summarizing such an image's meanings or effects. Asked whether there is a certain point at which he loses control over a work, he responds: 'I try to make good citizens of my ideas. But no matter what the seed of any idea is, it always takes on unpredictable turns in the process of painting it.'[4]

Gimi, Gimi, Gimi after Midnight, 2005–2006.
Oil on canvas, 250 x 250.2 x 4.5 cm.

1 *Tal R: The Elephant Behind the Clown*, video, Contemporary Fine Arts, Berlin.
 http://www.cfa-berlin.de/videos/zoomview/2c2cddd6407bc2bd8705d8bec3ea78fc
2 Ibid.
3 Ibid.
4 'Interview zwischen einem Spiegel und einem Elefanten (Interview between a Mirror and an Elephant)',
 Tal R: The Elephant Behind the Clown, exhibition catalogue, Berlin: Contemporary Fine Arts, 2011.

Tour Figur, 2004. Oil, paper collage on canvas, 250 x 250 cm.

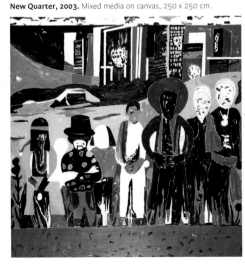

New Quarter, 2003. Mixed media on canvas, 250 x 250 cm.

Walid Raad/The Atlas Group

Born in Chbanieh, Lebanon, 1967; lives and works in Beirut and New York, USA. Raad's work, and that of The Atlas Group, have been exhibited at Documenta, the Venice Biennale, Whitney Biennial and Ayloul Festival, Beirut. Raad co-curated, with Akram Zaatari, 'Mapping Sitting: On Portraiture and Photography'. He is a winner of numerous awards including the Hasselblad Award, the Deutsche Börse Photography Prize, the Camera Austria Preis and the Alpert Award in the Arts. He has been an Associate Professor of Art at the Cooper Union School of Art, New York, since 2002.

In 1999, Walid Raad gathered a list of real and invented individuals and groups into a collective that he dubbed The Atlas Group. Framing his elusive organization as a forum for exploring the history and current condition of his native Lebanon, Raad began to produce photographs, drawings, prints, videos, notebooks and texts – the last in several languages – under its collective name. Focusing on the Lebanese civil war and the ongoing Arab-Israeli conflict, these works take an apparently analytical approach to their complex subjects, typically employing forms associated with the archive to question the continued utility of the documentary impulse. Often situating real, verifiable information within fanciful or distorted contexts, Raad's project critiques authority and authenticity against the backdrop of a struggle that is unrelenting without being consistently understood.

Critic Lee Smith sites The Atlas Group. within a history of invention that spans both art and writing. 'The forged institution,' he writes, 'is part of the legacy of Conceptual art and literary modernism, kin to Broodthaers's museum and Borges's library.' He points out too its place in a history of representations of its region of origin. In a turn away from the critique of Western images of Empire that was prompted by Edward Said's influential 1978 text *Orientalism*, The Atlas Group should be seen, Smith argues, 'in the context of Arab art redirecting its gaze inward, making its own work, its own audience, and its own institutions.' Raad also belongs to the Arab Image Foundation, which was established in 1997 to promote research into Arabic visual culture, and to support new work in video.

'The protracted wars in Lebanon shape a thorny yet rich ground for creative work,' confirms the artist. 'They shed light on how art and culture in Lebanon and elsewhere in the Arab world are affected materially and immaterially by various forms of violence.' In *My Neck is Thinner than a Hair*, Raad traces the use of car bombs in Lebanon from 1975 to 1991 via a series of prints that juxtapose collaged photographic images with handwritten texts. Purportedly based on the records of one Dr Fadl Fakhouri, a respected local historian, the portfolio was put together by Raad alone, and the shots therein, while representative of the types of vehicles that the bombers used, were taken more recently by the artist. Fakhouri never existed.

Scratching on Things I Could Disavow: A History of Art in the Arab World, 2010.
Mixed media, dimensions variable. Installation view, 'Told, Untold, Retold', Doha, Qatar.

In *Let's Be Honest, The Weather Helped*, brightly coloured dots scattered over black-and-white photographs mark the positions of bullet holes in buildings in war-torn locales. The hues of the dots correspond to those of the bullets' tips, themselves manufacturer's codes, making the final images a curious blend of informational graphics, urban photography and pure abstraction. More recent work has seen Raad pursue the historicization of his previous output, a process necessarily marked by ambiguity. 'The Atlas Group (1989-2004)', the 2006 exhibition in Berlin seemed to propose a new set of dates for the group, predating its previously stated establishment by a decade. Truth and fiction here, as ever, have an ambiguous relationship.

front back

Date: 28 June 1990
Photographer | Original Archive: Ibrahim Tawil | An-Nahar Research Center (Beirut, Lebanon)
Notes on Back: Lebanon_Crimes_Criminals (Explosions)_1990_Beirut

Let's Be Honest, The Weather Helped (Saudi Arabia), 1998. Archival colour inkjet print. One of a series of 17 prints, 46.4 x 71.8 cm (each).

Das Kreisen, 2011

Oil on canvas. Diptych, 300 x 500 cm (overall).

Neo Rauch

Born in Leipzig, Germany, 1960; lives and works there. Rauch has been the subject of solo exhibitions at venues including the Musée d'art contemporain de Montréal and Kunstmuseum Wolfsburg. In 2002, he won the Vincent Award and exhibited at the Bonnefantenmuseum, Maastricht. In 2010, a retrospective was held jointly at the Museum der Bildenden Künste Leipzig and the Pinakothek der Moderne, Munich. Rauch's work is represented in collections including those of the Gemeentemuseum, The Hague, and Museum der Bildenden Künste Leipzig.

Neo Rauch's epic diptych *Das Kreisen*, 2011 (the title, which translates literally as *revolving* or *surrounding*, is also that of a 1919 abstraction by Kurt Schwitters), seems to depict an artist's studio, though the space is oddly fragmented and filled with strange inhabitants. Against a backdrop of canvases leaned against easels and walls, a curious gathering assembles. A young woman in a turquoise mini-dress poses awkwardly atop a wooden bench while a bearded man in a skirt pirouettes, grim-faced, around her. A man in a heavy brown overcoat holds a large wreath in front of a wandering dog, while another motions toward a half-human, half-angel compatriot who lies face down on the floor. A self-contained vignette, which might represent a physical painting in the room or a collage-like superimposition, details an ambiguous domestic incident.

Typically for Rauch, *Das Kreisen* appears to be an illustration of a time and place in which discrete historical periods have been forced into an uncomfortable cohabitation. The figures' clothing, for example, dates them to specific periods, from the mid-19th century to the 1950s, the incongruous styles combining and clashing within the same imagined space. In this, and in its deliberate confusions of scale and perspective, realism and fantasy, the work owes a debt to Surrealists such as Giorgio de Chirico and René Magritte. The artist also makes explicit reference to Socialist Realism in his stiff, mannered rendering and burnished, gloomy palette. But Rauch's aesthetic has perhaps been shaped above all by his upbringing in the Eastern Bloc, and his training at Leipzig's Hochschule für Grafik und Buchkunst.

Traditionally associated with commerce, Leipzig became a centre of popular resistance to Communism prior to *Die Wende*, the shift to a capitalist economy that occurred at the end of the 1980s. In picturing aspects of the city's life that were suppressed under the old regime but recontextualizing them in ways that are enigmatic and elusive, Rauch refuses to adopt a dogmatic position but instead fuses two extant mythologies into something uniquely his. The pre-eminent representative of a new group of artists committed to figurative painting known as the New Leipzig School – other members include Tilo Baumgärtel, Matthias Weischer and Christoph Ruckhäberle – Rauch thus walks a fine line between conservative revivalism and what might be framed as a consciously eccentric new take on history painting.

'For me, painting means the continuation of dreaming by other means.'

Consistent with its relaxed approach to chronology, *Das Kreisen* also plays fast and loose with narrative and symbolism. The image feels heavy with meaning, but what it represents is finally a kind of no-man's-land, irredeemably disjointed and anachronistic. Even its atmosphere is indeterminate: murky and even slightly sinister, but also evocative of a vintage children's book or the mixed-together pieces of several different jigsaw puzzles. Though competently drawn, the figures have a curious lifelessness and independence from the scenes they inhabit that precludes a definitive reading of their intentions or significance. As the artist concludes in acknowledgment of this frustrated logic: 'For me, painting means the continuation of dreaming by other means.'

Leporello, 2005. Oil on canvas, 250 x 210 cm.

Die Aufnahme, 2008. Oil on canvas, 300 x 250 cm.

Pour Your Body Out (7354 Cubic Meters), 2008

Multi-channel colour video projection with sound, projector enclosures, seating, carpet. The Museum of Modern Art, New York.

Pipilotti Rist

Born in Grabs, St. Gallen, Switzerland, 1962; lives and works in Zurich. Rist studied graphic design and photography at the Institute of Applied Arts in Vienna, then video at the School for Design in Basel. She won the Premio 2000 Prize at the Venice Biennale in 1997 and has had solo exhibitions at the Fundació Juan Miró, Barcelona; the Museum of Modern Art, New York; Kiasma Museum for Contemporary Art, Helsinki; Museo Nacional Centro de Arte Reina Sofía, Madrid; and the Musée des Beaux-Arts, Montreal, among many other venues. Rist also lectured at the University of California, Los Angeles.

'A pool filled with images and sound.' Museum of Modern Art curator Klaus Biesenbach describes Pipilotti Rist's monumental video installation *Pour Your Body Out (7354 Cubic Meters)*, 2008, as a truly immersive experience.[1] Commissioned for the building's soaring Donald B. and Catherine C. Marron Atrium, the project was designed by the artist to at once 'melt into the architecture' and at the same time allow occupants of the space to make it their own. A circular seating island in the centre of the specially carpeted floor, modelled after an iris, encourages viewers to lie back and allow the moving frieze created by seven overlapping twenty-five-foot-high projections to surround and wash over them. It is of course possible to experience *Pour Your Body Out* by walking through it – atria are, after all, not often thought of as destinations in themselves – but the work's enveloping configuration encourages most people to stay for some time.

The filmic content of *Pour Your Body Out* consists of a series of interwoven segments from Rist's feature film *Pepperminta*. Non-narrative and poetic, these brief, allusive extracts range over aesthetic and thematic territory that the artist has occupied for some years. The stars of Rist's piece (in her words, 'one human, one pig, some earthworms and two snails'[2]) move through a colourful landscape suggestive in part of the verdant Swiss countryside, in part of the interior of a body. Close-up, fisheye and tracking shots of animals, plants and people dissolve into passages of oceanic abstraction. These images are accompanied by a gentle soundtrack in which corporeal noises dissolve into hypnotic melody. The whole has an ethereal, almost psychedelic feel, the real blending organically with the fanciful.

Pour Your Body Out is video on an epic scale, but Rist's first forays into the medium were, of necessity, more humble. As a student, she made short 8 mm cine films, experimenting with manipulations of colour, sound and tempo. She also produced music videos to accompany songs by experimental 'klezmer-punk-pop' band Les Reines Prochaines, of which she was a member from 1988 to 1994. Her 1992 video *Pickelporno* (Pimple Porno), constructed around the image of an embracing couple, became emblematic of a newly sensual, playful spirit in artistic approaches to female sexuality and power. And *Ever is Over All*, 1997, which MoMA acquired for their collection, presents the iconoclastic image of a woman casually smashing the windows of parked cars with an oversized tropical flower as she strolls down a city street.

In *Pour Your Body Out*, Rist combines her conceptual interest in reconciling mind and body with a formal investigation into the quasi-spiritual power of expansive interiors. In 2005, the artist represented Switzerland at the 51st Venice Biennale with *Homo sapiens sapiens*, 2005, a video projected onto the ceiling of the San Stae church, and the MoMA installation creates a similarly striking atmosphere. Both works enhance the feeling of spiritual uplift that airy interiors can impart, while their tone is also unashamedly upbeat. And in *Pour Your Body Out (7354 Cubic Meters)*, especially, we are given abundant space to dream.

1 'Curator Klaus Biesenbach discusses Pipilotti Rist, *Pour Your Body Out (7354 Cubic Meters)*, 2008'
 in *Special Exhibitions Video: Pipilotti Rist: Pour Your Body Out*, New York: Museum of Modern Art, 2008.
2 'Behind the Scenes with Pipilotti Rist, *Pour Your Body Out (7354 Cubic Meters)*'
 in *Special Exhibitions Video: Pipilotti Rist: Pour Your Body Out*, New York: Museum of Modern Art, 2008.

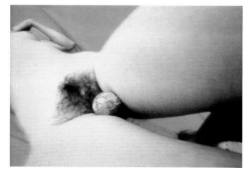

Homo sapiens sapiens, 2005. Video.

Ever is Over All, 1997. Two-channel colour video projection with sound. The Museum of Modern Art, New York.

Pickelporno (Pimple Porno), 1992.
Colour video projection with sound, 12 minutes.

Eva Rothschild

Born in Dublin, Ireland, 1972; lives and works in London, England. Rothschild has been the subject of solo exhibitions at the Hepworth Wakefield, West Yorkshire; Stuart Shave/Modern Art, London; The Modern Institute, Glasgow; La Conservera Centro de Arte Contemporáneo, Murcia, Spain; South London Gallery; and Kunsthalle Zürich. She was awarded the Duveens Commission in 2009 at the Tate Britain, London, and in 2010 showed a large-scale sculpture titled *Empire* near an entrance of New York's Central Park, in collaboration with the Public Art Fund.

'I'm interested in the ways of looking that go with concepts of faith and in how things are invested with a power above and beyond their materiality, the transference of spirituality onto objects.' In purely formal terms, the sculptures of Eva Rothschild are shaped in large part by an aesthetic derived from Minimalism, yet as critic Kristin M. Jones observes, they imbue the stripped-down style first championed by artists and critics in the 1960s and 1970s with many of the qualities – decorativeness, anthropomorphism, narrative – that the original proponents were turning their backs on. Rothschild draws heavily on the visual culture of New Age mysticism, constructing spheres, poles, pyramids and other elemental structures that seem to redefine not only the physical but also the psychical spaces they inhabit.

Rothschild's sculpture *Blackout*, 2007, is a tall, pyramid-like arrangement of three leaning triangles rendered in glossy plastic and black-painted wood. Two of these shapes have pieces cut out from them; one is nothing more than an empty black frame. At the pyramid's centre are three hexagons, which rest in a kind of frozen tumble. The work's hard, abstract geometry and dark, reflective surfaces suggest a focus on aesthetic purity, but there are echoes here too of visionary and speculative design, from Buckminster Fuller's geodesic domes to filmmakers' imaginings of alien technology and architecture (again looking back primarily to the 1960s and 1970s). There's a distinct sense of the religious in the sculpture's heraldic, monumental power.

There's a distinct sense of the religious in the sculpture's heraldic, monumental power.

While works like *Blackout* retain something of Minimalism's sleekness, Rothschild's frequent use of everyday methods and materials provides the viewer with an easy point of entry, an appeal that her artistic forebears habitually eschewed. In both two- and three-dimensional works, she has employed weaving or plaiting techniques to combine, with quasi-psychedelic complexity, two or more images into one, or to forge a link with the homespun craft techniques associated with a countercultural 'back-to-nature' impulse. Yet even when Rothschild makes use of a familiar material such as paper or (a particular favourite) leather, she does so with distinctive elegance. In *Higher Love*, 2007, for example, coloured leather strips wound round three aluminium rings cascade to the floor, suggesting both a maypole and dripping paint.

Blackout – the title might be read as an allusion to an altered state of consciousness as well as being a succinct visual description – is, then, indicative of the mercurial nature of Rothschild's practice insofar as its points of reference are both pop-cultural (it is reminiscent of a slice of Swiss cheese from a Tom and Jerry cartoon) and art-historical (Phillip King's 1963 sculpture *Genghis Khan* has a similar bold angularity). It also has the slight feeling of precariousness that characterizes so many of the artist's objects, which often feature thin, branching forms or incorporate slender stands or armatures. Yet while its heritage and associations are thus quite easily mapped, the other place or plane toward which *Blackout* seems to point remains a beguiling mystery.

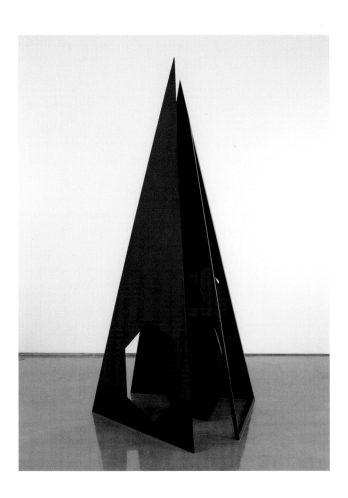

Someone and Someone, 2009. Painted aluminium, 450 x 400 x 100 cm.
Yorkshire Sculpture Park, Wakefield, England.

Free Jazz 2, 2002. Woven paper and vinyl, 190 x 83 cm.

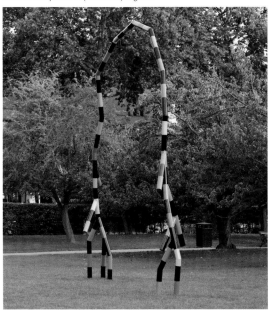

Mika Rottenberg

Born in Buenos Aires, Argentina, 1976; lives and works in New York, USA. Rottenberg has been the subject of solo exhibitions at the San Francisco Museum of Modern Art; La Maison Rouge, Paris; KW Institute for Contemporary Art, Berlin; and MoMA PS1, New York. Her work has also been included in the Whitney Biennial, and shown at Tate Modern, London; Guggenheim Museum, Bilbao; the Solomon R. Guggenheim Museum and Museum of Modern Art, New York. A monographic survey at De Appel Arts Centre, Amsterdam, was held in 2011.

'Bodies, at once repulsive and sensual, larger-than-life and ever-so-ordinary, are vital to factories: their products appropriated; their shapes subsumed; their excretions packaged; their quirks put to work. Here is where the freak show meets the sweatshop.' So critic Paul Kockelman sets the scene for Mika Rottenberg's video installation *Dough*, 2006, a treatise on the intersection of 'faceless' industrial manufacturing with the human beings that facilitate it. In Rottenberg's world, people – especially women and often extreme physical types – interact with equipment in curious and unexpected ways, seemingly closer to cows attached to milking machines than salaried employees engaged in meaningful labour. Her scenarios have a dreamlike quality that recalls absurdist contraptions from the Bachelor Machine in Marcel Duchamp's *Large Glass*, 1915-1923, or the convoluted gadgets of Heath Robinson and Rube Goldberg.

In *Dough*, the method by which the titular material is processed is characteristically bizarre and hyper-extended. The action takes place in a cramped building divided into seven interconnected rooms. In one upper-level space, an obese woman called Raqui (the name is embroidered on her uniform) kneads dough into umbilical ropes that she lowers down to a colleague stationed beneath, moistening it as she does so with her own tears. The recipient then passes the sticky stuff in front of a fluorescent light before handing it off to two further women stationed at a conveyor belt, who slice the product into pieces. Raqui then restarts the process by sniffing a bunch of flowers that, with the help of a fan that wafts pollen up her nose, causes her eyes to water. The tears drip through a hole in the floor, and the steam that is generated when they land causes the dough to rise once more.

Dough typifies the balance of offbeat humour and profound discomfort – both physical and psychological – that is characteristic of Rottenberg's project. The video's rhythmic momentum, achieved through distinct sound effects and precise, rapid editing, lends it an almost musical quality. Critics have also traced a connection to certain silent film comedies, Charlie Chaplin's classic *Modern Times*, 1936, in particular. But while there is an appealing lightness and 'what-will-happen-next?' unpredictability to the work, it retains a serious, post-Marxist subtext. Forced into close proximity with the women onscreen (the video is shown inside a kind of hutch that replicates the factory's oppressive interior), we are encouraged to consider the limitations of their repetitive task and the grim conditions in which it is pursued. A closed loop of exploitation and futility, *Dough* paints a highly critical picture of the brutal inequalities entailed by a capitalist economy.

Rottenberg pursues many of *Dough*'s themes and metaphors in other works. In *Squeeze*, 2010, she juxtaposes video footage of her Harlem studio with scenes from an Arizona lettuce farm and an Indian rubber plant, positing a kind of alienated collaboration. And at the Performa festival in 2011, she collaborated with fellow artist Jon Kessler on *SEVEN*, a performance and installation centred on a fantastical laboratory that again links geographically distant locations – in this case New York City and the African savannah – in a ritualized play on outsourcing.

Mika Rottenberg and Jon Kessler, SEVEN, 2011.
Performance view, Performa, New York.

Squeeze, 2010. Single-channel colour video with sound, 20 minutes.

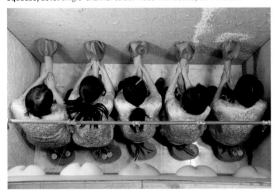

Cheese, 2008. Multi-channel video installation, with colour, sound, approximately 12 minutes. Installation view, Whitney Biennial, New York.

Doris Salcedo

Born in Bogotá, Colombia, 1958; lives and works there. After completing her BFA at the Universidad de Bogotá in 1980, Salcedo completed an MFA in Fine Art at New York University. Since then, she has exhibited in group exhibitions internationally, including 'The New Décor' at the Hayward Gallery, London, and 'NeoHooDoo' at MoMA PS1, New York. Her solo exhibitions include 'Plegaria Muda' at Museo Universitario de Arte Contemporáneo, Mexico City; 'Neither' at Inhotim, Brumadinho, Brazil; and 'Unland' at Tate Britain, London.

Crammed into the space between two buildings on an ordinary street in the centre of town, the chaotic jumble of 1,550 used wooden chairs that made up Doris Salcedo's contribution to the 2003 Istanbul Biennial was a strange, alarming and finally elegiac sight. Neighbouring hardware stores and ironmongers were thrown into sharp relief by this surreal accumulation, which rose to a height of nearly three storeys. An unforgettable image, Salcedo's site-specific installation was suggestive – as is much of her work – of the countless 'disappearances' that still occur in her country and around the world. In their haunting evocation of forced abandonment and absence, such collections have a powerful association with the photographs of heaps of spectacles and other belongings taken from inmates at Auschwitz.

Salcedo is absorbed by the turbulent political situation in her native Colombia, and has consistently pursued the themes of violence, displacement and loss that inform *Installation*. She prefers, however, to resist direct reference to her birthplace in favour of more broadly applicable allegory, using materials with immediate and near-universal resonance. Thus her early work is marked by an extensive use of everyday objects – often furniture – that, while usually salvaged from the streets of Bogotá, are internationally familiar. Salcedo alters these objects by conjoining them in semi-abstract hybrid forms, or by filling them with concrete to suggest the

Neighbouring hardware stores and ironmongers were thrown into sharp relief by this surreal accumulation.

brutal silencing of a human voice. Other sculptures incorporate items of clothing, conjuring an aura of personal history that recalls the oeuvre of French artist Christian Boltanski.

Moving gradually away from the production of discrete sculptures and toward large-scale works that reflect on their physical situation, Salcedo has continued to meditate on the burden of history via interventions in public and institutional space. The year before *Installation*, she exhibited a time-based work, *Noviembre 6 y 7,* in Bogotá's then-new Palace of Justice. It was a commemoration of the seventeenth anniversary of the violent seizing of the Supreme Court in Bogotá on 6 and 7 November 1985. Over the course of fifty-three hours – the duration of the siege – she lowered a series of chairs down the front of the building in a symbolic ritual of commemoration. And in *Shibboleth*, an installation for the Turbine Hall at Tate Modern in London in 2007-2008, she introduced a jagged chasm into the concrete floor that extended for the entire length of the interior. 'The Crack', as it became popularly known, divided the space and its audience, revealing the physical and ideological vulnerabilities of both.

Of her aims in making *Installation*, Salcedo recalls: 'I wanted to make a topography of war, one that was embedded, really *inscribed* in everyday life.' The result alludes to the point at which peaceful existence collapses into a state of crisis, at which the prosaic becomes intertwined with the extreme. The artist is at pains to contextualize this state as common to all peoples, so that while a knowledge of the particular events to which the work alludes adds a layer of specific reference, it is not essential to an understanding of its underlying theme. 'I'm not narrating a particular story,' she emphasizes, 'I'm addressing experiences.'

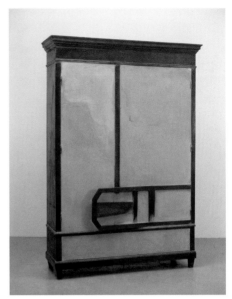

Untitled, 1998. Wood, cement and metal, 214 x 150 x 54.5 cm.

Noviembre 6 y 7, 2002. Palace of Justice, Bogotá.

Shibboleth, from the Unilever Series, 2007-2008. Installation, Tate Modern, London.

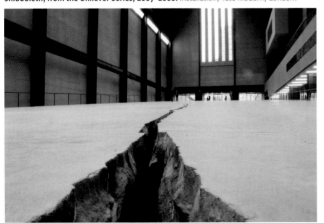

Doris Salcedo, installation for the 8th International Istanbul Biennial, 2003. Wooden chairs, site-specific installation.

Wilhelm Sasnal

Born in Tarnów, Poland, 1972; lives and works there. Sasnal has been the subject of solo gallery exhibitions throughout Europe and the USA, including major surveys at K21, Düsseldorf, and the Centro de Arte Contemporáneo de Málaga. He has also exhibited at the UC Berkeley Art Museum; Kunsthalle Zürich; and Whitechapel Gallery, London. His work was included in the São Paulo Biennial in 2004. Sasnal has written and directed two feature-length films, *Swineherd,* 2009, and *Fallout,* 2010.

In 1996, while still a student at the Jan Matejko Academy of Fine Arts in Krakow, Poland, Wilhelm Sasnal co-founded an artists' collective ironically dubbed the Ładnie ('pretty' or 'nice') Group. Formed in reaction to the perceived conservatism of the school's established teaching style and in-house aesthetic, it dispensed with academic methodology and concentrated on representing the banal and the everyday, often using imagery drawn from popular culture. The ensemble lasted only five years, but left an enduring mark on the artist's approach, especially in his use of photographs and comic strips as source material for paintings and films. In the years since Ładnie's dissolution, Sasnal has investigated a diverse range of themes, but his aesthetic retains much of the pared-down, graphic look of this formative enterprise.

Sasnal's overarching subject is nothing less than the extent to which images can represent the experience of contemporary life. To this end, he migrates between genres and media, skipping back and forth through time, crossing and re-crossing the border between private and public iconography. Fascinated by history – whether personal, societal, cosmic or artistic – he often paints his family as a way to reflect on his own and others' ever-changing relationship to the world around them. When picturing his wife and son in works such as *Untitled (Kacper and Anka)*, 2009, however, Sasnal omits identifying details, transforming the pair into anonymous stand-ins. In canvases based on works by other artists such as Georges Seurat's *Bathers at Asnières*, 1884, he tints well-known images with memories and associations of his own.

Sasnal often also adapts images from the news media, giving his paintings a sense of topicality that survives the omission of specific details. Even the most socio-politically significant shots are mined for their formal qualities as Sasnal pits 'meaning' against the 'purely' visual. Sometimes he filters this interest in the visual representation of world-shaping events through an existing interpretation. In a series based on Art Spiegelman's graphic novel *Maus*, 1972-1991, for example, he experiments with how much can be excised from an appropriated image before its meaning is altered or destroyed. In Spiegelman's original, animals enact the story of the Holocaust; in Sasnal's paintings, the strip's speech bubbles and other guides to this narrative have been removed, leaving only unnamed characters and stark, ambiguous settings.

While painting remains Sasnal's primary medium, he also makes photographs and films. These too reflect a division of interest between the flux of international culture and the sometimes harsh realities of post-Communist Polish life. One video, *The Band*, 2002, documents a performance by American art-rockers Sonic Youth, while a film, *The Other Church*, 2008, traces the murder of a Polish student. This apparent alternation between style and content is unsettling; we are never certain of the artist's position, and in this sense his works' meaning resides as much in its own development and construction as in any independent theme. Applying the languages of propaganda, advertising and 'objective' documentation via an idiosyncratic process of selection and stylization, Sasnal demonstrates the continuing flexibility of his means.

Bathers at Asnières, 2010.
Oil on canvas, 160 x 120 cm.

Partisans, 2005. Oil on canvas, 40 x 50 cm.

Maus 5, 2001. Oil on canvas, 50 x 40 cm.

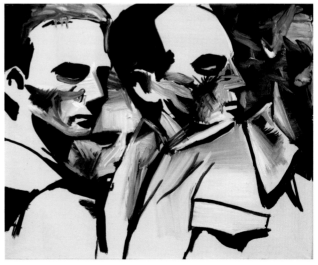

Presentation, 2005

Oil on canvas, 304.8 x 426.7 cm. The Museum of Modern Art, New York, fractional and promised gift of Michael and Judy Ovitz.

Dana Schutz

Born in Livonia, Michigan, USA, 1976; lives and works in New York. Schutz has been the subject of solo exhibitions in New York, Boston, Paris, Berlin and Santa Fe, and has participated in numerous group exhibitions including the Prague and Venice Biennales. Her work is represented in private and public collections including the Saatchi Gallery in London, and the Whitney Museum of American Art and Solomon R. Guggenheim Museum in New York. A retrospective of her work opened at the Neuberger Museum of Art, New York, in 2011.

On a scale that recalls the epic scenes of classical history painting, Dana Schutz's canvas *Presentation*, 2005, is crammed with incident and detail. It depicts a gigantic mutilated figure lying on a wooden board suspended above a grave-like hole in the ground. Another, smaller figure lies face down nearby, seemingly given up for dead, while a teeming crowd of grim-faced observers presses forward for a closer look, one of them poking idly at a red, raw patch of flesh with a long stick. The subject is still alive – his eyes peer out at us in a semi-conscious daze – but he has lost one leg below the knee, and his innards are visible through his stomach. At the far right edge of the painting, a surgeon makes an incision into the jaundiced patient's right arm; it is unclear, however, whether she is trying to save the patient or just dissect him to harvest spare parts.

Presentation was unveiled in 2005 at 'Greater New York', MoMA PS1's periodic metropolitan survey, and was subsequently purchased by the Museum of Modern Art. The work made a splash in both venues, heralding a renewal of energy and ambition in figurative painting. Schutz's handling is bold and tactile, and her ability as a colourist arguably unmatched among her contemporaries. Her aesthetic has been compared to those of senior figures such as Judith Linhares, who brings a similarly intense palette to bear on her own vividly imagined narratives, and to predecessors from American realist Thomas Eakins to unclassifiable Belgian James Ensor (compare *Presentation*'s crowd to the mob in Ensor's *Self-Portrait with Masks*, 1899). *Presentation* is thematically imposing too, focusing directly on our relationship with suffering and death by juxtaposing its physical reality with the singular mixture of fascination and indifference it elicits.

The human body, especially when pulled apart (metaphorically, but also always literally), has long taken centre stage in Schutz's work. In the series 'Frank from Observation', she documents the movements of the last man on earth, using the titular modern primitive as a kind of avatar for exploring the sometimes fractious relationship between artist, subject and viewer. In *Reclining Nude*, 2002, the blonde, bearded protagonist lies back on a desolate beach, his naked skin glowing an alarming bright pink while his pose signals an odd sort of come-on. Another series, 'Self Eaters', 2003–2005, depicts figures in the act of consuming their own flesh, seemingly in a desperate attempt not only to destroy their own lives, but also to erase their very identities. The gesture is grotesque, but also communicates a dark, visceral humour. *Face Eater*, 2004, suggests a playful take on Francis Bacon's *Three Studies for Figures at the Base of a Crucifixion*, 1944, as a bellowing, inverted face pulls its own features into a toothy, gaping maw. But Schutz herself rejects the idea that these auto-cannibals are all about destruction: 'They are self-created too,' she says. 'They have no original and are always in a state of becoming. They are defined by their own production.'[1]

Reclining Nude, 2002. Oil on canvas, 122 x 152 cm.

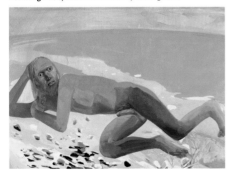

1 'Conversation Between Raphaela Platow and Dana Schutz', *Dana Schutz: Paintings 2002–2005*, exhibition catalogue, Waltham, Massachsetts: The Rose Art Museum, 2006, 87.

Face Eater, 2004. Oil on canvas, 58 x 46 cm.

Swimming, Smoking, Crying, 2009. Oil on canvas, 114.3 x 121.9 cm.

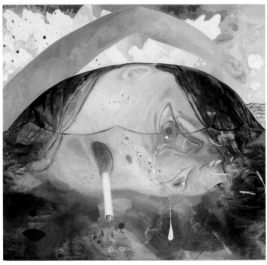

Tino Sehgal

Born in London, England, 1976; lives and works in Berlin, Germany. Sehgal has exhibited at venues including the CCA Wattis Institute for Contemporary Arts, San Francisco; Walker Art Center, Minneapolis; Villa Reale, Milan; the Haus Konstruktiv and Kunsthaus Zürich; and the Institute of Contemporary Arts and Tate Modern, London. He has taken part in group exhibitions including 'After Nature', at the New Museum, New York, and in 2005 took part in the Venice Biennale. Sehgal was shortlisted for the Hugo Boss Prize in 2006.

'The viewer in my work is always confronted with him- or herself, with his or her own presence in the situation, as something that matters, as something that influences and shapes this situation.'[1] Avoiding the term 'performance' for its suggestion of an impermeable boundary between artist and audience, Tino Sehgal refers to his works as 'constructed situations', 'sculptures' or simply 'pieces'. He is committed to a process that he terms 'deproduction', in which equal attention is devoted to a work's creation and its dissolution. With this in mind, he has taken the uncompromising step of allowing no photographic reproduction of his work. He also forbids the production of exhibition catalogues and press releases, and even of official paperwork accompanying sales.

What, then, do Sehgal's works consist of? Drawing on his training in dance, he stages deceptively simple actions that combine elements of choreography and theatre with the instruction-led 'procedural' approach of Conceptual art and the verbal-visual poetics of Fluxus. The specific form of each action is determined in large part by the site in which it appears, and often incorporates institutional elements, including staff. Sehgal does not employ professional actors but instead relies on volunteer 'interpreters' to do his bidding. Art-historical references are another ingredient; in his first work, *Instead of allowing some things to rise up to your face dancing bruce and dan and other things*, 2000, a performer squirms on the floor of an empty gallery, deriving some of his movements from those in videos by Dan Graham and Bruce Nauman.

'The viewer in my work is always confronted with him- or herself, with his or her own presence in the situation, as something that matters.'

In 2010, Sehgal was commissioned to make a work for the Solomon R. Guggenheim Museum in New York. Emptying Frank Lloyd Wright's spiral gallery of all other art, he positioned four individuals at strategic points along the ascending walkway. The first of these is a young girl, who poses a question to visitors – some variation on 'What is progress?' The second is a teenager and the third and fourth are a thirty-something and middle-aged adult respectively, each of them offering to steer the conversation along an alternate path. This kind of direct engagement has been typical of the artist's practice since its inception: visitors to *This objective of that object*, 2004, at the Institute of Contemporary Arts in London, for example, were met by a roomful of performers primed to launch into theoretical discussion.

This Progress is similarly emblematic of Sehgal's rejection of the fixity of the art object and his critique of the systems that surround it, but it is not framed as a statement of resistance to the art market as such. Rather, it questions the overproduction of material goods in general, replacing a physical artifact with a fleeting experience that is different for every participant (critic Jerry Saltz, for example, was horrified to find that his overly persistent line of inquiry had left the little girl in tears). That this experience enjoys a continued existence entirely in the form of memory, anecdote, rumour and reportage – and accounts such as this one – only adds to its enduring value.

1 The artist in Tim Griffin, 'Tino Sehgal: An Interview', *Artforum*, vol. XLIII, no. 9, May 2005, 218-219.

Sehgal has taken the uncompromising step of allowing no photographic reproduction of his work.

George Shaw

Born in Coventry, England, 1966; lives and works in Devon. Shaw has exhibited at the South London Gallery; Baltic Centre for Contemporary Art, Gateshead; Centre d'Art Contemporain, Geneva; Dundee Contemporary Arts; and Ikon Gallery, Birmingham. He was included in the touring exhibitions 'Subversive Spaces: Surrealism and Contemporary Art' and the British Art Show 7. Shaw won the TI Group Award in 1998 and was shortlisted for the Turner Prize in 2011.

In their book *Edgelands*, 2011, poets Paul Farley and Michael Symmons Roberts survey those elements of the English landscape that tend not to be incorporated into a picturesque, marketable image of national heritage. Exploring anonymous locales and features that skirt the definitive categories of town or country – and which are habitually dismissed as eyesores or studiously ignored – the authors discover a post-industrial suburban 'wilderness' flecked with surprising beauty. These landfill sites and retail parks, sewage farms and motorway sidings are, after all, as much a part of the experience of living in England – or in any other developed nation – as anything on a postcard. If the English landscape of the early 19th century was defined by the romantic vistas of Constable and Turner, its contemporary 'edgelands' are, as Farley and Symmons Roberts acknowledge, best represented by the immediately if uncomfortably familiar visions of painters such as David Rayson and George Shaw.

Though now based in Devon, Shaw still paints the council estate in Tile Hill near Coventry where he grew up, referring to his own cache of photographs. Using the glossy, opaque Humbrol enamel paints associated with model aeroplane hobbyists, Shaw documents the half-forgotten places of his youth with precise, detailed naturalism. Despite his work's regional focus and objective sheen, Shaw does not regard it as social documentation; his practice hinges, he insists, on an imaginative reflection of his own memories and anxieties. There is an elegiac quality to these scenes, emptied of people but bearing the scars of their activity, which distances them from deadpan realism or nostalgic kitsch; Shaw's use of enamel allows him to engage with painterly tradition without sliding back into conservative revivalism. But if the artist's work has a single theme, it is not a dialogue internal to art history but rather the bifurcated passage of time, the way in which things age differently in the mind and in the flesh.

There is an elegiac quality to these scenes, emptied of people but bearing the scars of their activity.

In depicting such ordinary sites, Shaw engineers a sense of mystery while allowing the viewer to fully occupy each scene. 'You find yourself wondering if these nondescript places hold bigger secrets: are they crime spots or even murder sites?' writes critic Sean O'Hagan. 'Could they be places that have a particular personal import for Shaw – an alley where he was beaten up, a wall beside which he had his first smoke, a garage in which he lost his virginity? He, cannily, is not telling.'[1] One prompt that Shaw does provide is his titles. Many of the Tile Hill paintings, for instance, are grouped under 'Scenes from the Passion', a reference to episodes in the suffering and death of Christ. In Shaw's hands, the Biblical story becomes a paean to adolescent self-mythologizing and a disarming counterpoint to the images' self-conscious mundanity. Other titles are more self-explanatory: *The Next Big Thing*, 2010, renders the site of the pub depicted in 2001's *Scenes from the Passion: The Hawthorn Tree* – a place that held a 'magical allure' for the young Shaw – as stripped clean of history, 'just a corner where weeds grow.'[2]

1 Sean O'Hagan, 'George Shaw: "Sometimes I look at my work and its conservatism shocks me"', *The Observer,* 12 February 2011.
2 http://www.channel4.com/news/turner-prize-2011-george-shaw

Scenes from the Passion: Late 2002.
Enamel on board, 91.7 x 121.5 cm. Tate Britain, London.

Stump with Roots, 2008–2009.
Enamel on board, 147.5 x 198 cm.

Scenes from the Passion: The Hawthorn Tree, 2001. Enamel on board.

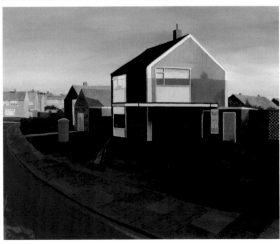

20 parts, 75 x 215 x 20 cm (each), mixed media.

Santiago Sierra

Born in Madrid, Spain, 1966; lives
and works in Mexico City, Mexico.
Sierra represented Spain at the 50th
Venice Biennale in 2003, and has had
solo exhibitions at venues including
Queensland Art Gallery, Brisbane; Museo
d'Arte contemporanea Donnaregina,
Naples; and Tate Modern, London.
His work is represented in the collections
of the Centro de Arte Contemporáneo de
Málaga; Kiasma Museum of Contemporary
Art, Helsinki; Daimler Kunst Sammlung,
Berlin; and Museo Arte Contemporaneo
Isernia, Italy.

Santiago Sierra is among the most confrontational and divisive of
contemporary artists. His consistently startling practice, which often centres
on seemingly purposeless or demeaning actions executed by workers hired
at minimal rates, draws attention to the harsh inequities of physical labour.
Sierra has often courted controversy by seeming to replicate the patterns of
exploitation that define the capitalist system he probes, thereby highlighting
the brutal logic of commerce in the context of poverty and oppression.
In a notorious project from 2000, he paid four drug-addicted prostitutes
12,000 pesetas each – the price of a heroin fix – to allow a straight line to
be tattooed across their backs, documenting the process on video. And in
2004's equally troubling *Polyurethane Sprayed on the Backs of Ten Workers*, he
presents the image of a line of Iraqi immigrants undergoing the torture-like
treatment spelled out in the work's prosaic title.

Sierra has exhibited at London's Lisson Gallery several times, famously
'launching' an additional space in 2002 by temporarily sealing the new
premises behind corrugated metal. As part of a show at the gallery in 2007,
he presented another large-scale installation, *21 Anthropometric Modules
made from Human Faeces by the People of Sulabh International, India*, 2005–
2006. Filling the space were large slabs of solid waste mixed with a plastic
binding agent, presented along with the coffin-like wooden crates used to
ship them from India. Gathered three years previously around Jaipur and New
Delhi, the work's organic component had long since dried out to become a
harmless adobe-like material. Seen in the context of the
Lisson, which built its reputation on promoting Minimalist
sculpture, the work's stark appearance seemed at once
respectful and subversive.

**Sierra has often courted controversy by
seeming to replicate the patterns of exploitation
that define the capitalist system he probes.**

But *Anthropometric Modules* is far more than just a dig at a formerly
influential tendency in art. In both its final form and the unique process
of its construction, the work offers pointed comment on a grim fact of
Indian life. At least a million people, most of them women, are employed
across the country as 'scavengers', low-caste workers charged with hand-
cleaning toilets and sewers. Wielding only the crudest of tools and routinely
forced to walk long distances in punishing conditions, these unfortunates
are vulnerable to serious illnesses including tuberculosis. Produced in
collaboration with Sulabh International that campaigns for human rights and
educational reform, Sierra's work employs the formal language of modernism
to point out that much of the world still subsists in conditions that the more
affluent might think of as belonging to an earlier age.

Piero Manzoni, Merda d'Artista (Artist's Shit)
(detail), 1961. 90 labelled cans of excrement,
4.8 x 6.5 cm (each).

The provocation contained in *Anthropometric Modules* is thus manifold.
An irreverent allusion to the aesthetic heritage of the site of its debut, the
work also directs viewers toward the site of its production, highlighting
the vast gap in living standards between the two. And while the reframing
of excrement as art is not without a heritage – Piero Manzoni famously
preserved his own as *Merda d'Artista* (Artist's Shit) in 1961, and Gelitin
designed a fecal font, *Das Kakabet*, in 2007 – Sierra's alchemy is the most
usefully transformative.

160 cm Line Tattooed on 4 People, 2000. Performance view, El Gallo Arte Contemporáneo. Salamanca, Spain.

Taryn Simon

Born in New York, USA, 1975; lives and works there. Simon's photographs and writing have been the subject of solo exhibitions at Tate Modern, London; Neue Nationalgalerie, Berlin; Whitney Museum of American Art and the Museum of Modern Art, New York; Museum für Moderne Kunst, Frankfurt. Her work is represented in the permanent collections of the Metropolitan Museum of Art, New York; Victoria and Albert Museum, London; High Museum of Art, Atlanta; Centre Pompidou, Paris; and Museum of Contemporary Art, Los Angeles. In 2011, Simon's work was included in the 54th Venice Biennale.

On the magnolia walls of an anonymous institutional corridor – it could be a hospital or school – hang two large abstract paintings protected by rope barriers. The canvases are angular and asymmetrical, and feature geometric compositions in flat, saturated colour. One boasts a polka-dot design that is reflected in the building's polished linoleum floor. Both are by Thomas Downing, a member of the post-war Washington Color School. And the bland interior they embellish is, it turns out, actually that of the CIA's original headquarters in Langley, Virginia. This fact immediately casts Taryn Simon's otherwise rather unremarkable photograph in an altogether different light; notoriously, the agency's relationship with modern art is complicated by the theory that its endorsement of Abstract Expressionism in particular was aimed at countering Soviet Communism.

The shot forms part of Simon's 2007 series 'An American Index of the Hidden and Unfamiliar', in which the artist documents objects, locations and events that are usually obscured from public view. Working with a broad spectrum of individuals and organizations over a four-year period, she gained entry and insight into numerous worlds generally considered to be inaccessible, or at least forbidding. Taken with a large-format camera, the photographs are precise, even hyper-real. And while some are infused with atmosphere, others appear more detached – at least until we discover from their lengthy captions exactly what they depict. Thus, 'An American Index' not only offers a glimpse behind various scenes, but also forms a composite portrait of the nation through that which it chooses to conceal.

Other photographs in Simon's series depict an outdoor recreational 'cage' for death row prisoners; an array of spent fuel rods glowing an eerie blue inside a nuclear waste storage facility; a cryogenic preservation unit occupied by the bodies of scientist Robert Ettinger's mother and first wife; a copy of *Playboy* magazine printed in Braille; and the U.S. Customs Contraband Room at John F. Kennedy Airport, piled high with confiscated animals and plants (the last image sparked another series, 'Contraband', 2009, in which the artist documented all the items seized from passengers over a five-day period). As such examples demonstrate, 'An American Index' also functions as a record of societal extremity, revealing the undercurrents of improbability, danger and crime that coexist with more familiar, official views.

Nuclear Waste Encapsulation and Storage Facility, Cherenkov Radiation, Hanford Site, U.S. Department of Energy, Southeastern Washington State, 2005/2007.
Chromogenic print, 94.6 x 113 cm.

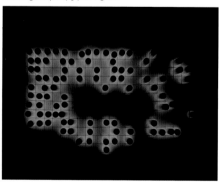

The Central Intelligence Agency raises fascinating questions about security in the context of government – what does it mean to take photographs in such a sensitive location, and how does one go about it? – but also encapsulates a conflicted moment in American cultural history. Downing and his contemporaries are recognized as having boosted Washington, D.C.'s standing as an artistic centre, and the paintings in Simon's image belong to Vincent Melzac, a former Administrative Director of the city's Corcoran Gallery of Art. But it has been suggested that the CIA may have encouraged such connections to promote a non-political aesthetic to counter the more politicized art of the Soviet Union. There are, then, two kinds of 'hidden' here: one physical, the other political.

Cryopreservation Unit, Cryonics Institute, Clinton Township,
Michigan, 2004/2007.
Chromogenic print, 94.6 x 113 cm.

Bird Corpse, Labeled as Home Décor, Indonesia to Miami,
Florida (prohibited) (detail), 2010

Lorna Simpson

Born in New York, USA, 1960; lives and works there. Simpson's work has been exhibited at the Museum of Modern Art, New York; Museum of Contemporary Art, Chicago; Miami Art Museum; Walker Art Center, Minneapolis; and Irish Museum of Modern Art, Dublin. A mid-career survey toured in 2006–2007 from the Museum of Contemporary Art in Los Angeles to the Miami Museum of Art; Whitney Museum of American Art, New York; Kalamazoo Institute of Art, Michigan; and Gibbes Museum of Art, Charleston. In 2010, Simpson won the International Center of Photography's Infinity Award for Art Photography.

Looking at the neatly gridded arrangements of small, black-and-white photographs in Lorna Simpson's series 'May, June, July, August '57/'09', 2009, it would be easy to mistake all the shots for vintage finds from family albums. Such an impression would be only partially accurate, however. Half the pictures do originate in a private collection that Simpson bought on eBay, but closer observation reveals that each snap is accompanied by a doppelganger, a not-quite-exact present-day copy in which the artist mimics the details of the original. Most of the purchased set, which is dated 1957, shows an African-American woman posing, pin-up style, in an ordinary Los Angeles home. In her remakes, the artist stands in for the subject and finds replacement settings, costumes and props. Such shifts between old and new add to the project's fascination.

Yet *May, June, July, August* is no mere spot-the-difference puzzle; nor is it simply a demonstration of the artist's facility for disguise and reconstruction. By walking in the shoes of an unknown individual who, half a century ago, acted out a semi-private fantasy of glamour in front of the camera, Simpson combines historical and cultural research with a feat of imaginative empathy. She reanimates images that were previously abandoned to obscurity, and the results suggest that the 'archival' may remain both infused with life and open to reinterpretation. The 2009 images serve to emphasize the peculiarities of the 1957 originals: the conventions of stance and gesture that the subject adopts in a quest for a 'professional' look, and the period style of her surroundings.

The history traced in *May, June, July, August* is of course also a racial one. While much has changed for the better during the period that the work brackets, America has still not shaken off all racism. By putting herself in the position of an unnamed predecessor, Simpson seems to suggest that progress is frequently superficial, and altogether too slow. This argument runs throughout her work, which since the mid-1980s has confronted the formation of cultural identity not only through images themselves, but also via their juxtaposition with written and spoken texts. Simpson first gained wide attention for elegant photographs – many of them presented in grouped formats or series – captioned to play on the viewer's assumptions about race and sex.

Easy to Remember, 2001.
16 mm black-and-white film with sound transferred to video, 2 minutes 35 seconds.

Guarded Conditions, 1989, for example, features the repeated image of a black woman in a white dress, standing with her back to the viewer and her hands behind her back. A caption above the images spells out the title, while a set of texts beneath it reads, over and over again, SEX ATTACKS / SKIN ATTACKS. The language is confrontational, suggesting a link between racial and sexual violence and oppression, yet the images are ambiguous. Does the woman's pose signify defensiveness or self-confidence? What exactly is her role in the 'attacks' to which Simpson alludes? By leaving such questions unanswered, Simpson prompts us to recognize and reassess our own received ideas by performing our own act of projection.

Guarded Conditions, 1989. 18 colour Polaroids, plastic letters, 21 engraved plastic plaques, 231 x 333 cm.

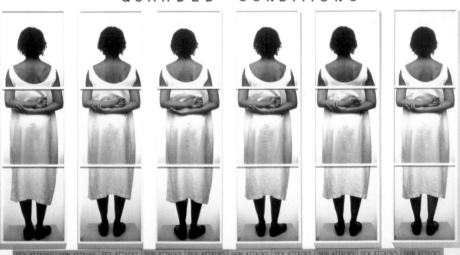

Simon Starling

Born in Epsom, England, 1967; lives and works in Copenhagen, Denmark, and Berlin, Germany. Starling has exhibited at venues including the Power Plant Contemporary Art Gallery, Toronto; Museum Folkwang, Essen; Kunstmuseum Basel; and the Museum of Contemporary Art, Sydney. His work is represented in the collections of Moderna Museet, Stockholm; Kröller-Müller Museum, Otterlo, the Netherlands; and San Francisco Museum of Modern Art. In 2003, he represented Scotland at the 50th Venice Biennale. Starling won the Turner Prize in 2005.

'When I'm making art, I'm thinking up novels in a way…. I'm involved in an activity which is similar to that of a narrator.' Suffused in historical reference, there is always more to Simon Starling's works than meets the eye. In objects, installations, films and photographs, he relates and restages the meandering stories that underlie – and frequently undermine – the utopian visions of philosophers, designers and architects. An adept researcher, Starling focuses on material culture as a way to unearth hidden connections, often including explanatory texts for additional context. Many of his projects involve physical transformations or circuitous journeys, and relate to the sites for which they were developed. And while they exhibit a profound engagement with influential ideas across a range of disciplines, they also reveal an artist with a healthy sense of the absurd.

As part of his Turner Prize-winning exhibition at Tate Britain in 2005, Starling exhibited *Shedboatshed (Mobile Architecture No. 2)*, 2005. Seemingly nothing more than a rough garden shack pieced together from mismatched bits of wood, this humble-looking structure had in fact undergone a process of conversion akin to alchemy. Starling had spotted the structure near the Rhine, but far from simply moving it from one location to another, he built a small boat with the disassembled pieces (those not used as component parts were transported inside it) and, with skipper in tow, paddled the craft downriver to Basel. Here, it was taken apart and reassembled into the original shed for an exhibition at the city's Kunstmuseum. Bearing the scars of its journey but still entirely functional, *Shedboatshed* embodies a unique form of recycling, in which even the humblest of objects are shown to be surprisingly adaptable.

Water travel also forms the basis of a sequence of *Autoxylopyrocycloboros*, 2006. In this sequence of projected slides, Starling and a partner are shown navigating a steamboat around Loch Long in Scotland. Again taking creative repurposing to a comic extreme, the artist steers the boat while his shipmate saws it into pieces that are then used as fuel. As the hull gradually gets lower and lower, the boat floods with water and sinks, the final image showing nothing but floating debris. The project has the quality of a cartoon, the two-man crew's doomed attempt to keep moving all the funnier for the predictability of its outcome.

Failure, especially in the context of social idealism, is a consistent theme in Starling's work.

Failure, especially in the context of social idealism, is a consistent theme in Starling's work. His sculpture *Inverted Retrograde Theme, USA (House for a Songbird)*, 2002, for example, explores the fate of a progressive housing development in Puerto Rico. Designed in 1952 by Simon Schmiderer, who attempted to incorporate the serialist techniques of modernist composer Arnold Schoenberg, the series of prefabricated structures are elegant but lack security, forcing later residents to add barricades. In Starling's sculpture, two model houses are held upside-down against the gallery ceiling by mahogany branches, becoming finch cages. The work's title, a reference to one of Schoenberg's compositional innovations, thus also describes a physical upset and its metaphorical associations with shortfall and discontinuity.

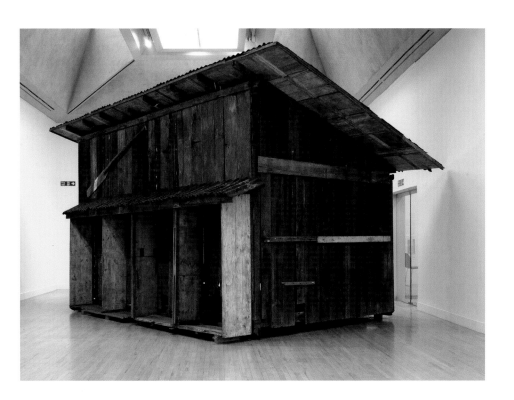

Autoxylopyrocycloboros, 2006. Colour slide projection.

Inverted Retrograde Theme, USA (House for a Songbird), 2002.
Wood, iron, mahogany, birds, 337.8 x 209.9 x 355.6 cm (each).

The Long Ton, 2009. Chinese marble, Carrara marble,
pulley system, clamps, rope, shackles, dimensions variable.

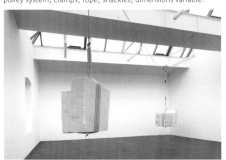

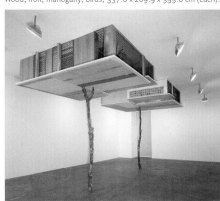

John Stezaker

Born in Worcester, England, 1949; lives and works in London. Stezaker has exhibited at The Approach, London; Galerie Gisela Capitain, Cologne; and Capitain Petzel, Berlin. An overview of his work was presented by the Whitechapel Gallery, London, and travelled to the Mudam, Luxembourg, and the Mildred Lane Kemper Art Museum at Washington University, St. Louis. He is represented in the public collections of the Museum of Modern Art, New York; Tate, London; Los Angeles County Museum of Art; Ellipse Foundation, Cascais, Portugal; and the Rubell Family Collection, Miami.

Acknowledged as a pioneer of Conceptual art in Britain – he was a member of the New Image group that challenged the dominant Pop art model of the mid-1960s – and abidingly influential as a teacher, John Stezaker reclaimed a more visible status as an artist in his own right in the mid-2000s, when a series of museum and gallery exhibitions brought his distinctive collages to the fore. In these deceptively simple works, Stezaker makes use of found printed matter, including vintage postcards and photographs clipped from old magazines, to produce eerie and unsettling hybrids. Begun in the 1980s, his 'Film Portrait' series follows this template, fusing movie stills with promotional headshots. Most of those depicted are long since lost to obscurity, though the odd still-famous face sometimes crops up.

In *Betrayal (Film Portrait Collage) VIII*, 2007–2008, a black-and-white photograph of a stiffly posed woman in a nurse's uniform is collaged onto a shot of a suit-wearing man. No attempt has been made to disguise the composite's construction; half of one photograph, cut diagonally down its centre, has simply been stuck on top of the other. The images are placed so that their subjects' facial features are aligned, but they look otherwise off-kilter. The nurse's arm has been severed by the slicing of the paper, and the top of her hat projects beyond the border that surrounds the image of the man. Yet while *Betrayal* contains no attempt at convincing visual illusion, this seemingly dashed-off vision of monstrosity retains an uncanny power.

If anything, the straightforwardness of Stezaker's technique, by making us clearly aware of the process of excision and concealment in which he is involved, adds to our discomfort. There is a violence to the artist's juxtapositions that recalls the disturbing fusions of Dada collagists such as Hannah Höch. Similarly, the apparent neutrality of the subjects' expressions in *Betrayal* finally reinforces its strangeness, giving the conjoined archetypes something of a zombie's hollow malevolence. And since the result is both male and female, the question of gender also rears its head. Stezaker sometimes refers to his combinations as 'Marriages', and by here forcing together clichéd representations of masculinity and femininity, he throws both open to renewed question.

Yet while he trades in a kind of grotesquery, Stezaker's touch is sufficiently light that the images he customizes retain their glamorous and nostalgic aura as remnants of a (recently) bygone age. He invests the defining product of modernism – the photograph – with both a pre-modern quality of the fantastic and a post-modern sense of fragmentation and doubt. Thus the subject of a work like *Betrayal* has less to do with the individuals or categories depicted than it does with the history and function of photographic – and, of course, filmic – representation. Can a single portrait ever be 'truthful', or might an irrational, absurdist interjection cut to the heart of some otherwise suppressed cultural or psychological reality? The transcendent 'third mind', which William S. Burroughs and Brion Gysin aimed for in writing via their improvised 'cut-ups', is achieved by Stezaker visually – and by not dissimilar means.

Dark Star XIV, 1979–1983. Collage, 53 x 41.6 cm.

Mask LXXVIII, 2007. Collage, 25 x 19.3 cm.

He (Film Portrait Collage) II, 2008. Collage, 25 x 19.3 cm.

Sam Ran Over Sand or Sand Ran Over Sam, 2004

Mixed media. Installation view, Rice University Art Gallery, Houston.

Jessica Stockholder

Born in Seattle, USA, 1959; lives and works in New Haven, Connecticut. Stockholder has exhibited at Dia Center for the Arts, New York; SITE Santa Fe; Kunstmuseum St. Gallen; and Centre Pompidou, Paris. Her work is represented in the collections of the Art Institute of Chicago and the Los Angeles County Museum of Art. A mid-career survey exhibition, 'Jessica Stockholder, Kissing the Wall: Works, 1988–2003' toured from the Blaffer Art Museum at the University of Houston to the Weatherspoon Art Museum at the University of North Carolina, Greensboro.

Jessica Stockholder has hinted that her original methodology arose out of a desire to break from her intellectual upbringing – her mother was a Shakespearian scholar – by operating in a fundamentally 'non-verbal' creative arena. While she has modified this approach and does now sometimes fit words to her works, Stockholder's sculptural-painterly installations remain rooted in immediate physical and visual experience. The artist discusses her practice in terms of a meeting of worlds, everyday objects and materials becoming the starting points for constructing an alternate – even fantastical – reality. Through a process of improvisational play, which she considers a variety of experimental thought, she explores the overlap between systematic planning and a kind of joyous physical flux.

A critical element of such works is their active relationship with the spaces they occupy. While Stockholder does produce discrete freestanding and wall-mounted sculptures and assemblages, the grandest of her large-scale installations cascade through interiors like lava flows, not only filling them with stuff but coating and colouring their walls, floors and ceilings. Designing such works with specific institutions in mind – her drawings act as recipes that structure each undertaking but allow for its further development on site – Stockholder aims to incorporate the museum or gallery's architectural peculiarities into each completed project. Using colour as a kind of binding agent, she implies or creates connections between otherwise disparate objects, never disguising their sources but often manipulating and recombining them in bold and surprising ways.

The grandest of Stockholder's large-scale installations cascade through interiors like lava flows.

Stockholder loves plastic, not only for its ready availability and visual punch, but also for the multiple roles it plays in contemporary culture. Plastic items appear throughout her work, along with myriad other components including pieces of furniture, food, domestic gadgetry and sporting equipment. 'Raw' ingredients such as concrete, wood and fibreboard also crop up, and applied to all these things – though rarely covering them entirely – is paint, in a rainbow of brilliant hues. The results, which betray the influence of Constructivism, Abstract Expressionism and the mixed-media innovations of Robert Rauschenberg, Richard Tuttle and others, are formal but hardly mute. On the contrary, they comment on – and actually embody – the continued value of pleasure in a physical and psychological environment that is continually remaking itself.

Sam Ran Over Sand or Sand Ran Over Sam was installed as part of Stockholder's 2004 exhibition of the same name at the Rice University Art Gallery in Houston. A typically sprawling work, it transforms a large, open room into a kind of fuzzy-bordered playground, fragmenting its surfaces via the introduction of a dizzying range of colours, shapes and textures, some harmonious, others distinctly jarring. Lighting is also key to *Sam Ran Over Sand*'s effect; the artist uses theatrical and conventional lamps as well as light bulbs and a digital projector to add further layers of visual and associative complexity to an already labyrinthine scenario. In her own writing, Stockholder imagines these elements as members of a theatrical cast: 'The Characters are orchestrated for the eye – riding on wheels – legs flapping in the wind. The eye screeches – along in the grooves laid out for it.'

344

Hollow Places Fat; Hollow Places Thin, 2011. American ash wood, paint, plywood.
Aldrich Contemporary Art Museum, Ridgefield, Connecticut.

Untitled, 2009. Mixed media, 230 x 76.2 x 63.5 cm.

Lily van der Stokker

Born in 's-Hertogenbosch, the Netherlands, 1954; lives and works in Amsterdam and New York, USA. Van der Stokker has been the subject of solo exhibitions at the Centre Pompidou, Paris; Walker Art Center, Minneapolis; Tate St. Ives; Museum Boijmans Van Beuningen, Rotterdam; Van Abbemuseum, Eindhoven; Aspen Art Museum; and Museum voor Moderne Kunst, Arnhem. She has also participated in group exhibitions at the South London Gallery; Herzliya Museum for Contemporary Art, Israel; and Bonnefantenmuseum, Maastricht.

The art of Lily van der Stokker has a transgressive edge, but not because the subjects it deals with are troubling or controversial in the way that we usually understand those terms. The radical nature of her practice resides instead in the very ordinariness of its themes, in the way she treats the apparently mundane details of life as an entirely appropriate foundation for serious creative work. The pleasures of family and friendship, the pressures of work and money, and the unexpected discovery of beauty and humour all provide the artist with ample inspiration for a disarming and optimistic practice. In its embrace of the decorative and the domestic, van der Stokker's oeuvre has also been characterized as incorporating a significant feminist or post-feminist component.

Generally beginning with modest drawings in felt-tip pen or crayon on paper, van der Stokker produces wall paintings, many of them juxtaposed with items of furniture or quasi-architectural outcroppings to create playful tableaux. She retains the casual quality of the original sketches in the larger works, but refines her execution so that their sugary colours appear almost mechanically applied. Combining abstract pattern with floral embellishment, they often incorporate short, hand-painted texts suggestive of notes jotted down on the back of an envelope. Van der Stokker is unabashed in her embrace of the private and sentimental, so these additions can seem more like notes-to-self than the stern pronouncements or conceptual in-jokes of much text-based art.

Van der Stokker is unabashed in her embrace of the private and sentimental.

In *Whoopy I am Ugly*, 2010, van der Stokker expresses a feeling of self-doubt, appearing almost to revel in its banality via the use of deliberately babyish language and a jaunty, cartoon-like visual style. The pastel-and-fluorescent palette of the painting and its comic-grotesque biomorphic shape evoke a doodle in a teenage girl's exercise book – a quasi-abstract, semi-conscious outpouring of insecurity. As originally installed at Leo Koenig Inc. in New York, part of the work covered a low door through which gallery visitors were required to pass – crouching, as if in embarrassment – in order to reach another part of the exhibition. It also has its own less functional portals in the shape of two pairs of small flaps, while a trio of plastic mats suggests that we might need to wipe our feet before or after looking.

Whoopy is part of a sequence of works for which van der Stokker consciously selected the drawings regarded as her least successful and expanded on their most aberrant details. This move – consistent with her roots in the 'abject art' tendency of the early 1990s – has allowed her to address the perceived disparity between celebrated artwork and its discarded or disregarded shadows while taking a cheeky sideswipe at her critics. The 'Ugly' series reveals that van der Stokker's work, while generally good-natured, is far from naïve. Claiming that she likes to make things with as little meaning as possible, her apparent innocence hides a commitment to addressing lived experience – especially when it seems, to quote the title of her 2010 exhibition at Tate St. Ives, 'no big deal thing'.

Sleeping in the Gallery, 2002. Acrylic on canvas, 24.9 x 29.8 cm.

Untitled, 2003. Acrylic paint and mixed media, dimensions variable.

Gonzalez-Torres Untitled (America), 2004

Light bulbs, rubber light sockets and cords, dimensions variable. Installation view, Palazzo Grassi, Venice.

Sturtevant

Born in Lakewood, Ohio, USA, 1930; lives and works in Paris, France. Since her first solo exhibition, at the Bianchini Gallery, New York, in 1965, Sturtevant has shown at venues around the world, including the Hamburger Bahnhof, Berlin; Walker Art Center, Minneapolis; Hayward Gallery, London; and White Columns, New York. She won the Francis J. Greenburger Award at the New Museum, New York, in 2008, and a retrospective of her work, 'The Razzle Dazzle of Thinking', opened at the Musée d'Art moderne de la Ville de Paris in 2010.

'Sturtevant makes copies of art works, but she is no copyist. She appropriates, but is not an Appropriationist. She was a renegade female artist, but not a feminist.' Critic Elizabeth Lamm's description portrays an artist whose practice embodies multiple contradictions, juxtaposing outward coolness with philosophical richness and percolating in the shadows of art history. Since 1964, Elaine Sturtevant (she uses only her last name) has made 'repetitions' of works by other artists, using them as starting points for what she describes as 'expanding and developing current aesthetic ideas, examining the concept of originality and exploring the relationship between original and originality, as well as accessing space for new thinking'. Displaying a remarkable ability to identify significant developments as they emerge, Sturtevant continues to keep pace with her inspirations.

Yet while the artist now enjoys widespread respect – she won a lifetime achievement award at the 2011 Venice Biennale – Sturtevant's career has been characterized by a succession of peaks and troughs. Launching her project with works derived from – and made almost contemporaneously with – Andy Warhol's flower paintings, she progressed to reinterpretations of signature images by other key artists of the 1960s, including Jasper Johns, Roy Lichtenstein and Frank Stella. She even reproduced several of Marcel Duchamp's readymades. But after she unveiled her version of Claes Oldenburg's showcase The Store, the tide of critical opinion turned against Sturtevant and her confrontational programme. She effectively dropped out of the art world; her work was entirely absent from group exhibitions between 1967 and 1985, and from solo appearances between 1974 and 1986.

It was only with the rise of Appropriationism in the late 1980s that a sympathetic climate for Sturtevant's work re-emerged. In the context of postmodernism, with its mix-and-match approach to history and style, artists like Sherrie Levine and Mike Bidlo began questioning ideas around value and authorship with a startling new directness. By recontextualizing existing images and forms, they destabilized the artwork's aura and redefined our understanding of 'uniqueness'. Sturtevant insists that her works are not 'simulations' (a term then popular thanks to French sociologist Jean Baudrillard's treatise *Simulacres et Simulation* [Simulacra and Simulation], 1981), but rather 'performances' of their sources. Nonetheless, the theoretical context in which they were reconsidered allowed the artist to probe 'the leap from image to concept' with fresh energy.

First shown in Sturtevant's landmark exhibition 'The Brutal Truth' at the Museum für Moderne Kunst Frankfurt am Main in 2004-2005, *Gonzalez-Torres Untitled (America)*, 2004, is based on Felix Gonzalez-Torres's 1994-1995 installation of hanging illuminated light bulbs. Insofar as it does not rely on having been made by hand, the echo the work represents is physically perfect, arguably throwing the debates it references into still-sharper relief. Sturtevant has also produced responses to other of the revered late Cuban artist's works, and her choice again reflects a consistent gravitation toward the most emblematic of contemporary methodologies (Gonzalez-Torres exemplifying the adaptation of Conceptualist and Minimalist strategies to more poignant, personal ends). *Gonzalez-Torres Untitled (America)* demonstrates its maker's commitment to her credo 'thought is power'.

Gonzalez-Torres, Untitled (Go-Go Dancing Platform), 1995. Wood, light bulbs, acrylic paint, wire, and go-go dancer in silver lamé shorts and Walkman, 54.5 x 183 x 183 cm.

Gober Partially Buried Sinks, 1997. Plaster, wood, wire lathe, enamel paint and artificial grass, 61.4 x 59.5 x 6.5 cm and 61.4 x 60.8 x 7 cm (sinks), 5 x 820 x 530 cm (platform).

Tilting Planet, 2006

Mixed media, dimensions variable. Installation view, Malmö Konsthall, Sweden.

Sarah Sze

Born in Boston, Massachusetts, USA, 1969; lives and works in Brooklyn, New York. Sze's work has been included in numerous international exhibitions, including 'Cities on the Move' at the Secession, Vienna, and 'Migrateurs' at the Musée d'Art moderne de la Ville de Paris, as well as in the Berlin and Venice Biennales. Solo exhibitions of her work have been mounted at White Columns, New York; Institute of Contemporary Arts, London; Museum of Contemporary Art, Chicago, and Fondation Cartier pour l'art contemporain, Paris. In 2003, Sze was a recipient of the MacArthur Fellowship.

It was a trip to India that turned Sarah Sze on to the sculptural potential of everyday household objects. While in Delhi, the artist visited an exhibition of gold artifacts, which prompted her to reconsider the value of materials in relation to the role of craft. She began her own exploration of the theme with *Untitled (Soho Annual)*, 1996, an installation comprised of dozens of tiny forms modelled in toilet paper. Here, material was virtually worthless, the makers' transformative skill critical. From this point on, the manipulation and marshalling of familiar stuff became Sze's stock-in-trade; ladders, lamps, tea bags, plastic bottles, drawing pins and hundreds of other day-to-day items have been incorporated into her intricate arrangements. Often distributed throughout large interiors, these sprawling, towering free-form assemblages also function to colour the viewer's experience of architectural space.

In Sze's multipart installation *Tilting Planet*, 2006, this transformative quality is allied with a degree of flexibility that allows the work to be reconfigured each time it is shown; originally produced for an exhibition at Malmö Konsthall in 2006, it reappeared in different versions at Victoria Miro in London and the Baltic Centre for Contemporary Art in Gateshead. At the last venue, its viral aesthetic was especially prominent, certain components appearing to have migrated from one level of the building to the next. Sze often uses clusters and swarms of identical or similar objects, arranging them to suggest group communication and activity. Approached from one direction, *Tilting Planet* suggests a city plan; from another, a collection of esoteric construction toys or eccentric lab apparatus. Sze also responds to an exhibition's site by acquiring most of her 'ingredients' locally. This results in a kind of material survey in which local variations on common forms are integrated into the work's structure and signification. Thus it was not only the compositional arrangement but also the specific makeup of *Tilting Planet* that shifted according to the more or less divergent commercial cultures of its three venues.

These sprawling, towering free-form assemblages colour the viewer's experience of architectural space.

Tilting Planet is also characteristically rich in visual terms, intersecting with sculpture in its reliance on texture and form, and with painting in its exploration of colour and pattern. Sze's networks of differently scaled objects and part-objects have also drawn comparison with the interlinked flow of the World Wide Web. The artist has also spoken of her interest in making art that has a 'live' feel, that seems to exist spontaneously and in the moment, and which evinces a uniqueness and personality even when it has been assembled from mass-produced and cheaply available goods. By recontextualizing the objects she uses so completely, Sze not only imbues them with their own character, but also engineers a composite portrait of the society from which they are drawn. Also key to *Tilting Planet*'s lasting effect is the dialogue it sparks between public and private – a dialogue that, suggested as it is by the 'seeding' of a large-scale public arena with a succession of more intimate experiences, gives rise to a powerful sense of discovery.

Still Life with Landscape, 2011. Mixed media, dimensions variable. Installation view, the High Line, New York.

Untitled (Portable Planetarium), 2009. Mixed media, dimensions variable. Installation view, Biennale de Lyon.

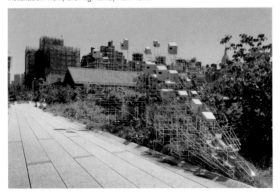

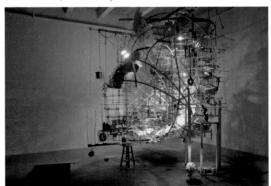

Wolfgang Tillmans

Born in Remscheid, Germany, 1968; lives and works in Berlin. Tillmans's work has been the subject of solo exhibitions at venues including MoMA PS1, New York; Hirshhorn Museum and Sculpture Garden, Washington, D.C.; Serpentine Gallery, London; Museo Tamayo, Mexico City; Zachęta National Gallery of Art, Warsaw; and Hamburger Bahnhof, Berlin. In 2000, he won the Turner Prize, and in 2009 was included in 'Making Worlds' at the Venice Biennale. Tillmans has been a professor of interdisciplinary art at the Städelschule, Frankfurt, since 2003.

It is no exaggeration to say that Wolfgang Tillmans has, over the past twenty years, been responsible for a wholesale redefinition of the photographic medium. His influence has spread beyond the confines of the art world and into visual culture at large, becoming visible in editorial and fashion photography, advertising and graphic design. He has achieved this ubiquity not only through the loose-limbed style of his images, which borrow from the aesthetics of the amateur snapshot, but also through their radically diverse presentation. Tillmans has thrown away the rulebook that governs museum-style display; he shows large-format colour prints alongside black-and-white photocopies, framed works next to others casually pinned or taped to the wall, and makes extensive use of everyday formats such as magazines and posters.

The subject-matter of Tillmans's works is relentlessly contemporary – and unapologetic in its reference to the artist's own personal and professional life – but remains rooted in the time-honoured pictorial genres of landscape, still-life and portraiture. What first brought Tillmans to wide attention, however, was his direct engagement with identity politics via the milieu of youth culture; the intimacy of his images conveys the sense of artist as active participant rather than objective observer. Intimate sex scenes and domestic tableaux rub up against shots of clubs, celebrities and records of international travel. The result is a cumulative portrait of the artist through details of the world he inhabits, the spontaneous, diary-like quality of many of the images making a virtue of formally 'incorrect' composition, colour and lighting.

Intimate sex scenes and domestic tableaux rub up against shots of clubs, celebrities and records of international travel.

Tillmans's *Eierstapel*, 2009, depicts two precarious-looking stacks of cardboard cartons filled with white eggs. A dangling fluorescent lamp provides stark illumination but we can make out nothing else apart from a few garish food packets and empty plastic containers. The cartons recede into darkness, denying us even a glimpse of their location (presumably a market). The image has a quotidian feel, yet there is a measure of absurdity to it that pulls us in, and a grim beauty that keeps us looking. While there are no people in *Eierstapel*, a human touch is apparent in every detail of the oddly sculptural make-do arrangement it depicts, and there is even a certain sensuality in the textural contrasts between the smooth eggs and their wrinkled containers.

Over the past few years, Tillmans has also been experimenting with photographic chemistry itself, creating abstract works that record nothing but accidents of developing, and others that treat the print as a sculptural object. Though they might appear to diverge from the established direction of his oeuvre by abandoning its figurative, observational and autobiographical elements, these new works are consistent with the artist's absorption in fleeting moments of the sublime. Tillmans also continues to test the possibilities of mixing found and original imagery in projects such as the 'Truth Study Center' installations. Made up of sets of vitrines and tables filled with newspaper clippings alongside his own photographs, these quasi-museological displays juxtapose reports of injustice with images that make a contrary case for the endurance of beauty and love.

Truth Study Center Table VIII, 2005.
Wood and glass, chromogenic prints, 77.9 x 198 x 76.4 cm.

Lighter, green/yellow V, 2010.
Unique chromogenic print in Plexiglas hood, 64 x 54 cm.

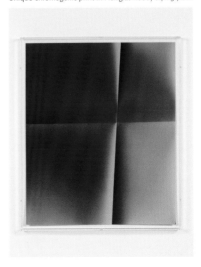

Rirkrit Tiravanija

Born in Buenos Aires, Argentina, 1961; lives and works in Berlin, Germany, Chiang Mai, Thailand, and New York, USA. Tiravanija has been the subject of touring retrospective exhibitions organized by the Kunsthalle Bielefeld and Museum Boijmans Van Beuningen, Rotterdam. He is president of the Land Foundation, a founding member of the Utopia Station collective of artists, art historians and curators, and a member of Bangkok-based alternative space VER. Tiravanija is a recipient of the Hugo Boss Prize, the Absolut Art Award, and the Lucelia Artist Award.

'So when you first walked in, what you saw was a kind of haphazard storage space. But as you approached this you could start to smell the jasmine rice. That kind of drew you through to the office space. And in this place I made two pots of curries, green curries. One was made how Thai restaurants in New York were making it. To counter that, in the other pot was an authentically made Thai curry. I was working on the idea of food, but in a kind of anthropological and archaeological way. It was a lot about the layers, of taste and otherness'. Describing the making of his cult installation *Untitled 1992 (Free)*, 1992, at 303 Gallery in New York, Rirkrit Tiravanija reveals the ideas that led him to convert a gallery office into a kitchen, and to offer complimentary food to its visitors.

Interested not only in cooking, but also in deconstructing the gallery's behind-the-scenes operations, Tiravanija made 303's usually hidden inventory visible to all, and stocked an area customarily dedicated to administration with a fridge, a rice cooker, pans, tables and stools. Preparation and consumption continued daily as visitors came and went, often making repeat visits over the course of the project. The gesture was simple but transformative, erasing at a stroke the hands-off mystique of the conventional exhibition and replacing it with an easy and enjoyable participatory experience. The artist became, in the words of critic Jerry Saltz, 'a medicine man who literalized art's primitive functions: sustenance, healing, and communion.' *Untitled 1992 (Free)* was not something to be looked at from a distance, but generated the potential for new and active relationships between all its participants, interactions centred on physicality as well as intellect and emotion.

'I was working on the idea of food, but in a kind of anthropological and archaeological way.'

Over the past two decades, Tiravanija has staged numerous variations of the work, and on each occasion, the shift in time and place has subtly inflected its meaning. A 2007 restaging at David Zwirner in New York, for example, served to underline shifts in the economy by concentrating attention on the upward trajectory of its host, making the strategy of occupying space with nothing to sell feel all the more pointed and pertinent. Other projects by the artist also experiment with allowing the ungovernable realities of everyday life to seep into the über-controlled environment of art and its markets. 1999's *Untitled (Tomorrow can shut up and go away)* took the form of a plywood replica of Tiravanija's East Village apartment, erected across town inside Gavin Brown's Enterprise. In typical New York fashion, the fully functional living space was kept open to all comers twenty-four hours a day. And for 'Fear Eats the Soul' at the same gallery's new premises in 2011, he built a miniature factory that turned out T-shirts emblazoned with provocative slogans like THE DAYS OF THIS SOCIETY IS NUMBERED. Such sentiments, which might sound apocalyptic in the mouths of other artists managed, coming from this amiable figurehead of the relational, to convey a defiant and joyful optimism.

'Fear Eats the Soul', Gavin Brown's Enterprise, New York, 2011.

Untitled (The Future of Chrome), 2008.
Mirror polished stainless steel and glass, 274.3 x 152.4 x 76.2 cm.

Luc Tuymans

Born in Mortsel, Belgium, 1958; lives and works in Antwerp. Solo exhibitions of Tuymans's paintings have been presented at Tate Modern, London; Kunsthalle Bern; Portikus, Frankfurt; De Pont Foundation, Tilburg; UC Berkeley Art Museum; Kunstmuseum Wolfsburg; San Francisco Museum of Modern Art; and Bozar, Brussels. His work has also featured in group exhibitions including 'Painting – The Extended Field' at Rooseum Center for Contemporary Art, Malmö. In 1999, Tuymans curated the group exhibition 'Trouble Spot' at Museum of Contemporary Art (M HKA), Antwerp.

In Luc Tuymans's canvas *Panel*, 2010, four seated figures on a bare stage are bathed in an obliterating white light while an audience looks on from the shadows. The upper two-thirds of the painting is essentially empty, vertical brushstrokes suggesting an echoing, high-ceilinged room. The stark lighting and grim coloration add to the evocation of a torture chamber, but it remains uncertain who holds the whip hand. The centrepiece of Tuymans's 2010 exhibition 'Corporate' at David Zwirner in New York, *Panel* comments on the anonymity of those in real economic power by portraying them as spectral entities beyond the reach of ordinary people. In this sense they are quasi-religious figures, a point underlined by the picture's echo of British painter Francis Bacon's famous images of anguished popes.

Panel is characteristic of Tuymans's ability to invest everyday imagery with a sense of dread by focusing on ordinary-looking interiors and objects that turn out to have a problematic history or implication. 'Anything banal can be transformed into horror,' the artist states. 'Violence is the only structure underlying my work.' Adding to this uncomfortable aura is a consistently washed-out palette dominated by dour greys and greens, and dry, deliberate paint handling. This creates a look that owes much to the sickly light of television, hinting that our perception of such events is invariably mediated, and our emotional reactions deadened. Tuymans spent a few years experimenting with film and video in the mid-1980s, and while he ultimately returned to painting, electronic means continue to inform his use of 'sampled' or second-hand imagery.

'Anything banal can be transformed into horror....
Violence is the only structure underlying my work.'

The theme of collective memory implied by Tuymans's interest in the mass media is key to a practice concerned with the idea of history as fabrication or distortion. Tuymans is fascinated by repression, whether it occurs as a result of psychological trauma or official censorship, and by the impossibility of picturing momentous experience in a lastingly meaningful way. In paintings like *Gas Chamber*, 1986, he openly acknowledges this poverty of imagination, allowing it to guide his creative process. First producing a small watercolour from a photograph of the gas chamber at Dachau concentration camp, Tuymans then reproduced the painting on canvas, retaining the paper's worn-out texture. The end result has an even more profoundly forsaken air than its source, speaking of a common unwillingness to confront the subject. Many of Tuymans's works share this deliberately shabby, exhausted look, as if burdened by their own fragile existence.

In some more recent paintings, Tuymans has shifted his focus toward the depiction of more contemporary subjects. *The Secretary of State*, 2005, for example, shows an instantly recognizable Condoleezza Rice. The politician's face, taken from an official portrait photograph posted online, almost fills the canvas, and her expression conveys an intense determination that the painter identifies as belonging specifically to a black woman. But there is a critical ambiguity to even this image, a sense that the subject's power is sustained by a system whose goals are uncertain, even amoral.

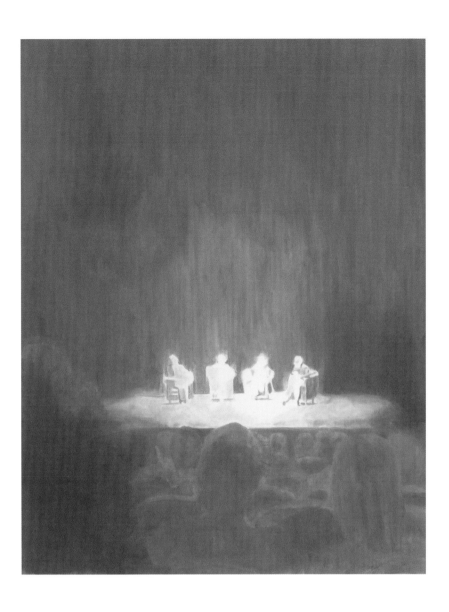

Gas Chamber, 1986.
Oil on canvas, 61 x 82.5 cm. Collection Overholland, Amsterdam.

Bend Over, 2001.
Oil on canvas, 60 x 60 cm. Private collection.

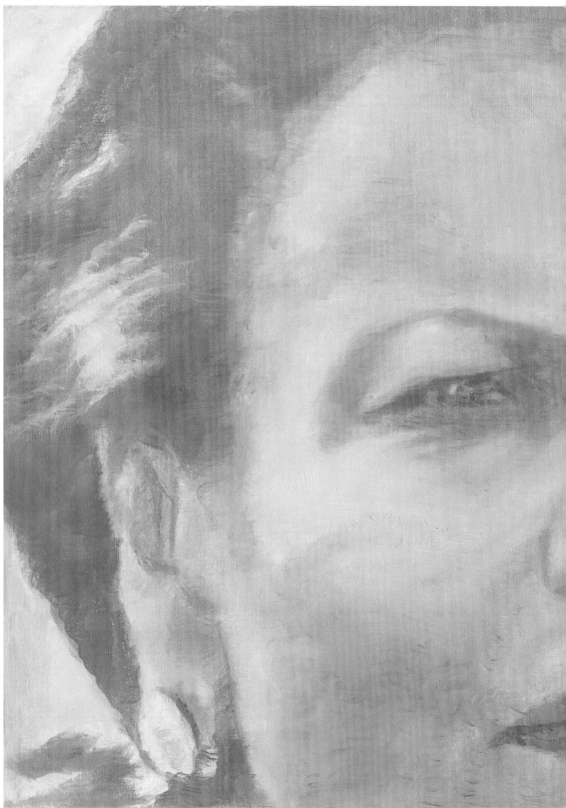

Luc Tuymans, The Secretary of State, 2005. Oil on canvas, 45.5 x 61.5 cm. The Museum of Modern Art, New York.

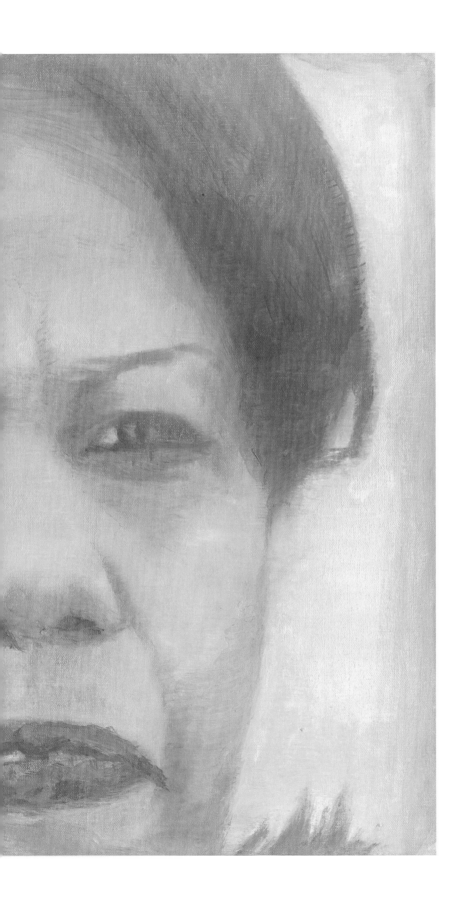

From Night School, 2008–2009. Monthly weekend seminars.

Anton Vidokle

Born in Moscow, Russia, 1965; lives and works in New York, USA. Vidokle has exhibited at the Venice and Dakar Biennales; Portikus, Frankfurt; Moderna Galerija, Ljubljana; and the Hammer Museum, Los Angeles. With Julieta Aranda, he organized 'e-flux video rental', and has also produced other projects including 'The Next Documenta Should Be Curated By An Artist', 'Do It' and the 'Utopia Station' poster project.

Some readers may find the inclusion of Anton Vidokle in a book about artists and their work surprising; his activities are well known throughout the contemporary art world, but he is frequently identified as something other than a 'practitioner' in his own right. Vidokle achieved his influential visibility in large part through the founding of e-flux, a free online bulletin that announces exhibitions, publications, conferences and other events and opportunities to 90,000 subscribers internationally. He has also been involved in numerous curatorial and pedagogical projects, typically of an experimental, collaborative or peripatetic nature. Yet while Vidokle has for the past dozen years also exhibited his own art in a relatively conventional manner, his identity has been largely subsumed by the very scope and inclusiveness of his practice as a whole.

In 2006, Vidokle was slated to co-curate – along with Mai Abu ElDahab and Florian Waldvogel – the sixth instalment of Manifesta, a biennial of European art staged in Nicosia. When the show was abruptly cancelled, Vidokle refused to quit the scene but instead set up a new, independent project in Berlin called Unitednationsplaza. Tucked away behind a supermarket on the east side of the city, this extraordinary open forum was arguably more engaging and diverse than the biennial itself had promised to be, involving more than a hundred artists and other participants and continuing for a whole twelve months. Vidokle's interest in education found expression in a series of readings, discussions, screenings and other exchanges that contributed to Unitednationsplaza's successful usurping of the 'exhibition-as-school' format originally proposed for Manifesta.

Two years later, in New York, Vidokle was involved in yet another year-long enterprise, the Night School series, presented in collaboration with the New Museum's ongoing Museum as Hub initiative. This took the form of eleven monthly seminars centred around three distinct themes – 'progressive cultural practices', 'artistic legacy today' and 'self-organization in the field of cultural production' – and expanded outward from the space of the institution to occupy various additional sites around New York City. Night School's programme featured contributions from artists, curators and theorists including Boris Groys, Maria Lind, Okwui Enwezor and Raqs Media Collective. And like Unitednationsplaza, it was framed as a work-in-progress rather than a predetermined exhibition or class.

Night School was framed as a work-in-progress rather than a predetermined exhibition or class.

As these and other projects such as An Image Bank for Everyday Revolutionary Life and the Martha Rosler Library demonstrate, what makes Vidokle's creative profile both significant and unusual is as much a radical openness to dialogue as it is any fixed personal agenda, ideology or even aesthetic. By moving within a matrix of thought and action facilitated in part by the exponential growth of the Web, he is able to reconfigure his own and other artists' relationships with their contexts. The established structures of the art world, including its still-expanding market, are thereby rendered only as meaningful as Vidokle and his collaborators – a group that may include the viewer or reader – decide they need to be at any given juncture. By working on the assumption that critique *and* practice imply a multiplicity of voices, Vidokle transforms communication into art.

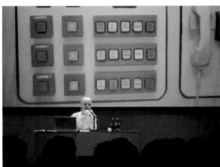

Night School Public Seminar 4: Contemporary Models of Agency, A seminar with Maria Lind, Carey Young, Tirdad Zolghadr and others, 24–27 April 2008.
From Night School, 2008–2009. Monthly weekend seminars.

PAWNSHOP in New York City, 2007.
Exterior view.

Unitednationsplaza, Berlin, 2007. Aerial view.

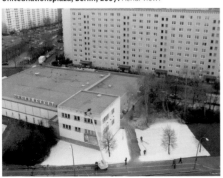

Stephen Vitiello

Born in Richmond, Virginia, USA, 1964; lives and works in Richmond and New York. Since 1989, Vitiello has collaborated with numerous visual and sound artists including Tony Oursler, Scanner, Pauline Oliveros, Nam June Paik and Tetsu Inoue. His CD releases include *Bright and Dusty Things* and *Scanner/Vitiello*, and his sound installations have been presented at The Project in New York and Los Angeles; Whitney Museum of American Art, New York; and the Fondation Cartier pour l'Art contemporain, Paris. Vitiello was the organizer of 'Young and Restless', a programme of new video work that toured over forty international venues, for the Museum of Modern Art, New York.

In late 2010, strollers on the High Line – a disused elevated stretch of the New York subway system – encountered a curious addition to the existing aural landscape. Set up in a pedestrian tunnel was Stephen Vitiello's site-specific audio installation *A Bell for Every Minute*. The work's premise was simple: every sixty seconds, overhead speakers would broadcast the sound of a different bell recorded somewhere in or close to the city. A map displayed on one of the tunnel's columns located each one and listed it by start time, from 00:01 GOOD STUFF DINER COUNTER to 00:59 NY STOCK EXCHANGE CLOSING BELL. And at the top of every hour, a mixed chorus of bells echoed through the space.

Situated outdoors, and in a busy part of town, *A Bell for Every Minute* not only documents the life of the city through a focused selection of sounds, but also seems to commune with it by interjecting those sounds into an already cacophonous environment. The last-orders bell from McSorley's Old Ale House must compete with the chatter of sightseers, the barking of dogs, the honking of car horns, and a thousand other sources of noise. Many passers-by will have missed, ignored or disregarded Vitiello's installation, but those who arrived at the right time and paused to listen will have found their awareness of the immediate environment unexpectedly enhanced. Public art often struggles in vain to compete with its surroundings; here Vitiello succeeds by admitting that his work is just one piece of a larger puzzle.

While he makes sculptures and drawings, and uses photography and video, sound remains at the heart of Vitiello's work. Starting out as a punk guitarist, he soon found that the art world offered him an expanded arena for creativity and collaboration, and so he began manipulating ambient sound as a way of altering listeners' perceptions. As an artist-in-residence at the World Trade Center in 1999, he made a work based on sounds recorded using a contact microphone attached to the windows of his 91st-floor studio. *World Trade Center Recordings: Winds after Hurricane Floyd*, 2002, documents the effect of wild weather on the building, revealing an unsettling symphony of creaks and groans that make the wavering structure sound like a galleon at sea. After 9/11, the work assumed a still deeper resonance.

In addition to weaving sound into immersive installations – and composing soundtracks for films and projects by Nam June Paik, Joan Jonas and others – Vitiello produces discrete objects. In some of these, he subjects audio equipment itself to cruel and unusual treatment: *Ax/Speakers/Mismatched Twins*, 2002 – his take on Robert Morris's *Box with the Sound of Its Own Making*, 1961 – features two damaged speakers, one with a hatchet still buried in it, broadcasting the sounds of their own partial destruction. He also performs live, and in some unusual settings. A 2007 concert with Steve Roden at the Chinati Foundation in Marfa, Texas, took place inside an artillery shed filled with Donald Judd sculptures. The audience remained outside, watching through the glass as evening turned to night.

Robert Morris, Box with the Sound of Its Own Making, 1961.
Mixed media, 116.8 x 24.8 x 24.8 cm. Seattle Art Museum.

World Trade Center Recordings: Winds after Hurricane Floyd, 1999 and 2002.
Audio: 8 minutes 20 seconds, and colour photograph: 152.4 x 109.2 cm. Whitney Museum of American Art, New York.

Stephen Vitiello and Steve Roden, From Perfect Cubes to Broken Trains..., 2008.
Four-channel audio, wood, solar panels. Commissioned by Ballroom Marfa.

Kara Walker

Born in Stockton, California, USA, 1969; lives and works in New York. Walker's work is included in the collections of the Baltimore Museum of Art; DESTE Foundation for Contemporary Art, Athens; and Museum voor Moderne Kunst, Arnhem. Her survey show, 'Kara Walker: My Complement, My Enemy, My Oppressor, My Love', premiered at the Walker Art Center, Minneapolis, in 2007 before travelling to the Musée d'Art moderne de la Ville de Paris, France; Whitney Museum of American Art, New York; Hammer Museum, Los Angeles; and the Modern Art Museum, Fort Worth.

Initially drawn to the genteel and archaic medium of the cut-paper silhouette while a graduate student in the early 1990s, Kara Walker has since made the outwardly anachronistic technique her own. The craft, which attained popularity in the United States during the 1700s but was later consigned to the status of a hobby, also has ties to the 18th-century pseudo-science of physiognomy, which ascribed intellectual and psychological significance to the human profile. Walker was drawn to this phenomenon as a tool for exploring and deconstructing the representation of race. By reducing human forms to their two-dimensional essence, she reveals some of the ways in which stereotyping continues to misread, infantilize and confine its subjects.

Slavery! Slavery!, 1997 (the work's full title chimes with critic Bob Nickas's assessment of Walker as 'one of the most inventive, lyrical, and humorous writers ever to set pen to paper'), is a panoramic tableau of silhouetted figures applied to a curved white wall. The imagery belongs to the Antebellum South, but its racial and sexual components are exaggerated to the point of caustic absurdity. The twenty-plus figures are slightly larger than life-size, and the scene as a whole borrows from Eastman Johnson's genre painting Negro Life at the South (Old Kentucky Home), 1859. But where Johnson's picturesque original shows a white mistress encountering a slave playing the banjo while a boy dances with his mother, Walker imagines a wild nocturnal procession.

The work is divided into three parts, with sections set around a fountain, under a crescent moon, and outside the slave's quarters. The parade shows a woman with a baby strapped to her back. She pulls a cart from which a boy tumbles in the direction of a pitchfork-wielding man. Behind this unfortunate scene, a family dances to the beat of a wandering drummer, while a couple having sex on a rooftop begin to tumble off, dropping their slice of watermelon. Elsewhere, a woman vomits onto the ground while attendants scoop up the liquid and hurl it into the boat that another wears like a skirt. And so it goes on. The 360-degree format of the work evokes the cyclorama, a proto-cinematic form of painting fashionable in the 19th century that Walker uses to create an immersive narrative without fixed sequence – an allusion to the cyclical resurgence of prejudicial attitudes and policies in a nation still struggling with its identity.

The 360-degree format of the work evokes the cyclorama, a proto-cinematic form of painting.

In her reading of Slavery! Slavery!, critic Yasmil Raymond highlights Walker's use of objects such as tools, weapons and especially clothing in reference to the contested nature of property and unequal balance of power that defined the era of slavery, and which still inflect American race relations today. The presence or absence of shoes on the figures' feet, for example, represents, she argues, an allegorical element with almost fetishistic implications. As Nickas writes, 'with Walker, whether via image or word, we are always delving on a subtextual level'. Couched in delicate technique, this work shatters the myth of civilized tolerance.

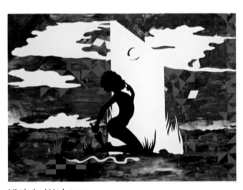

Mississippi Mud, 2007.
Mixed media, cut paper, casein on gessoed panel,
152.4 x 213.4 x 5.1 cm.

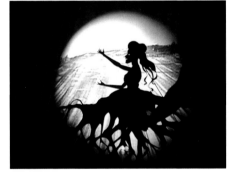

Fall From Grace, Miss Pipi's Blue Tale, 2011.
Colour video with sound, 17 minutes.

Darkytown Rebellion, 2001. Cut paper and projection on wall, 457.2 x 1005.8 cm

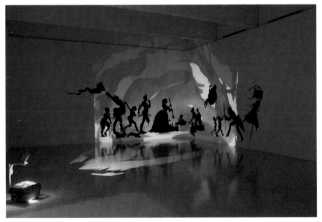

Cover design for The ACME Novelty Library #1, 1993

From a colour, 36-page offset litho-printed magazine, 24 x 17 cm. Published by Fantagraphics, Seattle.

Chris Ware

Born in Omaha, Nebraska, USA, 1967; lives and works in Chicago. In 2002, Ware became the first comics artist to feature in the Whitney Biennial. His work has also been the subject of solo exhibitions at the Museum of Contemporary Art, Chicago, and the University of Nebraska's Sheldon Museum of Art, and has also been shown at the Cooper-Hewitt National Design Museum in New York. Ware has been published in *The New Yorker*, *The New York Times* and the influential comics magazine *RAW*. *Jimmy Corrigan: The Smartest Kid on Earth* won the 2001 Guardian First Book Award.

Among the few American cartoonists to have achieved recognition in the contemporary art world – only R. Crumb, Charles Burns, Gary Panter and a handful of others share his profile – Chris Ware is perhaps the most widely venerated. In his extraordinary comics and books, Ware has truly expanded the medium's scope, pushing its established aesthetic in unexpected new directions and investing its narrative form with a never-before-attempted psychological profundity. Trained as a painter and printmaker and inspired by cinema and graphic design, Ware brings a transcendent sophistication to the page. And while cartooning remains associated with comedy, his tales of damaged characters and strained relationships, though peppered with knowing references to vintage pop culture, are distinguished by their haunting pathos.

In 2000, Pantheon Books published Ware's graphic novel *Jimmy Corrigan: The Smartest Kid on Earth*, a collection of strips previously issued as part of the artist's 'ACME Novelty Library' series. The volume became the biggest 'literary' comics success since Art Spiegelman's *Maus*, 1972–1991, introducing a new readership to Ware's themes of isolation, miscommunication, depression and death, and to his intricate drawing and lettering. *Jimmy Corrigan* recounts the life of an emotionally wounded man from early childhood through adolescence and into dysfunctional adulthood, its narrative interweaving past and present, memory and action in a multi-layered character study. While retaining the panels and speech bubbles of a traditional comic strip, it deviates frequently from straightforward linear narrative, sending the reader through a visual and textual labyrinth.

Ware has a particular fondness for the depiction of periods that long predate his own experience.

Writing about Ware in the catalogue for the travelling exhibition 'Masters of American Comics', author Dave Eggers considers the role of nostalgia in *Jimmy Corrigan* and other of the artist's works. Ware has, he observes, a particular fondness for the depiction of periods that long predate his own experience. 'It's clear that Ware looks fondly back to a time before modernism crushed almost all of art's flourishes, eccentricities and organic forms,' he writes. 'But instead of simply reappropriating old forms, he channels the past by sublimating it, creating a style that is, in the end sui generis, and almost untraceable to any artist before him.' Ware looks to the past not only in his imagery but also in his writing, which frequently incorporates the argots and idioms of bygone times.

Thanksgiving #2: Conversation, 2006.
Cover design for *The New Yorker*.

In *Jimmy Corrigan*, the tragic cast of the protagonist's story is initially softened but finally made even more affecting by Ware's association of the comic form with childhood via nods to the kinds of costumed superheroes and tie-in toys familiar from Marvel and DC Comics. As readers, we can no more escape the past than can its tortured, inert, almost silent protagonist. Similar associations haunt other strips such as *Rusty Brown*, which details the misadventures of a lonely action-figure collector, and *Quimby the Mouse*, which pushes the juxtaposition of all-too-human characterization and violent absurdity laid down by George Herriman in his famous *Krazy Kat* strip to jarring new extremes. In Eggers's winking assessment, 'Ware gives the impression of being, himself, antisocial, self-lacerating, dystopic, and perhaps dangerous to his fellow man and pets.'

Rusty Brown, 2000. Ink on paper, 72.1 x 51.6 cm.

Quimby the Mouse, 2009. Animation drawings, dimensions variable.

Gillian Wearing

Born in Birmingham, England, 1963; lives and works in London. Wearing has been the subject of solo exhibitions at the Whitechapel Gallery, London; Museum of Contemporary Art, Chicago; Galleria Civica di Arte Contemporanea di Trento; and the Australian Centre for Contemporary Art, Melbourne. Her feature-length video *Self Made* was chosen to open the Museum of Modern Art in New York 's Documentary Fortnight in 2011. Wearing won the Turner Prize in 1997 and the Grazia 02 X Award for Art in 2007, and was made an Officer of the Order of the British Empire (OBE) in 2011.

'Confess all on video.' This problematic but compelling invitation encapsulates Gillian Wearing's approach to garnering subject-matter. Her interest is in people – their stories and memories, declarations and confessions – and she uses techniques more commonly associated with documentary filmmaking and investigative journalism to dig as deep as possible into their past and present lives. Employing simple visual devices to protect individuals' anonymity, she explores the full range of human emotions, confronting the construction of personal identity and the nature of truth as communicated through the portrait form. *Secrets and Lies*, 2009, one of several works to which the artist's open calls – which most recently took the form of an online advertisement – have given rise, is a video housed in a small chamber that suggests a confessional box. A succession of respondents wearing masks and wigs recount the intimate details of pivotal and traumatic events in their lives, holding nothing back in a series of raw, heart-rending testimonies.

The work that earned Wearing her reputation as the agony aunt of the Young British Artist generation is *Signs that say what you want them to say and not signs that say what someone else wants you to say*, 1992–1993, a set of photographs depicting volunteers holding up sheets of paper on which they have been asked to write messages of their own choosing. The often surprising and ambiguous quality of their slogans, and the frequent disjunction between participants' words and their physical appearance, invest an outwardly light-hearted project with genuine gravitas. The lesson of *Signs that say what you want them to say* seems to be that we should take nothing and no one at face value, that what lurks beneath exercises a powerful influence even as it remains unseen. In more recent photographs, Wearing has also depicted herself: *Self-Portrait*, 2000, shows her wearing an expressionless mask with lips sealed shut in recognition of her own unease with language and self-expression.

Respondents wearing masks and wigs recount the intimate details of pivotal and traumatic events.

Wearing cites British 'fly-on-the-wall' documentaries such as Franc Roddam and Paul Watson's *The Family*, 1974, and Paul Almond's *7 Up*, 1964, as having influenced her concern with social roles and public behaviour. Videos such as *Drunk*, 1997–1999, in which the artist directs a steady gaze at three intoxicated individuals, filling a trio of adjoining screens with their figures in stark black-and-white, rework some of the techniques used in these ground-breaking films to reveal the subjects in all their tragic vulnerability. The protagonists of *Drunk* are recognizable as archetypes but emerge too, over time, as unique individuals, finally achieving an almost iconic status via the scale and focus of Wearing's depiction. *Secrets and Lies* is similarly affecting. The nine stories featured, which include a man's devastating account of the circumstances that drove him to commit murder and his thoughts on the lonely life he is now forced to lead, have a directness that utterly transcends exploitation or sentimentality. 'I just want to hear what people's real lives are like,' says the artist. 'When they feel free to talk, you find out more about the world.'[1]

1 Linda Yablonsky, 'Artifacts: Gillian Wearing's True Stories', *The New York Times Magazine*, 12 May 2011.

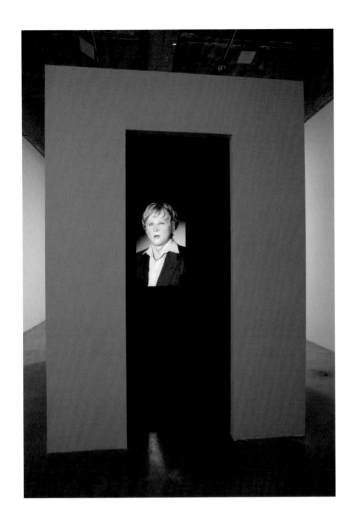

Signs that say what you want them to say and not signs that say what someone else wants you to say: I'm Desperate, 1992–1993.
Chromogenic print on aluminium, 44.5 x 29.7 cm.

Drunk, 1997–1999. Three-channel video in black and white with sound, 29 minutes. Installation view, The Museum of Modern Art, New York.

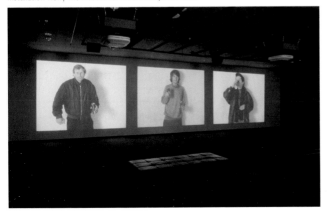

Self-Portrait, 2000.
Chromogenic print, 172 x 172 cm.
Heather and Tony Podesta Collection, Washington, D.C.

Smoke Knows, 2009

Cotton and polyester, 289.6 x 670.6 cm. San Francisco Museum of Modern Art.

Pae White

Born in Pasadena, California, USA, 1963; lives and works in Montecito Heights, Los Angeles. White has been the subject of solo exhibitions at venues such as the Govett-Brewster Art Gallery, New Plymouth, New Zealand; Contemporary Art Gallery, Vancouver; greengrassi, London; and 1301PE, Los Angeles. She has also participated in group exhibitions including 'The Americans: New Art' at the Barbican Art Centre, London, and 'Made in California: Art, Image, and Identity, 1900–2000', at the Los Angeles County Museum of Art. White has also designed publications for a number of museums.

Identifying a 'signature' work by Pae White is no easy task. Not only does her practice involve a wide variety of forms and formats, but it also regularly takes her outside the sphere of art altogether as it crosses over into the territories of product design, graphics and even architecture. But far from classifying such projects as separate from those made for museum and gallery exhibition, White thinks of them as directly comparable and equally important. She is interested too in blurring the boundaries between materials, especially when those materials are fugitive or fragile. *Smoke Knows*, 2009, which was first exhibited in the 2010 Whitney Biennial, is a wall-filling tapestry depicting a swirl of white smoke drifting in front of an inky black background. The image is derived from a photograph and the embroidery was achieved mechanically, but the work still manages to communicate its subject's ephemeral nature.

White has described the cotton in *Smoke Knows* as being lost in a kind of transformative fantasy, dreaming of 'becoming something other than itself', and the work as a whole also seems to be in transition from one state to another. Traditionally, tapestry's large scale and labour-intensive process of production has allied it with epic scenes and heroic narratives. Like bronze statuary, it seems to belong to commemorative and decorative traditions rather than to a modern view of the work of art as a vessel for individual ideas and emotions. White's work, however, straddles the divide between snapshot and monument, questioning the values we assign to each. It also functions as both a coherent figurative image and as an abstract surface marked by varieties of texture and tone. Picturing and embodying a moment in time that can never be regained, White conjures up an affecting metaphor for memory and loss that evokes art's capacity to preserve.

White conjures up an affecting metaphor for memory and loss that evokes art's capacity to preserve.

White began making tapestries in 2006, initially working from photographs depicting crumpled sheets of aluminium foil before developing more complex 'collaged' compositions. The format is unusual in modern and contemporary art, but White's project is not entirely without precedent. Modernist architect Le Corbusier was an admirer of the form, calling tapestries 'nomadic murals' in reference to their combination of easy portability and architectural scale. And in the early 1900s, Sonia Delaunay made fabric works that combine geometric shapes with the intense coloration characteristic of the Fauvist movement in painting. White's palette can be similarly intense, but more often revolves around hues characteristic of 1970s fashion – she has an extensive collection of Vera floral scarves – and of her well-lit Southern Californian milieu.

Smoke Knows is, then, an entirely characteristic work of the artist's, but represents just one aspect of her dynamic and multifaceted practice. Moving freely between contexts and techniques, White applies the methods of one discipline to the aims of another, thereby testing and extending the possibilities of both. What her work finally demonstrates, however, is not merely a formal or theoretical flexibility, but the ability to convey a love of real places and everyday experience.

Resin and granite, 900 x 510 x 240 cm. Sculpture for the Fourth Plinth in Trafalgar Square, London.

Rachel Whiteread

Born in London, England, 1963; lives and works there. Whiteread won the 1993 Turner Prize for her public sculpture *House*, represented Great Britain in the 1997 Venice Biennale and has been the subject of solo exhibitions at venues including the Kunsthalle Basel; Serpentine Gallery, London; and the Deutsche Guggenheim, Berlin. In 2001, her sculpture *Monument* occupied the Fourth Plinth in London's Trafalgar Square. Her work is represented in the collections of the Museum of Modern Art, New York; Van Abbemuseum, Eindhoven; and the Centre Pompidou, Paris.

Rachel Whiteread rose to prominence in the early 1990s alongside other members of the Young British Artist generation such as Damien Hirst and Tracey Emin. But while her more outgoing contemporaries continue to seek out tabloid headlines, the quieter Whiteread seems happier away from the limelight. Nevertheless, many of the sculptor's best-known works have been made specifically for public sites, and have often generated their own controversy and debate. Responding to negative and vacated space via the use of casting techniques and industrial materials, Whiteread produces rough-hewn but elegant forms that are hauntingly infused with memory and loss. These may take the form of small objects or, as in the case of *House*, 1993, installations on a large scale.

Whiteread conceived of *Monument*, 2001, specifically for London's Fourth Plinth, an empty stone pedestal in Trafalgar Square that has, since 1999, been offered to artists as a site for temporary projects. Whiteread was the third artist charged with tackling the high-profile commission, and the work she produced is consistent with both her own methodology and the location's specificities. *Monument* is a transparent resin cast of the plinth itself, inverted and placed atop it to create a three-dimensional mirror-image effect. The object's liquid appearance forges a connection to the 1805 naval battle after which the square was named and recalls *Water Tower*, 1998, another work by the artist in the same material that was originally installed on a Manhattan rooftop. Reportedly the largest object ever made in resin, *Monument* is also a technical milestone.

But the work is not simply an exercise in stretching material boundaries; it is also an affecting demonstration of the range of associations with which Whiteread invests even outwardly simple forms. Trafalgar Square is necessarily linked to military history, but is significant too as a locus of popular protest and celebration. Embodying both presence and absence, *Monument* as it was originally installed reflected this dual role by at once drawing attention to its surroundings and existing in gentle opposition to them. A massively heavy object, the sculpture appeared light as air when contrasted with its solid base. And while it has something of the look of a coffin or sarcophagus, it might equally be compared to an aquarium or vitrine. Like the best monumental statuary, it succeeded in celebrating life even as it alluded to death.

The year before *Monument* was unveiled, and following a fraught five-year gestation, Whiteread completed another – this time permanent – commission addressing the necessity of commemoration. The *Holocaust Memorial* is a cast concrete structure with walls composed of the impressions of books with spines turned outward. Though again formally simple, the work's associations – from the veneration of sacred texts to the book burnings that characterized the Nazi regime – are diverse and emotionally charged. As an artist for whom the interaction of positive and negative space is so significant, it seems apt that Whiteread also stands revealed as equally sensitive to other kinds of oppositions and coexistences.

Holocaust Memorial, 1995–2000.
Concrete, 390 x 752 x 1058 cm.
Judenplatz, Vienna.

Water Tower, 1998. Translucent resin and painted steel,
370.8 cm high, 274.3 cm diameter.
The Museum of Modern Art, New York.

House, 1993. Concrete, lifesize.
Grove Road, London (demolished).

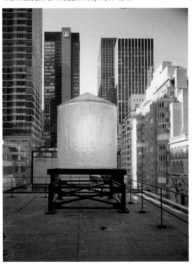

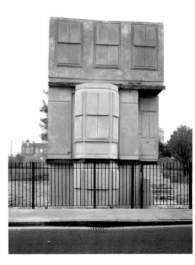

The Heir and Astaire, 2010

Colour video with sound, 10 minutes 27 seconds. Metro Pictures, New York.

T. J. Wilcox

Born in Seattle, USA, 1965; lives and works in New York. Wilcox has been the subject of solo exhibitions at the Stedelijk Museum, Amsterdam; Kunstverein München and UC Berkeley Art Museum; he has also participated in group exhibitions at Museum Ludwig, Cologne; Museum of Modern Art, New York; Museo Nacional Centro de Arte Reina Sofía, Madrid. He has also taken part in film festivals in the United Kingdom and Mexico. Wilcox's work is represented in the collections of, among others, the Museum of Contemporary Art, Chicago; Museum of Contemporary Art, Los Angeles; and Sammlung Goetz, Munich.

T. J. Wilcox is known for short films that he shoots on a low-tech Super-8, then edits on video together with found footage before transferring to 16 mm celluloid. This laborious multi-stage process lends the works' imagery an antique feel, as the patinas of age and distortion are layered over dreamlike narratives of long-gone personalities from Marie-Antoinette to Casanova and Marlene Dietrich. The films are also projected onto old-fashioned glass bead screens, adding a sense of familial intimacy and physicality to their mood of romantic nostalgia. As critic Charles LaBelle writes of the artist's aesthetic: 'His camera moves (through a city, across a newspaper clipping) with a flâneur's gait; leading the eye but aiming at the heart, visual pleasure in Wilcox's work is always distinctly corporeal.'[1]

Wilcox's film *The Heir and Astaire*, 2010, explores the thoroughly modern marriage of early 20th-century American theatre actress Adele Astaire (Fred Astaire's sister) to the aristocrat Lord Charles Cavendish. We are told, via still photographs and an interview with the current Dowager Duchess of Devonshire, how the subject retired from onstage performance to live at Lismore Castle in Ireland, the Cavendish family's ancestral home. In a characteristic oscillation between past and present, Wilcox uses contemporary images of the castle and its setting to emphasize the changes wrought by the passage of time. Revelling in the details of its historical subject, the film finally paints its central characters as unknowable, and their history as - like all others - a blend of truth and fabrication that has gradually become inextricable.

Revelling in the details of its historical subject, the film finally paints its central characters as unknowable.

Wilcox also makes folding screens, decorative objects that form a sculptural accompaniment to his films while referencing their wider contexts. *The Heir and Astaire* is paired with a set of screens that harks back to the style of the 1920s and 1930s, an age in love with lush ornament. 'Screens, by artists and architects such as Eileen Gray, Jean Dupas and Jean Dunand, formed an essential part of the interior design background of a modern life like Adele Astaire's, as she crisscrossed the Atlantic aboard the Normandie', explains the artist.[2] All the sculptures in the 'Screen for Astaire' series are double-sided, one face of each providing a surface onto which films can be projected, while the other is blanketed in a collage of colour images printed on plastic and foil.

The Heir and Astaire Screen #3, 2010.
Acetate, foil, birch plywood and MDF, 14 panels, 208.3 x 21 x 2.5 cm (each); 208.3 x 293.4 x 2.5 cm (overall). Metro Pictures, New York.

Wilcox has also described his films as collages insofar as they are accumulations of material, but he aims to preserve the integrity of each ingredient in the finished work so that repeat viewings reveal additional detail. The artist's use of subtitles adds yet another layer of information, though these captions are not simply transcriptions of dialogue or narration but have a character all of their own. The process of composing text concise enough to appear legibly on a screen as the film progresses results in a kind of poetry that steers artist and viewer toward the essentials of each work and its subject. And for Wilcox, even the sound of film passing through a projector has significance, evoking childhood memories of his grandfather's home movies.

1 Charles LaBelle, 'T. J. Wilcox, Metro Pictures', *frieze*, issue 90, April 2005.
2 The artist in Ricky Lee, 'ArtTalks - T. J. Wilcox: Starring Patsy Kline', *AnOther*, January 2011.

Lismore was her first home.

Tragedy (Sissi at the Sala Terrena), 2007.
Archival inkjet print on watercolour paper with watercolour and collage,
201.9 x 151.1 cm. Metro Pictures, New York.

The Funeral of Marlene Dietrich, 1999.
16 mm film with sound, 12 minutes 30 seconds.
Metro Pictures, New York.

Garland 5, 2005. 16 mm film, 6 minutes 49 seconds.
Metro Pictures, New York.

to her finest hour.

Stephen Willats

Born in London, England, 1943; lives and works there. Willats has been the subject of numerous solo exhibitions including 'Concerning Our Present Way of Living' at the Whitechapel Gallery, London; 'Meta Filter and Related Works' at the Tate, London; 'COUNTERCONSCIOUSNESS' at Badischer Kunstverein, Karlsruhe; 'In Two Minds' at Galerie Erna Hécey, Brussels; 'Person to Person People to People' at MK Gallery, Milton Keynes, England; and 'How the World is and How it Could Be' at the Museum für Gegenwartskunst, Siegen. Willats is the founding publisher of *Control* magazine.

'Whatever you imagine is happening *is* happening. It's as simple as that in the end.'

'The idea of relativism is very powerful,' observes Steven Willats. 'You tend to assume that the way you see the world is the way the world is. But it isn't! There is a multiplicity of views – infinite views….' Willats's art mirrors this perspective by devoting special attention to its audiences, treating them as active participants without shepherding them toward a homogeneous response. The artist's interest is in establishing structures that prompt people not only to imagine new worlds, but also to compare those imaginings with those of others. Since the 1960s, this focus has led him to incorporate research into systems of communication and learning – as well as their attendant technologies – into his creative practice. Yet however complex Willats's frameworks become, they remain firmly anchored in familiar social experience.

In *Imaginary Journey*, 2006, Willats uses photography, video, sound and text to portray a suburban high street, a public park and a journey between the two. Panels pose direct questions to viewers, asking them to imagine their own versions of this short trip and its unlimited potential outcomes. Willats collaborated with a group of volunteers to produce the work, asking each one to document a particular element of their surroundings. The results became the horizontal elements in a grid, the vertical columns representing geographical markers. An interactive 'guidebook' accompanying the work elaborates: '*Imaginary Journey* invites you to project yourself into the reality it represents, one that symbolizes the very normality within contemporary life, and to create a relationship with someone else that you might envisage meeting within that symbolic world.'

The interactive component of *Imaginary Journey*, as well as its systematically organized array of media, harks back to some of Willats's earliest projects. In the early 1970s, having become interested in the particular – and somewhat controversial – matrix of circumstances presented by London's then-new tower blocks, he made a series of works investigating the ways in which residents perceived their environments, and presented the results in situ. In *West London Social Resource Project*, 1972, he shifted the focus to a street, asking participants to record their ideas about life in form-like booklets. These were then copied and displayed in a local library. While the format belongs to a pre-Web world, the work remains contemporary: 'It was fluid,' says the artist. 'There was no object, no product, nothing to market.'

Willats chose Pinner High Street as one of the locations for *Imaginary Journey* because it seemed to him entirely typical, both in the way it confronted the user with a jumble of competing signs, and in its status as a 'random variable', a kind of open stage for the acting out of everyday life. The artist posits the work as a tool for the viewer to use in beginning to more accurately define his or herself in relation to society at large. 'It questions the idea of how we construct reality itself, of what we hang on to,' he states. 'It's a work that says: Whatever you imagine is happening *is* happening. It's as simple as that in the end.'

West London Social Resource Project 'Public Monitor',
originally shown...1972. Reproduced 2006-2007,
Art Link, Götenborgs Konsthall, Sweden.

Cybernetic Still Life No. 6, 2010. Acrylic and pencil on wall,
two colour videos with sound, wood plinths.
Installation view, Thomas Schulte Galerie, Berlin.

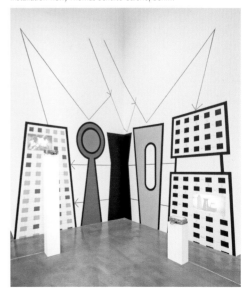

Sue Williams

Born in Chicago, USA, 1954; lives and works in New York. Williams's work has been exhibited internationally at institutions including the Museum of Modern Art, New York; Art Institute of Chicago; Museum of Contemporary Art, Los Angeles; Vancouver Art Gallery; Dallas Museum of Art; Museum voor Moderne Kunst, Arnhem; Palais de Tokyo, Paris; and SITE Santa Fe. She has been the subject of solo exhibitions at the Carpenter Center for Visual Arts at Harvard University, Cambridge, Massachusetts; Instituto Valenciano de Arte Moderno, Valencia; Secession, Vienna; and the Centre d'Art contemporain, Geneva.

A key figure in American art of the 1990s, Sue Williams first gained critical attention in the early 1980s for images that take issue with the attitudes and aesthetics of much contemporaneous feminist art, proposing a visceral and caustically funny alternative. Many of these early works draw on the artist's experience of domestic abuse, bringing the personal and the political together with provocative force. In paintings, drawings, collages and sculptures, Williams explores the corporeal with a candour that has broadened the scope of critical discourse around art made by women while remaining direct and engaging. In recent years, the artist's practice has undergone repeated refinement and revision, but remains concerned with gender politics and the body at its most crudely organic.

In Williams's large painting *War of the Testicles*, 2010, a tangled network of bulbous, distinctly cartoon-like forms in shades of acid pink and bile green, blood red and fleshy beige spills across a flat, pale blue ground. Some of these resemble bulging intestines, others the titular gonads. The overall effect is of an exuberant bio-cartography, an unsparing but not unsmiling depiction of all that is moist, pulsating and problematic within the male form. 'In this abstracted image of testosterone stress,' writes critic Walter

Williams explores the corporeal with a candour that that has broadened the scope of critical discourse around art made by women.

Robinson, 'Williams's invention could be called the "scrotal line", a kind of ragged arabesque that is peculiarly familiar but never before committed to canvas. And that would be, of course, decrepit old-man scrotum, not fresh new baby scrotum.'

As Robinson's description implies, Williams's recent and current work exists on the border between abstraction and figuration. This is a position that she has arrived at gradually, moving from the narrative and illustrative touches of her 1980s and early 1990s output to a non-representational phase in the early-to-mid 2000s, before latterly achieving a consciously uneasy synthesis of the two approaches. In the drawing *Ballerinas Attempt to Rematerialize, Knowing They Face Technical Difficulties*, 1991, for example, fragments of dancers' bodies seem to shift in and out of focus, reflecting a system of anxiety around 'feminine' style and power. In *Re-uptake Inhibitors*, 2002, however, Williams eschews such recognizable imagery in favour of a mass of pink squiggles, the painting's title being the only element that roots it in her established themes.

War of the Testicles, which was featured in a retrospective, called 'Al-Qaeda Is the CIA', curated by artist Nate Lowman for New York's 303 Gallery in 2010, also reflects a gradual shift in Williams's compositional approach. While works like *Your Bland Essence*, 1993, employ a deliberately raw, episodic layout representing a set of arguments-in-progress, *War* belongs to an extended group of 'all-over' paintings that present their subjects in the form of uninterrupted visual fields. The latter strategy is no less unnerving in that it allows no escape, weaving the blood and guts of desire and repulsion into a claustrophobic human tapestry that recalls the absurdist excesses of English cartoonist Baxendale as much as it does the formal innovations of Abstract Expressionism, or the philosophical breakthroughs of feminist thought.

Your Bland Essence, 1993. Acrylic on canvas, 152.4 x 172.7 cm.

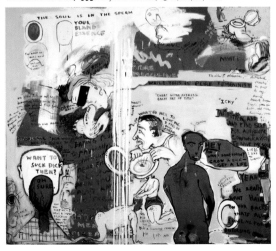

Ballerinas Attempt to Rematerialize, Knowing They Face Technical Difficulties, 1991.
Graphite and acrylic on paper on canvas, 81.3 x 81.3 cm.

Book from the Ground, 2003–

Installation view with two computers, The Museum of Modern Art, New York.

Xu Bing

Born in Chongqing, China, 1955; lives and works in New York, USA. Xu's work has been the subject of solo exhibitions at the Arthur M. Sackler Gallery, Smithsonian Institution, Washington, D.C.; the New Museum, New York; and the British Museum, London. He has also exhibited at the Venice Biennale, the Biennale of Sydney and the Johannesburg Biennale. Xu was the recipient of a MacArthur Fellowship in 1999.

Monkeys Grasp for the Moon, 2001.
Lacquer on wood,
2591 x 78 x 4 cm,
Smithsonian Institution,
Washington, D.C.

'In the past decade,' writes Xu Bing in his essay-statement Regarding Book from the Ground, 2006, 'I have spent countless hours in airports and aboard airplanes. The design of airport signs and airline safety manuals is based upon image recognition. Diagrams there are employed as the primary means of communication in an attempt to explain relatively complex matters with a minimum of words. It was this that truly fascinated me.' One of several projects that has emerged from Xu's preoccupation has been *Book from the Ground*, 2003– , a novel 'written' in visual icons of the kind that dominate the transitional, transnational environments he describes. The artist began collecting airline safety cards in 1999, but it was an instruction on the back of a chewing-gum wrapper that finally inspired him to explore pictographic language in his work.

Launching a more extensive and purposeful survey into extra-linguistic communication, Xu proceeded to assemble an archive of icons and insignia with a global reach, taking into account many new examples associated with personal computing and the Internet. He also researched the history of written language and the ideal of a 'single script', noting the possibility's enhanced significance in an era of accelerating globalization. 'Our existing languages are based on geography, ethnicity and culture (including all-powerful English),' he observes, 'and all fall short.' This emergent deficiency has, Xu suggests, resulted in a process that mirrors early linguistic development by again positioning images at the forefront of human communication.

In *Book from the Ground*, pre-existing representative and organizational principles are combined in the making of a work of fiction that may also come to function as a dictionary of sorts ('I believe that the significance of a work does not lie in its resemblance to art,' writes Xu, 'but in its ability to present a new way of looking at things'). Formally, *Book* exists as a piece of computer software that allows users to compose their own sentences in the artist's font. When the work is exhibited, a pair of computers separated by a Plexiglas screen facilitates dialogue between two users but, in an allusion to the ubiquity of e-mail and instant messaging, precludes face-to-face contact between them. The screen also displays a sample narrative with a telling theme: a conversation on a plane.

Book from the Ground might be considered a companion piece to Xu's *Book from the Sky*, 1987–1991. In the earlier work, handmade rice-paper books and scrolls have been printed, using carved wooden blocks, with invented and thus unintelligible faux-Chinese characters. The 'reader' is thus rendered illiterate regardless of heritage or knowledge, and the utility of writing itself is both highlighted and called into question. While *Book from the Sky* thus speaks to the capacity of language to exclude, *Book from the Ground* aims to identify the democratic potential of a new communicative method that expands on a shared historical form. For Xu, who grew up in China during the Cultural Revolution and moved to the United States aged 35, both projects reflect on the experience of learning and relearning in order to understand and to make oneself understood.

Book from the Ground (detail), 2003– .

The Living Word, 2001. Cut and painted acrylic characters.

Book from the Sky, 1987–1991.
Mixed media. Installation view, National Gallery of Canada, Ottawa, 1998.

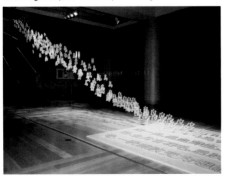

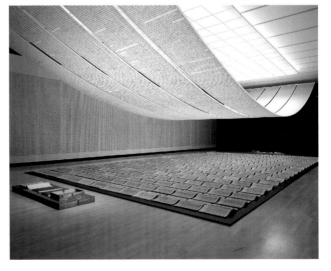

In Just a Blink of an Eye, 2007

Performance view, James Cohan Gallery, New York, 2007. Co-presented with Long March Project as part of Performa 07.

Xu Zhen

Born in Shanghai, China, 1977; lives and works there. Xu Zhen's work has been featured in numerous important group exhibitions and biennials including 'The Real Thing: Contemporary Art from China' at Tate Liverpool; 'Mahjong,' Kunstmuseum Bern; 'Art of Change: New Directions from China' at the Hayward Gallery, London; the 2nd Guangzhou Triennial; and the 2001 and 2005 Venice Biennales. He has also been the subject of solo exhibitions at Long March Space, Beijing; Museum Boijmans Van Beuningen, Rotterdam; and James Cohan Gallery, New York. Zhen also now works under the company name MadeIn Inc.

Visitors to James Cohan Gallery in New York during the Performa 07 live art festival were confronted with a seemingly impossible situation. Distributed around the space were several individuals frozen at gravity-defying angles. Leaning awkwardly as if caught mid-tumble, they remained suspended without visible means of support, action photographs made flesh. Xu Zhen's dance-like performance-installation *In Just a Blink of an Eye*, 2007, which recalls Robert Longo's drawings of besuited men twisting in seeming helplessness, makes for supremely disconcerting viewing. Even the knowledge that hidden metal frames are facilitating the participants' stances fails to banish its profoundly unnerving edge. There is a certain giddy pleasure in its apparent refusal of physical laws, but also an anxiety in its feeling of unnatural suspension and imminent collapse.

At James Cohan, *In Just a Blink of an Eye* was performed entirely by migrants recruited from Manhattan's Chinatown, a choice that pushed it beyond physical trickery or optical illusion and into the differently complex realm of cultural politics. Once we are aware of their origins, the fact of the participants' suspension takes on metaphorical significance: might they be described as 'stuck' in a particular living situation, caught between one nationality, one society, and another? The work's title suggests that we tend to give such possibilities only glancing acknowledgment, as if any associated

Once we are aware of their origins, the fact of the participants' suspension takes on metaphorical significance.

problems will cease to exist once we stop looking. The context of the gallery itself here represents another kind of liminal space, potentially functioning as a space for directing attention toward that which might otherwise remain overlooked.

When *In Just a Blink of an Eye* was included in the 2009 survey 'China! China! China!' at the Sainsbury Centre for Visual Arts in Norwich, England, curator Davide Quadrio made another connection: the physical instability on which the work hinges had taken on an added set of connotations since the global economic downturn. In this international exhibition, subtitled 'Contemporary Chinese art beyond the global market', it was hard to avoid the idea that Xu Zhen's performance encapsulated a new mood of uncertainty around global trade with serious implications for already vulnerable communities. That the work opens itself to such additional readings is an indicator of its strength: even as the image of those weirdly listing men and women resonates with specific new situations, the dreamlike impression it creates remains universally affecting.

In Just a Blink of an Eye may not immediately suggest a design sensibility, but Xu Zhen trained at a design school, and the lucidity of thinking this encouraged brings its influence to bear on his conceptual approach to art. In exploring issues around the shifting positions of contemporary China and its people, he meditates on their intersection with forms and situations familiar throughout the world. *ShanghART Supermarket*, 2007, for example, reproduces a typical convenience store in all but the contents of its packages, highlighting similarity and difference as reflected in an everyday setting. Xu Zhen is also an influential curator; in 1999, he initiated the Long March Project, a creative organization that combines the roles of gallery, atelier, consultancy and publishing house.

ShanghART Supermarket, 2007.
Cash register, counter, shelves, refrigerator and multiple consumer products, dimensions variable.

Things I see every morning when I wake up and think of every night before I sleep, 2009. Mixed media, 213.4 x 213.4 x 213.4 cm approx.

Dual Game, 2009. Mixed media, soil, snooker table, 82.6 x 205.7 x 383.5 cm.

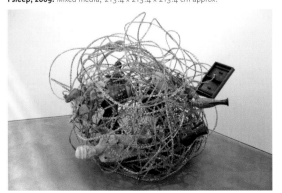

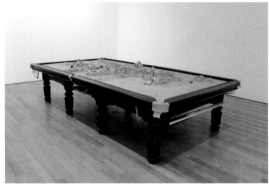

Professional call centre agent, direct-dial telephone connection, two telephones, chair, lamp, table, framed photograph of call centre agent.

Carey Young

Born in Lusaka, Zambia, 1970; lives and works in London, England. Young has been the subject of solo exhibitions at the Power Plant, Toronto, and Contemporary Art Museum St. Louis. Her work has also been presented at the Taipei Biennial; Moscow Biennale; Modern Art Oxford; and Performa 05, New York. A solo show, debuted at Eastside Projects, Birmingham, England, in November 2010 before touring to Cornerhouse, Manchester, and MiMA, Middlesborough, in 2011.

Disclaimer (Reality), 2010.
Vinyl text. Installation view, Walker Art Center, Minneapolis.

* There is no reality independent of subjective bias, but there is a reality that is influenced by it. In other words, there is a sequence of events which actually happens, and this sequence incorporates the effect of the participants' biases. It is likely, that is, that the actual course of events differs from the expectations of the participants, and the divergence can be assumed as an indication of the distortion that comes into play. Unfortunately, it only serves as an indication – not as a measure of the full bias – because the actual course of events already incorporates the effects of the participants' bias.

The call centre, with all of its attendant frustrations, has become a virtually unavoidable feature of modern life. While few people aside from employees ever visit one, most of us deal with them on a regular basis, making requests, performing transactions and lodging complaints. In her 2009 exhibition 'Speech Acts' at the Contemporary Art Museum St. Louis, Carey Young presented a series of works that use the structures and conventions of the call centre as a basis for considering problems of identity and interaction within a controlled and mediated virtual space. Young's work often probes the quirks and complexities of language, particularly as used and abused in the public spheres of commerce and law, so the call centre phenomenon provides her with an ideal forum.

Among the works featured in 'Speech Acts' was *The Representative,* 2005, an expansion on the telephone piece *Nothing Ventured,* 2000, in which Young paid a call centre to 'represent' her to viewers calling from a gallery. *The Representative* is a 'portrait' of an individual call centre agent that takes the form of a phone conversation conducted by visitors from a lounge constructed inside the gallery. Working with a carefully selected call centre agent, Young developed a loose script that revolves around aspects of the agent's life but allows for the possibility of being directed 'off-topic' by participants' comments and queries. The resultant calls are, in the artist's words, 'somewhere between a personal chat, an interview, the reality-TV style exposure of a "civilian", a script, an exposé of working conditions, a piece of journalistic research, a portrait, and a service, with the caller put in the position of researcher, audience, voyeur, client and potential friend.'

While it is accessed via a telephone and revolves around an exchange that can never be fully spontaneous, *The Representative* offers an unusually intimate experience. Key to this impression is the contrast between the shared physical space occupied by the installation in its museum setting and the privacy and invisibility of each unique conversation. 'The works act as negative spaces,' Carey explains, 'which reflect, invert and critique the exhibition site while alluding to the corporatization and globalization of culture, as well as the importance of agonism and rhetoric to the artistic context.'[1] Thus while *The Representative* hinges on interpersonal communication, it also represents a commentary on the socio-economic conditions that originate and maintain this radically alienated form.

Other 'negative spaces' that have come under Young's scrutiny include the advertising slogan (in the video *Product Recall,* 2007, a psychoanalyst prompts the artist to match up various slogans concerning creativity with their associated multinational brands), the contract (another video, *Uncertain Contract,* 2008, shows an actor interpreting legal terminology from a contract from which all specific detail has been excised), and disclaimers (the wall text *Disclaimer [Reality],* 2010, reframes a statement about bias in the context of financial investment as a more general philosophical argument about the nature of reality itself). And in a uniquely uncomfortable bit of linguistic and legal sleight-of-hand, *Declared Void,* 2005, delineates an area of the gallery in which the viewer is invited to contractually and temporarily relinquish their constitutional rights.

1 '500 Words: Carey Young on "Speech Acts"', interview by Miriam Katz, *artforum.com,* 5 May 2009. http://artforum.com/words/id=22759

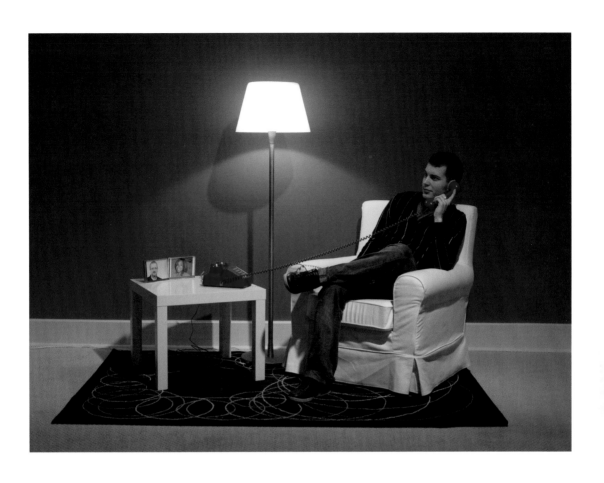

Uncertain Contract, 2008.
Colour video with sound, 14 minutes 57 seconds. Production still.

Declared Void, 2005.
Vinyl drawing and text, dimensions variable.
Installation view, Paula Cooper Gallery, New York.

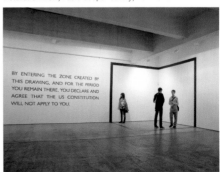

Lisa Yuskavage

Born in Philadelphia, USA, 1962; lives and works in New York. Yuskavage has been the subject of solo exhibitions at the Museo Tamayo, Mexico City; Centre d'Art Contemporain, Geneva; and the Institute of Contemporary Art at the University of Pennsylvania. Her work was also included in the Whitney Biennial in 2000. Yuskavage's work is represented in numerous collections, including those of the Art Institute of Chicago; Museum of Contemporary Art, San Diego; Stedelijk Museum, Amsterdam; and the Whitney Museum of American Art, New York.

Dubbed one of the 'bad girls' of American art in the 1990s along with Sue Williams, Rita Ackermann and Cecily Brown, Lisa Yuskavage has continued to pursue her own heightened vision of female sexuality, drawing on both art-historical and pop-cultural sources to imagine a provocative new strain of figure painting. Like her contemporary John Currin, she exercises considerable academic skill in picturing her over-the-top characters, using every trick in the illustrational book to lend them extra visual punch. Yuskavage's nudes, with their oversized breasts and behinds, pinched waists and flowing locks, are like pornographic cartoons made flesh. Bathed in atmospheric light, they seem to exist in a kind of romantic dream world, lost in private sensual pleasure and isolated from the trials of everyday life.

Fireplace, 2010, riffs off Manet's *Olympia*, 1863, but does so in characteristically pulpy style. It depicts a naked woman with a red ribbon tied around her neck and her legs spread toward the viewer. Another woman looms behind her, while a fireplace in the background casts a warm glow over the scene. The interior is comfortably domestic, but the relationship between its inhabitants appears coldly professional, conveying a hint of menace that is unusual for the artist. Yet while the main figure's pallid complexion and vulnerable pose seem to promise a shot of dirty realism, the painting finally retains the self-consciously kitsch styling of Yuskavage's work in general. Its expansive scale also adds a suggestion of the cinematic, distancing the action still further from reality.

> **Yuskavage's nudes, with their oversized breasts and behinds, pinched waists and flowing locks, are like pornographic cartoons made flesh.**

Poet Mónica de la Torre picks up on this tendency, describing the artist as possessed of 'a director's sense of narrative and character'. Yuskavage's subjects, again like Currin's, often feel like players in a perverse or perverted drama. In *PieFace*, 2008, an absurdly voluptuous woman, naked bar a pair of lilac panties, clutches a handful of flowers to her crotch as cream from the titular pie dribbles from her face onto her balloon-like breasts. The artist acknowledges 'pie-ing' as a form of violent-comedic protest, but also points to its link with erotic role-play: 'I started to look it up on the web,' she remembers, 'and I discovered there was this whole category called "Messy Fun", which is about people who like to throw food at each other as a way of getting sexual kicks.' *PieFace* thus invests the cruelty of real humiliation with 'a certain kind of covert Expressionism'.

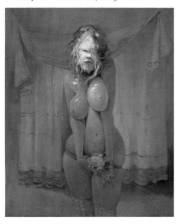

PieFace, 2008. Oil on linen, 121.9 x 102.2 cm.

The cream in *PieFace* also transforms its subject's visage into an opaque mask that disguises her identity, again directing the viewer toward Yuskavage's complex relationship to the male gaze - the inherently gendered act of observation that slides all too easily into a voyeuristic expression of power. The pastel sweetness of Yuskavage's palette, the lush ripeness of her always-female figures, and their consciously detached homely or pastoral settings parody the clichés of softcore fantasy. Yet rather than merely poking fun, Yuskavage actually seems to reanimate these overfamiliar scenarios by claiming them for herself, fascinatingly throwing the paintings' own 'orientation' into doubt.

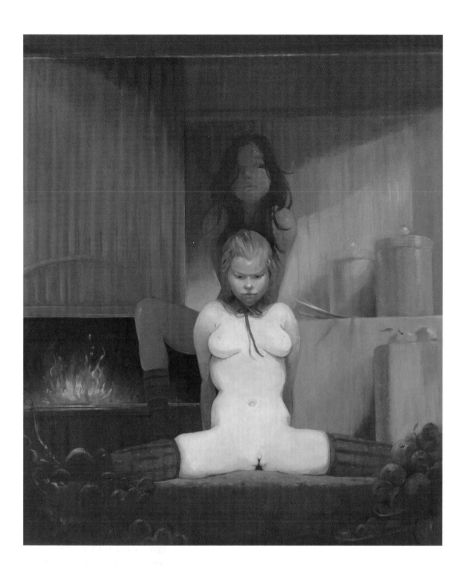

Balls, 2004. Oil on linen, 97.2 x 153 cm.

Day, 1999–2000. Oil on linen, 195.6 x 157.5 cm.

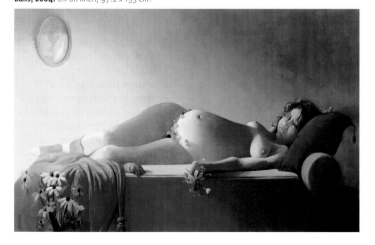

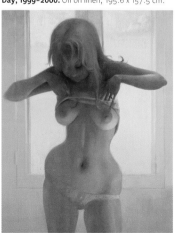

Selected Bibliography and Further Reading

General background and group exhibition catalogues

Julieta Aranda, Brian Kuan Wood, Anton Vidokle, Cauauhtemoc Medina, Boris Groys, Raqs Media Collective, Hans Ulrich Obrist, Hu Fang, Jorg Heiser and Martha Rosler, *What is Contemporary Art?* (e-flux journal), Berlin: Sternberg Press, 2010.

Michael Archer, *Art Since 1960*, London and New York: Thames & Hudson, second edition 2002.

Jack Bankowsky, Alison Gingeras and Catherine Wood (eds.), *Pop Life: Art in a Material World*, London: Tate Publishing, 2009.

Daniel Birnbaum, Connie Butler, Suzanne Cotter, Bice Curiger, Okwui Enwezor, Massimiliano Gioni, Bob Nickas and Hans Ulrich Obrist, *Defining Contemporary Art: 25 Years in 200 Pivotal Artworks*, London: Phaidon Press, 2011.

Daniel Birnbaum (ed.), *Making Worlds: 53rd International Art Exhibition: La Biennale di Venezia*, New York: Marsilio, 2011.

Claire Bishop, *Participation*, Whitechapel: Documents of Contemporary Art, Cambridge, Massachusetts: MIT Press, 2006.

Claire Bishop, *Installation Art*, London: Tate Publishing, 2011.

Francesco Bonami and Garry Carrion-Muryari (eds.), *Whitney Biennial 2010*, New York: Whitney Museum of American Art, 2010.

Nicholas Bourriaud, *Relational Aesthetics*, Dijon: Les presses du réel, 1998.

Nicholas Bourriaud, *Altermodern: Tate Triennial*, London: Tate Publishing, 2009.

Martha Buskirk, *The Contingent Object of Contemporary Art*, Cambridge, Massachusetts: MIT Press, 2005.

Melissa Chiu and Benjamin Genocchio, *Asian Art Now*, New York: The Monacelli Press, 2010.

Charlotte Cotton, *The Photograph as Contemporary Art*, London and New York: Thames & Hudson, second edition, 2009.

Bice Curiger (ed.), *ILLUMInations: 54th International Art Exhibition: La Biennale di Venezia*, New York: Marsilio, 2011.

Jeffrey Deitch, Roger Gastman and Aaron Rose, *Art in the Streets*, New York: Skira Rizzoli, 2011.

Emma Dexter, *Vitamin D: New Perspectives in Drawing*, London: Phaidon Press, 2005.

Hal Foster, *The Return of the Real: The Avant-Garde at the End of the Century*, Cambridge, Massachusetts: MIT Press, 1996.

Hal Foster, Rosalind Krauss, Yve-Alain Bois and Benjamin Buchloh, *Art Since 1900: Modernism, Antimodernism, Postmodernism*, London and New York: Thames & Hudson, 2005.

Andrea Fraser, *Museum Highlights: The Writings of Andrea Fraser*, Cambridge, Massachusetts: MIT Press, 2005.

Michael Fried, *Why Photography Matters as Art as Never Before*, New Haven and London: Yale University Press, 2008.

Liam Gillick and Lionel Bovier (eds.), *Proxemics: Selected Essays (1988-2006)*, Zurich: JRP|Ringier, 2006.

RoseLee Goldberg, *Performance Art: From Futurism to the Present*, London and New York: Thames & Hudson, third edition, 2011.

Rachel Greene, *Internet Art*, London and New York: Thames & Hudson, 2004.

Jonathan Harris (ed.), *Globalization and Contemporary Art*, London: Wiley-Blackwell, 2011.

Charles Harrison and Paul Woods (eds.), *Art in Theory 1900-2000: An Anthology of Changing Ideas*, London: Blackwell, second edition, 2002.

Eleanor Heartney, *Postmodernism*, London: Tate Publishing, 2001.

Eleanor Heartney, *Art & Today*, London: Phaidon Press, 2008.

Laura Hoptman, Richard Flood, Massimiliano Gioni and Trevor Smith, *Unmonumental: The Object in the 21st Century*, London: Phaidon Press, 2007.

Craig Houser, Leslie C. Jones, Simon Taylor and Jack Ben-Levi, *Abject Art: Repulsion and Desire in American Art* (ISP Papers No. 3), New York: Whitney Museum of American Art, 1993.

Henrietta Huldisch, Shamim M. Momin and Rebecca Solnit, *Whitney Biennial 2008*, New York: Whitney Museum of American Art, 2008.

IRWIN (eds.), *East Art Map: Contemporary Art and Eastern Europe*, London: Afterall, 2006.

Stephen Johnstone (ed.), *The Everyday*, Whitechapel: Documents of Contemporary Art, Cambridge, Massachusetts: MIT Press, 2008.

Rosalind Krauss, '*A Voyage on the North Sea': Art in the Age of the Post-Medium Condition (Walter Neurath Memorial Lecture)*, London and New York: Thames & Hudson, 2000.

Alan Licht and Jim O'Rourke, *Sound Art: Beyond Music, Between Categories*, New York: Rizzoli, 2007.

Charlotte Mullins, *Painting People: Figure Painting Today*, London and New York: Thames & Hudson, 2006.

Takashi Murakami, *Superflat*, Tokyo: Madora Shuppan, 2000.

Bob Nickas, *Painting Abstraction: New Elements in Abstract Painting*, London: Phaidon Press, 2009.

Brian O'Doherty, *Inside the White Cube: The Ideology of the Gallery Space*, University of California Press, expanded edition, 2000.

Michael Petry, *The Art of Not Making: The New Artist/Artisan Relationship*, London and New York: Thames & Hudson, 2012.

Al Rees, David Curtis, Duncan White and Steven Ball (eds.), *Expanded Cinema: Art, Performance, Film*, London: Tate Publishing, 2011.

Aaron Rose, Christian Strike, Alex Baker, Arty Nelson, Jocko Weyland et al., *Beautiful Losers: Contemporary Art and Street Culture*, New York: Distributed Art Publishers / Iconoclast, second edition, 2005.

Jerry Saltz, *Seeing Out Loud: The Voice Art Columns Fall 1998-Winter 2003*, Great Barrington: The Figures, 2003.

Jerry Saltz, *Seeing Out Louder: Art Criticism 2003-2009*, Manchester: Hudson Hills Press, 2009.

Barry Schwabsky, *Vitamin P: New Perspectives in Painting*, London: Phaidon Press, 2004.

Katy Siegel, *Since '45: America and the Making of Contemporary Art*, New York: Reaktion Books, 2011.

Julian Stallabrass, *Art Incorporated: The Story of Contemporary Art*, Oxford University Press, 2005.

Nato Thompspon, *The Interventionists: User's Manual for the Creative Disruption of Everyday Life*, North Adams: Mass MoCA, second edition, 2006.

Sarah Thornton, *Seven Days in the Art World*, New York: W.W. Norton and Company, 2009.

Kirk Varnedoe, Adam Gopnik and Earl A. Powell III, *Pictures of Nothing: Abstract Art since Pollock*, Princeton University Press, 2006.

Tracey Warr (ed.) and Amelia Jones, *The Artist's Body*, London: Phaidon Press, 2000.

Monographs, monographic exhibition catalogues and artists' books

Marina Abramović and Arthur C. Danto, *Shirin Neshat*, New York: Rizzoli, 2010.

Eija-Liisa Ahtila, *Eija-Liisa Ahtila: Where is Where*, Cologne: Walther König, 2011.

Ai Weiwei, *Ai Weiwei's Blog: Writings, Interviews, and Digital Rants, 2006-2009*, Cambridge, Massachusetts: MIT Press, 2011.

Doug Aitken and Noel Daniel, *Broken Screen: Expanding the Image, Breaking the Narrative*, New York: Distributed Art Publishers, Inc., 2005.

Jennifer Allora and Guillermo Calzadilla, *Allora & Calzadilla: & Etcetera*, Cologne: Walther König, 2010.

Ulrich Baer, Dave Eggers, Caoimhin Mac Giolla Leith and Thomas Demand, *Thomas Demand: L'esprit d'escalier*, Dublin: Irish Museum of Modern Art, 2007.

Mieke Bal, *Of What One Cannot Speak: Doris Salcedo's Political Art*, University Of Chicago Press, 2011.

Ute Meta Bauer, Anja Casser, Philipp Ziegler and Stephen Willats, *Stephen Willats: Art Society Feedback*, Vienna: Verlag für Moderne Kunst Nurnberg, bilingual edition, 2011.

Christopher Bedford, Hamza Walker, Hilton Als, Robert Storr, Richard Shiff, Katy Siegel and Carol S. Elie, *Mark Bradford*, Wexner Center for the Arts / Yale University Press, 2010.

Klaus Biesenbach (ed.), Peter Fischli, David Weiss and Douglas Gordon, *Douglas Gordon: Timeline*, New York: Museum of Modern Art, 2006.

Klaus Biesenbach and Mark Godfrey (eds.), *Francis Alÿs: A Story of Deception*, New York: Museum of Modern Art, 2010.

Klaus Biesenbach, Arthur C. Danto, Chrissie Iles, Nancy Spector and Jovana Stokić, *Marina Abramović: The Artist is Present*, New York: Museum of Modern Art, 2010.

Claire Bishop, Thomas Bizzari (ed.) and Thomas Hirschhorn, *Thomas Hirschhorn: Establishing a Critical Corpus*, Zurich: JRP|Ringier, 2011.

Dan Cameron, Kate Eilertsen and Pam McClusky, *Nick Cave: Meet Me at the Center of the Earth*, San Francisco: Yerba Buena Art Center for the Arts, 2009.

Gary Carrion-Murayari, *Rudolf Stingel*, Ostfildern: Hatje Cantz, 2009.

Matthew Coolidge (ed.), Sarah Simons (ed.) and Ralph Rugoff, *Overlook: Exploring the Internal Fringes of America with the Center for Land Use Interpretation*, New York: Metropolis Books, 2006.

Jonathan Crary, Russell Ferguson, Holly Myers and Uta Barth, *Uta Barth: The Long Now*, New York: Gregory R. Miller & Co., 2010.

T.J. Demos, *Zarina Bhimji*, Manchester: Cornerhouse Publications, 2010.

Tom Eccles, Iwona Blazwick and Jack Bankowsky, *Rachel Harrison: Museum with Walls*, Center for Curatorial Studies, Bard College / Whitechapel Gallery / Portikus, 2010.

Harrell Fletcher and Miranda July, *Learning to Love You More*, New York: Prestel USA, 2007.

Stephen Foster (ed.), *John Latham: Time-Base and the Universe*, Southampton: John Hansard Gallery, 2006.

David Frankel, *Russell Crotty*, Seattle: Marquand Books, 2006.

Massimiliano Gioni, *Matthew Barney*, Milan: Electa, 2007.

Paul Graham, *a shimmer of possibility*, London: steidlMACK, 2011.

Jeffrey Grove, *Michaël Borremans: Paintings*, Ostfildern: Hatje Cantz, 2010.

Adrian Heathfield and Tehching Hsieh, *Out of Now: The Lifeworks of Tehching Hsieh*, Cambridge, Massachusetts: MIT Press, 2008.

Damien Hirst, *I Want to Spend the Rest of My Life Everywhere, With Everyone, One to One, Always, Forever, Now*, London: Booth-Clibborn Editions, 1997.

Laura Hoptman, Bruce Hainley and Jan Verwoert, *Tomma Abts*, London: Phaidon Press, 2008.

Laura Hoptman et al., *Live Forever: Elizabeth Peyton*, London: Phaidon Press, reprint edition, 2011.

Branden W. Joseph, *Beyond the Dream Syndicate: Tony Conrad and the Arts After Cage*, New York: Zone, 2011.

Roman Kurzmeyer, Adam Szymczyk, Suzanne Cotter and Paweł Althamer, *Paweł Althamer*, London: Phaidon Press, 2011.

Sean Landers, *[sic.]*, New York: Glenn Horowitz Bookseller, third edition, 2010.

Elisabeth Lebovici et al., *À l'attaque: Adel Abdessemed,* Zurich: JRP|Ringier, 2007.

Susan May (ed.), *Olafur Eliasson: The Weather Project*, London: Tate Publishing, 2003.

Charles Merewether and Ann-Sofi Noring, *Karin Mamma Andersson*, Göttingen: Steidl, 2008.

Jessica Morgan, *Carsten Höller: Test Site (Unilever Series)*, London: Tate Publishing, 2007.

Gloria Moure and Vito Acconci, *Vito Acconci: Writings, Works, Projects*, Barcelona: Ediciones Polígrafa, 2001.

Kirsi Peltomäki, *Situation Aesthetics: The Work of Michael Asher*, Boston: MIT Press, 2010.

Scott Rothkopf, *Glenn Ligon: America*, New York: Whitney Museum of American Art, 2011.

Jean-Christophe Royoux, Marina Warner and Germaine Greer, *Tacita Dean*, London: Phaidon Press, 2006.

Taryn Simon, *An American Index of the Hidden and Unfamiliar*, Göttingen: Steidl, 2008.

Nancy Spector and Maurizio Cattelan (ed.), *Maurizio Cattelan: All*, New York: Guggenheim Museum Publications, 2011.

Raimar Stange, Thierry Davila and Michael Newman, *Pierre Bismuth*, Paris: Flammarion, 2006.

John Stezaker, Dawn Ades and Michael Bracewell, *John Stezaker*, London: Ridinghouse / Whitechapel Gallery, 2011.

Terrie Sultan (ed.), *Chantal Akerman: Moving Through Time and Space*, Blaffer Gallery, The Art Museum of the University of Houston, 2008.

Ann Temkin, Briony Fer and Benjamin Buchloh, *Gabriel Orozco*, New York: Museum of Modern Art, 2009.

Hsingyuan Tsao and Roger T. Ames (eds.), *Xu Bing and Contemporary Chinese Art: Cultural and Philosophical Reflections*, Albany: SUNY Press, 2011.

Philippe Vergne, Sander Gilman, Thomas McEvilley, Robert Storr, Kevin Young and Yasmil Raymond, *Kara Walker: My Complement, My Enemy, My Oppressor, My Love*, Minneapolis: Walker Art Center, 2007.

Chris Ware, *Jimmy Corrigan: The Smartest Kid on Earth*, New York: Pantheon, 2003.

Articles and reviews

Eric Aho, 'Meeting of Minds: Eric Aho Puts Five Questions to Ellen Altfest', *Modern Painters*, April 2010, 40.

Daniel Birnbaum, John Kelsey and Jessica Morgan, 'Man without Qualities: The Art of Michael Krebber', *Artforum,* October 2005, 220-227.

Claire Bishop, 'The Social Turn: Collaboration and Its Discontents', *Artforum,* February 2006, 179-185.

Alex Farquharson, 'Jeremy Deller', *frieze,* issue 61, September 2001, 108.

Orit Gat, 'Artist Profile: Keren Cytter', *Rhizome,* 11 October 2011. http://rhizome.org/editorial/2011/oct/11/artist-profile-keren-cytter/

Martin Herbert, 'The Wormhole Theory', *Parkett,* no. 86, 2009, 78-83.

Tom Holert, 'Band of Outsiders: The Art of Kai Althoff', *Artforum,* October 2002.

Sarah Hromak, 'A Thing Remade: A Conversation with Paul Chan', *Rhizome,* 25 August 2011. http://rhizome.org/editorial/2011/aug/25/a-thing-remade-conversation-paul-chan/

Michael Hubl, 'Susan Hiller', *frieze,* issue 92, June-August 2005.

Scott Indrisek, 'Newsmaker: Gabriel Kuri', *Modern Painters*, March 2011, 17.

Jordan Kantor, 'The Tuymans Effect: Wilhelm Sasnal, Eberhard Havekost, Magnus von Plessen', *Artforum*, November, 2004, 164-171.

Jerry Saltz, 'Conspicuous Consumption', *New York Magazine*, 7 May 2007.

Elizabeth Schambelan, 'Lucy McKenzie', *Artforum*, November 2005.

Debra Singer, 'First Take: Debra Singer on Tamy Ben-Tor', *Artforum*, January 2006, 192-193.

David Velasco, 'Larry Clark', *Artforum*, December 2007, 350.

David Velasco, 'Gelitin', *Artforum*, April 2010, 198.

Anne M. Wagner, 'Field Trips: Anne M. Wagner on the Art of Mary Heilmann', *Artforum*, November 2007.

Michael Wilson, 'Graphic Equalizer: Michael Wilson on Dan Perjovschi', *Artforum*, May 2006, 83-84.

Michael Wilson, 'Richard Aldrich', *Artforum*, March 2009, 242.

Rachel Wolff, 'Fear and Fancy', *New York Magazine*, 5 September 2010.

Websites

0100101110101101.org, http://www.0100101110101101.org/blog/

Afterall, http://www.afterall.org/

ArtAsiaPacific, http://artasiapacific.com/

Art Babble, http://www.artbabble.org/

Art 21, http://www.pbs.org/art21/

Artinfo, http://www.artinfo.com/

Artforum, http://artforum.com/

Artnet, http://www.artnet.com/

Bruce High Quality Foundation http://thebrucehighqualityfoundation.com/Site/home.html

e-flux, http://www.e-flux.com/

Frieze, http://www.frieze.com/

Jodi, http://www.jodi.org/

Learning to Love You More (Harrell Fletcher and Miranda July), http://www.learningtoloveyoumore.com/

net-art.org, http://www.net-art.org/

Rhizome, http://rhizome.org/

Index of Proper Names

Page numbers in bold refer to illustrations.

Photographic Credits

Every effort has been made to contact copyright-holders of photographs. Any copyright-holders we have been unable to reach or to whom inaccurate acknowledgment has been made are invited to contact the publisher.

1301PE, Los Angeles: 373; 303 Gallery, New York: 189 (top), (centre), (bottom left), 181 (top), (bottom right), 319 (top), (bottom left), (bottom right), 381; 303 Gallery, New York / Galerie Eva Presenhuber, Zurich / Victoria Miro, London / Regen Projects, Los Angeles: 25 (centre left), (centre right), (bottom); 303 Gallery, New York / Hauser & Wirth: 180 (bottom), 181 (bottom left); 303 Gallery, New York / Victoria Miro Gallery, London / Galerie Eva Presenhuber, Zurich / Regen Projects, Los Angeles: 25 (top); Acconci Studio / Sabam Belgium: 19 (top left), (top right), (bottom left), (bottom right); © Adel Abdessemed, ADAGP Paris 2012, courtesy the artist and David Zwirner New York / London: 11-13; Alexander and Bonin, New York: 121 (top), (centre left); Anders Sune Berg: 132 (bottom); Andrew Kreps Gallery: 49 (top), 71 (bottom left), 239 (top left), (bottom left); Anton Kern Gallery, New York: 208 (bottom); Anton Kern Gallery New York / Covi-Mora, London / Marc Foxx, Los Angeles: 100 (bottom), 101 (top), (bottom right); archive Kubisch: 221 (bottom right); Art Production Fund, New York / Ballroom Marfa, Marfa: 133 (top), (bottom left); Art Production Fund, New York / Ballroom Marfa, Marfa: 133 (top), (bottom left); artdce.de: 47 (bottom right); Artspace and Michael Lett, Auckland: 292 (bottom); Art: Concept, Paris / Produzentengalerie, Hamburg / Pilar Corrias Gallery, London: 77 (top), (bottom right); Axel Schneider, Frankfurt: 281 (bottom), 349 (bottom right); Basel & Wilkinson Gallery, London: 333 (bottom left); Bortolami Gallery, New York: 28 (bottom), 29 (top left), (top right), (bottom left), (bottom right); Brent Sikkema Gallery, New York: 366 (bottom left); carlier|gebauer: 257 (centre), (bottom left), (bottom right); Carroll / Fletcher, London: 9 (top), (centre); Casey Kaplan, New York: 86 (bottom), 87 (top), (bottom), 183 (centre), (bottom left), 341 (centre left), (bottom right); © Takashi Murakami / Kaikai Kiki Co., Ltd. All Rights Reserved, photos Cedric Delsaux: 267; Center for Land Use Interpretation photo archive: 92 (bottom), 93 (top), (bottom); Cheim & Read, New York: 303 (bottom left), (bottom right); Contemporary Fine Arts, Berlin: 311 (top); Courtesy David Zwirner, New York: 39-41; Courtesy David Zwirner, New York and Galerie Eigen + Art, Berlin / Leipzig: 315; Courtesy David Zwirner, New York and Zeno X Gallery, Antwerp: 67; Courtesy greengrassi, London and David Zwirner, New York: 17; Courtesy Galleria Continua (San Gimignano / Beijing / Le Moulin): 286-287; Courtesy M HKA (Antwerp) and the collection of the Flemish Community / Sabam Belgium: 285 (bottom); Courtesy the artist and David Zwirner, New York: 43, 384-385; Courtesy the artist and Galleria Continua (San Gimignano / Beijing / Le Moulin) Galerie Krinzinger (Vienna), Xavier Hufkens (Brussels), Marianne Boesky Gallery (New York), Galerie Ron Mandos (Rotterdam / Amsterdam) / Sabam Belgium: 285 (top); Creative Time: 275 (top); CRG Gallery, New York: 105 (bottom right); © Damien Hirst and Science Ltd. All rights reserved, Dacs 2012 / Sabam Belgium: 190-191, photo Prudence Cuming Associates Ltd. 191 (top); David Bordes: 255 (bottom right); David Zwirner, New York and Maccarone, New York: 68 (bottom), 69 (top), (bottom); dépendance, Brussels: 218 (bottom); Dieter Scheyhing: 221 (bottom left); Digital Image Museum Associates / LACMA / Art Resource New York / Scala, Florence: 303 (top), 303-304; Digital image, The Museum of Modern Art, New York / Scala, Florence: 40-41, 150 (bottom), 177 (top), 189 (bottom right), 195 (centre), (bottom left), 226 (bottom), 253 (top), 339 (top), 357 (top), 371 (bottom left), 374 (bottom); Dijon Consortium and Kimsooja Studio: 215 (bottom right); Eckehard Güther: 221 (bottom left); Eliot Wymann: 45 (top), (centre); Eungie Joo: 363 (top), (centre); e-flux: 363 (bottom left), (bottom right); Foskal Gallery, Warsaw: 186-187; Friedrich Petzel Gallery, New York: 182 (bottom), 183 (top), (bottom left), (bottom right), 329 (bottom right), 342 (bottom), 343 (top), (bottom left), (bottom right); Frith Street Gallery, London: 295 (top left), (top right), (centre right); Frith Street Gallery, London and Marian Goodman Gallery New York / Paris: 111 (centre), (bottom); Gagosian Gallery: 153 (top), (centre left), (centre right), (bottom left), 165 (top), (bottom left), (bottom right), 193 (bottom left), (bottom right); Gagosian Gallery and Hauser & Wirth: 153 (bottom right); Galeria Artiaco: 207 (bottom right); Galleria Franco Noero, Turin: 223 (bottom right); Galeria Helga de Alvear: 133 (bottom right); Galerie Barbara Weiss, Berlin: 259 (bottom); Galerie Buchholz, Berlin / Cologne: 161 (bottom), (bottom right), 219 (bottom left), (bottom right), 353 (top), 354-355; Galerie BUGADA & CARGNEL: 65 (bottom left); Galerie Chantal Crousel, Paris: 160 (bottom), 183 (top), 289 (bottom left); Galerie Christian Nagel: 149 (centre), (bottom left); Galerie Eva Presenhuber, Zurich: 141 (bottom right); Galerie Michel Rein, Paris: 125 (bottom left), (bottom right); Galerie Suzanne Tarasieve, Paris: 105 (bottom left); Galerie Thaddaeus Ropac: 349 (bottom left); Galerie Tschudi Zuoz: 198 (bottom), 199 (top), (bottom left), (bottom right); Galerija Gregor Podnar, Berlin / Ljubljana: 297 (top), (centre right); Gasworks and Kate MacGarry, London: 239 (bottom); Gavin Brown's enterprise, New York: 141 (top); GB Agency: 155 (bottom left); Gladstone Gallery, New York and Brussels: 31 (bottom left), (bottom right), 37 (top), (bottom right), 55, 56-57, 189 (top), (bottom left), (bottom right), 277 (top), (bottom); Greene Naftali, New York: 95 (top), (centre left), (centre right), (bottom), 102 (centre left), (bottom), 103, 157 (top), (bottom), 177 (bottom left), (bottom right); greengrassi, London: 17 (top), 139 (bottom left); Grey Art Gallery, New York University: 283 (top); Haus der Kunst, Munich: 31 (top); Hauser & Wirth: 172 (bottom), 173 (bottom left), (bottom right), 195 (bottom left); Hauser & Wirth and Arario Gallery, Beijing: 173 (top); ICA, Boston and kurimanzutto, Mexico City: 223 (bottom left); Indianapolis Museum of Art: 235 (bottom); Institute of Contemporary Arts, London and Tulips & Roses gallery, Brussels: 273 (bottom); INVISIBLE-EXPORTS: 309 (top), (bottom left), (bottom right); Jack Shainman Gallery, New York: 91 (right); James Cohan Gallery, New York / Shanghai: 260 (bottom), 261, 386 (bottom), 387 (top), (bottom), 388-389; Jan Bauer.net and Jonathan Meese.com: 250 (bottom), 251 (top), (bottom right); Jochen Littkemann: 311 (bottom left), (bottom right); John Latham Foundation and Lisson Gallery: 227 (top), (bottom left), (bottom right); Katrin Schilling: 125 (top); Kewenig Galerie and Kimsooja Studio: 215 (top), (centre); Kimsooja Studio: 215 (bottom left); Kunsthaus Zürich: 142-143; kurimanzutto, Mexico City: 223 (top left), (top right), 291 (top); L&M Arts: 174 (bottom), 175 (top); Laura Bartlett Gallery, London: 145 (bottom); Lehmann Maupin Gallery, New York: 81 (top), (bottom left), (bottom right); Leo Koenig Inc., New York: 126 (bottom), 127 (top), (bottom left), 347 (top), (centre), (bottom left); Leslie Tonkonow Artworks + Projects, New York: 271 (top), (centre), (bottom left), (bottom right); Lisson Gallery: 147 (bottom © Sabam Belgium), 155 (top), (bottom right), 335 (top); Lisson Gallery and Marina Abramović Archives: 15 (bottom right); Luc Demers: 307 (top); Luhring Augustine, New York and Gagosian Gallery: 375 (top), (bottom left), (bottom right); Luhring Augustine, New York and Galerie Barbara Weiss, Berlin: 83 (top), 97 (top), (centre left), (bottom right); Luhring Augustine, New York and Hauser & Wirth: 317 (top), (centre), (bottom left), (bottom right); Luhring Augustine, New York and Regen Projects, Los Angeles: 232 (bottom left); Marco Anelli: 15 (top); Marian Goodman Gallery, New York / Paris: 20 (bottom), 21 (top), (bottom), 27 (top), (centre left), (centre right), 111 (top), 118 (top), (bottom left), (bottom right), 201 (top), (centre left), (centre right), (bottom left), (bottom right), 202-203, 289 (top right), (bottom left); Mary Boone Gallery, New York: 65 (bottom left), 371 (top), (centre), (bottom left), (bottom right); Mary Boone Gallery and Jack Shainman Gallery, New York: 91 (left);

Matt's Gallery, London: 121 (bottom right); Massimo De Carlo: 158-159; Matthew Marks Gallery: 139 (top), (centre); Maureen Paley, London: 353 (bottom left), (bottom right), 371 (top left), (top right); Maureen Paley, London / Heather and Tony Podesta Collection, Washington DC: 371 (bottom right); Metro Pictures, New York: 376, 377 (top), (centre right), (bottom left), (bottom right); Michael Lett, Auckland: 293 (top), (bottom left), (bottom right); Mitchell-Innes and Nash Gallery, New York: 306 (bottom), 345 (bottom left), (bottom right); © Takashi Murakami / Kaikai Kiki Co., Ltd. All Rights Reserved, photos Cedric Delsaux: 267; Murray Guy, New York: 229 (top), (centre), (bottom left), (bottom right); Nathalie Karg / Cumulus Studios: 357 (bottom right); Nationalgalerie im Hamburger Bahnhof, Berlin: 83 (bottom right); Nationalgalerie im Hamburger Bahnhof, SMB: 192 (bottom); neugerriemschneider, Berlin and Foksal Gallery Foundation, Warsaw: 35 (bottom left), (bottom right); neugerriemschneider Berlin and Tanya Bonakdar Gallery, New York: 128 (bottom), 129, 130-131; Nicole Klagsbrun Gallery, New York: 321 (bottom right); Nicole Klagsbrun Gallery, New York and Andrea Rosen Gallery, New York: 321 (top), (bottom left); Nick Robertson: 135 (top), (bottom left); Niels Klinger: 297 (bottom left); Open Art Projects: 35 (top); Orcutt and van der Putten: 225 (bottom right); Oren Slor: 225 (top); Pace / MacGill Gallery, New York: 187 (top); Palazzo Grassi: 349 (top); Parisah Taghizadeh: 113 (bottom); Paul Hester: 345 (top); Paula Cooper Gallery, New York: 313 (top), (bottom); Paula Cooper Gallery, New York and Galerie Sfeir-Semler, Beirut / Hamburg: 312 (bottom); Performa: 320 (bottom); Pilar Corrias, London: 77 (bottom left), (bottom right), 107 (top), (centre), (bottom left), (bottom right), 108-109; Postmasters Gallery, New York: 9 (bottom); Public Art Fund, New York: 83 (bottom right); Ratio 3, San Francisco: 240 (bottom), 241 (top), (bottom); Regen Projects, Los Angeles: 232 (centre left), 303 (centre left); Regis Hertrich: 49 (top), (centre left); Renato Ghiazza: 282 (bottom); Romain Lopez: 188 (bottom); Ryuichi Maruo: 205 (top), (centre); Saatchi Gallery, London: 74-75, 241 (top right), 259 (top), 328 (bottom), 329 (bottom left); © Sabam Belgium: 15, 19-21, 60, 117, 147, 150-151, 170-171, 188-189, 192-193, 198-199, 201-203, 206-207, 221, 250-251, 259, 262-263, 291, 315, 334-335, 364; Sadie Coles HQ, London: 298 (bottom), 299 (top), (bottom left), (bottom right), 326, 327 (top), (bottom left), (bottom right); Salon 94, NewYork: 338 (bottom), 339 (bottom); Santa Monica Museum of Art: 47 (top), (centre left); Science Ltd.: 190 (bottom), 191 (top), (bottom left), (bottom right); Sculpture Center: 51 (centre right); Sean Kelly Gallery, New York: 85 (top), (bottom left), (bottom right); Sean Kelly Gallery, New York and Marina Abramović Archives: 15 (bottom left); Sean Landers Studio: 225 (bottom left); Serpentine Gallery, London: 255 (top); Sheldan C. Collins: 281 (top), (centre left); Sikkema Jenkins & Co., New York: 73 (top), (bottom), 366 (centre right); Solomon R. Guggenheim Foundation, New York: 15 (centre), 183 (bottom right); Solomon R. Guggenheim Museum, New York: 88 (bottom), 89, 233 (bottom); Stephen Friedman Gallery, London: 279 (top), (centre); Stephen Friedman Gallery, London and New Museum, New York: 279 (bottom); Susan Inglett Gallery, New York: 79 (top), (bottom right); Susanne Vielmetter, Los Angeles Projects: 71 (top), (centre), (bottom left), 127 (bottom right), 269 (top); Studio Wim Delvoye: 114 (bottom), 115 (top), (bottom left), (bottom right); Tanya Bonakdar Gallery, New York: 303 (top), (centre), (bottom left), (bottom right); Tanya Bonakdar Gallery, New York / 1301PE, Los Angeles: 59 (top), (bottom left), (bottom right); Tanya Leighton Gallery: 179 (top), (centre left), (centre right), (bottom right); Tate, London: 123 (bottom left), 184 (bottom), 193 (top), 255 (bottom left), 274 (bottom), 295 (bottom left), (bottom right), 323 (bottom left), 341 (top); Team Gallery, New York: 65 (top), 243 (top), (centre left), (bottom right), 282 (bottom), 283 (bottom); The Arts Council Collection & Wilkinson Gallery, London: 333 (top); The Bruce High Quality Foundation: 146 (bottom); The Museum of Contemporary Art, Los Angeles: 281 (top); The Museum of Modern Art, New York: 51 (bottom), 137 (bottom); The Pace Gallery: 235 (centre), (bottom), 236-237; Tilton Gallery: 175 (bottom left), (bottom right); Timothy Taylor Gallery, London: 185 (top); Timothy Taylor Gallery, London and Galerie Karin Sachs, Munich: 185 (bottom); Toby Webster Ltd, Glasgow: 113 (bottom); Tomio Koyama Gallery, Tokyo: 286-287; Tulips & Roses gallery, Brussels: 272, 273 (top), (centre right); VG BILD-KUNST, Bonn: 151 (top), 170, 171 (top), (bottom left), (bottom right); VG Bild-Kunst, Bonn / ARS, New York: 117 (top), (centre right), (bottom left), (bottom right); VG Bild-Kunst, Bonn / Matthew Marks Gallery: 151 (bottom left), (bottom right); Victoria Miro Gallery, London: 269 (bottom right), 310 (bottom), 351 (top), (bottom left), (bottom right), 379 (top), (bottom left); Western Project, Los Angeles: 49 (bottom right); White Cube: 33 (top), (bottom), 209 (top), (bottom right), 253 (bottom), 323 (top right), (bottom right); White Cube and Alexander and Bonin, New York: 323 (top left), 324-325; Whitney Museum of American Art, New York: 51 (bottom left), 233 (top); Wilkinson Gallery, London: 333 (centre left), (bottom right); Xu Bing Studio: 382 (bottom), 383 (top), (centre left), (bottom left), (bottom right); Yamaguchi Center for Arts and Media (YCAM): 205 (centre); Zach Feuer Gallery, New York: 53 (bottom left), 60 (bottom), 61 (top), (bottom); © Zarina Bhimji / Sabam Belgium: 63; Zeno X Gallery Antwerp / Sabam Belgium: 213.